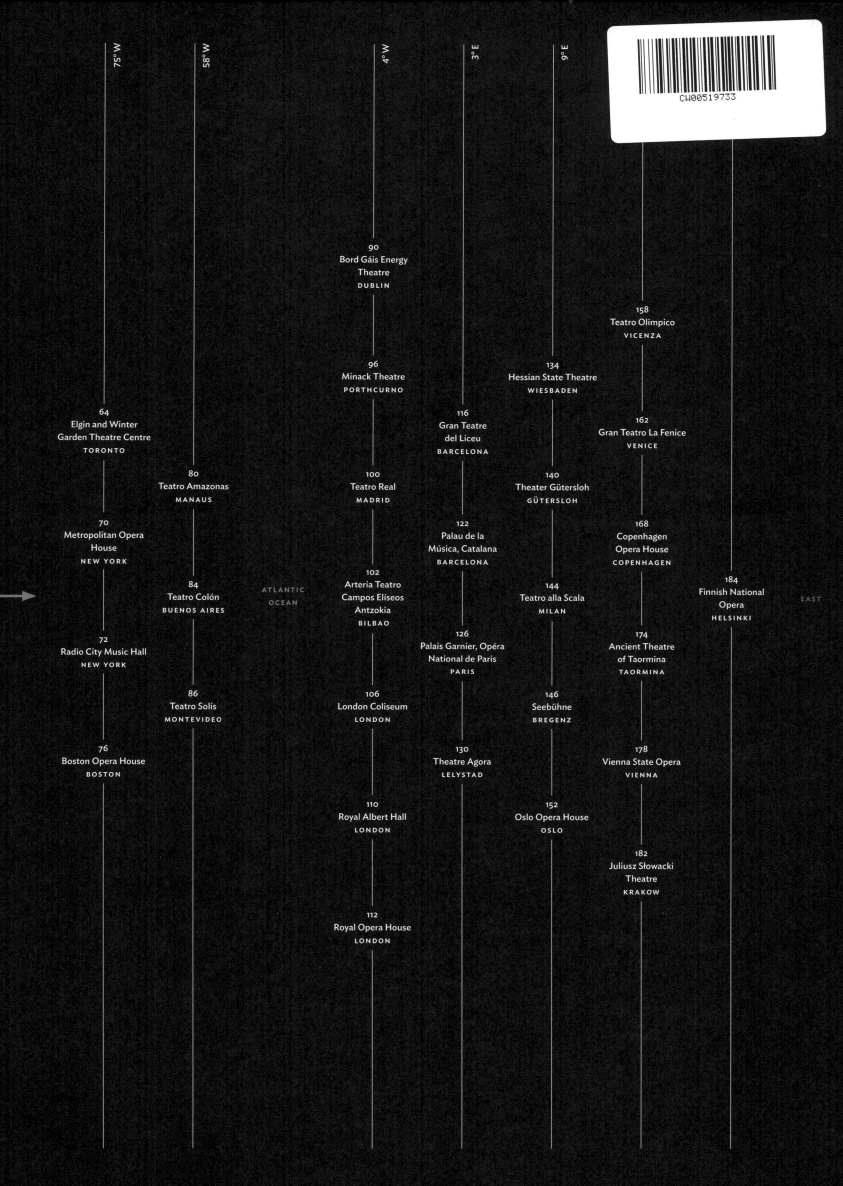

75° W

58° W

4° W

3° E

9° E

90
Bord Gáis Energy
Theatre
DUBLIN

158
Teatro Olimpico
VICENZA

96
Minack Theatre
PORTHCURNO

134
Hessian State Theatre
WIESBADEN

64
Elgin and Winter
Garden Theatre Centre
TORONTO

116
Gran Teatre
del Liceu
BARCELONA

162
Gran Teatro La Fenice
VENICE

80
Teatro Amazonas
MANAUS

100
Teatro Real
MADRID

140
Theater Gütersloh
GÜTERSLOH

70
Metropolitan Opera
House
NEW YORK

122
Palau de la
Música, Catalana
BARCELONA

168
Copenhagen
Opera House
COPENHAGEN

ATLANTIC
OCEAN

184
Finnish National
Opera
HELSINKI

EAST

84
Teatro Colón
BUENOS AIRES

102
Arteria Teatro
Campos Elíseos
Antzokia
BILBAO

144
Teatro alla Scala
MILAN

72
Radio City Music Hall
NEW YORK

126
Palais Garnier, Opéra
National de Paris
PARIS

174
Ancient Theatre
of Taormina
TAORMINA

86
Teatro Solís
MONTEVIDEO

106
London Coliseum
LONDON

146
Seebühne
BREGENZ

76
Boston Opera House
BOSTON

130
Theatre Agora
LELYSTAD

178
Vienna State Opera
VIENNA

110
Royal Albert Hall
LONDON

152
Oslo Opera House
OSLO

182
Juliusz Słowacki
Theatre
KRAKOW

112
Royal Opera House
LONDON

Roads Publishing
19–22 Dame Street
Dublin 2
Ireland

www.roads.co

First published 2014

1

Theatres
Roads Reflections
Text copyright © Roads Publishing
Design and layout copyright © Roads Publishing
Image copyright © the copyright holders; see p. 191
Design by Conor & David

Printed in India

British Library Cataloguing in Publication Data
A catalogue record for this book is available
from the British Library

Upper front-cover image:
Gran Teatro La Fenice, Michele Crosera
Lower front-cover image:
Copenhagen Opera House, Adam Mÿrk,
Henning Larsen Architects
Back cover image:
Wuxi Grand Theatre, Jussi Tiainen

978-1-909399-11-2

THEATRES

ROADS

PUBLISHING

Foreword

Pekka Salminen
PES-Architects

The human inclination to tell stories, and to listen to them, lies deep within us all. These days, new theatres are still being constructed all around the world, while many historical theatres are undergoing extensive renovation and modernisation. It is remarkable that this continues to be the case, in a time when the internet has made the exchange of ideas so freely and rapidly available to many people. Evidently, the internet cannot replace our love of public performance.

This book presents theatres from across the globe and from various eras. Many of those featured are historical milestones of theatre architecture. There are also many remarkable new theatres included, allowing us to analyse how the architecture of theatre as a public cultural space has developed over the last fifty years, since the Danish architect Jørn Utzon won the competition for the Sydney Opera House in 1957. Its revolutionary and unique form shaped Sydney's city landscape as a world heritage landmark and changed the way we think about theatre architecture.

Originally, the Greek *theatron* signified a group of people gathered to watch and listen to a performance or play. This first form of theatre in ancient Greece did not have a roof and was located on a hill slope, which created an amphitheatre-type auditorium for a large number of spectators.

By the time the Greek Epidaurus Theatre (349 BC) was constructed, the basic elements of the modern theatre building were in place: the orchestra, the round stage, and the skene (the backstage dressing and storage room, which could also serve as painted scenery).

In ancient Rome, theatres were constructed as free-standing structures and did not depend on natural slopes. Vitruvius, the Roman author, architect, and engineer in the first century BC, even gave detailed instructions for the seating comfort of the audience and laid down rules for vertical sight lines. He was also concerned with acoustics.

In the Middle Ages, there was not much interest in building designated theatre houses. Often, the interior and exterior spaces of churches served this purpose instead.

During the Renaissance, the endeavours of the ancient Greeks were further developed by covering the performance space completely with a roof; this type of building started to be called a theatre. At the time of the Renaissance, different kinds of machinery for creating spectacular effects became widely used.

One example of these early Renaissance theatres is Palladio's Teatro Olimpico (1585) in Vicenza, Italy, with its architectural stage set. In Britain, Shakespeare's remarkable Globe Theatre was constructed in 1599. An almost round building, its three floors of roofed galleries were surrounded by an open yard, and the stage, also roofed, projected into the middle of the audience.

The concept of opera was born in Italy, as a combination of music, poetry and theatre. At the beginning of the seventeenth century, it developed into an art form in its own right. The first opera house, the San Cassiano, was built in Venice in 1637.

In the mid-seventeenth century, the proscenium stage was introduced. It provided a frame for a fixed-perspective view. Another standard feature of Baroque theatre buildings was several levels of galleries and loges surrounding the auditorium.

In the nineteenth century, many grand theatres and opera buildings were designed in Europe to meet the demand for imposing bourgeois structures and urban landmarks. The Palais Garnier (1875), the famous opera house in Paris, named after its architect, has a magnificent foyer and central staircase, providing the most grandiose example of the theatre as a stage for social display.

In the twentieth century, modern theatre designers began to explore the integration of the stage with the auditorium, for instance Walter Gropius in his Totaltheater in 1927.

However, the fully flexible audience–stage relationship was mainly realised in smaller, experimental 'black box' type auditoriums, while the mainstream theatre and opera buildings followed the traditional idea of the proscenium theatre.

Today, the boom in building new cultural institutions, including theatres, in developing countries such as China, is the result of the desire for urbanisation and a growing middle-class with a need for cultural services. In these countries, the rapid pace of development can lead to an emphasis on the construction of impressive buildings without enough thought being given to the cultural activities for which they are built.

The importance of building such monumental structures has been appreciated through the centuries for the social value and prestige they possess. These buildings have often become uniting local or national symbols.

The special requirements set by the art of the opera for technology and acoustics lend these buildings a special glamour. Historically, opera houses were designed with a rather short reverberation time in order to make the words of the singers understandable.

The latest trend in Europe, however, has been to design new opera houses to adapt more flexibly to different kinds of music performances, even symphony concerts, with a longer reverberation time. Copenhagen Opera House by Henning Larsen and Oslo Opera House by Snøhetta are good examples of this kind of innovation. Oslo Opera House particularly is designed with the user experience in mind. This emphasis on the user begins as they approach the building and continues throughout all the public areas before entering the auditorium.

This same idea of user experience and the multi-functional use of the grand opera auditorium was the basic principle of my design team during the four-year design and construction period of Wuxi Grand Theatre in China.

Our digital era has created new possibilities and scope for performing artists. Performance can incorporate dance, light, music and drama together with a projection of fixed or moving images. As a result, there is no longer a special typology for performing-art buildings.

A contemporary theatre could even be a hybrid building, combining with other cultural or commercial facilities. The new parametric design techniques have made it possible to design and produce a completely new type of theatre. All these trends make performance halls a truly inspiring challenge for architects.

Vorwort

Die menschliche Neigung, Geschichten zu erzählen und diesen zuzuhören, ist tief in uns allen verwurzelt. Auch heute noch werden in aller Herren Länder neue Theater errichtet und bestehende historische Spielstätten ausgiebig renoviert und modernisiert. Es ist bemerkenswert, dass sich dies auch in Zeiten unverändert fortsetzt, die vom freien und raschen Massenaustausch von Ideen über das Internet gekennzeichnet sind. Offenbar ist das Internet nicht fähig, die Freude zu ersetzen, die wir bei öffentlichen Darbietungen empfinden.

Das vorliegende Buch präsentiert Theaterhäuser aus der ganzen Welt sowie aus verschiedenen Zeitaltern und bei so manchem der vorgestellten Gebäude handelt es sich um einen historischen Meilenstein der Theaterarchitektur. Darüber hinaus zeigt dieses Werk aber auch bemerkenswerte Neubauten, wodurch sich die Entwicklung der Architektur von Theatern als öffentliche kulturelle Räume während der letzten 50 Jahre analysieren lässt, seit der dänische Architekt Jørn Utzon den Wettbewerb zur Gestaltung der Oper von Sydney im Jahr 1957 für sich entscheiden konnte. Die revolutionäre und einzigartige Gestalt dieses Weltkultur-Monuments formte Sydneys urbane Landschaft und veränderte unsere Auffassung von Theaterarchitektur.

Ursprünglich bezeichnete das altgriechische Theatron eine Gruppe von Menschen, die gemeinsam einer Darbietung bzw. Aufführung beiwohnten. Diese Urform des antiken griechischen Theaters fand noch unter freiem Himmel und auf einem Hang statt, wodurch ein natürliches, amphitheaterförmiges Auditorium entstand, in dem zahlreiche Zuschauer Platz fanden.

Als im Jahr 349 n. Chr. das Theater im griechischen Epidaurus errichtet wurde, existierten bereits sämtliche zentralen Elemente moderner Theatergebäude: Das Orchester, die Rundbühne sowie die Skene genannten Umkleide- bzw. Lagerräume des Bühnenhauses, die gleichzeitig als bemalte Kulissen dienen konnten.

Im antiken Rom wurden Theater als freistehende Strukturen errichtet, die nicht mehr auf natürliche Hänge angewiesen waren. Der römische Autor, Architekt und Ingenieur des ersten vorchristlichen Jahrhunderts, Vitruv, formulierte sogar detaillierte Anweisungen hinsichtlich des Sitzkomforts des Publikums sowie Regeln für vertikale Sichtachsen und befasste sich außerdem mit Akustik.

Das Mittelalter ist nicht durch ein übermäßiges Interesse an der Errichtung von Theatergebäuden gekennzeichnet. Häufig wurden Innenräume bzw. Außenanlagen von Kirchen zu diesem Zweck benutzt.

Während der Renaissance wurden die Bemühungen der Hellenen weiterverfolgt und Spielstätten schließlich mithilfe eines Dachs vollständig geschlossen; für diese Gebäude etablierte sich mit der Zeit die Bezeichnung „Theater". Der Renaissance verdankt sich auch die weitverbreitete Verwendung verschiedenster Apparaturen zur Erzeugung spektakulärer Effekte.

Ein Beispiel dieser frühen Renaissance-Theater ist das aus dem Jahr 1580 stammende und von Andrea Palladio entworfene Teatro Olimpico in italienischen Vicenza mit seinem architektonischen Bühnenbild. Beim 1599 in Großbritannien errichteten und beeindruckenden Shakespeare's Globe Theatre wiederum handelt es sich um ein beinahe kreisrundes Gebäude, dessen auf drei Stockwerken liegende, überdachte Galerien von einem offenen Hof umgeben waren und dessen ebenfalls überdachte Bühne mitten aus dem Publikum aufragt.

Das Konzept der Oper bzw. des Musikdramas stammt ursprünglich aus Italien und vereint Musik, Dichtung und Theater. Zu Beginn des 17. Jahrhunderts entwickelte sich daraus eine eigenständige Kunstgattung. Das erste Opernhaus wurde 1637 in Venedig unter dem Namen San Cassiano errichtet.

Mitte des 17. Jahrhunderts kamen die ersten Proszenien oder Vorbühnen auf und bildeten den Rahmen für festgelegte Publikumsperspektiven. Ein weiteres typisches Merkmal barocker Theatergebäude bildeten mehrere Stockwerke von Galerien und Logen, die rund um das Auditorium angeordnet waren.

Avant-propos

L'inclination naturelle à conter des histoires et à les écouter est profondément ancrée dans l'humanité. Encore aujourd'hui, aux quatre coins de la planète, de nouveaux théâtres sortent de terre, alors que de nombreux théâtres historiques, en pleine restauration, font peau neuve. Le phénomène mérite d'autant plus d'être noté qu'à l'heure d'Internet, les échanges d'idées n'ont jamais été aussi libres, aussi rapides. De toute évidence, Internet ne semble pas prêt de détrôner notre amour de la représentation en public.

Le présent ouvrage propose une rétrospective fouillée du Théâtre dans le monde, à travers différentes époques. Parmi les édifices présentés, nombreux ont marqué un tournant historique de l'architecture du théâtre. Les nouvelles constructions ne sont pas oubliées, si bien que l'ouvrage offre une analyse pertinente de l'évolution architecturale du théâtre en tant qu'espace culturel public durant ces cinquante dernières années, depuis que l'architecte danois Jorn Utzon a remporté le concours pour concevoir l'Opéra de Sydney en 1957. Avec ses lignes révolutionnaires et singulières, l'édifice a définitivement élevé le cadre urbain de Sydney au rang des hauts lieux du patrimoine mondial et bouleversé notre façon d'appréhender l'architecture théâtrale.

A l'origine, le theatron grec désignait un lieu de rassemblement public où l'on assistait à un spectacle ou une pièce. Dans la Grèce antique, ces théâtres primitifs, dépourvus de toit, étaient généralement construits à flanc de colline, pour aménager un auditorium en forme d'amphithéâtre capable d'accueillir un grand nombre de spectateurs.

A l'époque où fut érigé le théâtre grec d'Epidaure (349 av. J.-C.), les éléments fondamentaux du théâtre moderne étaient déjà en place : orchestre, scène circulaire et skene (salle d'essayage des costumes et d'entreposage située en coulisse, pouvant également faire office de décor peint).

Dans la Rome antique, les théâtres étaient bâtis sur des structures autoportantes, totalement libérées des inclinaisons naturelles du terrain. Vitruve, auteur, architecte et ingénieur romain ayant vécu au premier siècle av. J.-C., a même donné des instructions précises pour offrir une assise plus confortable au public et défini des règles pour dégager un champ de vision vertical. Il a également étudié l'acoustique du théâtre.

La construction d'ouvrages dédiés au théâtre perdit de son intérêt au Moyen Age, les églises et leurs enceintes étant alors souvent utilisées à cette fin.

Puis la Renaissance contribua à parfaire les efforts des Grecs en couvrant d'une toiture tout l'espace de représentation ; ce type de constructions prit véritablement le nom de théâtre. C'est également à la Renaissance que se sont vulgarisées diverses sortes de machines pour créer des effets spectaculaires.

Le Teatro Olympico de Palladio (1580) à Vicence, en Italie, avec son appareil scénique architectural, offre un parfait exemple de ces premiers théâtres de la Renaissance. En Grande-Bretagne, l'incroyable Shakespeare's Globe Theatre fut érigé en 1599. De forme quasi-circulaire, ses galeries couvertes sur trois étages étaient entourées d'une cour extérieure, et la scène, également couverte, projetée au beau milieu du public.

Associant musique, poésie et théâtre, le concept de l'opéra, ou théâtre en musique, est né en Italie. Au début du dix-septième siècle, l'opéra s'impose comme une forme d'expression artistique à part entière. Le San Cassiano, tout premier opéra public, fut construit à Venise en 1637.

L'avant-scène ou proscenium fit son apparition vers le milieu du dix-septième siècle. Son cadre permettait de fixer le point le vue. Autres caractéristiques communes aux théâtres baroques, les galeries érigées sur plusieurs étages tout autour du parterre.

Le dix-neuvième siècle vit la construction de nombreux grands théâtres et opéras en Europe en réponse à la demande en édifices bourgeois imposants et en monuments historiques urbains. Le Palais Garnier (1875), célèbre opéra de Paris baptisé du nom de son architecte, frappe par son magnifique hall et son escalier central, offrant l'exemple le plus grandiose de théâtre à représentation sociale.

Prólogo

La inclinación humana a contar historias, y a oírlas, forma parte de nuestra más honda esencia. En la actualidad, se siguen construyendo nuevos teatros en todo el mundo, a la vez que se renuevan y modernizan considerablemente numerosos teatros históricos. Es extraordinario que siga siendo así, en una época en la que Internet ha generalizado el intercambio de ideas de forma rápida y libre para mucha gente. Es obvio, no obstante, que Internet no puede suplir nuestra pasión por la representación pública.

En este libro se presentan teatros de todas partes y de distintas épocas. Muchos de los que aquí mostramos constituyen auténticos hitos históricos de la arquitectura del teatro. Se han incluido asimismo numerosos teatros nuevos notables, lo que nos permite analizar el modo en que se ha desarrollado la arquitectura del teatro como espacio cultural público en los últimos cincuenta años, desde que el arquitecto danés Jorn Utzon se alzara con el triunfo en el concurso para la Ópera de Sidney en 1957. Su forma única y revolucionaria ha otorgado al paisaje urbano de Sidney el sello de patrimonio de la humanidad y ha modificado nuestro concepto sobre la arquitectura del teatro.

Originalmente, en griego, theatron significaba un grupo de personas reunidas para ver y oír un espectáculo o representación. La primera forma de teatro en la antigua Grecia no tenía techo y se encontraba en la ladera de una colina, lo que dio lugar a un auditorio de tipo anfiteatro que acogía a un gran número de espectadores.

En la época en la que se construyó el gran teatro griego de Epidauro (349 a. C.), ya estaban en vigor los elementos básicos del moderno edificio de teatro: la platea, el escenario redondo y el skene (el espacio de vestuario y almacenamiento entre bastidores, que podía servir igualmente de decorado pintado).

En la antigua Roma, los teatros se construyeron como estructuras autónomas y no dependían de las pendientes naturales. Vitruvio, el escritor, arquitecto e ingeniero romano del siglo I a. C., facilitó incluso instrucciones detalladas para la comodidad de los asientos del público y estableció normas para las líneas verticales de visión. También se preocupó por la cuestión de la acústica.

En la Edad Media, no se mostró gran interés por la construcción de teatros específicos. A menudo, se utilizaban para este fin los espacios interiores y exteriores de las iglesias.

Durante el Renacimiento, el empeño de los antiguos griegos se desarrolló aún más al cubrir por completo el espacio de la representación con un techo; este tipo de edificio comenzó a llamarse teatro. En época renacentista, se difundieron considerablemente distintos tipos de maquinaria para la creación de efectos espectaculares.

Un ejemplo de estos teatros del primer Renacimiento lo vemos en el Teatro Olímpico de Palladio (1580) en Vicenza, Italia, que presenta un escenario arquitectónico. En Gran Bretaña, se construyó en 1599 el excepcional Teatro del Globo de Shakespeare. Es un edificio prácticamente redondo, con tres pisos de galerías techadas rodeadas por un patio abierto y un escenario, también techado, que se adentra hacia el centro del público.

El concepto de ópera, o drama musical, nació en Italia, como una combinación de música, poesía y teatro. A comienzos del siglo XVII, evolucionó como una forma de arte por derecho propio. El primer edificio de ópera, el San Cassiano, se construyó en Venecia en 1637.

A mediados del siglo XVII, se introdujo el proscenio. Proporcionaba un marco para una vista de perspectiva fija. Otra característica habitual de los edificios de teatro barrocos eran los distintos niveles de galerías y palcos que rodeaban el auditorio.

En el siglo XIX, se diseñaron en Europa numerosos grandes teatros y edificios de ópera para satisfacer la creciente demanda de estructuras burguesas e hitos urbanos imponentes. El Palais Garnier (1875), el famoso Teatro de la Ópera de París, llamado así en honor a su arquitecto, consta de un foyer y una escalera central espléndidos, lo que constituye el ejemplo más grandioso de teatro como escenario para la ostentación social.

Im 19. Jahrhundert wurden in Europa schließlich unzählige bedeutende Theater- und Operngebäude mit dem Ziel entworfen, bürgerliche Strukturen und urbane Sehenswürdigkeiten zu etablieren. Die nach ihrem Erbauer benannte Pariser Opéra Garnier, stammt aus dem Jahr 1875 und ist mit ihrem prächtigen Foyer und ihrer zentralen Treppe wohl das grandioseste Beispiel eines Theaters als Bühne gesellschaftlicher Zurschaustellung.

Beginnend mit dem 20. Jahrhundert versuchten schließlich moderne Theaterplaner Bühne und Auditorium miteinander zu verbinden, beispielsweise Walter Gropius mit seinem Totaltheater aus dem Jahr 1927.

Nichtsdestotrotz erfolgte die Umsetzung einer vollkommen flexiblen Interaktion zwischen Publikum und Bühne vor allem in kleineren, experimentellen „Blackbox"-Auditorien, während Mainstream-Theater- bzw. Operngebäude der traditionellen Idee des Proszenium-Theaters verhaftet blieben.

Heute ist der Bauboom, der zur Errichtung neuer Kultureinrichtungen, darunter Theatern, in Entwicklungsländern wie China führt, das unmittelbare Ergebnis eines Wunsches nach Urbanisierung und eines wachsenden Bürgertums mit einem Bedürfnis nach kulturellen Angeboten. In diesen Ländern kann das hohe Entwicklungstempo aber auch dazu führen, dass die Errichtung beeindruckender Gebäude gefördert wird, ohne deren kulturelle Funktion entsprechend zu berücksichtigen.

Jahrhundertelang wurden solch monumentale Strukturen vor allem aufgrund ihres gesellschaftlichen Nutzens bzw. jenes Prestiges errichtet, das sie ausstrahlen. Diese Bauwerke wurden häufig zu verbindenden lokalen oder gar nationalen Symbolen.

Die besonderen technischen und akustischen Anforderungen, die die Kunstgattung Oper an eigens dafür entworfene Spielstätten stellt, verleihen Operngebäuden ihren einzigartigen Zauber. Für gewöhnlich wurde in Opernhäusern Wert auf eine eher kurze Nachhallzeit gelegt, um das Gesungene so gut als möglich zu verstehen.

Der jüngste Trend in Europa besteht jedoch darin, neue Opernhäuser mit größerer Flexibilität und Anpassungsfähigkeit zu bauen, um unterschiedlichste Musikdarbietungen und sogar Auftritte von Symphonieorchestern mit längerer Nachhallzeit zu ermöglichen. Das von Henning Larsen entworfene Opernhaus von Kopenhagen oder die von Snøhetta gebaute Oper von Oslo sind hervorragende Beispiele für diesen innovativen Ansatz. Besonders das Osloer Opernhaus wurde unter Berücksichtigung der Erlebniswelt von Opernbesuchern entworfen. Diese Hinwendung zum Benutzer ist bereits außerhalb des Gebäudes spürbar und setzt sich in dessen Inneren in sämtlichen öffentlichen Bereichen bis zum Betreten des Auditoriums fort.

Besonders das Prinzip der Benutzerperspektive sowie die multifunktionale Verwendbarkeit des großen Konzertsaales lagen auch der Arbeit unseres Entwurfsteams während der vierjährigen Planungs- und Errichtungsphase des Grand Theatre im chinesischen Wuxi zugrunde.

Darstellende Künstler verdanken unserer digitalen Ära vollkommen neue Möglichkeiten und Betätigungsfelder und von ihnen Dargebotenes kann Tanz, Licht, Musik, Schauspiel, ja sogar Projektionen statischer bzw. beweglicher Bilder umfassen, weshalb eigens dafür vorgesehene Spielstätten nicht mehr nur Merkmale einer ganz bestimmten Typologie aufweisen.

Zeitgenössische Theater könnten ebenso gut hybride Gebäude und mit anderen kulturellen bzw. kommerziellen Einrichtungen verbunden sein. Mithilfe neuer parametrischer Designtechniken lassen sich noch nie dagewesene Theater entwerfen und verwirklichen, deren Konzeption und Ausführung Architekten über die Einbeziehung der genannten Tendenzen vor eine inspirierende Herausforderung stellt.

Au vingtième siècle, les architectes du théâtre moderne se sont mis à explorer la possibilité d'intégrer la scène à la salle, à l'instar de Walter Gropius et de son Totaltheater en 1927.

Toutefois, cette relation totalement flexible entre le public et la scène est restée pour l'essentiel cantonnée aux petites salles intimistes de type "boîte noire", alors que le principal courant architectural du théâtre et de l'opéra a poursuivi l'idée traditionnelle du théâtre à l'italienne.

Aujourd'hui, les pays en développement comme la Chine connaissent une véritable vague de constructions pour de nouvelles institutions culturelles, dont les théâtres, résultant d'une volonté d'urbanisation et d'une classe moyenne grandissante en demande de prestations culturelles. Forts de leur développement fulgurant, ces pays tendent à privilégier la construction d'édifices imposants sans réfléchir suffisamment aux activités culturelles qu'ils sont censés abriter.

De tout temps, l'humanité a jugé important de bâtir des monuments illustres, appréciés pour leur valeur sociale et le prestige dont ils sont auréolés, et souvent érigés au rang de symbole d'union régionale ou nationale.

Les exigences particulières que requiert l'art de l'opéra en termes de technologie et d'acoustique confèrent à ces bâtiments une aura incomparable. Jusqu'à présent, les opéras étaient conçus de manière à raccourcir la durée de réverbération pour rendre le chant des interprètes audible.

Mais, dernièrement en Europe, la construction de nouveaux opéras tend à mieux s'adapter aux différents types de représentations musicales, y compris les concerts symphoniques, avec une durée de réverbération allongée. L'Opéra de Copenhague conçu par Henning Larsen, de même que l'Opéra d'Oslo signé Snøhetta sont de parfaits exemples de ce type d'innovations. L'Opéra d'Oslo, notamment, a entièrement été pensé pour et autour de l'expérience du spectateur, laquelle débute dès l'approche de l'édifice pour se poursuivre dans toutes les zones réservées au public avant d'entrer dans la salle.

Ce même principe élémentaire centré sur l'expérience du spectateur et sur l'usage multifonctionnel de la grande salle d'opéra n'a pas cessé de guider mon équipe d'architectes pendant les quatre années de conception et de construction du Grand Théâtre de Wuxi en Chine.

Notre ère du numérique offre aux artistes de scène de nouvelles perspectives, de nouveaux champs à explorer. Danse, éclairage, musique et intrigue peuvent désormais se mêler à la projection d'images fixes ou animées, avec pour effet d'éliminer tout code architectural permettant de distinguer les constructions auparavant réservées aux arts de la scène.

Rien n'interdit désormais de concevoir un théâtre contemporain dans un complexe hybride, accueillant d'autres installations culturelles ou commerciales. Les nouvelles techniques paramétriques de conception rendent aujourd'hui possible la construction et la production de nouveaux théâtres d'un genre totalement inédit. Toutes ces tendances sont autant de sources d'inspiration qui exaltent les architectes de salles de spectacle.

En el siglo XX, los diseñadores de teatro modernos comenzaron a estudiar la integración del escenario con el auditorio, por ejemplo, Walter Gropius con su concepto del teatro total en 1927.

Sin embargo, la relación escenario-público más flexible se plasmó principalmente en los auditorios de tipo "caja negra" más pequeños y experimentales, mientras que los edificios de teatro y ópera de la corriente dominante seguían la idea tradicional del teatro de proscenio.

Actualmente, en los países en vías de desarrollo como China, el auge en la construcción de nuevas instituciones culturales, teatros incluidos, refleja el resultado del deseo de urbanización y de una clase media en aumento, para poder satisfacer las necesidades de servicios culturales. En estos países, el ritmo de desarrollo acelerado puede llevar a hacer hincapié en la construcción de edificios impresionantes sin tener demasiado en cuenta las actividades culturales para las que están destinados.

A lo largo de los siglos se ha resaltado la importancia de construir este tipo de estructuras monumentales por el valor y prestigio sociales que transmiten. Estos edificios se han convertido con frecuencia en símbolos locales o nacionales unificadores.

Los requisitos especiales impuestos por el arte de la ópera en lo que a tecnología y acústica se refiere otorgan a estos edificios un glamour especial. Históricamente, los edificios de ópera se diseñaron con un tiempo de reverberación muy corto a fin de que las palabras de los cantantes fueran inteligibles.

La última tendencia en Europa, no obstante, ha sido diseñar nuevos teatros de ópera que se adaptan de forma más flexible a los distintos tipos de espectáculos musicales, incluidos los conciertos sinfónicos, con un tiempo de reverberación mayor. El Teatro de Ópera de Copenhague de Henning Larsen y el Teatro de Ópera de Oslo de Snøhetta constituyen excelentes ejemplos de este tipo de innovación. El Teatro de Ópera de Oslo ha sido especialmente diseñado pensando en la experiencia del usuario. La prioridad dada al usuario comienza en cuanto se acerca al edificio y continúa a lo largo de todas las zonas públicas antes de que entre en el auditorio.

Esta idea en concreto de experiencia del usuario y el uso multifuncional del gran auditorio de la ópera fueron los principios básicos que guiaron a mi equipo de diseño durante el período de cuatro años de proyecto y construcción del Gran Teatro de Wuxi en China.

La era digital ha creado nuevas posibilidades y ámbitos para los artistas escénicos. Un espectáculo puede incorporar danza, luces, música y drama junto con una proyección de imágenes fijas o en movimiento. En consecuencia, ya no existe una tipología especial para los edificios de artes escénicas.

Un teatro contemporáneo podría incluso ser un edificio híbrido que se combinara con otras instalaciones culturales o comerciales. Las nuevas técnicas de diseño paramétrico han hecho posible proyectar y construir un tipo de teatro totalmente nuevo. Todas estas tendencias convierten las salas de espectáculos en un reto realmente motivador para los arquitectos.

Theatre of Dionysus Eleuthereus
Original capacity 17,000

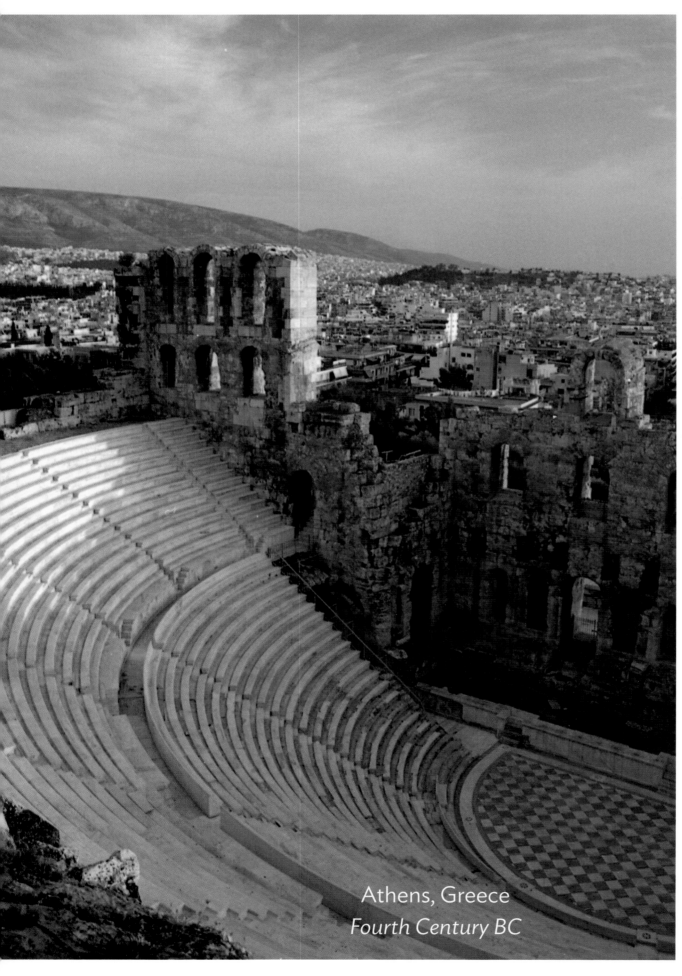

Athens, Greece
Fourth Century BC

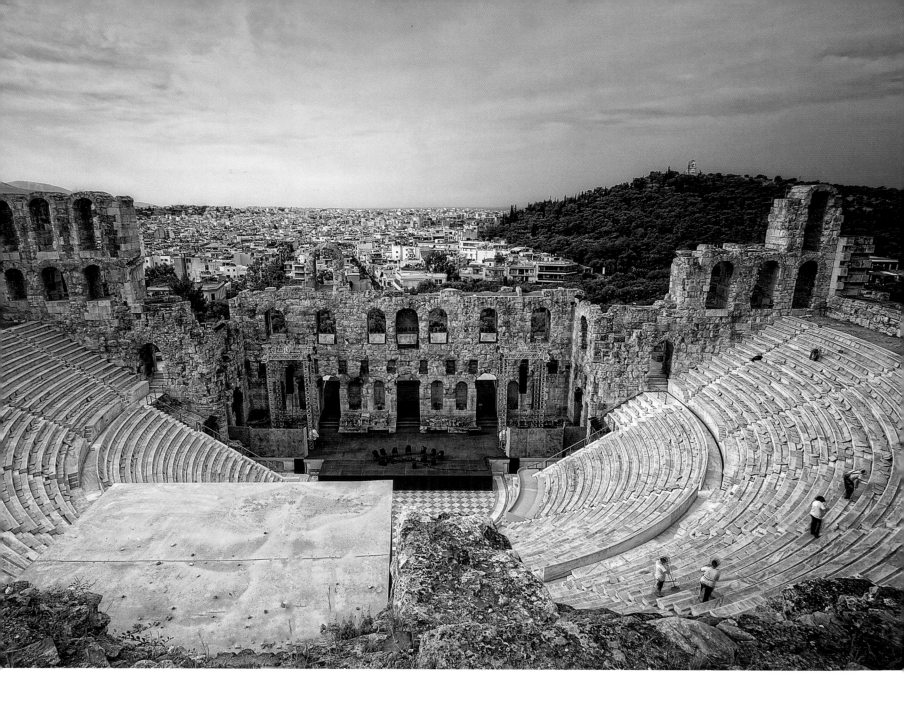

Situated at the foot of the Acropolis Hill's south slope, the Theatre of Dionysus is one of the earliest preserved theatres. It was host to the famous Athenian dramatists who took part in the Dionysia Festival, dedicated to the God of Wine. Sixty-seven thrones, inscribed with the names of the dignitaries that occupied them, were a later addition to the theatre; the largest was reserved for the priest of Dionysus. The theatre was first excavated in the eighteenth century, by the Greek Archaeological Society.

Das am Fuße der Südflanke des Akropolis-Hügels gelegene Dionysos-Theater ist eines er ältesten erhaltenen Theater der Welt. Einst war es Schauplatz der berühmten Dionysien, Festspiele zu Ehren von Dionysos, dem Gott des Weins, an denen auch die berühmten attischen Dramatiker teilnahmen. Später wurden dem Theater siebenundsechzig Throne hinzugefügt, die mit den Namen jener Würdenträger versehen waren, welche auf ihnen Platz nahmen, wobei der größte von ihnen dem Hohepriester des Dionysos vorbehalten war. Erstmals freigelegt wurde das Theater im achtzehnten Jahrhundert durch die Archäologische Gesellschaft Athen.

Situé au pied du versant Sud de l'Acropole, le Théâtre de Dionysos est l'un des théâtres antiques les mieux conservés. On y jouait les tragédies de célèbres dramaturges athéniens à l'occasion des grandes fêtes des Dionysies organisées en l'honneur du Dieu du vin. Les soixante-sept sièges gravés au nom des dignitaires qui les occupaient ont été ajoutés ultérieurement au théâtre ; l'enceinte était pour l'essentiel réservée aux prêtes de Dionysos. Les premières fouilles du site remontent au dix-huitième siècle, sur l'initiative de la Société archéologique de Grèce.

Situado al pie de la pendiente sur de la colina de la Acrópolis, el Teatro de Dionisos es uno de los teatros más antiguos que se conservan. Aquí venían los famosos dramaturgos atenienses que participaban en el Festival de Dionisias, dedicado al dios del vino. Posteriormente, se añadieron al teatro sesenta y siete tronos, con los nombres de los dignatarios que los ocupaban inscritos en ellos; el trono mayor estaba reservado al sacerdote de Dionisos. El teatro fue excavado por primera vez en el siglo XVIII por la Sociedad Arqueológica Griega.

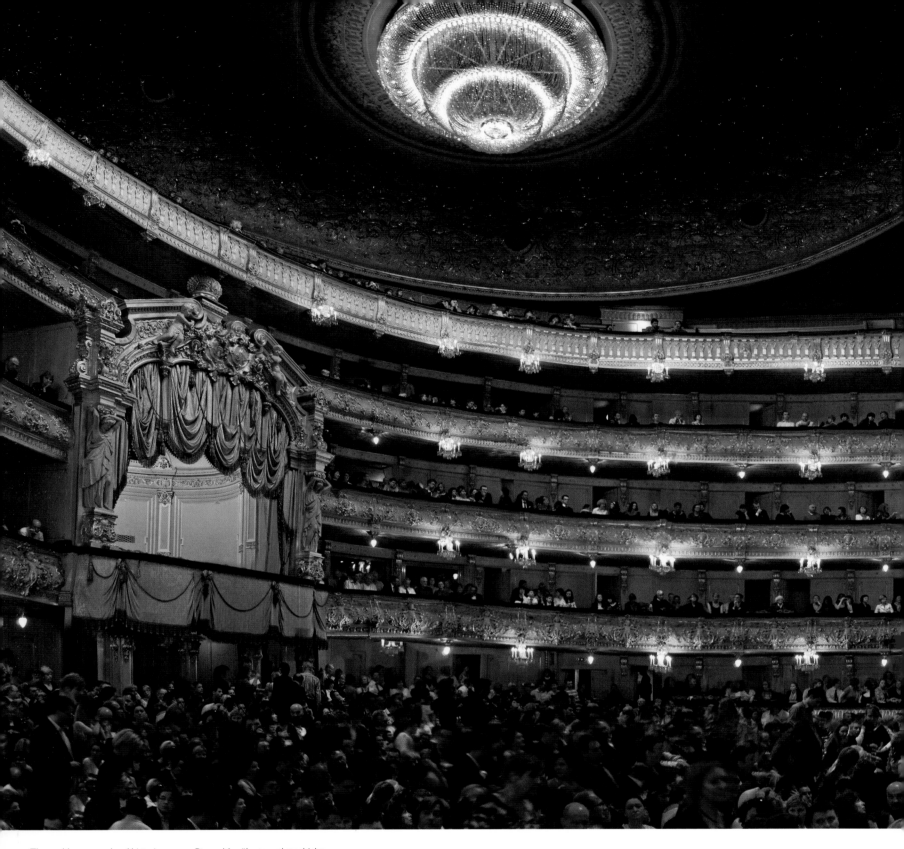

The world-renowned and historic Mariinsky Theatre was named after Empress Maria Alexandrovna, wife of Tsar Alexander II. A venue for opera and ballet performances, it was known during Soviet times as the Kirov Opera and Ballet Theatre. It reverted to its original name in 1992, and in May 2013, it was joined by the ultra-modern Mariinsky II, another stage on which to host Russia's most celebrated classical performers.

Das weltberühmte und geschichts-trächtige Mariinski-Theater wurde nach Kaiserin Alexandrowna, der Frau des Zaren Alexander II., benannt. Dieser Stätte für Opern- und Ballettinszenierungen war in Sowjetzeiten als Kirow-Opern- und Balletttheater bekannt. Im Jahr 1992 bekam sie ihren ursprünglichen Namen zurück und wurde im Mai 2013 um das hochmoderne „Mariinski II" erweitert, das Russlands gefeiertsten klassischen Interpreten als weitere Bühne für ihre Kunst dient.

Mariinsky Theatre
Capacity 1,625

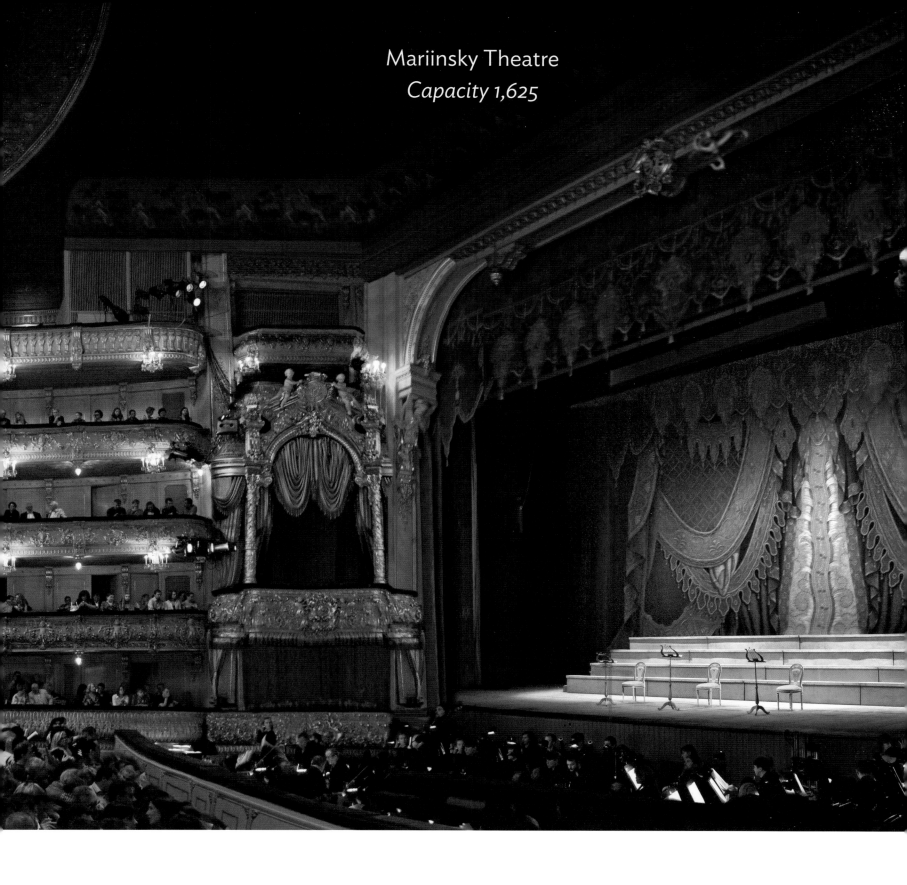

St Petersburg, Russia
Alberto Cavos, 1860

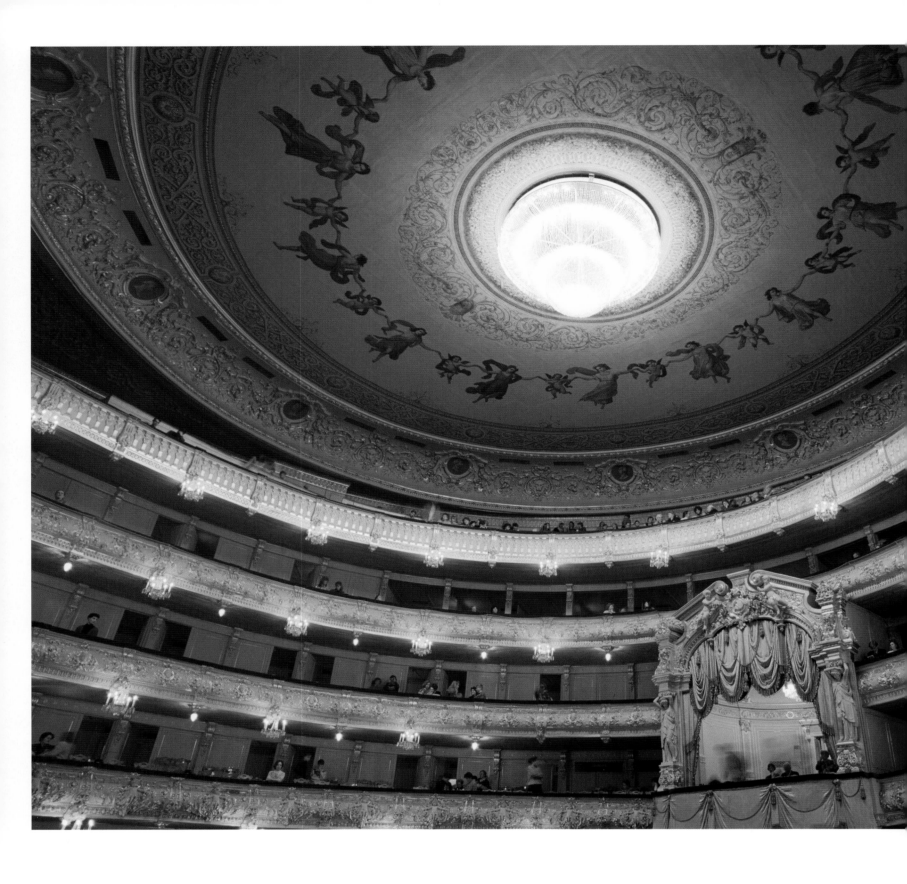

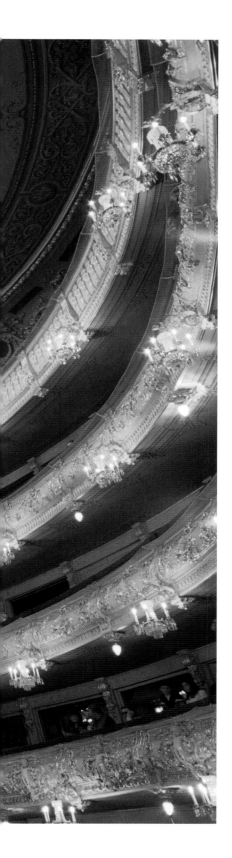

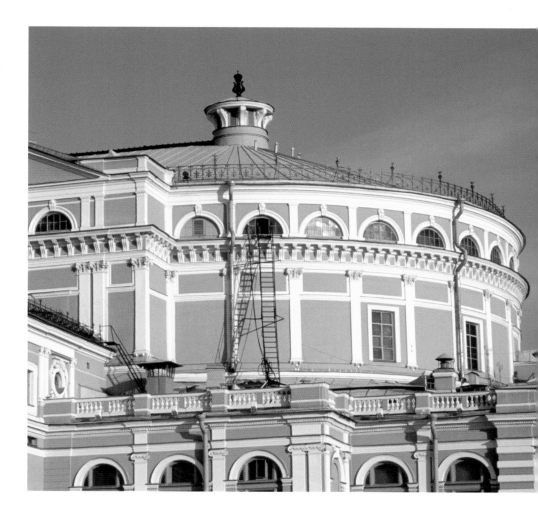

Mondialement connu, le théâtre historique Mariinsky a été nommé en hommage à l'Impératrice Maria Alexandrovna, épouse du Tsar Alexandre II. Compagnie d'opéra et de ballet, le théâtre était appelé pendant la période soviétique l'Opéra Kirov et le Théâtre du Ballet. Il ne reprit son nom actuel qu'en 1992. En mai 2013, le théâtre se dote d'une nouvelle scène supplémentaire ultra-moderne, la Mariinsky II, pour accueillir les plus grands interprètes classiques de Russie.

El histórico Teatro Mariinsky, mundialmente célebre, debe su nombre a la emperatriz María Alexandrovna, esposa del zar Alejandro II. Sede de espectáculos de ópera y ballet, durante la época soviética era conocido con el nombre de Teatro de Ballet y Ópera Kirov. Recuperó su nombre original en 1992 y en mayo de 2013, se le unió el ultramoderno Mariinsky II, otro escenario en el que representar los espectáculos clásicos más famosos de Rusia.

Bolshoi Theatre
Capacity 2,100

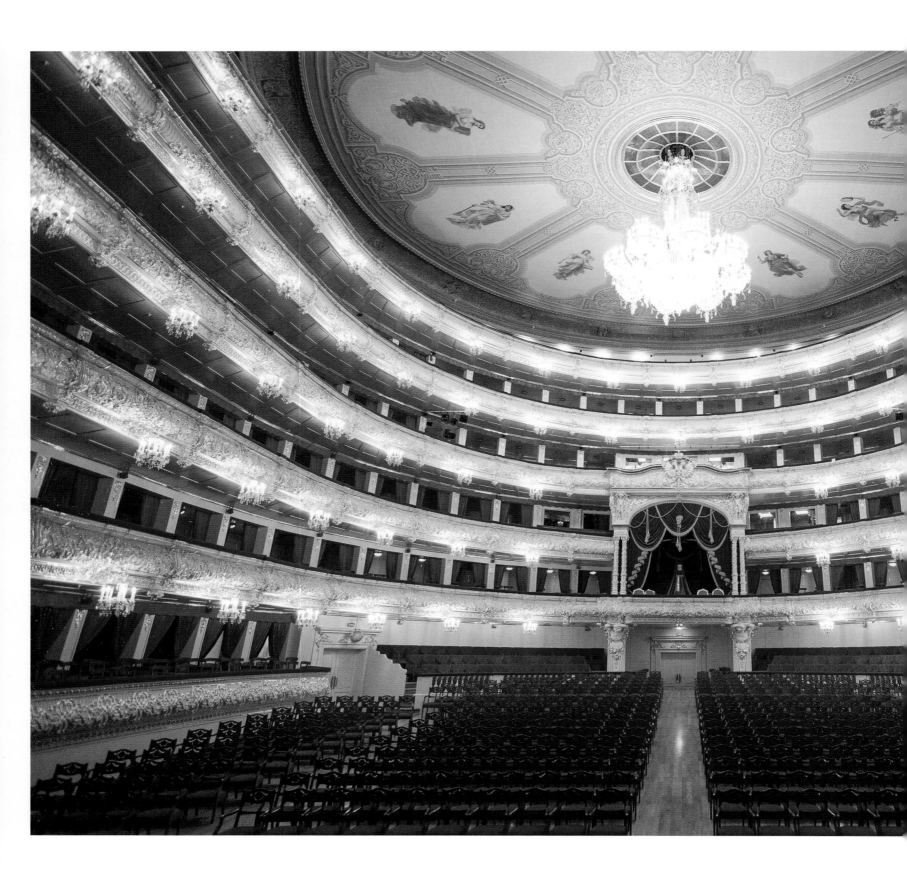

Moscow, Russia
Joseph Bové, 1825; Alberto Cavos, 1856

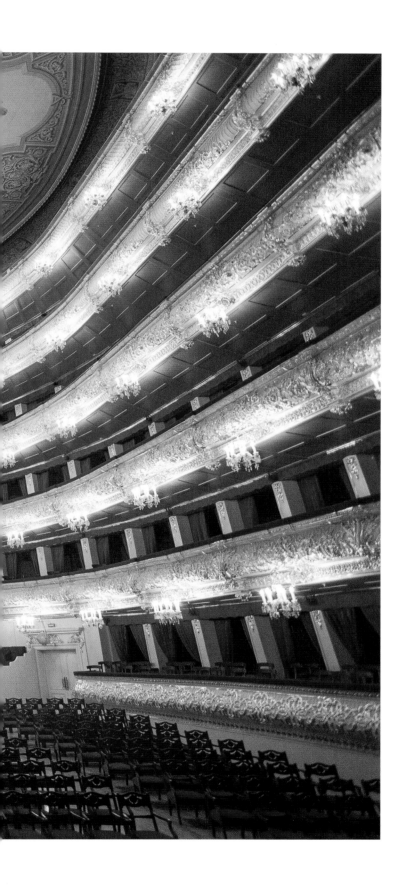

The original Bolshoi Theatre, which stood on this same site, was designed by the prominent architect Joseph Bové in 1824. After it burnt down in 1853, Alberto Cavos rebuilt the theatre that we know today. It is famous for its prestigious ballets and operas, but also for being the venue for many important social and political events, such as the All-Russia Congress of Soviets. The Bolshoi reopened its doors in 2011, after an extensive six-year renovation.

Das ursprünglich an derselben Stelle gelegene Bolschoi-Theater wurde vom berühmten Architekten Joseph Bové im Jahr 1824 entworfen. Nachdem es 1853 einem Brand zum Opfer gefallen war, errichtete Alberto Cavos das Theater, wie wir es heute kennen. Das Boschoi-Theater ist aufgrund seiner prestigeträchtigen Ballet- und Opernaufführungen aber auch als Veranstaltungsort für bedeutende soziale und politische Ereignisse wie beispielsweise den Allrussischen Sowjetkongress weltberühmt. Das Bolschoi-Theater wurde nach einer umfangreichen, sechs Jahre dauernden Sanierung 2011 feierlich wiedereröffnet.

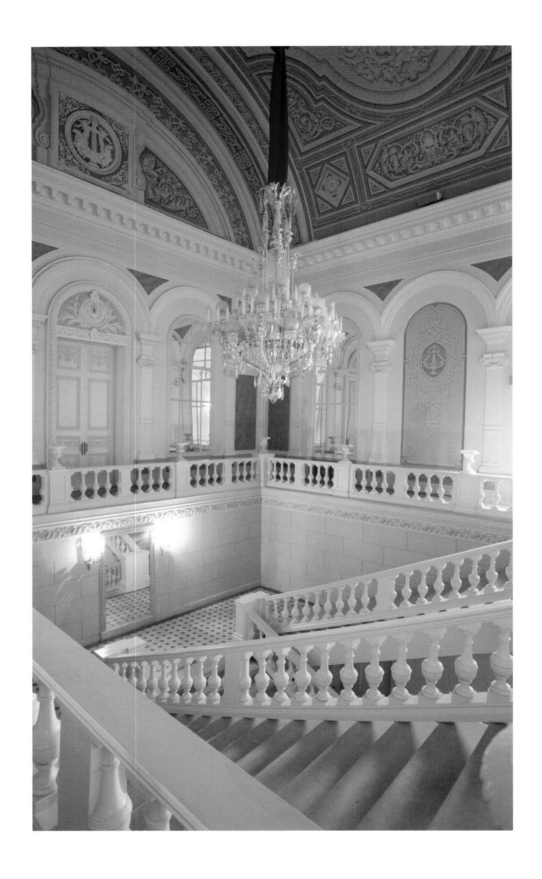

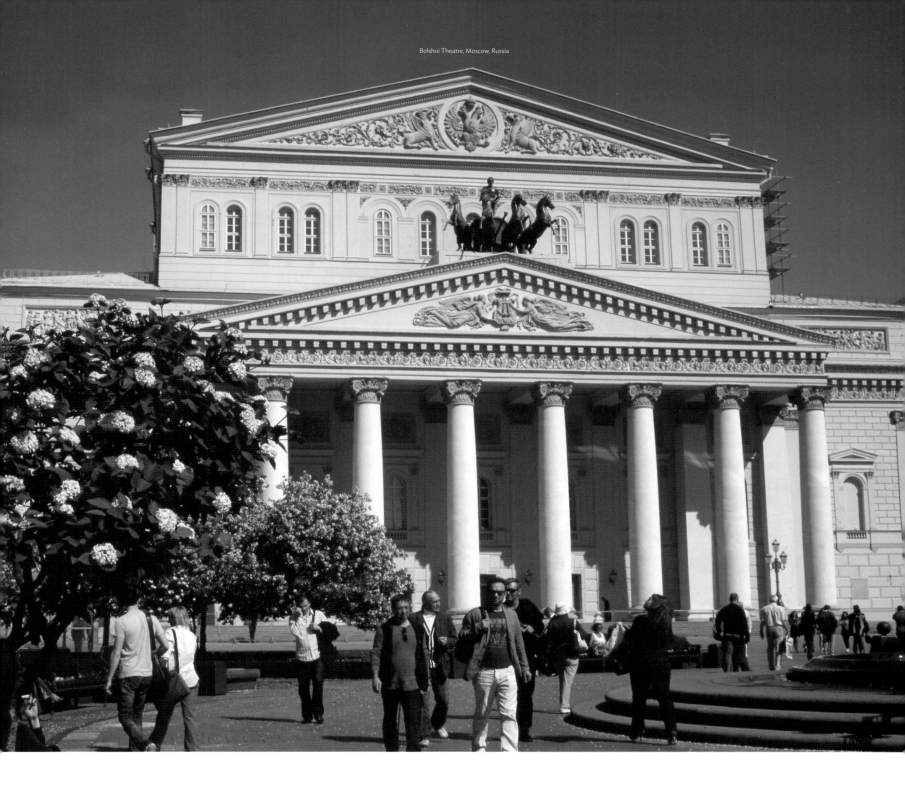

Bolshoi Theatre, Moscow, Russia

Le Théâtre Bolchoï original, qui s'élève sur le même site, a été conçu par l'éminent architecte Joseph Bové en 1824. Après avoir complètement brûlé en 1853, Alberto Cavos reconstruisit le théâtre que nous connaissons aujourd'hui. Le Bolchoï doit ses lettres de noblesse à ses ballets et à ses opéras prestigieux, mais aussi aux nombreuses manifestations sociales et politiques majeures qu'il accueille comme le Congrès panrusse des Soviets. Le Bolchoï rouvrit ses portes en 2011, après six années d'importants travaux de rénovation.

El Teatro Bolshoi original, que se encontraba en el mismo lugar, fue diseñado por el destacado arquitecto Joseph Bové en 1824. Tras su incendio en 1853, Alberto Cavos lo reconstruyó tal y como lo conocemos en la actualidad. Es célebre no solo por sus prestigiosos ballets y óperas, sino también por haber sido la sede de numerosos eventos sociales y políticos de importancia, como el Congreso de los Sóviets de todas las Rusias. El Bolshoi abrió sus puertas de nuevo en 2011, después de una renovación de gran envergadura que duró seis años.

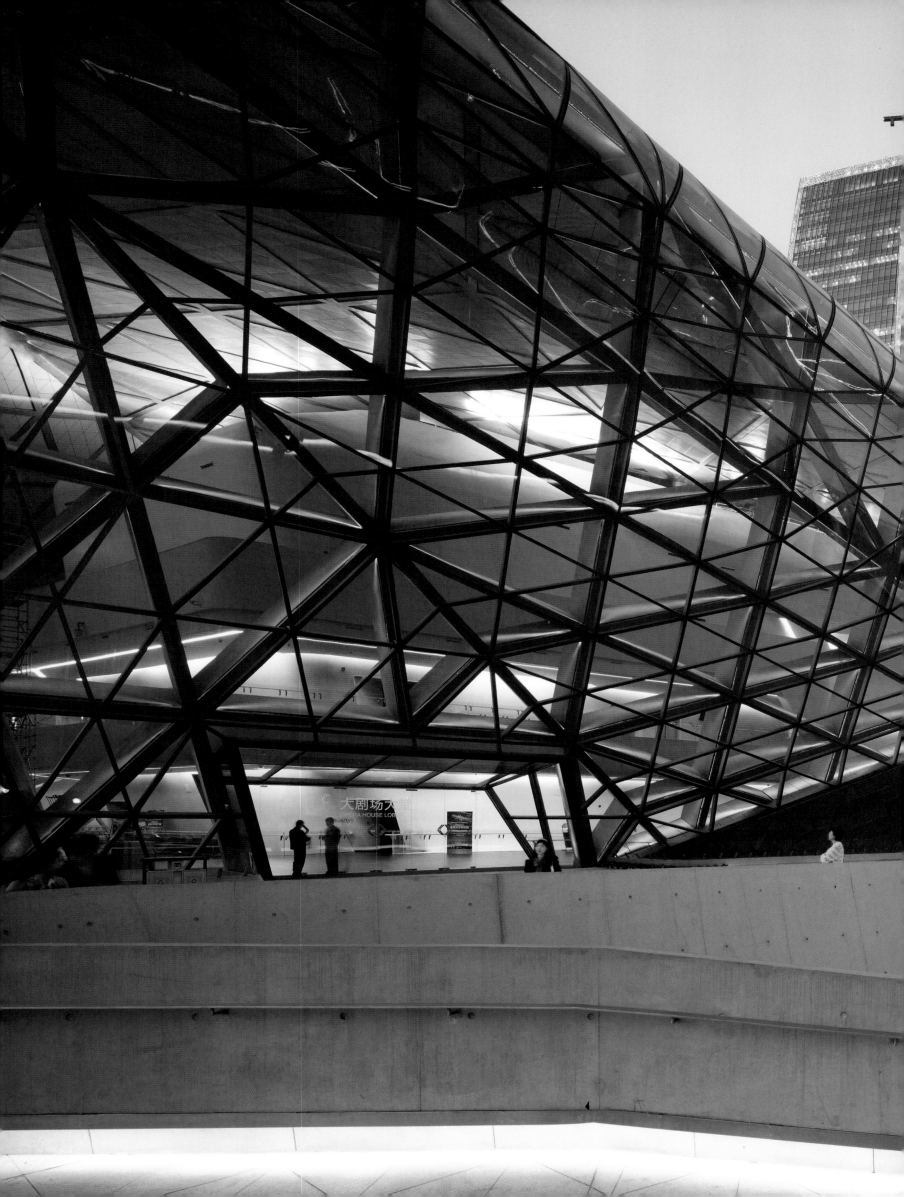

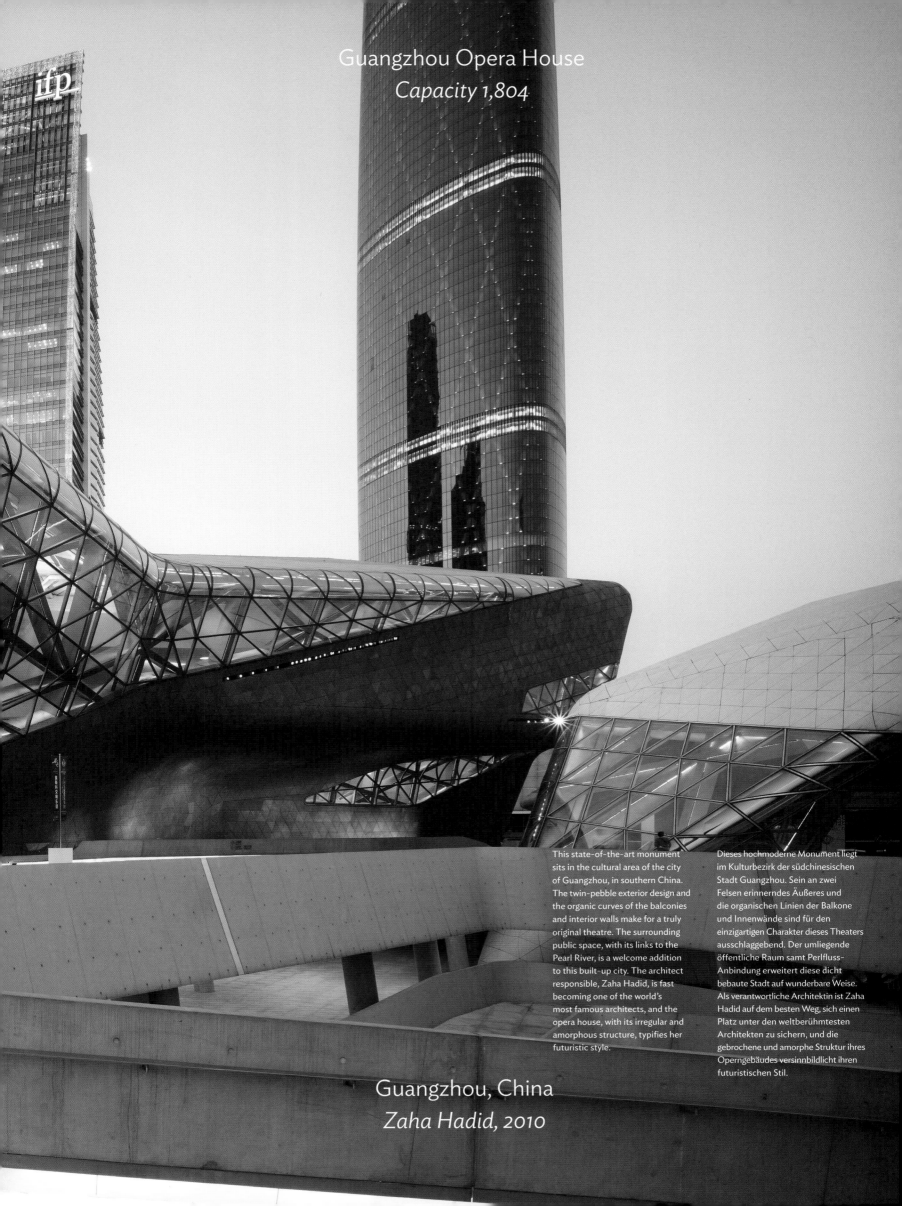

Guangzhou Opera House
Capacity 1,804

This state-of-the-art monument sits in the cultural area of the city of Guangzhou, in southern China. The twin-pebble exterior design and the organic curves of the balconies and interior walls make for a truly original theatre. The surrounding public space, with its links to the Pearl River, is a welcome addition to this built-up city. The architect responsible, Zaha Hadid, is fast becoming one of the world's most famous architects, and the opera house, with its irregular and amorphous structure, typifies her futuristic style.

Dieses hochmoderne Monument liegt im Kulturbezirk der südchinesischen Stadt Guangzhou. Sein an zwei Felsen erinnerndes Äußeres und die organischen Linien der Balkone und Innenwände sind für den einzigartigen Charakter dieses Theaters ausschlaggebend. Der umliegende öffentliche Raum samt Perlfluss-Anbindung erweitert diese dicht bebaute Stadt auf wunderbare Weise. Als verantwortliche Architektin ist Zaha Hadid auf dem besten Weg, sich einen Platz unter den weltberühmtesten Architekten zu sichern, und die gebrochene und amorphe Struktur ihres Operngebäudes versinnbildlicht ihren futuristischen Stil.

Guangzhou, China
Zaha Hadid, 2010

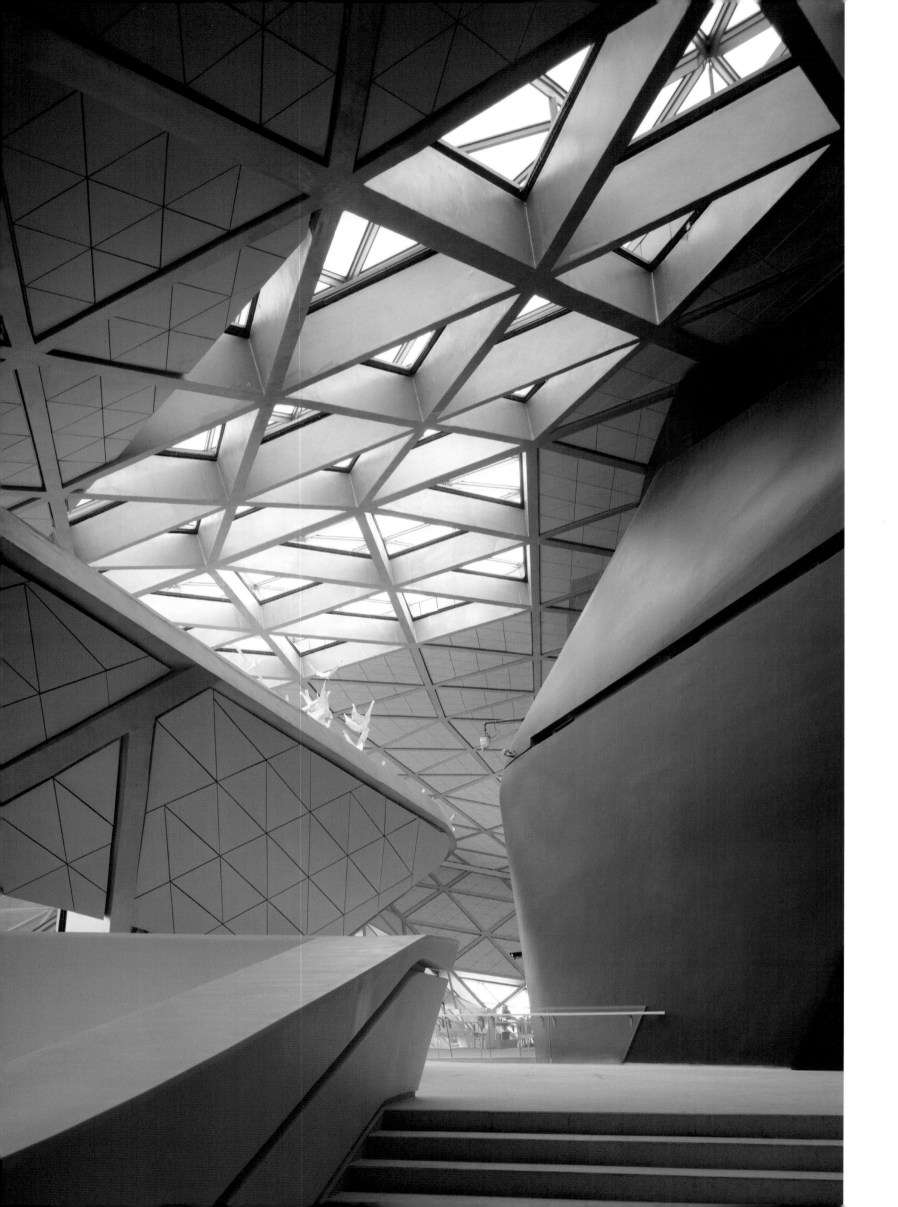

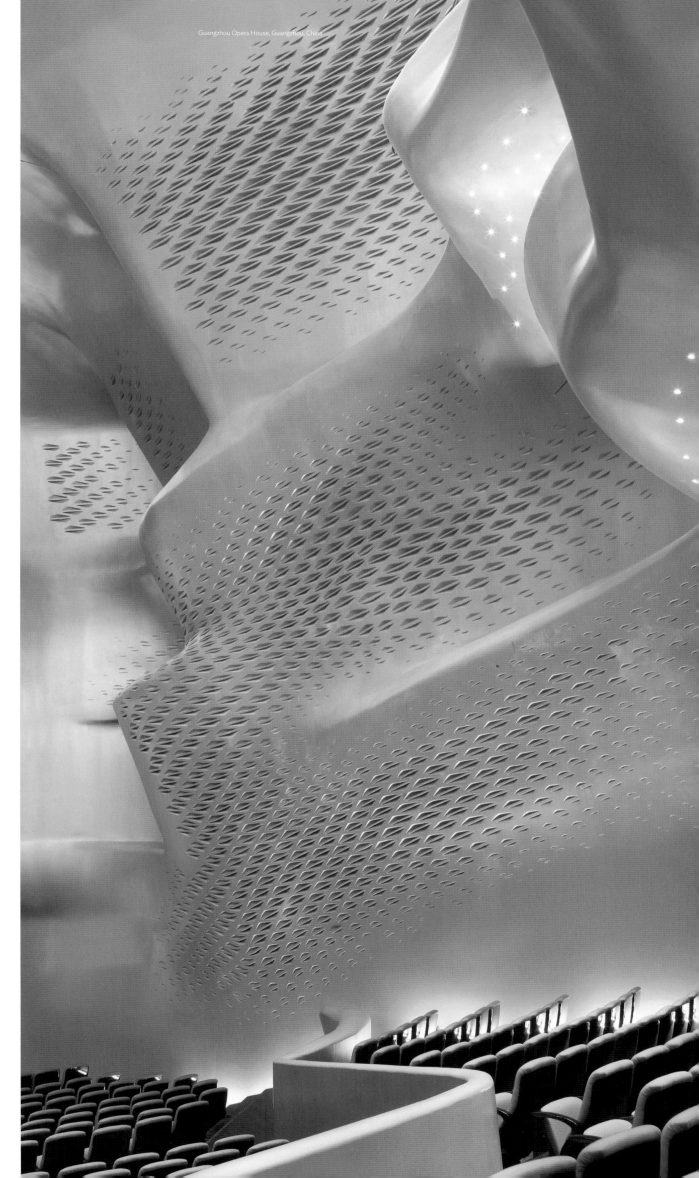

Guangzhou Opera House, Guangzhou, China

Ce monument avant-gardiste s'élève
en plein cœur du quartier culturel
de Canton, dans le Sud de la Chine.
L'extérieur en forme de double galet,
lui-même prolongé par des balcons
et des parois intérieures incurvées
aux accents organiques, confère
à cet opéra une allure totalement
inédite. L'espace public qui entoure
le complexe, avec ses passerelles
donnant sur la rivière des perles,
ajoute à l'invitation de découvrir
cette ville moderne. Avec cet opéra
à la structure irrégulière et amorphe,
emblématique de son style futuriste,
l'architecte en charge, Zaha Hadid,
jouit d'une reconnaissance mondiale
des plus fulgurantes.

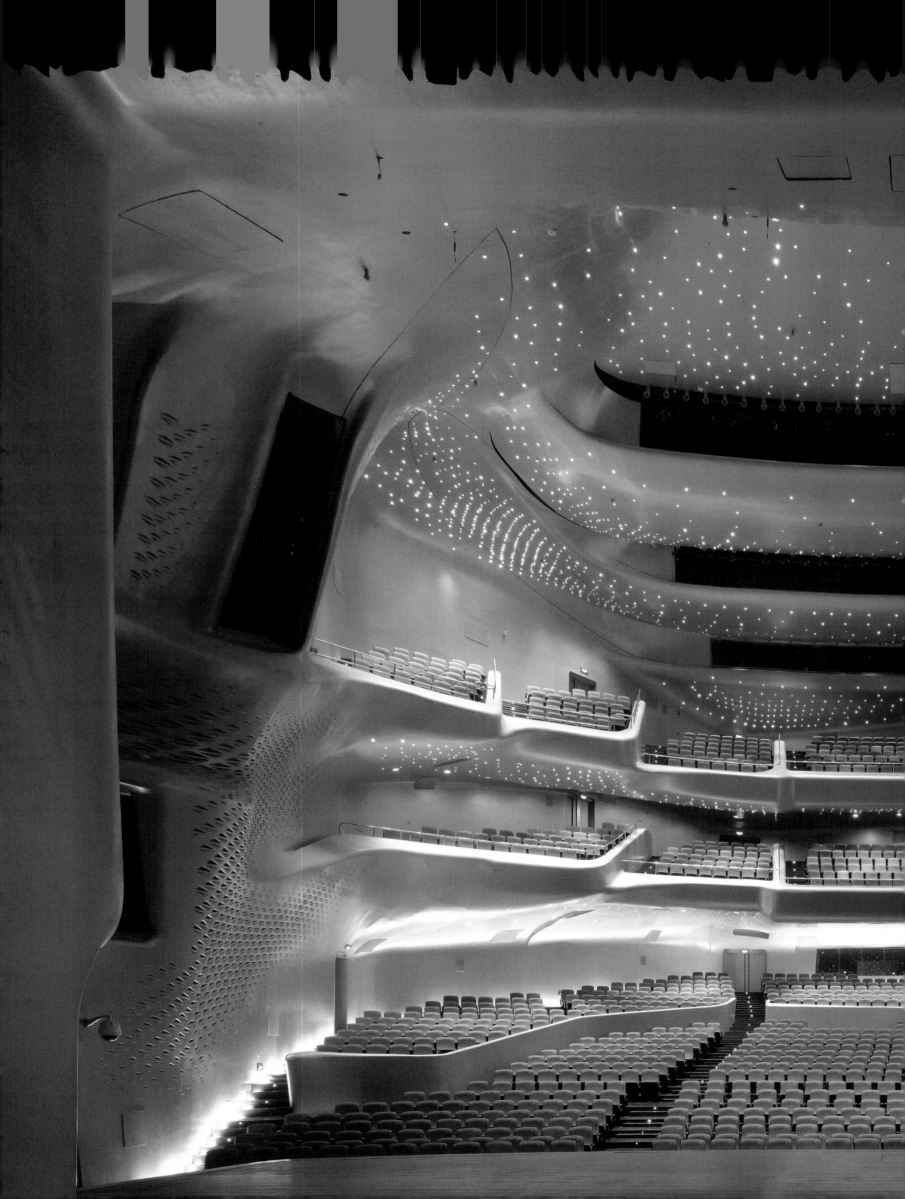

Este monumento vanguardista se encuentra en el barrio cultural de la ciudad de Cantón, al sur de China. El diseño exterior en forma de doble guijarro y las curvas orgánicas de las galerías y paredes interiores conforman un teatro realmente original. El espacio público circundante, y sus conexiones con el río Pearl, son una excelente contribución a favor de esta ciudad tan urbanizada. La arquitecta responsable, Zaha Hadid, se ha convertido en poco tiempo en uno de los arquitectos más famosos del mundo y el teatro

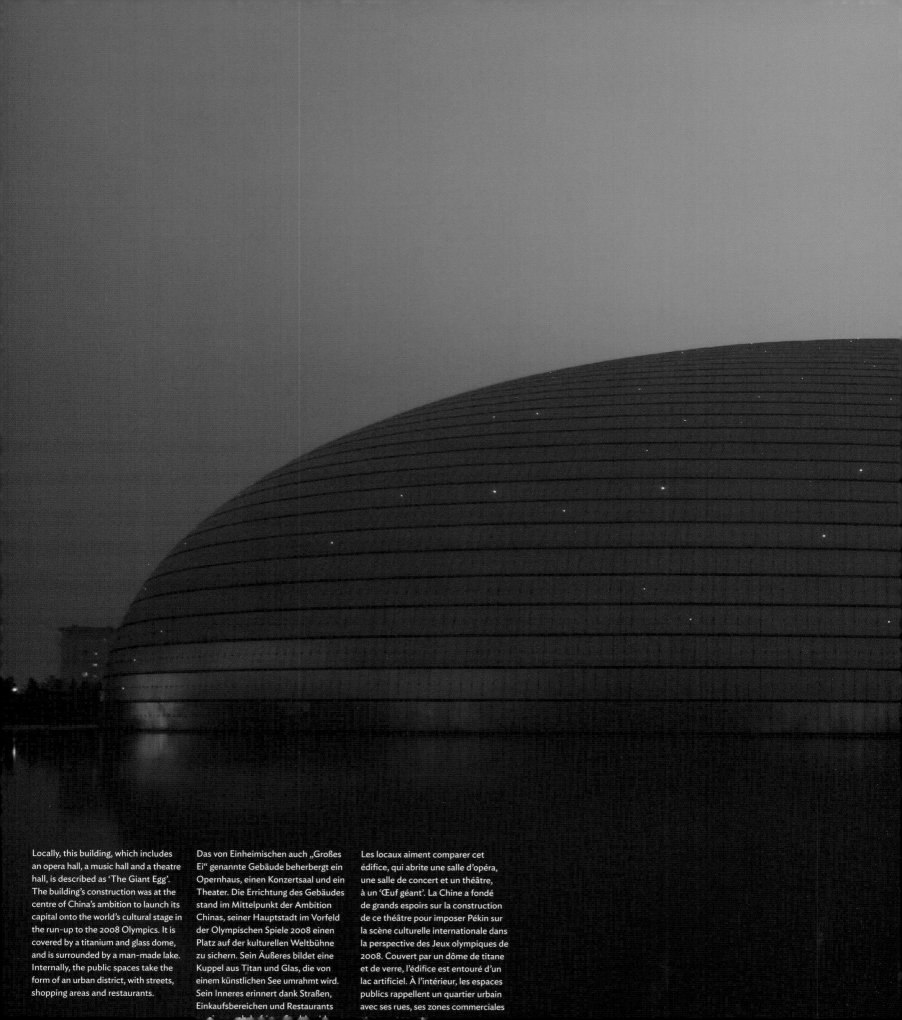

Locally, this building, which includes an opera hall, a music hall and a theatre hall, is described as 'The Giant Egg'. The building's construction was at the centre of China's ambition to launch its capital onto the world's cultural stage in the run-up to the 2008 Olympics. It is covered by a titanium and glass dome, and is surrounded by a man-made lake. Internally, the public spaces take the form of an urban district, with streets, shopping areas and restaurants.

Das von Einheimischen auch „Großes Ei" genannte Gebäude beherbergt ein Opernhaus, einen Konzertsaal und ein Theater. Die Errichtung des Gebäudes stand im Mittelpunkt der Ambition Chinas, seiner Hauptstadt im Vorfeld der Olympischen Spiele 2008 einen Platz auf der kulturellen Weltbühne zu sichern. Sein Äußeres bildet eine Kuppel aus Titan und Glas, die von einem künstlichen See umrahmt wird. Sein Inneres erinnert dank Straßen, Einkaufsbereichen und Restaurants

Les locaux aiment comparer cet édifice, qui abrite une salle d'opéra, une salle de concert et un théâtre, à un 'Œuf géant'. La Chine a fondé de grands espoirs sur la construction de ce théâtre pour imposer Pékin sur la scène culturelle internationale dans la perspective des Jeux olympiques de 2008. Couvert par un dôme de titane et de verre, l'édifice est entouré d'un lac artificiel. À l'intérieur, les espaces publics rappellent un quartier urbain avec ses rues, ses zones commerciales

National Centre for the Performing Arts
Capacity 5,425

Beijing, China
Paul Andreu, 2007

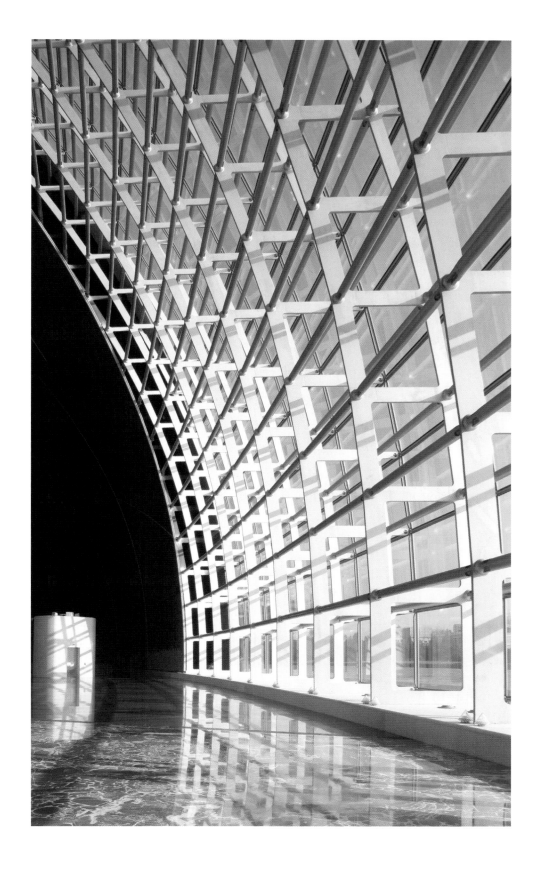

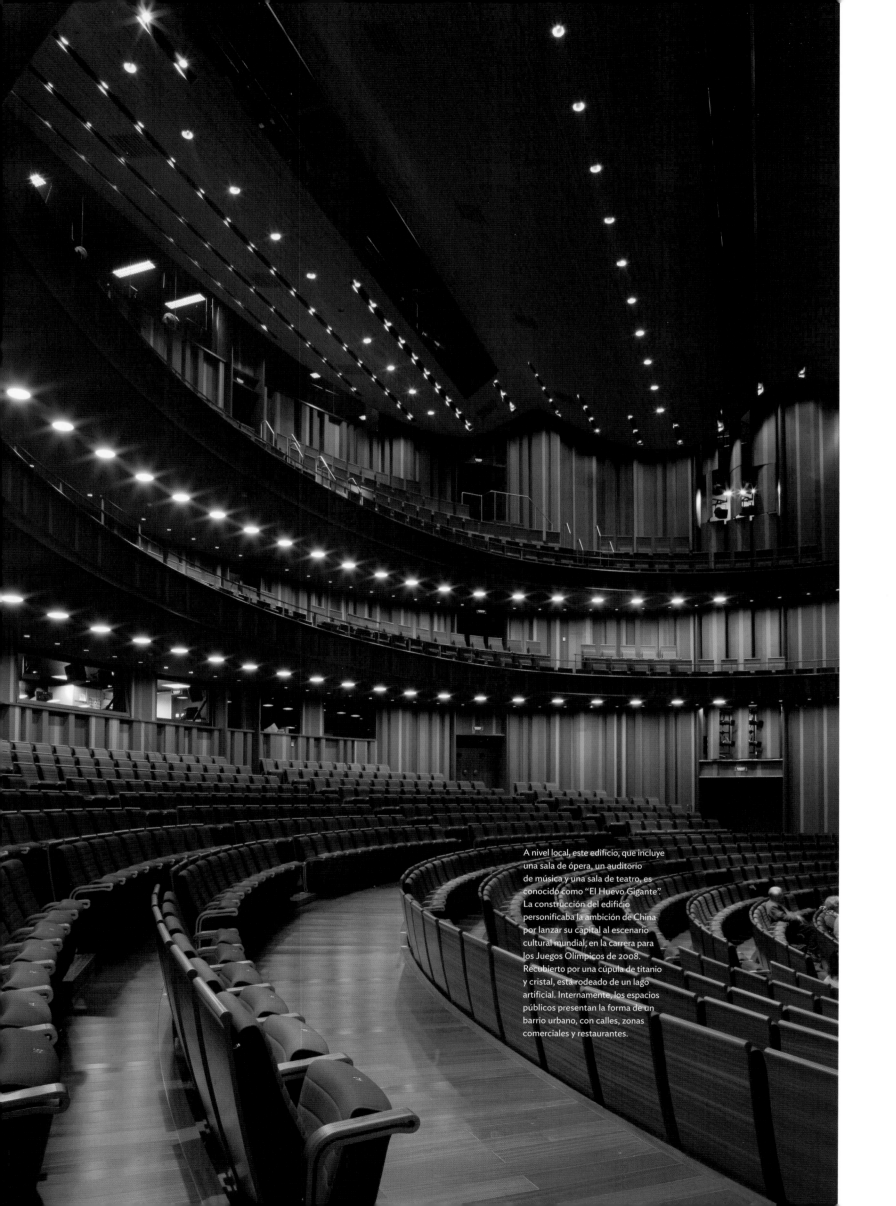

A nivel local, este edificio, que incluye una sala de ópera, un auditorio de música y una sala de teatro, es conocido como "El Huevo Gigante". La construcción del edificio personificaba la ambición de China por lanzar su capital al escenario cultural mundial, en la carrera para los Juegos Olímpicos de 2008. Recubierto por una cúpula de titanio y cristal, está rodeado de un lago artificial. Internamente, los espacios públicos presentan la forma de un barrio urbano, con calles, zonas comerciales y restaurantes.

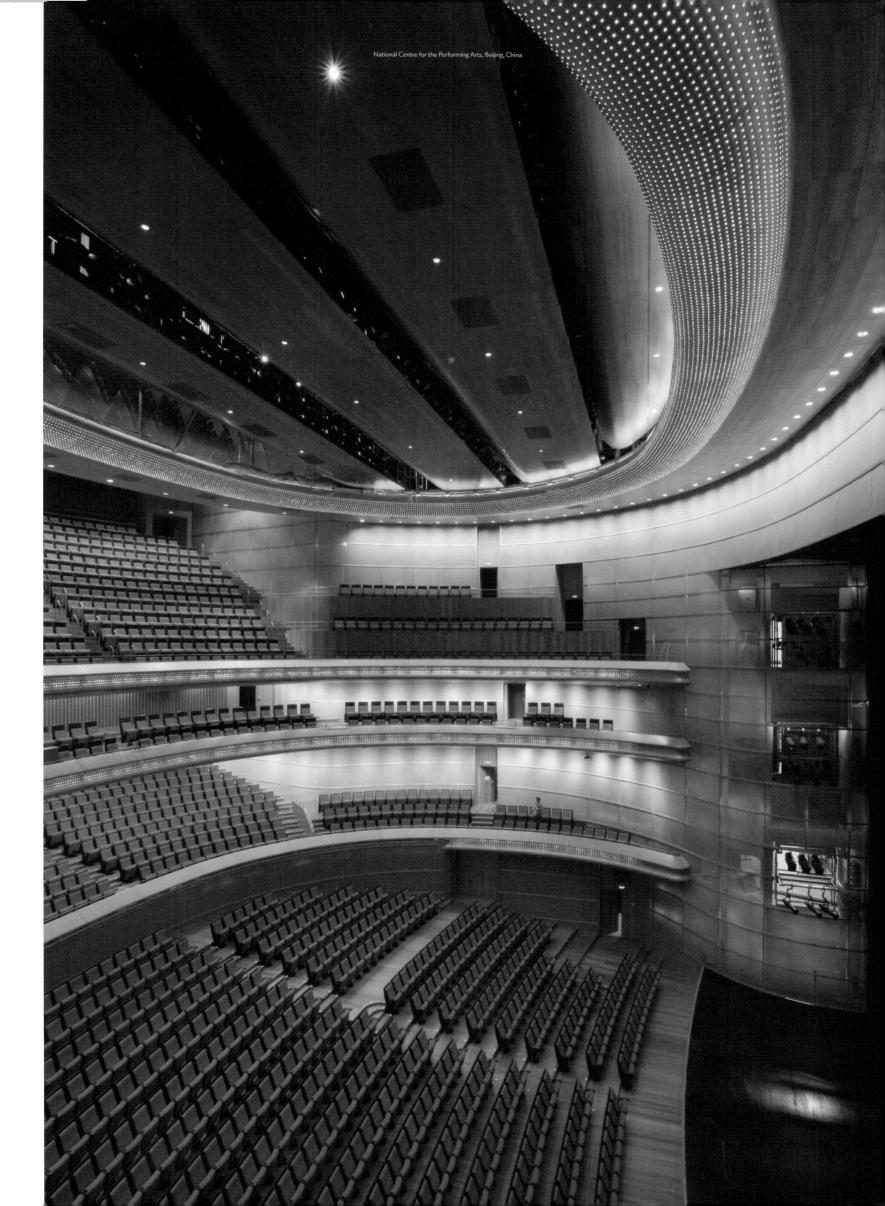
National Centre for the Performing Arts, Beijing, China

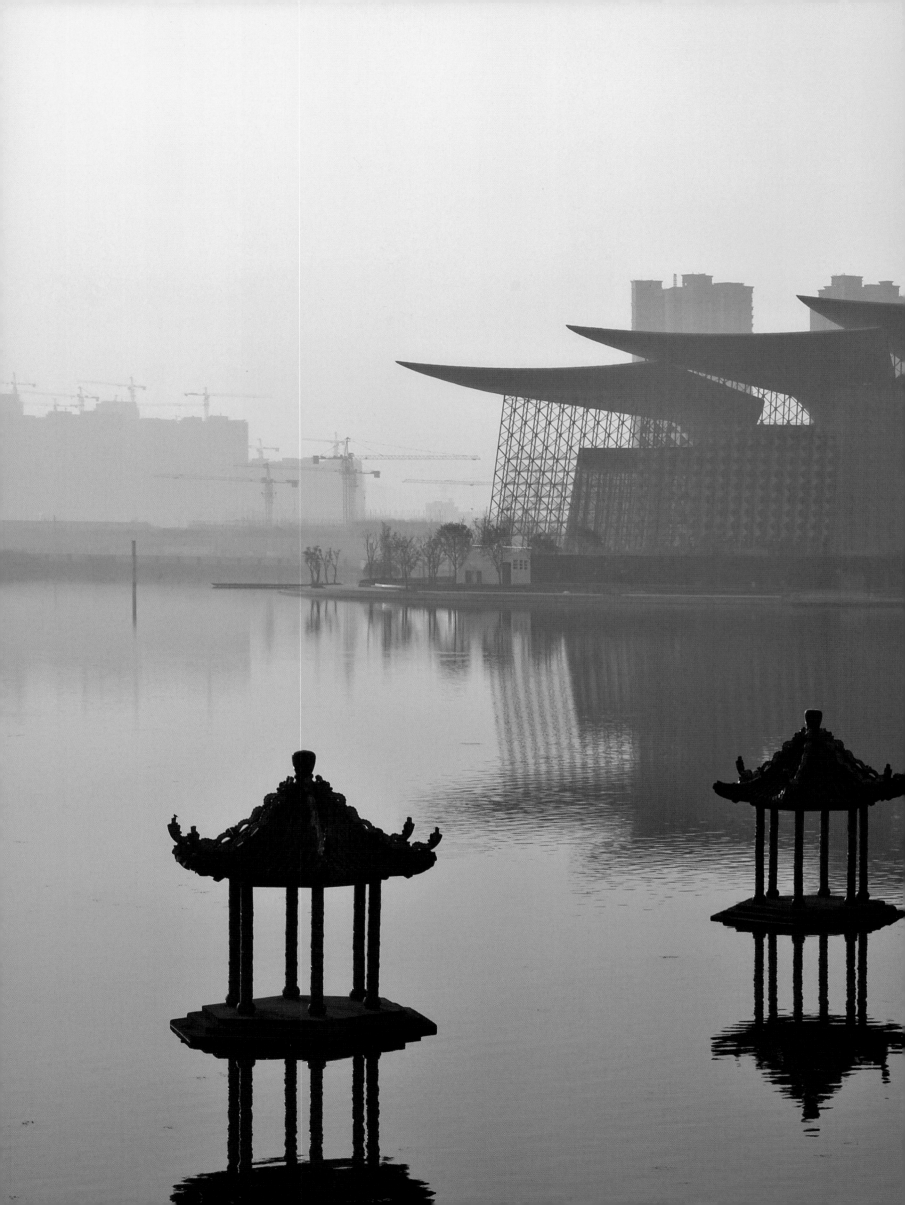

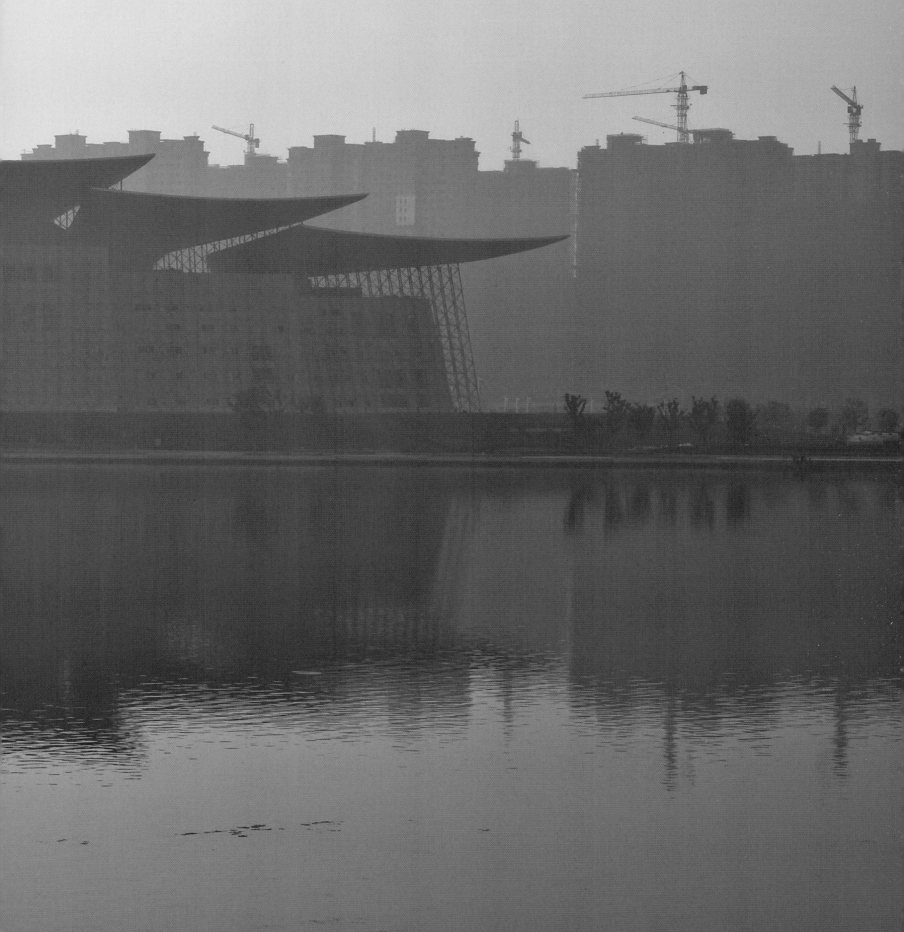

Wuxi Grand Theatre
Capacity 1,680

Wuxi, China
PES Architects, 2012

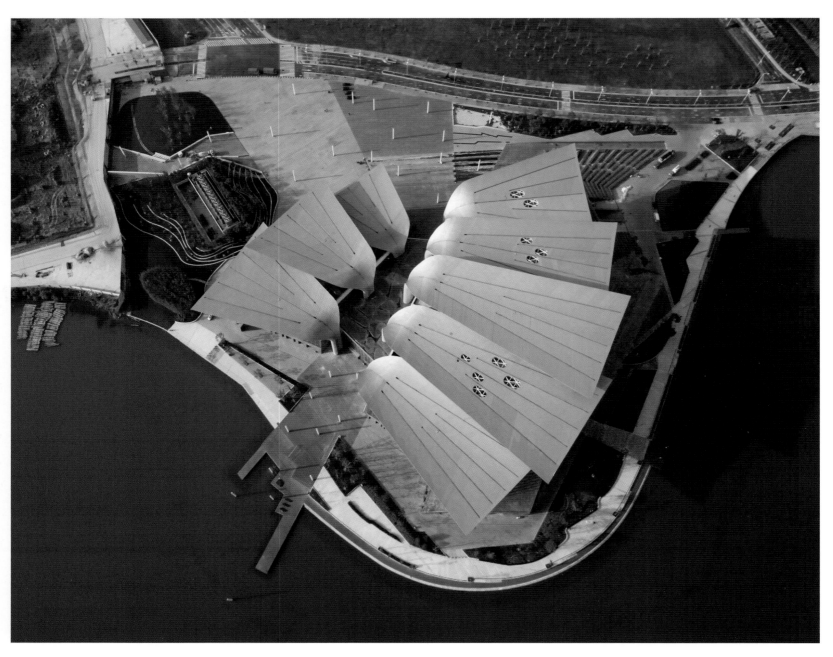

Wuxi Grand Theatre is situated on a man-made peninsula on Taihu Lake, in the city of Wuxi. Many have commented on the similarity in setting between it and the Sydney Opera House, in that they both have made their homes on reclaimed land. The Helsinki-based architects blended Chinese and Finnish design in their conception of this mammoth project, which combines programmable LED lighting and the large-scale use of bamboo. Its most striking feature is the set of eight fifty-metre-tall fins that span the entire theatre.

Das Wuxi Grand Theatre liegt auf einer künstlich angelegten Halbinsel am Ufer des Taihu-Sees in der Stadt Wuxi. Häufig wird auf seine Ähnlichkeit mit dem Opernhaus von Sydney verwiesen, wurden beide Gebäude doch auf einem dem Meer abgerungenen Stück Land errichtet. Bei der Konzeption dieses Mammutprojekts kombinierten seine in Helsinki ansässigen Architekten chinesisches mit finnischem Design, wovon beispielsweise der Einsatz programmierbarer LED-Beleuchtung in Verbindung mit der umfangreichen Verwendung von Bambus zeugt. Sein wohl auffälligstes Merkmal aber sind die acht beinahe 50 Meter hohen Dachflügel, die das gesamte Theater bekränzen.

Le Grand Théâtre de Wuxi surplombe la péninsule artificielle au bord du lac Tai dans la ville de Wuxi. Beaucoup ont comparé l'édifice à l'Opéra de Sydney tant ces deux cadres similaires sont parvenus à mettre en valeur des terrains gagnés sur l'eau. Le cabinet d'architectes basé à Helsinki a su marier styles chinois et finlandais dans la conception de cet ouvrage titanesque, alliant éclairage par LED programmables et plaques de bambou de grande envergure. L'édifice finit de surprendre avec les huit ailes de papillon de cinquante mètres de haut chacune qui coiffent l'ensemble du théâtre.

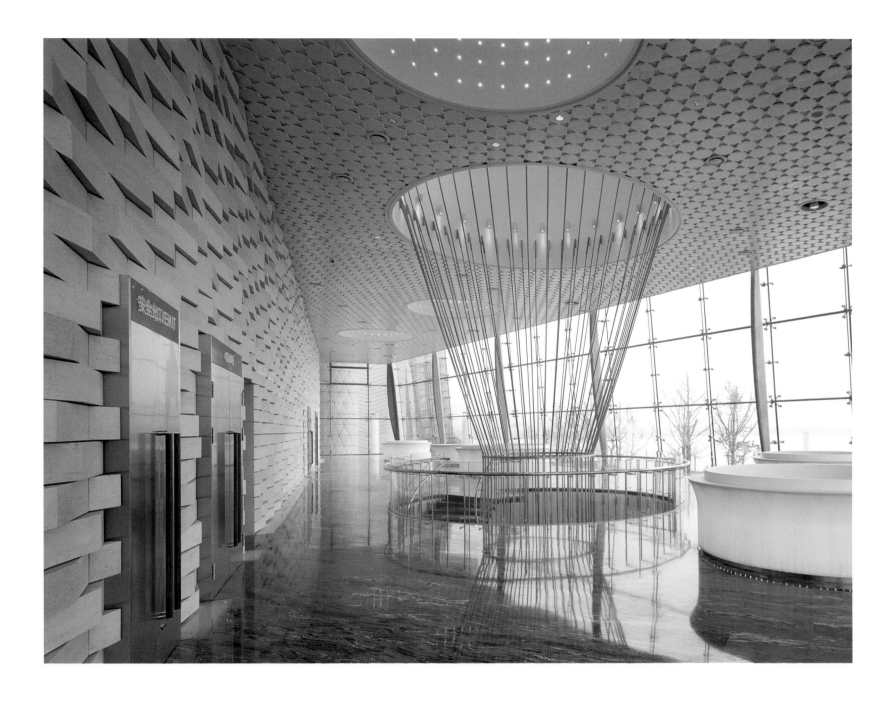

El Gran Teatro de Wuxi se encuentra en una península artificial del Lago Taihu, en la ciudad de Wuxi. Son numerosas las personas que han comentado la semejanza del entorno de este teatro y el de la Ópera de Sydney, ambos asentados en terrenos ganados al mar. Los arquitectos, con sede en Helsinki, han combinado el diseño chino y el finlandés en la concepción de este colosal proyecto, que combina una iluminación de LED programable con un uso intensivo del bambú. Su característica más emblemática reside en una serie de ocho alas de 50 metros de altura que se extienden sobre todo el teatro.

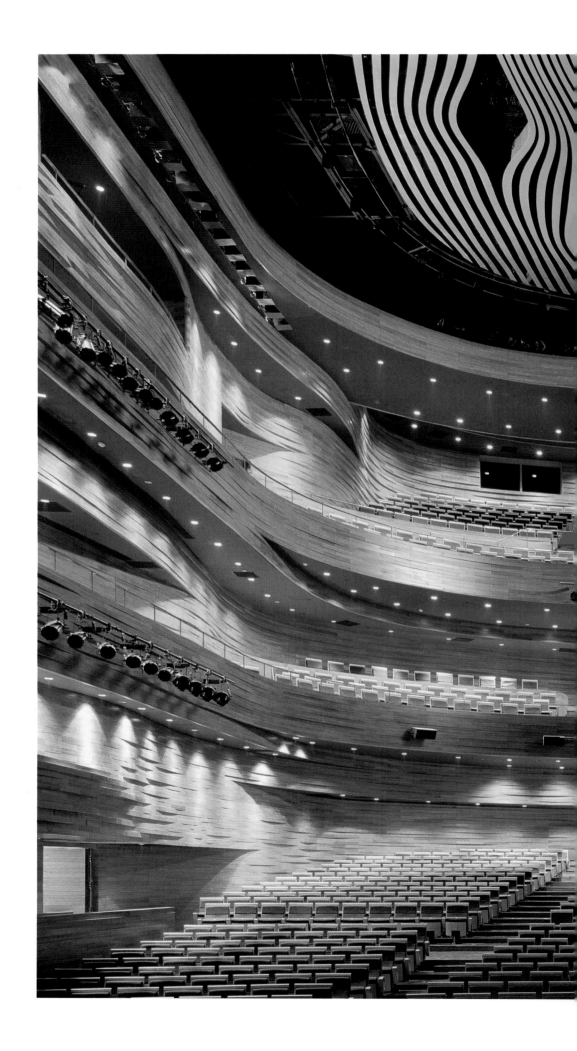

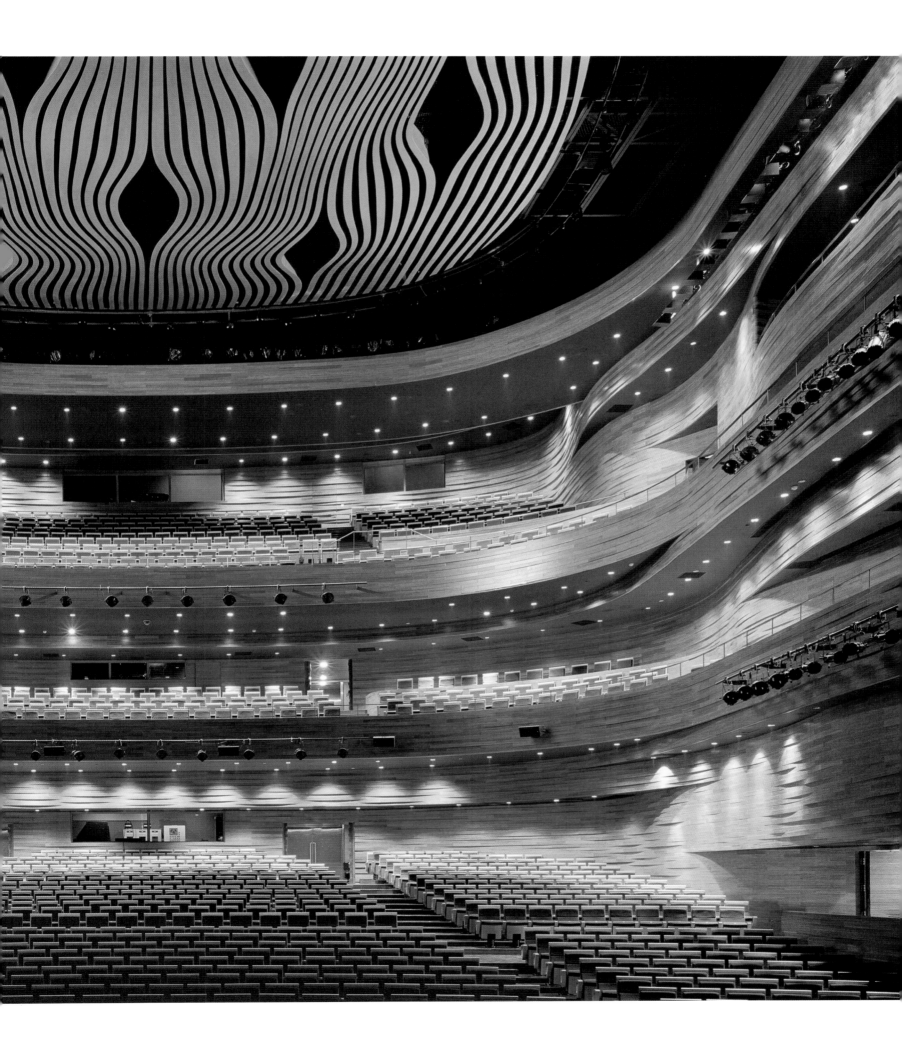

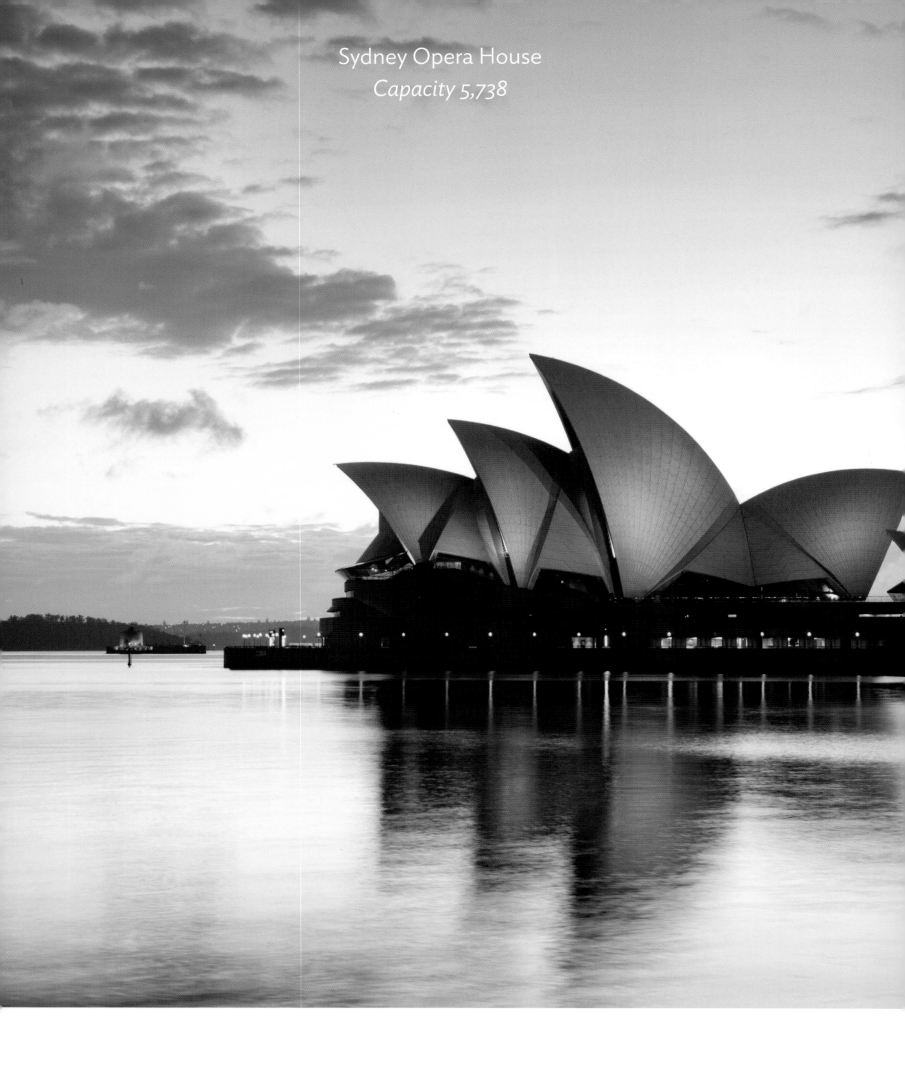

Sydney Opera House
Capacity 5,738

Sydney, Australia
Jørn Utzon, 1973

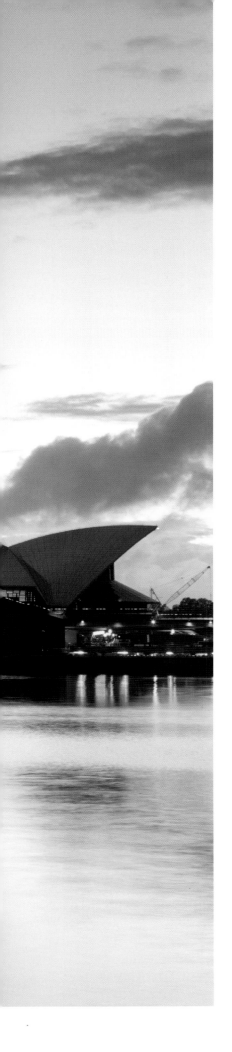

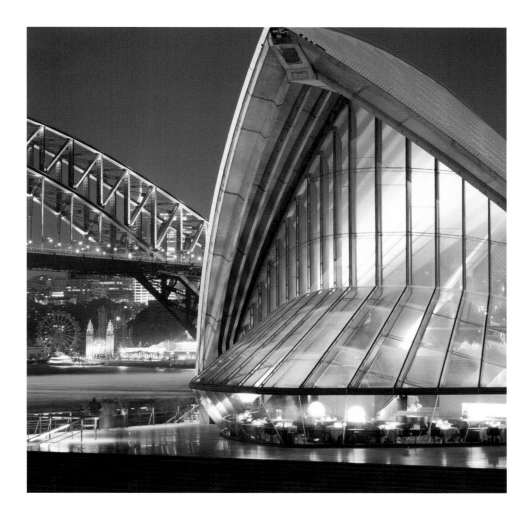

The enormous concrete shells of the Sydney Opera House have made it one of the most instantly recognisable buildings on the planet. Conceived in 1957, the construction of the Danish architect's bold design was a turbulent affair, with delays, design flaws, resignations, and reappointments delaying its completion for some eighteen years. Contrary to its name, the building actually contains a number of venues, including a concert hall, an opera house and a drama theatre.

Dank der beeindruckenden Ausführung unter Verwendung von Betonschalen zählt das Opernhaus von Sydney zu den bekanntesten und unverwechselbarsten Gebäuden der Welt. Die Umsetzung des kühnen Entwurfs des dänischen Architekten Jørn Utzon aus dem Jahr 1957 erwies sich als von Verzögerungen, Design-Problemen, Resignation und Neuberufungen geprägte turbulente Angelegenheit, die die Fertigstellung des Gebäudes um insgesamt achtzehn Jahre verzögerte. Anders als sein Name vermuten lässt, beherbergt das Gebäude heute gleich mehrere unterschiedliche Veranstaltungsorte, darunter eine Konzerthalle, eine Oper und ein Theater.

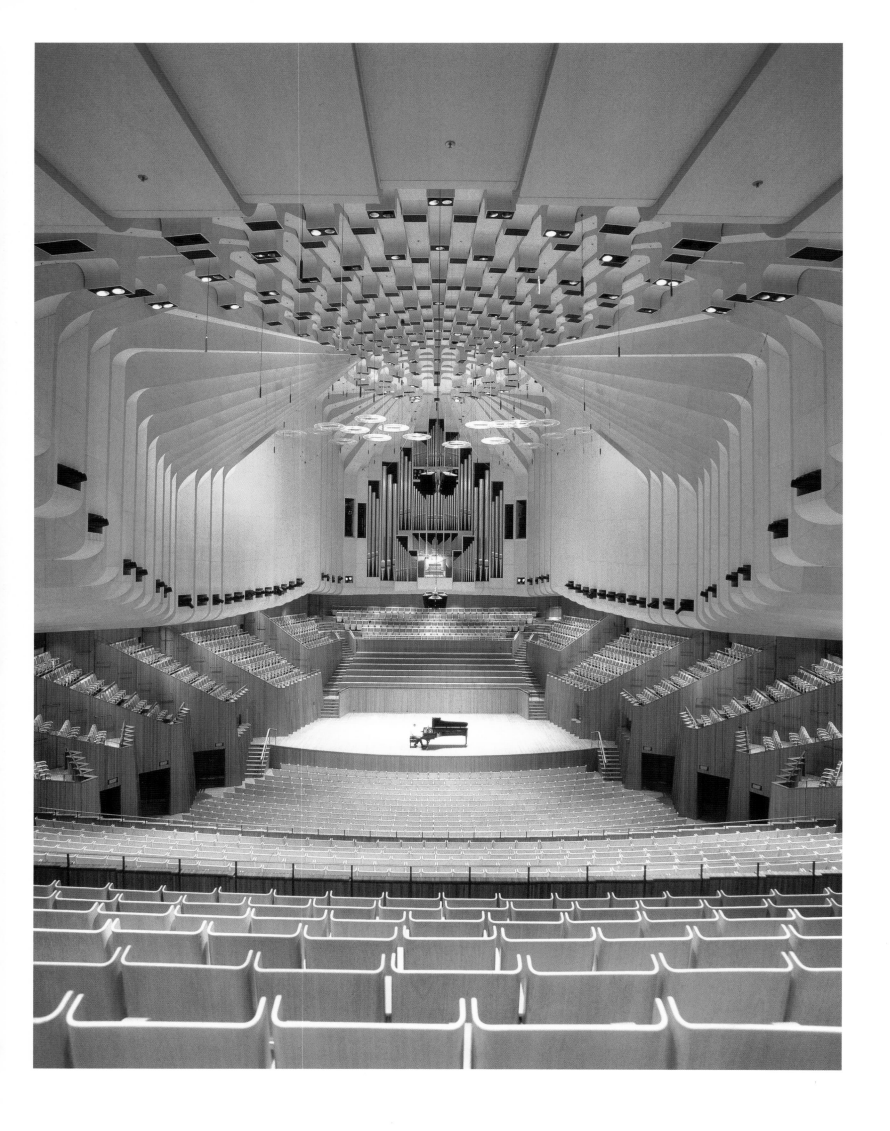

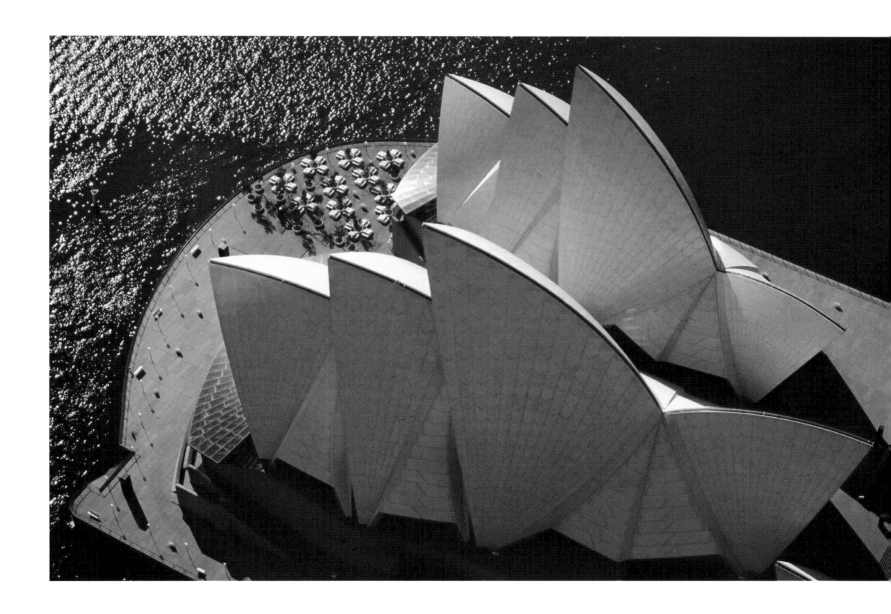

Avec ses énormes coques de béton, l'Opéra de Sydney figure parmi les grandes constructions mondiales immédiatement identifiables. Conçue en 1957, l'œuvre audacieuse de l'architecte danois a rencontré d'importants problèmes de construction. Retards, défauts de fabrication, démissions et autres renomminations ont reporté son achèvement quelques dix-huit ans plus tard. Contrairement à ce qu'indique son nom, l'édifice abrite en réalité un certain nombre de complexes, dont une salle de concert, une salle d'opéra et un théâtre d'art dramatique.

Las inmensas estructuras de hormigón que caracterizan al Teatro de la Ópera de Sidney han hecho de él uno de los edificios más fácilmente reconocibles de todo el planeta. Diseñado en 1957, la construcción del audaz diseño del arquitecto danés tuvo una historia turbulenta, con retrasos, defectos de diseño, dimisiones y reelecciones, lo que retardó su finalización en unos ocho años. A pesar de su nombre, el edificio contiene en realidad varias sedes, entre ellas un auditorio de conciertos, una sala de ópera y un teatro de arte dramático.

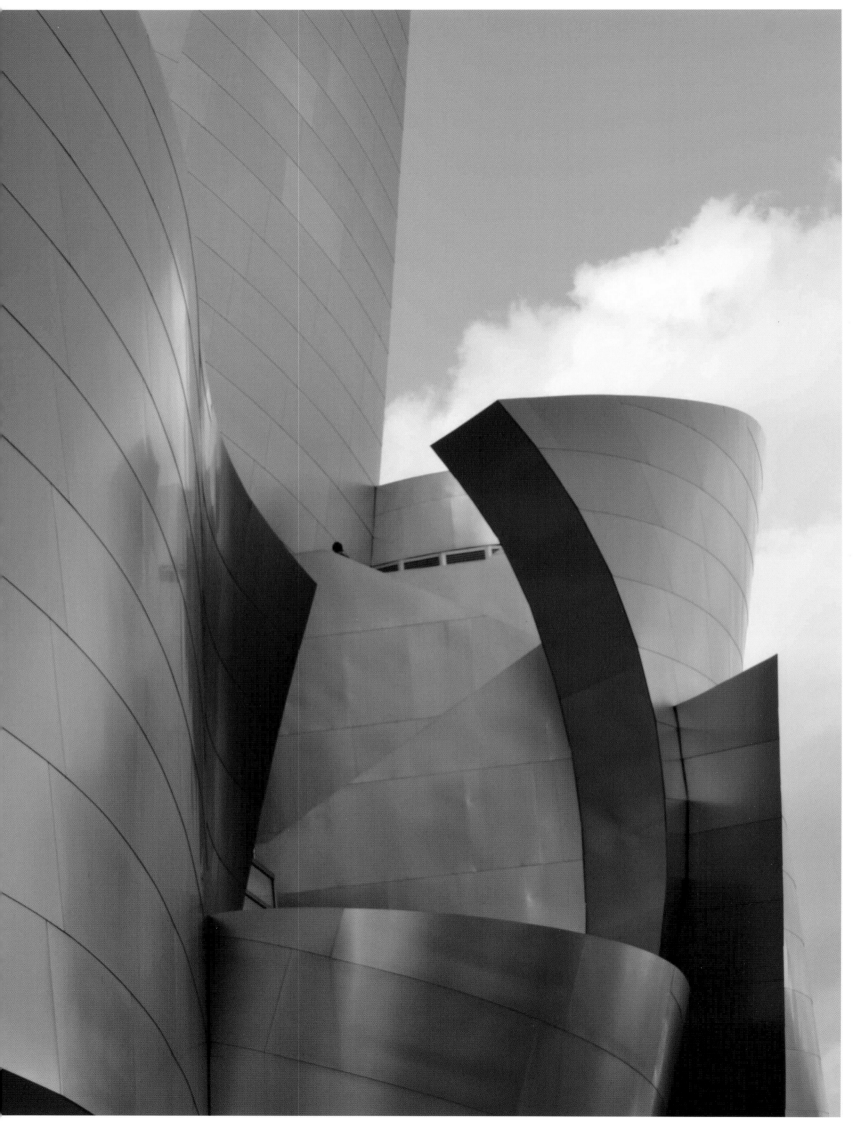

Walt Disney Concert Hall
Capacity 2,265

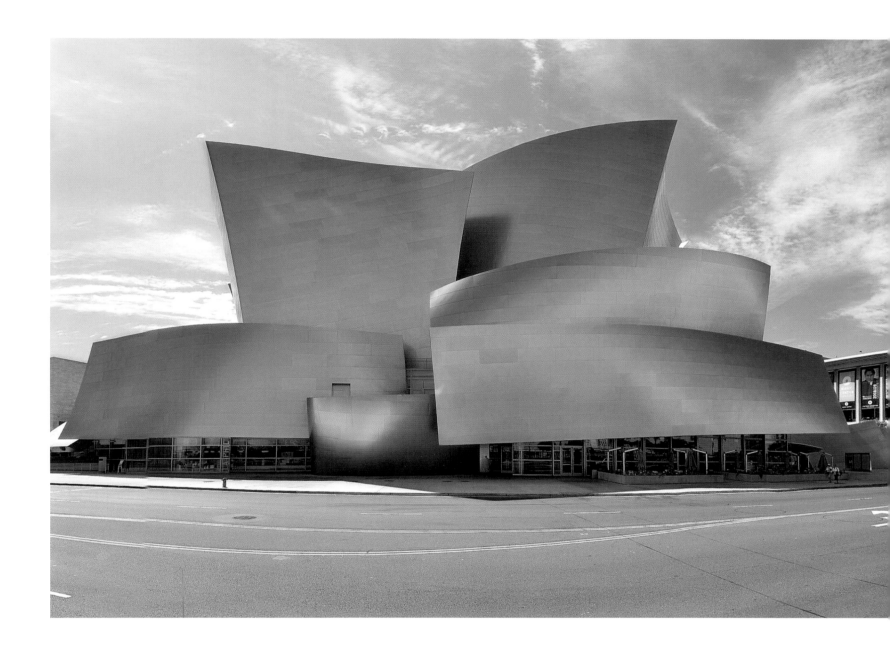

Situated in downtown Los Angeles, the Walt Disney Concert Hall was designed to be one of the most acoustically sophisticated venues in the world. Because of its acoustics and the enormous stainless-steel curves of the exterior, some consider this architectural marvel to be Frank Gehry's masterpiece, following the success of the Guggenheim Museum in Bilbao. It is home to the Los Angeles Philharmonic Orchestra and the Los Angeles Master Chorale.

Die im Stadtzentrum von Los Angeles gelegene Walt Disney Concert Hall gilt aufgrund ihrer modernen, ausgefeilten Akustik als einer der weltweit modernsten Veranstaltungsorte überhaupt. Aufgrund seiner außergewöhnlichen akustischen Eigenschaften und beeindruckenden äußeren Erscheinung mit geschwungenen Formen aus rostfreiem Stahl wird dieses architektonische Kleinod manchmal neben dem gefeierten Guggenheim-Museum in Bilbao als das Meisterwerk Frank Gehrys angesehen. Die Walt Disney Concert Hall beherbergt das Philharmonische Orchester von Los Angeles und den Los Angeles Master Chorale.

Los Angeles, California, USA
Gehry Partners, 2003

En plein centre de Los Angeles, le Walt Disney Concert Hall a été conçu pour abriter l'une des salles les mieux dotée en acoustique du monde. Pour son acoustique incomparable et son impressionnant extérieur incurvé en acier inoxydable, beaucoup considère cette merveille architecturale comme le chef-d'œuvre de Frank Gehry, après le succès du Guggenheim Museum à Bilbao. Le Walt Disney Concert Hall héberge l'Orchestre philharmonique de Los Angeles, ainsi que la Los Angeles Master Chorale.

Situado en el centro de Los Ángeles, el Walt Disney Concert Hall se diseñó para ser una de las salas más sofisticadas del mundo en lo que a acústica se refiere. Gracias a su acústica y a las enormes curvas exteriores de acero inoxidable, hay quien considera que esta maravilla arquitectónica es la obra maestra de Frank Gehry, siguiendo la estela del éxito del Museo Guggenheim de Bilbao. Es la sede de Los Angeles Philharmonic Orchestra y Los Angeles Master Chorale.

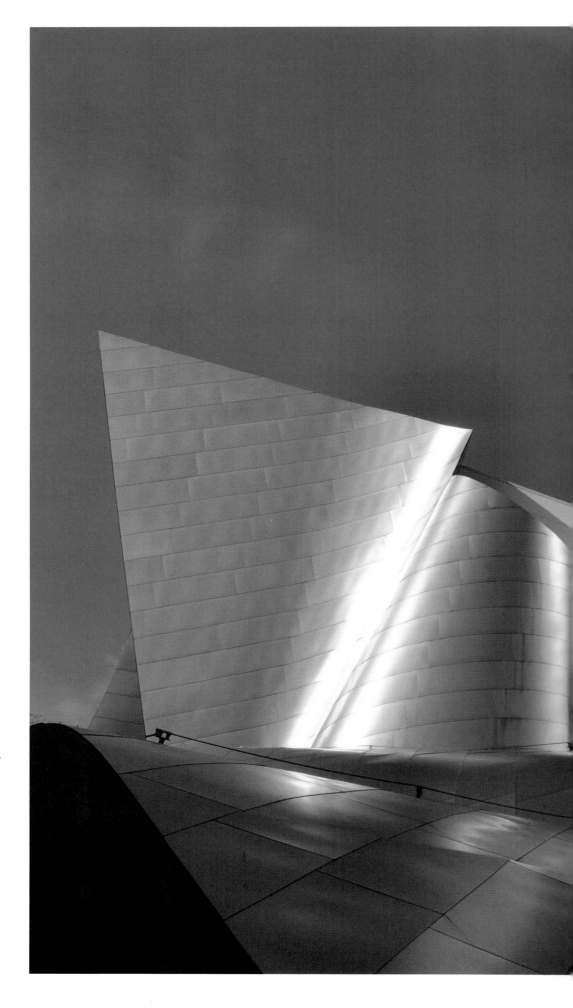

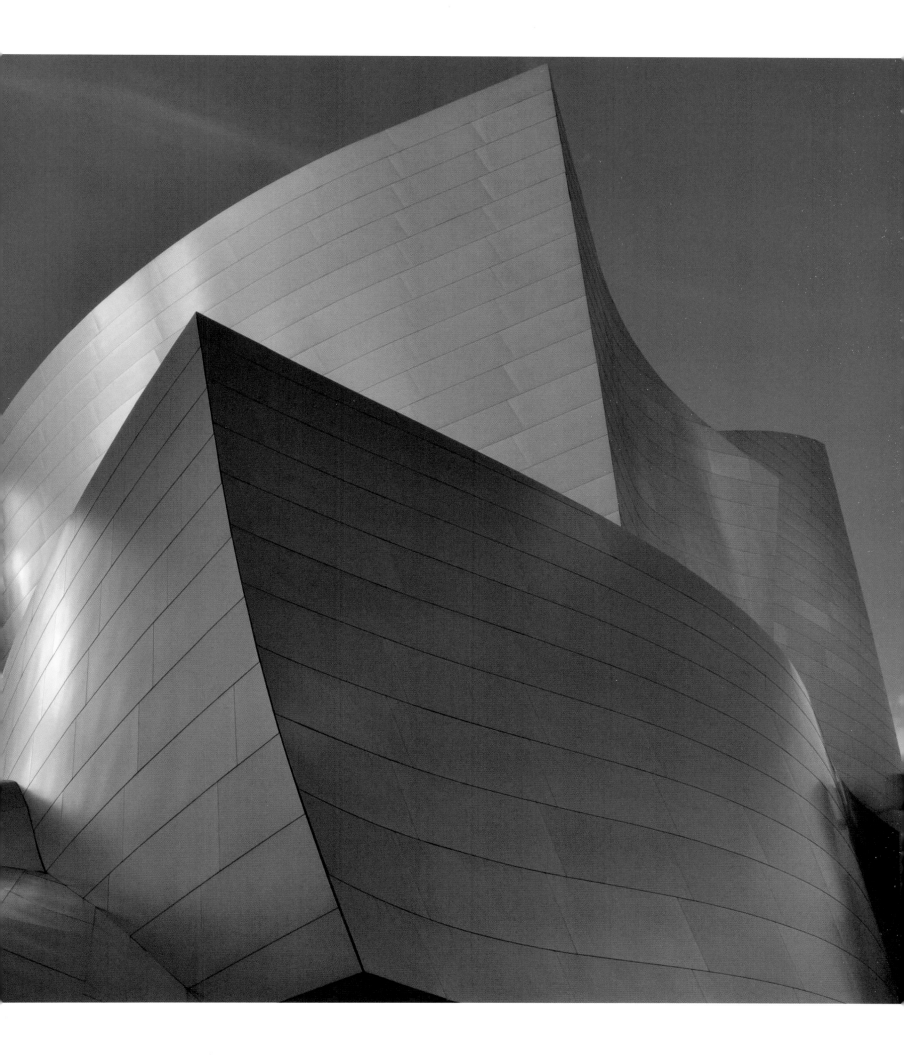

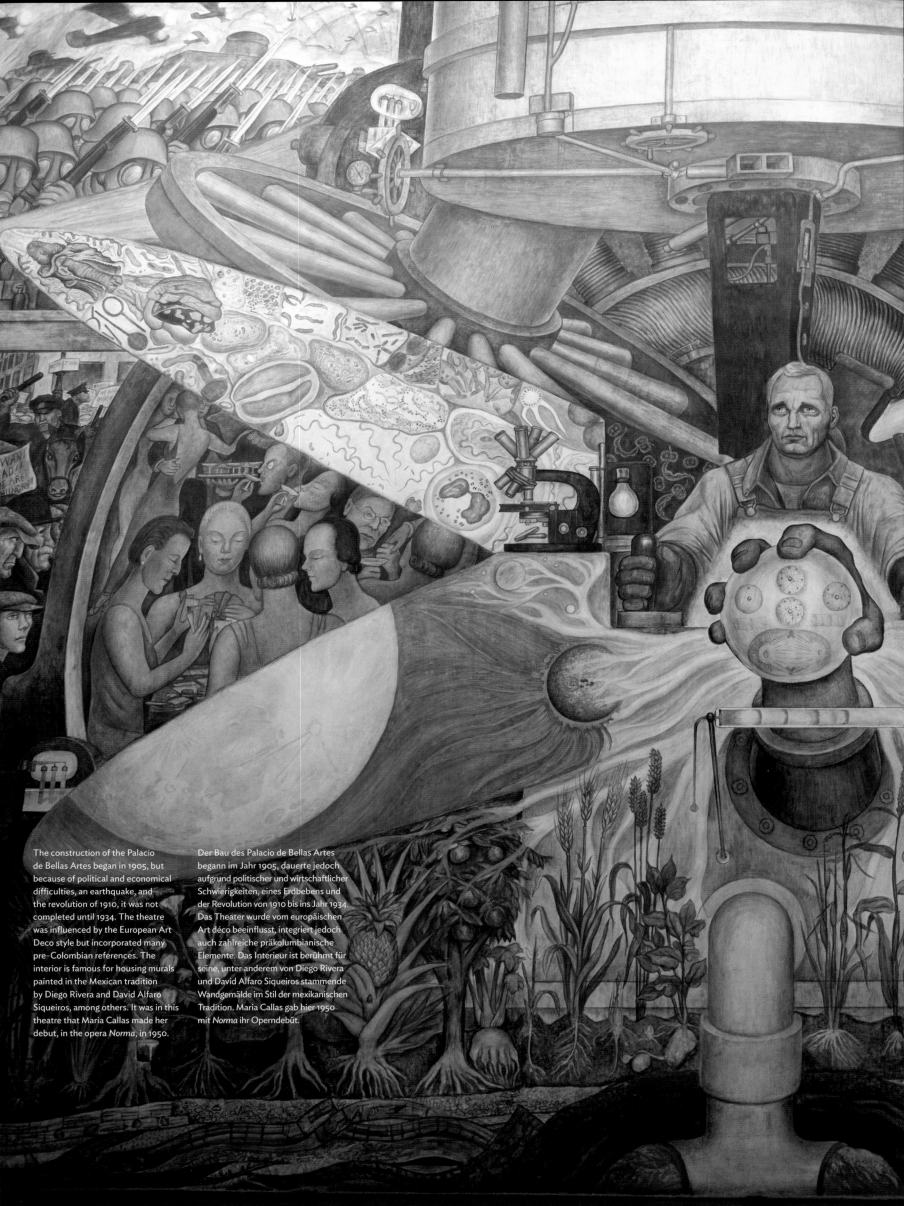

The construction of the Palacio de Bellas Artes began in 1905, but because of political and economical difficulties, an earthquake, and the revolution of 1910, it was not completed until 1934. The theatre was influenced by the European Art Deco style but incorporated many pre-Colombian references. The interior is famous for housing murals painted in the Mexican tradition by Diego Rivera and David Alfaro Siqueiros, among others. It was in this theatre that María Callas made her debut, in the opera *Norma*, in 1950.

Der Bau des Palacio de Bellas Artes begann im Jahr 1905, dauerte jedoch aufgrund politischer und wirtschaftlicher Schwierigkeiten, eines Erdbebens und der Revolution von 1910 bis ins Jahr 1934. Das Theater wurde vom europäischen Art déco beeinflusst, integriert jedoch auch zahlreiche präkolumbianische Elemente. Das Interieur ist berühmt für seine, unter anderem von Diego Rivera und David Alfaro Siqueiros stammende Wandgemälde im Stil der mexikanischen Tradition. Maria Callas gab hier 1950 mit *Norma* ihr Operndebüt.

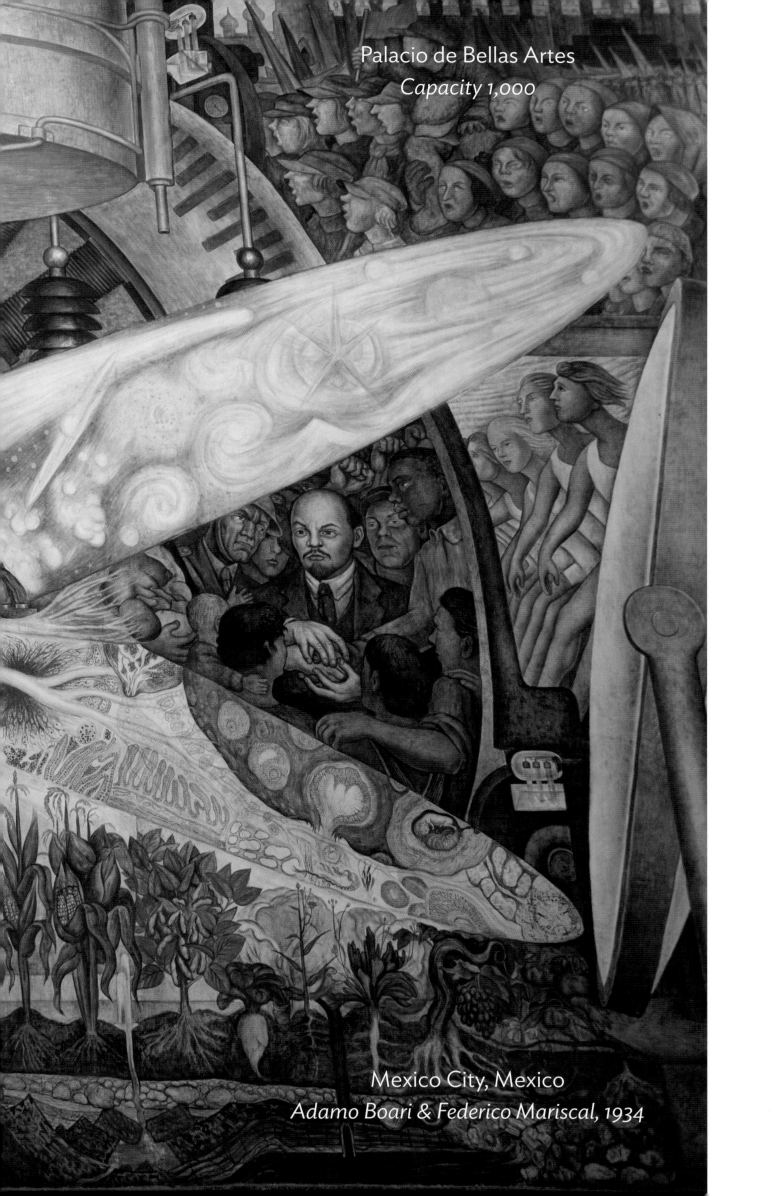

Mexico City, Mexico
Adamo Boari & Federico Mariscal, 1934

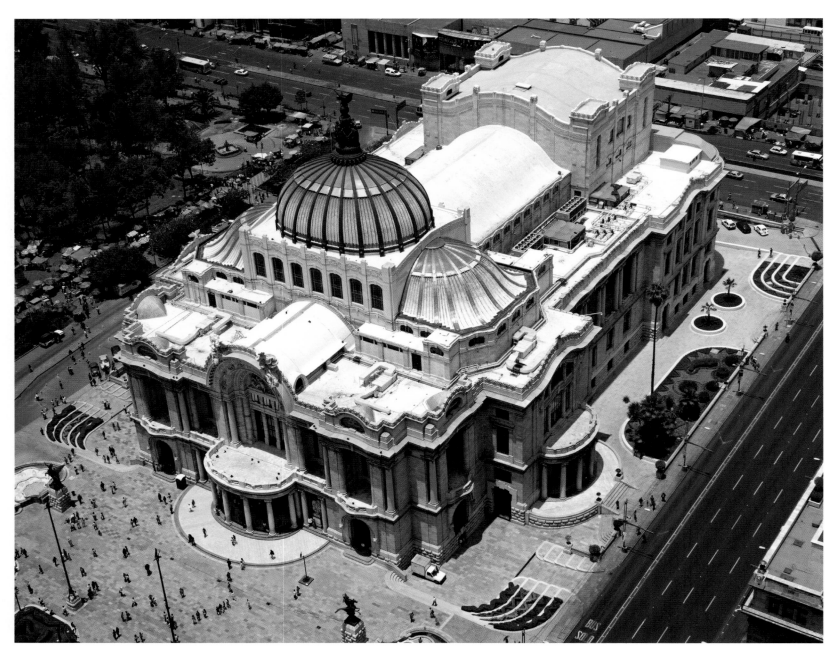

Débutée en 1905, la construction
du Palacio de Bellas Artes ne fut
terminée qu'en 1934 en raison de
difficultés politiques et économiques,
d'un tremblement de terre et de la
révolution de 1910. Influencé par le
style européen Art déco, le bâtiment
comporte également de nombreuses
références précolombiennes. L'intérieur
est célèbre pour ses peintures murales
réalisées dans la plus pure tradition
mexicaine par les artistes Diego Rivera
et David Alfaro Siqueiros, pour ne citer
qu'eux. Maria Callas y fit ses débuts en
interprétant l'opéra Norma en 1950.

La construcción del Palacio de Bellas
Artes comenzó en 1905 y, debido a
problemas políticos y económicos,
a un terremoto y a la revolución de
1910, no finalizó hasta 1934. El teatro
mostraba influencias del estilo europeo
Art Decó, aunque incorporaba además
numerosas referencias precolombinas.
Su interior es famoso por albergar
murales pintados, siguiendo la tradición
mexicana, por Diego Rivera y David
Alfaro Siqueiros, entre otros. Fue en
este teatro en el que debutó María
Callas, en la ópera Norma, en 1950.

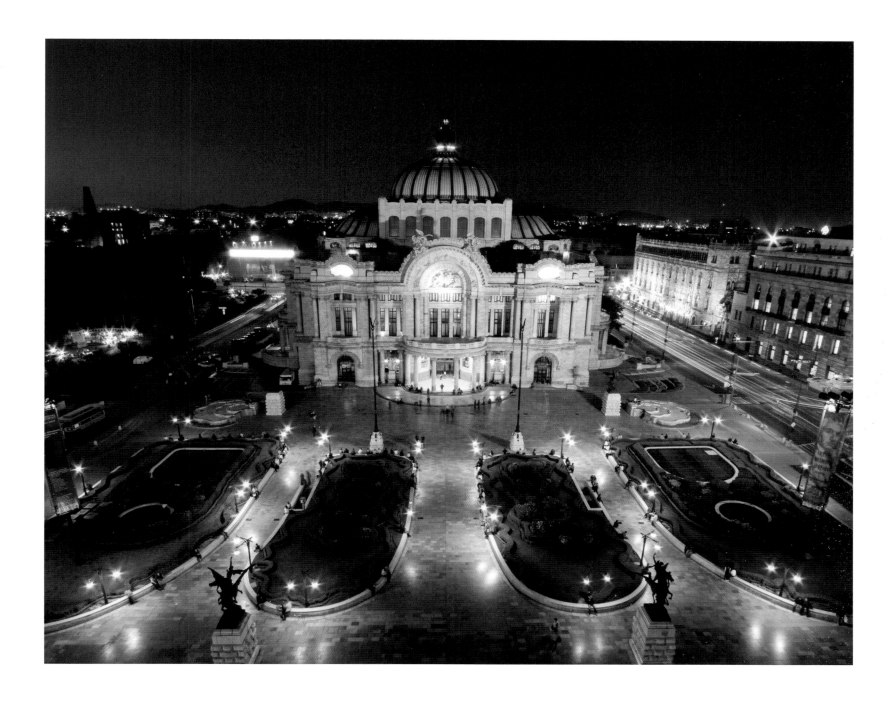

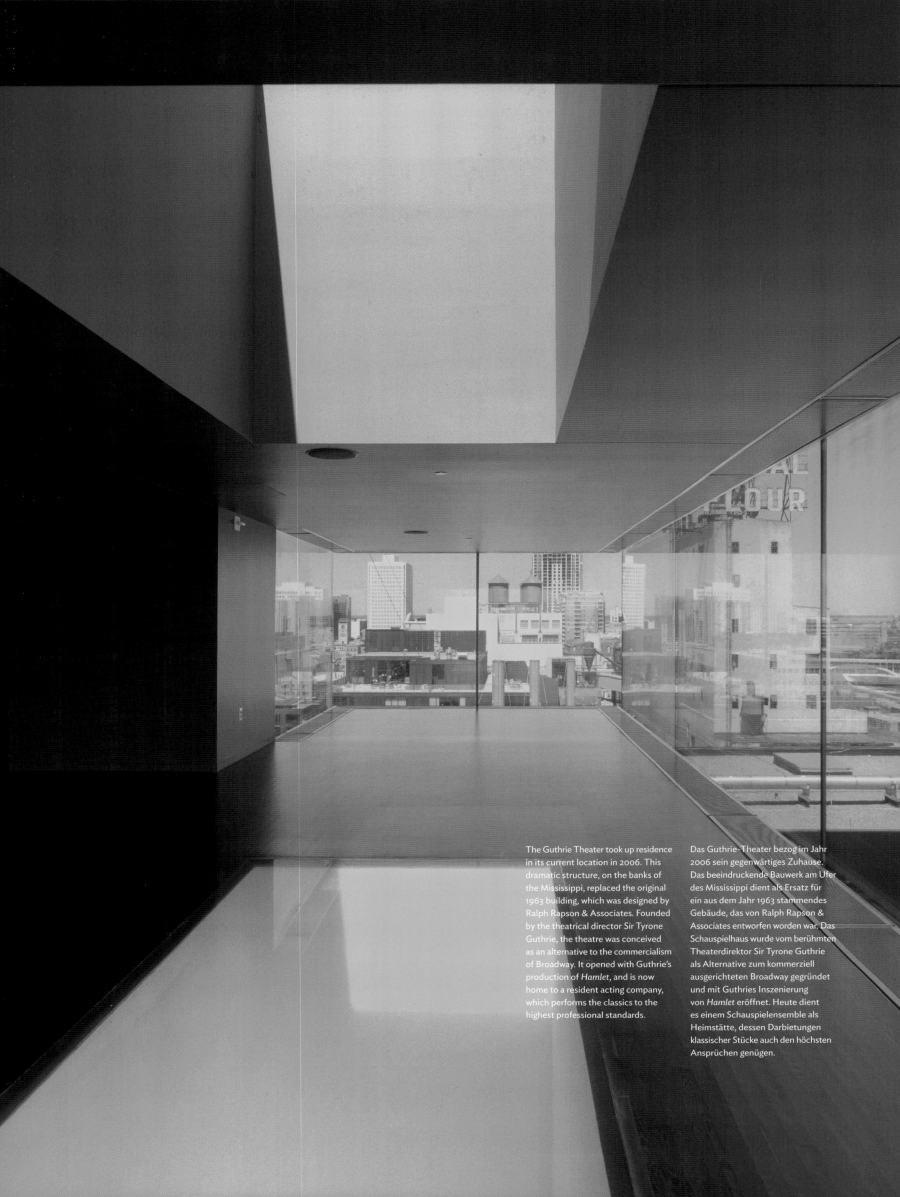

The Guthrie Theater took up residence in its current location in 2006. This dramatic structure, on the banks of the Mississippi, replaced the original 1963 building, which was designed by Ralph Rapson & Associates. Founded by the theatrical director Sir Tyrone Guthrie, the theatre was conceived as an alternative to the commercialism of Broadway. It opened with Guthrie's production of *Hamlet*, and is now home to a resident acting company, which performs the classics to the highest professional standards.

Das Guthrie-Theater bezog im Jahr 2006 sein gegenwärtiges Zuhause. Das beeindruckende Bauwerk am Ufer des Mississippi dient als Ersatz für ein aus dem Jahr 1963 stammendes Gebäude, das von Ralph Rapson & Associates entworfen worden war. Das Schauspielhaus wurde vom berühmten Theaterdirektor Sir Tyrone Guthrie als Alternative zum kommerziell ausgerichteten Broadway gegründet und mit Guthries Inszenierung von *Hamlet* eröffnet. Heute dient es einem Schauspielensemble als Heimstätte, dessen Darbietungen klassischer Stücke auch den höchsten Ansprüchen genügen.

Guthrie Theater
Capacity 2,050

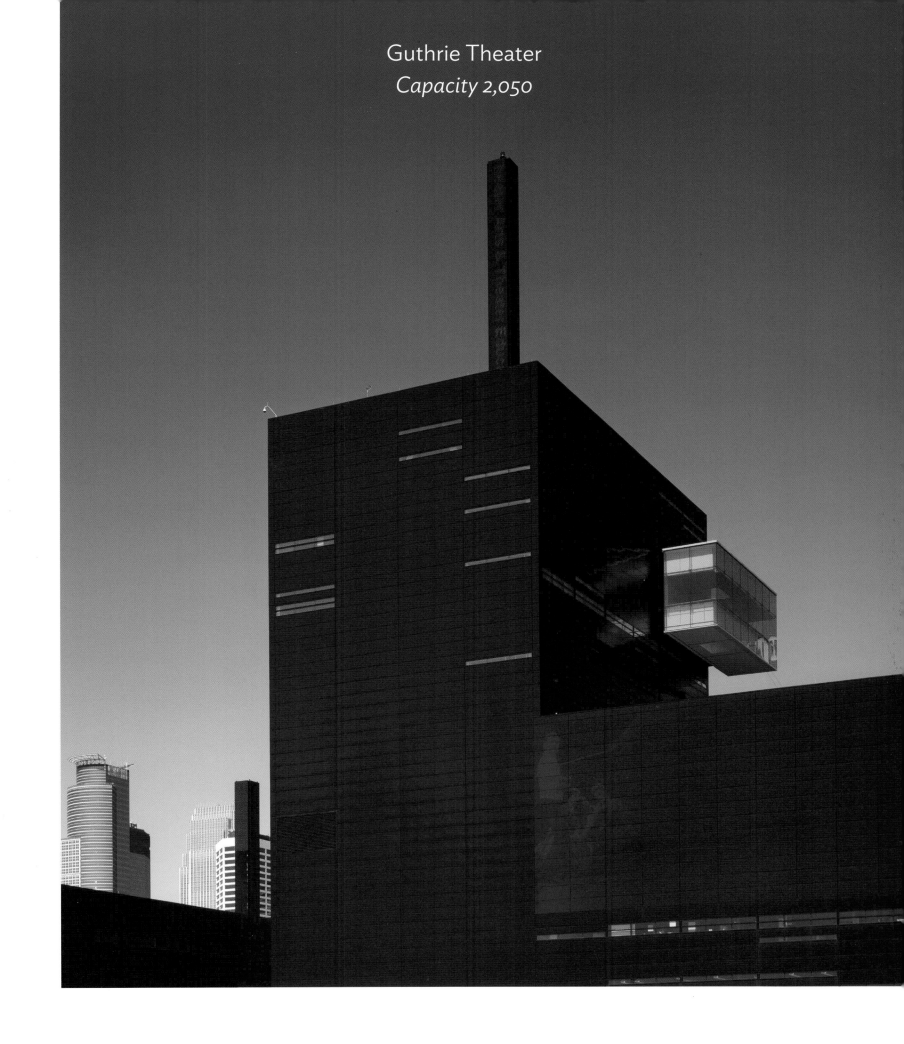

Minneapolis, Minnesota, USA
Jean Nouvel, 2006

Le Guthrie Theater n'a élu domicile sur son site actuel qu'en 2006. L'édifice aux proportions spectaculaires, construit sur les berges du Mississippi, a remplacé le bâtiment original de 1963, conçu par le cabinet Ralph Rapson & Associates. Fondé par le metteur en scène Sir Tyrone Guthrie, le théâtre a été pensé pour offrir une alternative à l'esprit commercial de Broadway. Il a été inauguré avec une représentation d'*Hamlet* mis en scène par Guthrie en personne, et sert désormais de résidence à une compagnie de théâtre permanente connue pour son interprétation de très grande qualité des plus grands classiques.

El Teatro Guthrie se instaló en su actual ubicación en 2006. Esta estructura dramática, a orillas del Misisipi, sustituyó al edificio original de 1963, obra de Ralph Rapson & Associates. Founded by the theatrical director Sir Tyrone Guthrie, the theatre was conceived as an alternative to the commercialism of Broadway. It opened with Guthrie's production of *Hamlet*, and is now home to a resident acting company, which performs the classics to the highest professional standards.

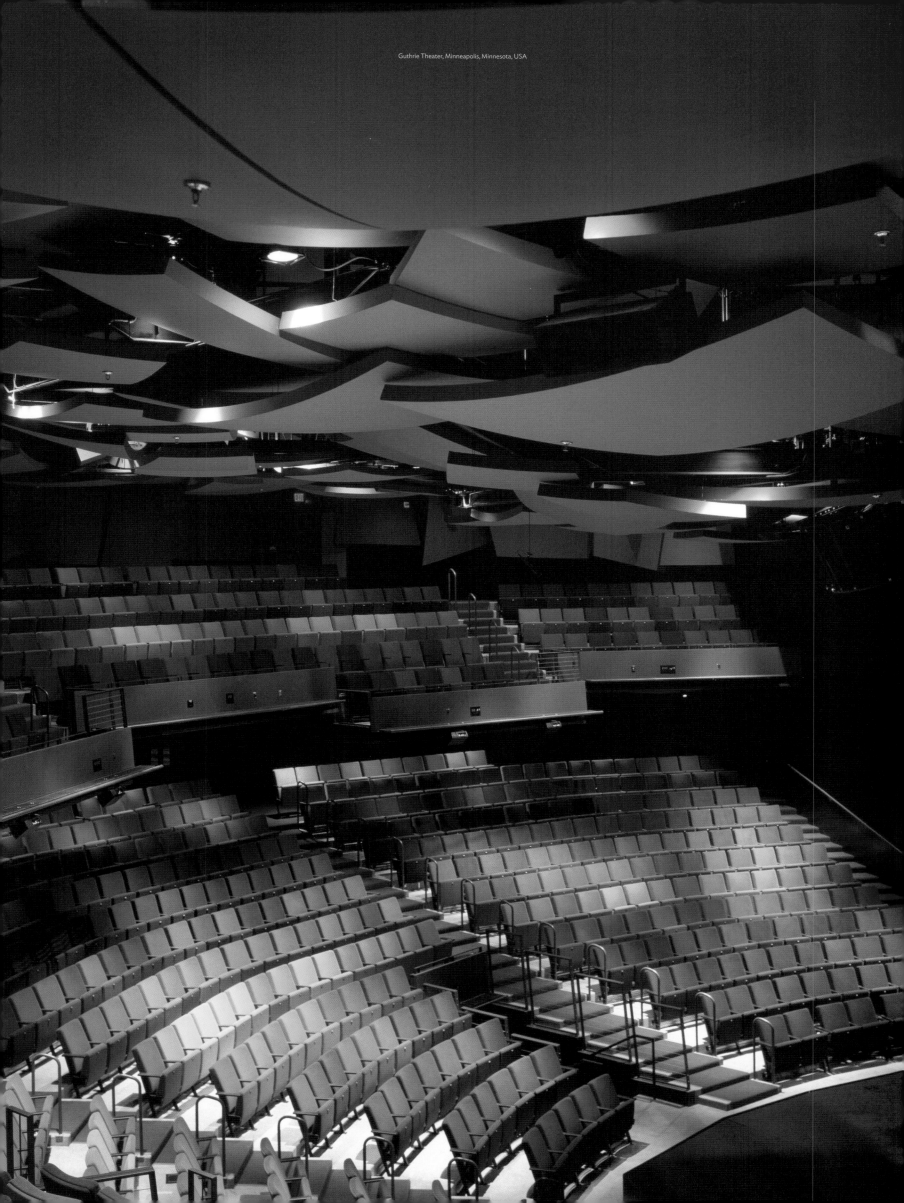

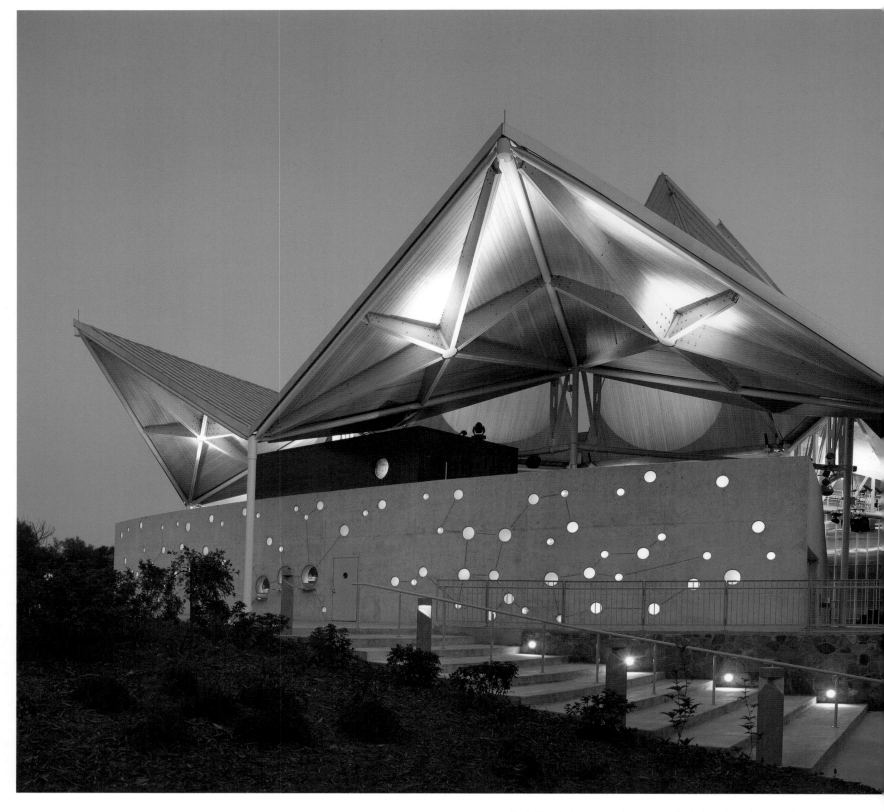

Studio Gang Architects were charged with the job of expanding and improving on the Starlight Theatre in the Rock Valley Campus. The design maintains a tradition of open-air performances at Rock Valley College, but offers flexibility by allowing the theatre company to extend its season and guarantee shows, even when it rains. A kinetic roof, which opens like the petals of a flower in fair weather, provides the theatre with both shelter and drama.

Der Auftrag des Architektenbüros Studio Gang lautete, das Starlight Theatre am Rock Valley Campus zu erweitern und zu verbessern. Der Entwurf setzt die Tradition der Freiluftdarbietungen am Rock Valley College fort, schenkt dem Theaterensemble jedoch mehr Flexibilität und erlaubt ihm, die Spielsaison zu verlängern und Aufführungen auch bei Schlechtwetter über die Bühne zu bringen. Zu diesem Zweck verleiht eine bewegliche Dachkonstruktion, die sich bei Schönwetter gleich Blütenblättern einer Blume öffnet, dem Theater gleichzeitig Schutz gegen die Unbilden des Wetters sowie einen Hauch Dramatik.

Bengt Sjostrom/Starlight Theatre
Capacity 1,100

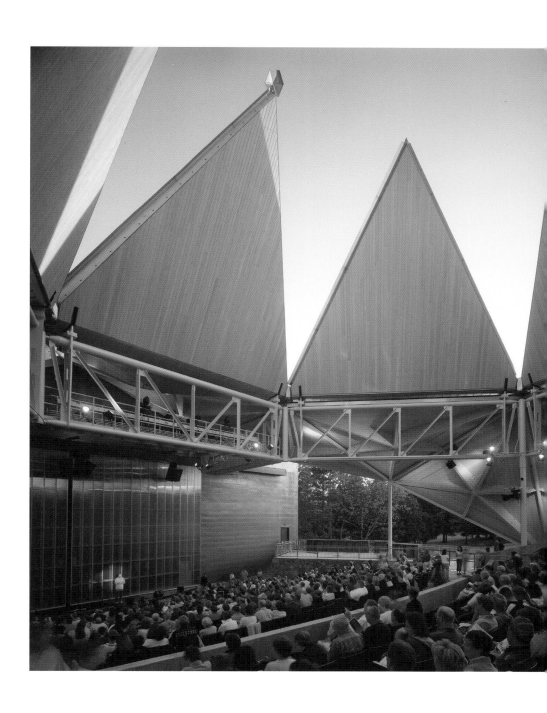

Rockford, Illinois, USA
Built 1983, Remodelled by Studio Gang Architects, 2003

Le cabinet Studio Gang Architects a été chargé de concevoir l'extension et d'apporter des améliorations au Starlight Theatre situé sur le Campus Rock Valley. Fidèle à la tradition des représentations en plein air du Rock Valley College, l'architecture offre une certaine souplesse qui permet à la compagnie de théâtre de prolonger sa saison et d'assurer le spectacle même par temps de pluie. Outre son rôle d'abri, le toit cinétique, qui s'ouvre comme les pétales d'une fleur par beau temps, dote le théâtre d'un surprenant élément scénique.

Studio Gang Architects recibió el encargo de ampliar y mejorar el Teatro Starlight en el campus de Rock Valley. El diseño mantiene la tradición de los espectáculos al aire libre de la Universidad de Rock Valley. Ofrece, no obstante, la posibilidad de que la compañía teatral pueda ampliar su temporada y garantiza las representaciones incluso cuando llueve. Una cubierta móvil, que se abre igual que los pétalos de una flor, en los días de buen tiempo, proporciona al teatro protección y espectacularidad a la vez.

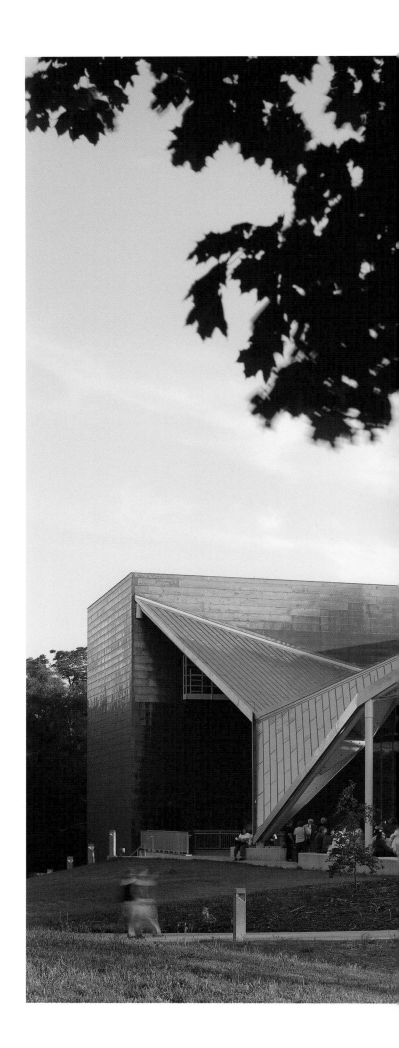

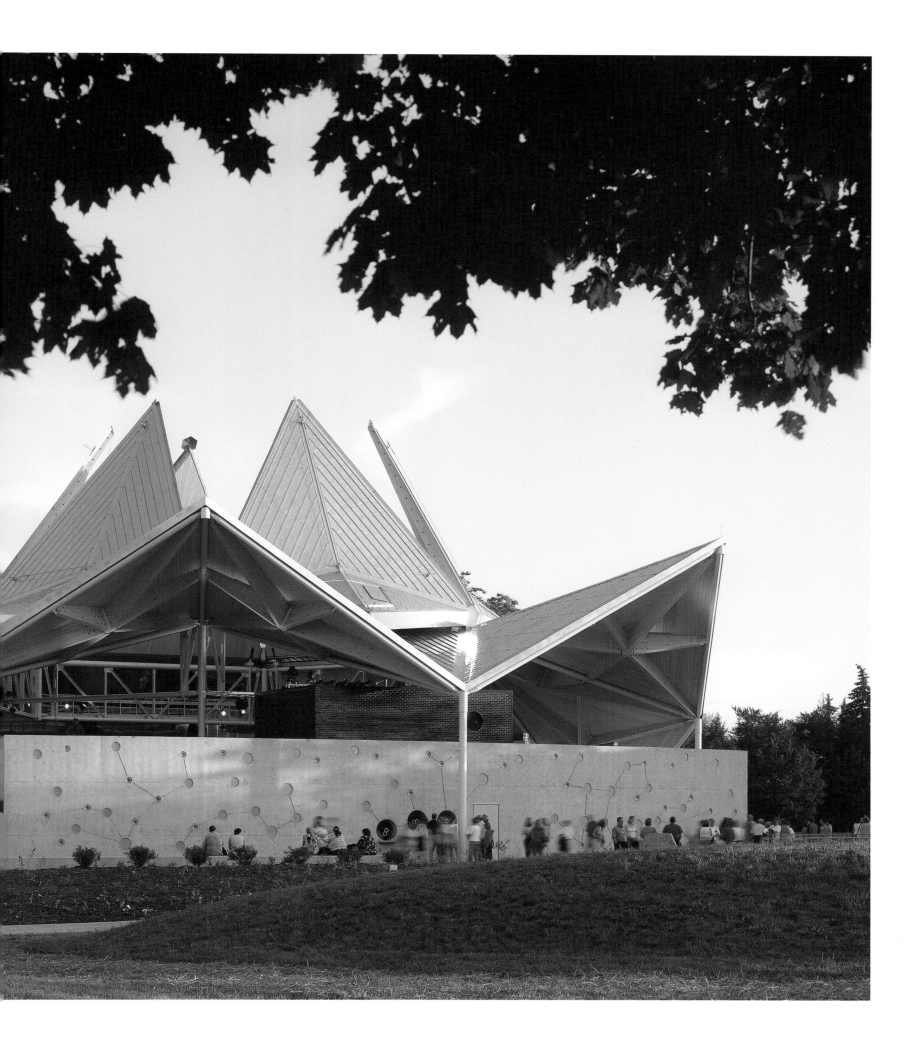

Auditorium Theatre of Roosevelt University
Capacity 3,929

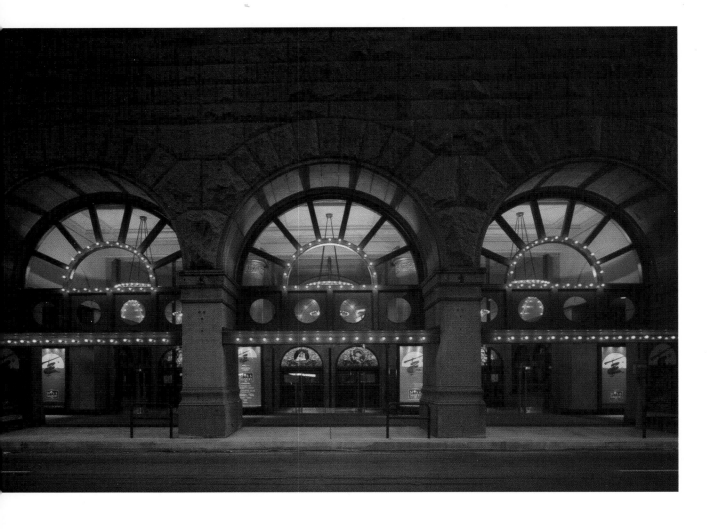

In 1889, US President Grover Cleveland laid the cornerstone of the historic Auditorium Building, which includes the Auditorium Theatre, an office block, and a hotel. The theatre was originally rented by the Civic Opera Company, before they moved to their own premises in 1929. The theatre was closed during the Great Depression, and opened as a servicemen's centre during the Second World War. In 1946, Roosevelt University moved into the building. In more recent years, the theatre has hosted many large rock concerts.

Im Jahr 1889 legte US-Präsident Grover Cleveland den Grundstein für das historische Auditorium Building, in dem sich das Auditorium Theatre, ein Bürogebäude und ein Hotel befinden. Das Theater diente ursprünglich der eingemieteten Civic Opera Company als Spielstätte, bevor dieses Ensemble 1929 ein eigenes Gelände für sich fand. Während der Weltwirtschaftskrise der Großen Depression war das Theater bis zu seiner Nutzung als Soldatenunterkunft während des zweiten Weltkrieges geschlossen. 1946 bezog die Roosevelt University das Gebäude und im Laufe seiner jüngeren Vergangenheit fanden hier zahlreiche bedeutende Rockkonzerte statt.

Chicago, Illinois, USA
Dankmar Adler & Louis Sullivan, 1889

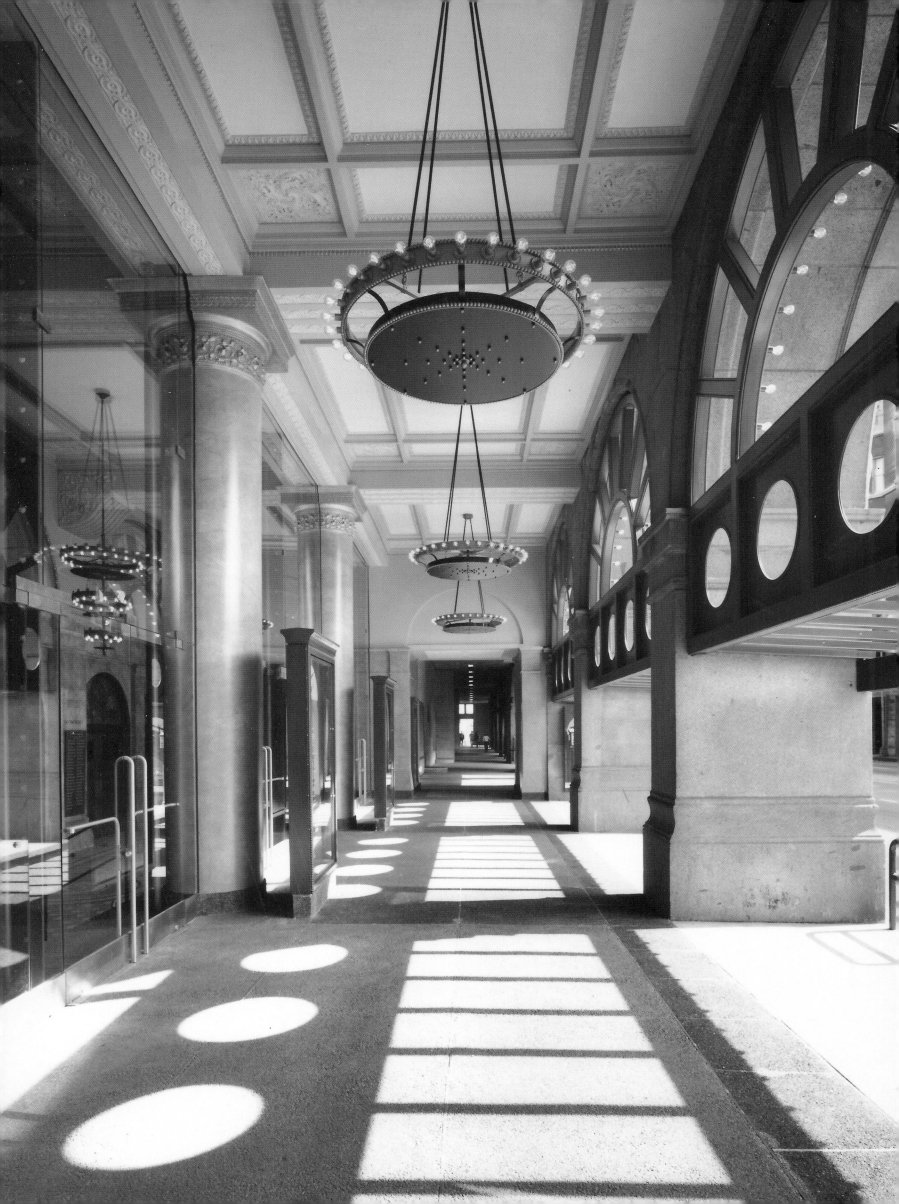

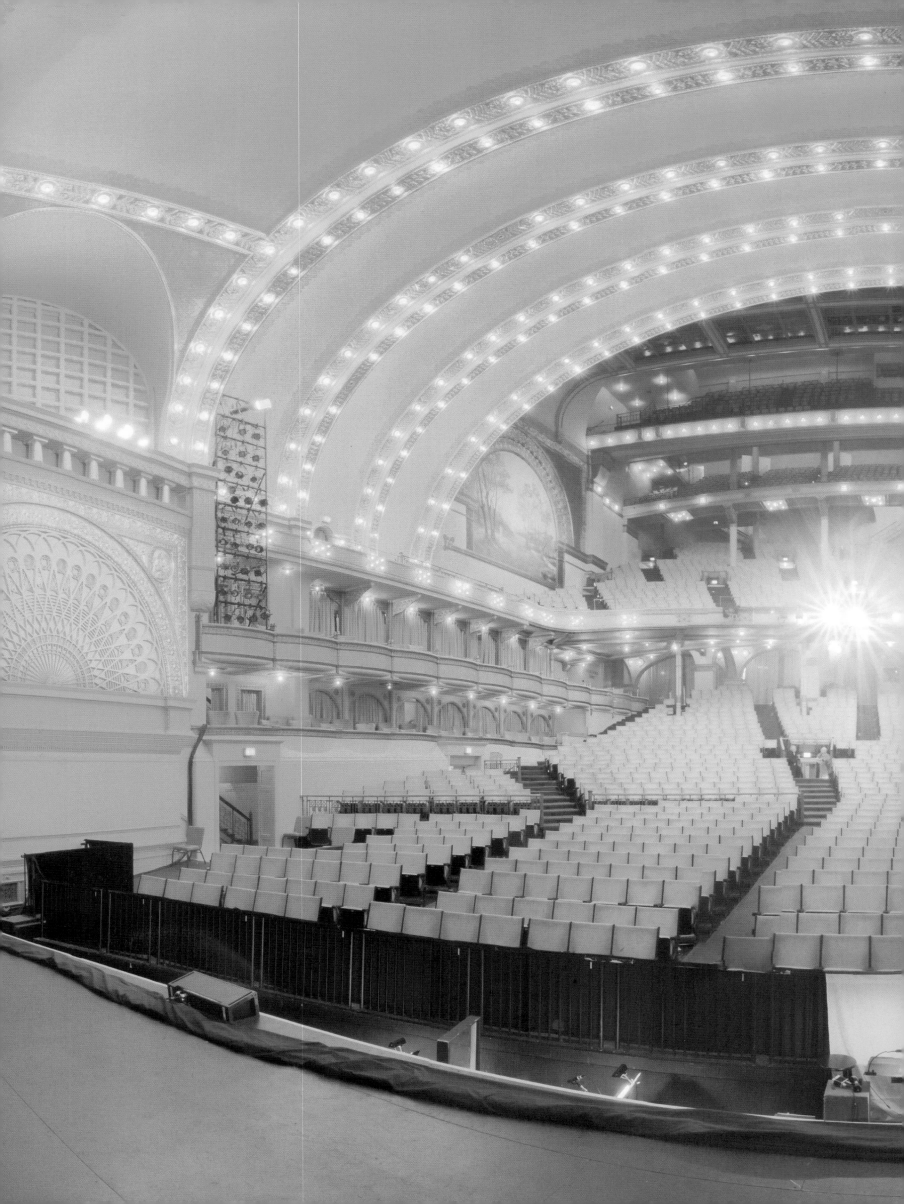

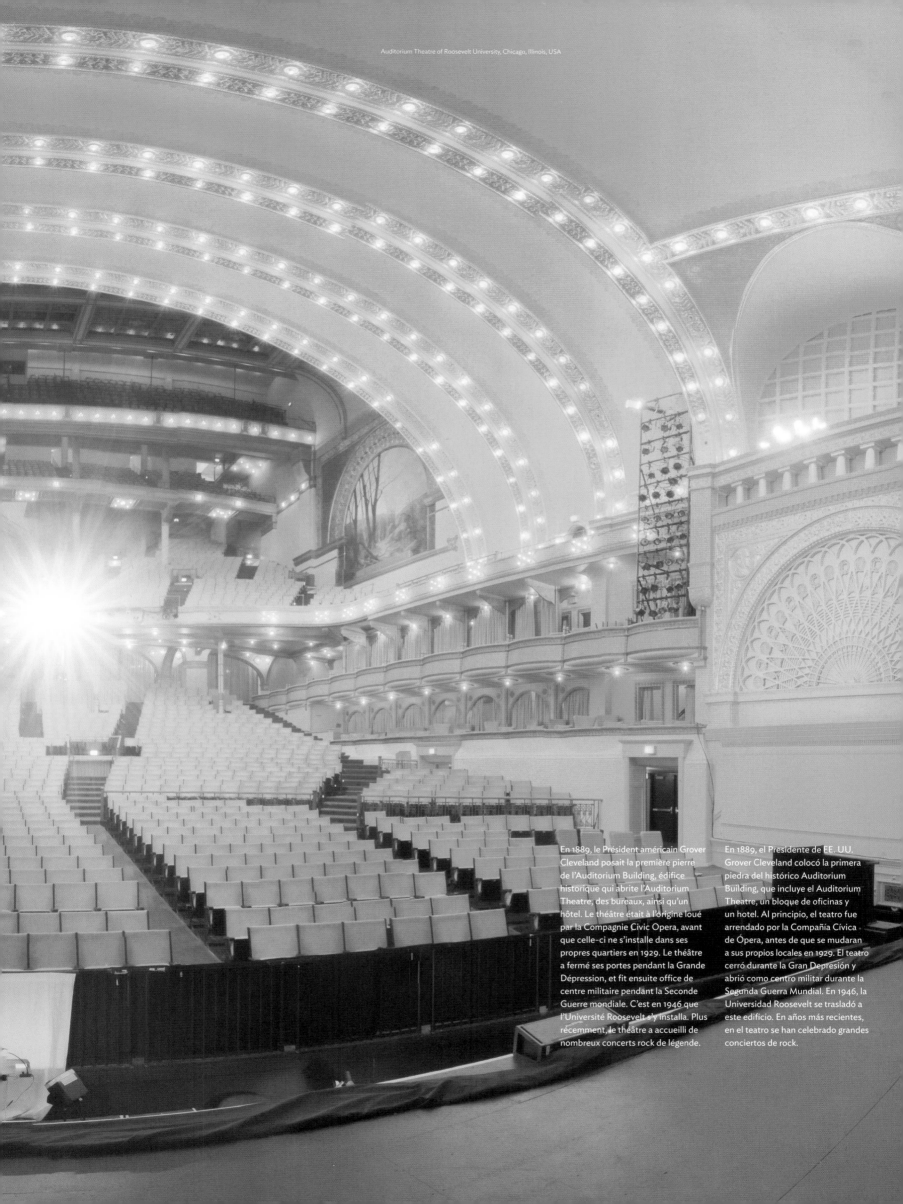

En 1889, le Président américain Grover Cleveland posait la première pierre de l'Auditorium Building, édifice historique qui abrite l'Auditorium Theatre, des bureaux, ainsi qu'un hôtel. Le théâtre était à l'origine loué par la Compagnie Civic Opera, avant que celle-ci ne s'installe dans ses propres quartiers en 1929. Le théâtre a fermé ses portes pendant la Grande Dépression, et fit ensuite office de centre militaire pendant la Seconde Guerre mondiale. C'est en 1946 que l'Université Roosevelt s'y installa. Plus récemment, le théâtre a accueilli de nombreux concerts rock de légende.

En 1889, el Presidente de EE. UU. Grover Cleveland colocó la primera piedra del histórico Auditorium Building, que incluye el Auditorium Theatre, un bloque de oficinas y un hotel. Al principio, el teatro fue arrendado por la Compañía Cívica de Ópera, antes de que se mudaran a sus propios locales en 1929. El teatro cerró durante la Gran Depresión y abrió como centro militar durante la Segunda Guerra Mundial. En 1946, la Universidad Roosevelt se trasladó a este edificio. En años más recientes, en el teatro se han celebrado grandes conciertos de rock.

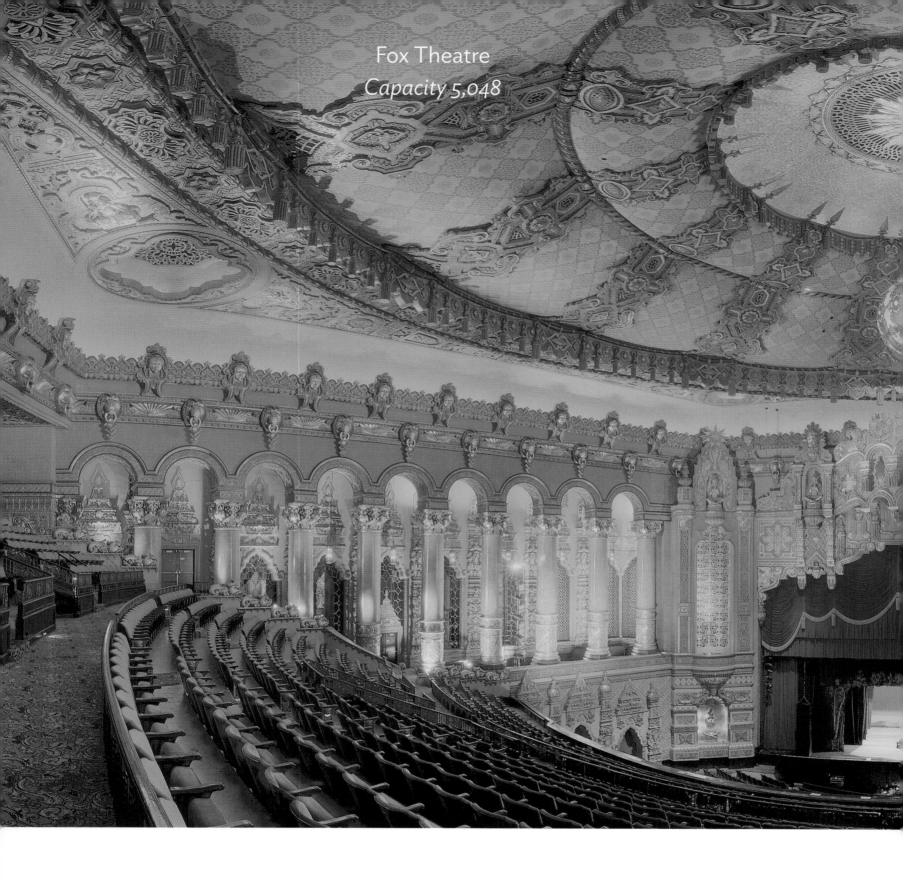

Fox Theatre
Capacity 5,048

Detroit, Michigan, USA
C. Howard Crane, 1928

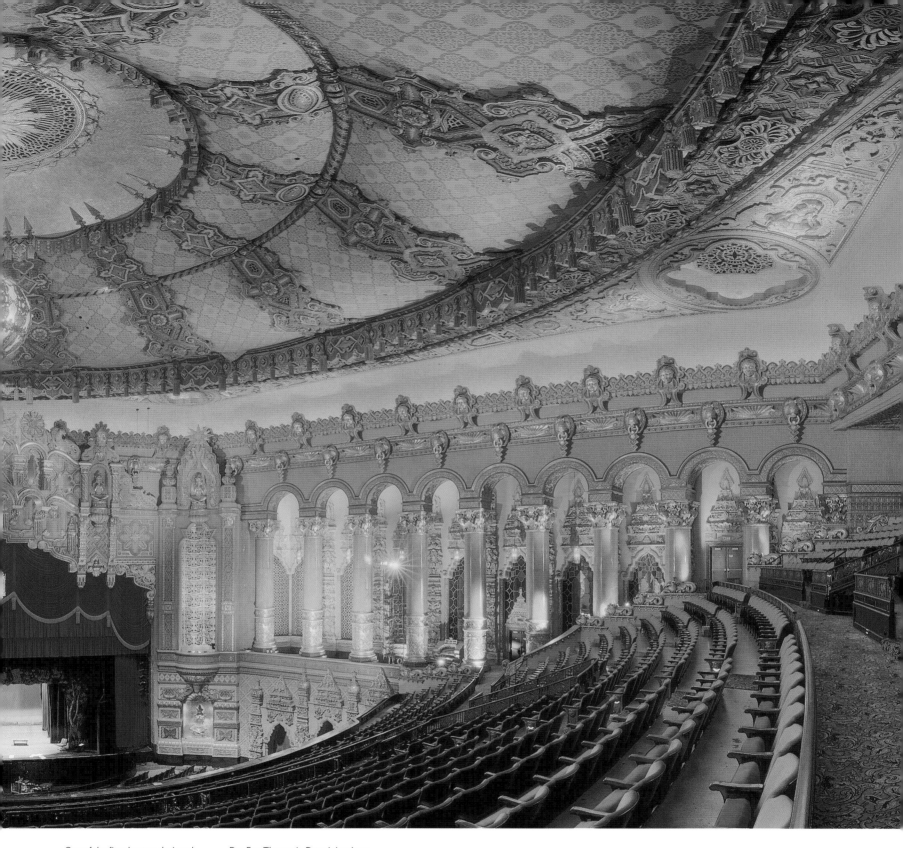

One of the five theatres designed
and built for Fox Film Corporation in
the 1920s, the Fox Theatre, Detroit,
features a blend of African and Asian
motifs. The façade of the ten-storey
building is illuminated at night, and it
was the first theatre to be constructed
with built-in sound systems for film. By
the 1980s, it had become considerably
run down, and was closed to be restored
to its original grandeur. In June 1989,
the theatre was designated a National
Historic Landmark.

Das Fox-Theater in Detroit ist eines
der fünf in den 1920er-Jahren für die
Fox Film Corporation entworfenen
und errichteten Theater und zeichnet
sich durch eine Verbindung aus
afrikanischen und asiatischen Motiven
aus. Die Fassade des zehnstöckigen
Gebäudes ist nachts beleuchtet
und das Fox war das erste Theater
überhaupt, das von vornherein mit
Tonanlagen für Filmvorführungen
errichtet wurde. Das in den
1980er-Jahren bereits beträchtlich
heruntergekommene Gebäude
wurde letztendlich geschlossen,
um es zu restaurieren und in alter
Pracht wiedererstehen zu lassen.
Im Juni 1989 wurde dem Theater
schließlich der Status eines Nationalen
Kulturdenkmals verliehen.

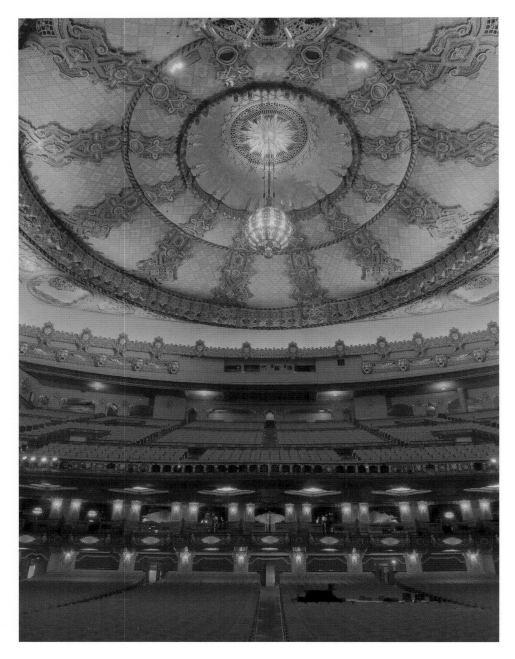

Parmi les cinq théâtres conçus et construits pour la Fox Film Corporation dans les années 20, le Fox Theater de Détroit se caractérise par une profusion de décors d'inspiration africaine et asiatique. La façade de l'édifice à dix étages est illuminée la nuit. Ce fut également la première salle de spectacle à intégrer des dispositifs sonores dédiés à la projection de films. Dans les années 80, dans un état très dégradé, le bâtiment a fermé ses portes pour subir une vaste restauration et retrouver sa splendeur d'antan. En juin 1989, le théâtre a été classé National Historic Landmark (monument historique classé au patrimoine américain).

El Teatro Fox, de Detroit, uno de los cinco teatros diseñados y construidos para la Fox Film Corporation en los años veinte, presenta una combinación de motivos africanos y asiáticos. La fachada del edificio de diez pisos se ilumina de noche. Fue el primer teatro que se construyó con sistemas de sonido incorporados para las películas. Ya en la década de 1980, había entrado en franca decadencia y cerró sus puertas para recuperar su antiguo esplendor original. En junio de 1989, el teatro fue declarado Monumento Histórico Nacional.

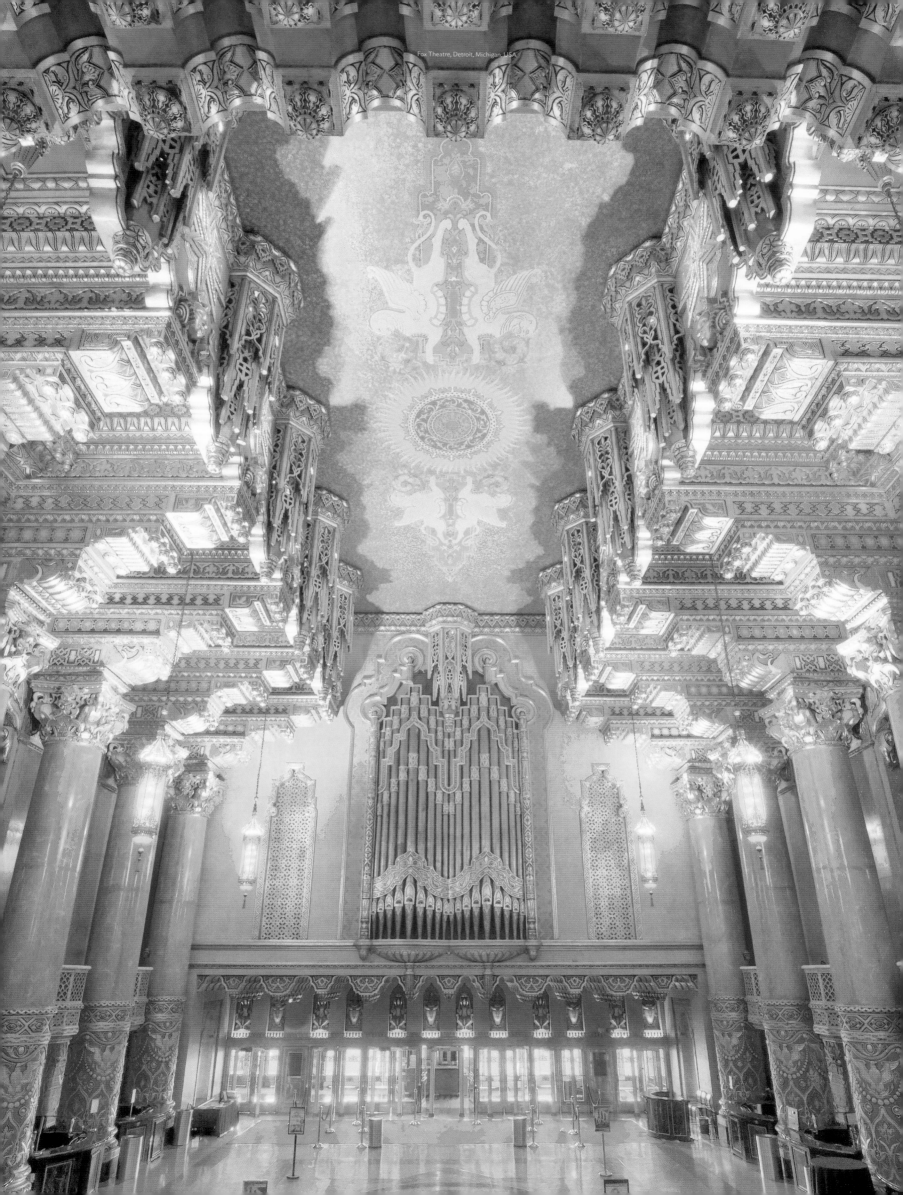

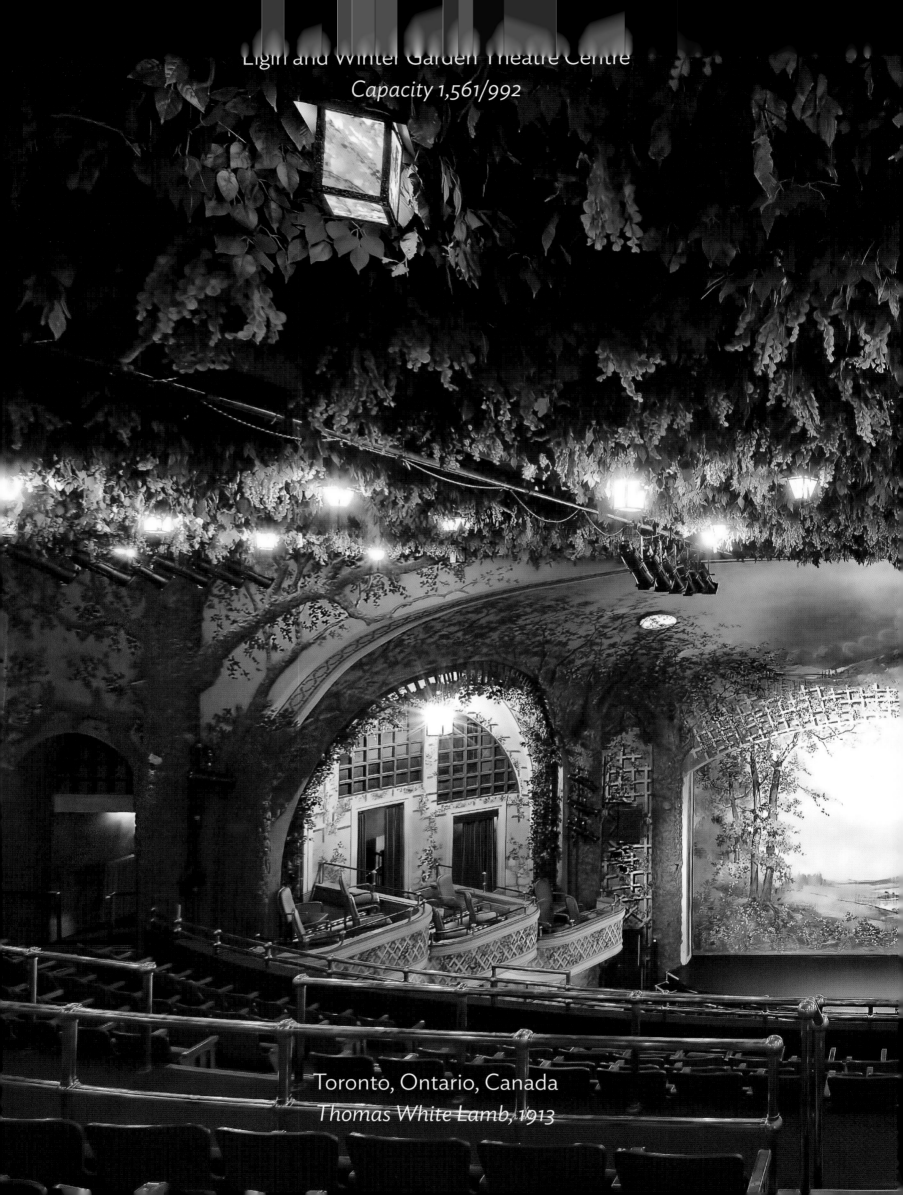

Elgin and Winter Garden Theatre Centre

Capacity 1,561/992

Toronto, Ontario, Canada

Thomas White Lamb, 1913

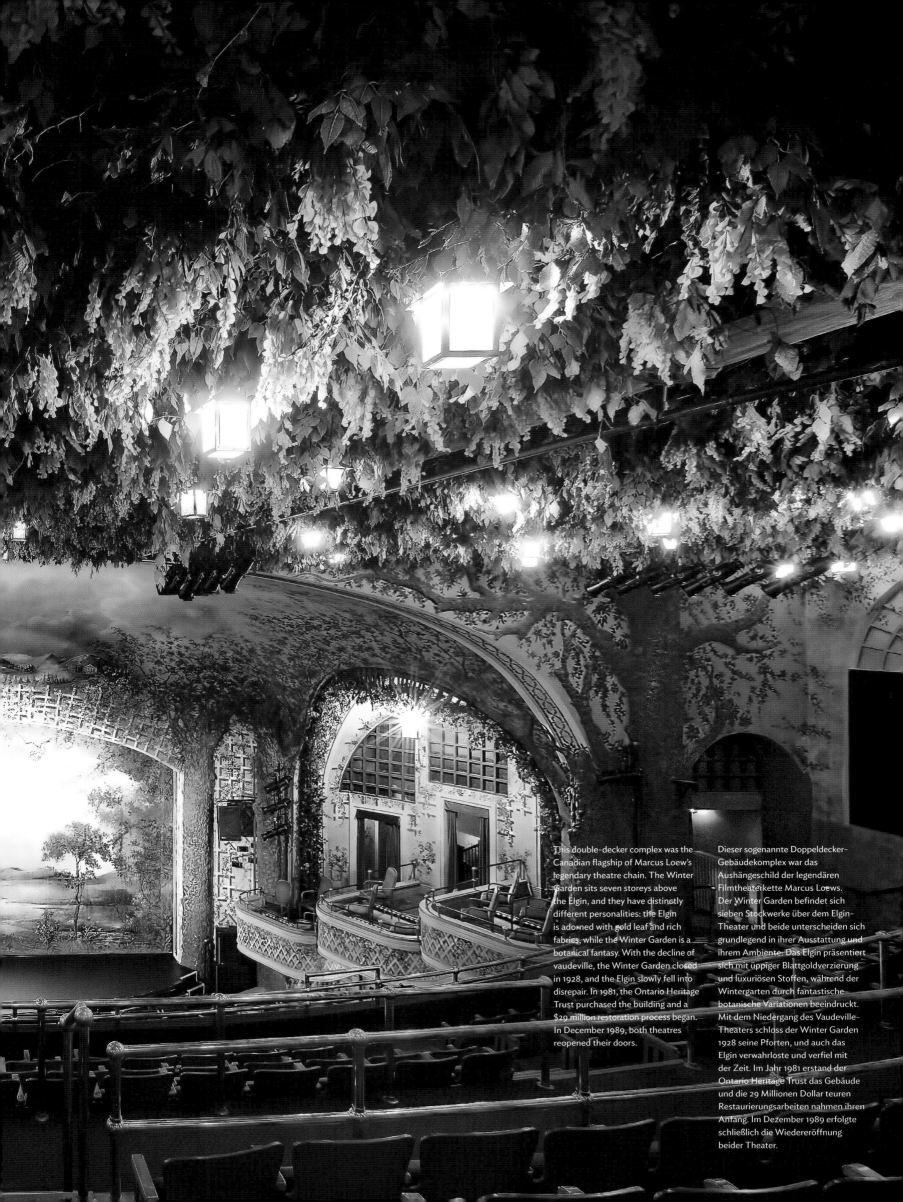

This double-decker complex was the Canadian flagship of Marcus Loew's legendary theatre chain. The Winter Garden sits seven storeys above the Elgin, and they have distinctly different personalities: the Elgin is adorned with gold leaf and rich fabrics, while the Winter Garden is a botanical fantasy. With the decline of vaudeville, the Winter Garden closed in 1928, and the Elgin slowly fell into disrepair. In 1981, the Ontario Heritage Trust purchased the building and a $29 million restoration process began. In December 1989, both theatres reopened their doors.

Dieser sogenannte Doppeldecker-Gebäudekomplex war das Aushängeschild der legendären Filmtheaterkette Marcus Loews. Der Winter Garden befindet sich sieben Stockwerke über dem Elgin-Theater und beide unterscheiden sich grundlegend in ihrer Ausstattung und ihrem Ambiente: Das Elgin präsentiert sich mit üppiger Blattgoldverzierung und luxuriösen Stoffen, während der Wintergarten durch fantastische botanische Variationen beeindruckt. Mit dem Niedergang des Vaudeville-Theaters schloss der Winter Garden 1928 seine Pforten, und auch das Elgin verwahrloste und verfiel mit der Zeit. Im Jahr 1981 erstand der Ontario Heritage Trust das Gebäude und die 29 Millionen Dollar teuren Restaurierungsarbeiten nahmen ihren Anfang. Im Dezember 1989 erfolgte schließlich die Wiedereröffnung beider Theater.

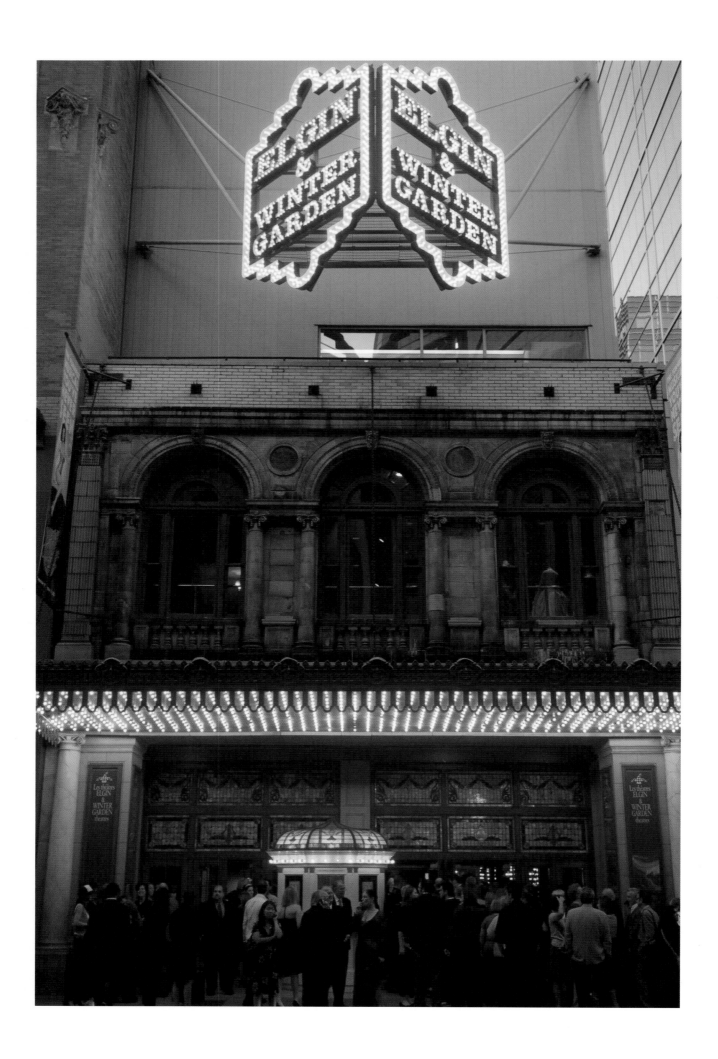

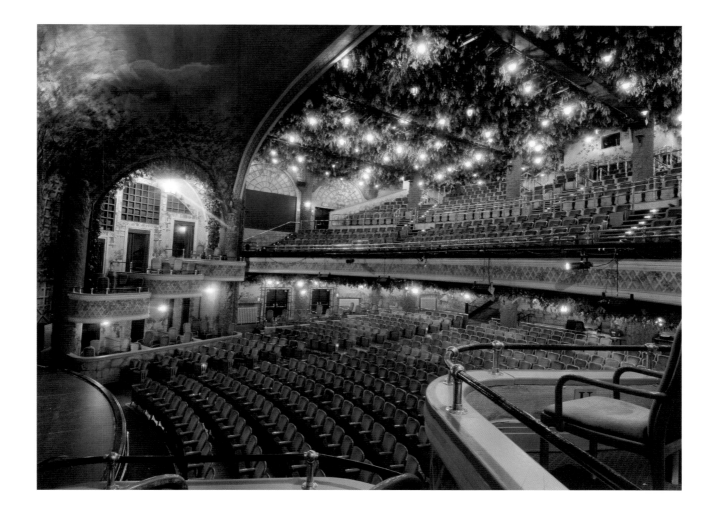

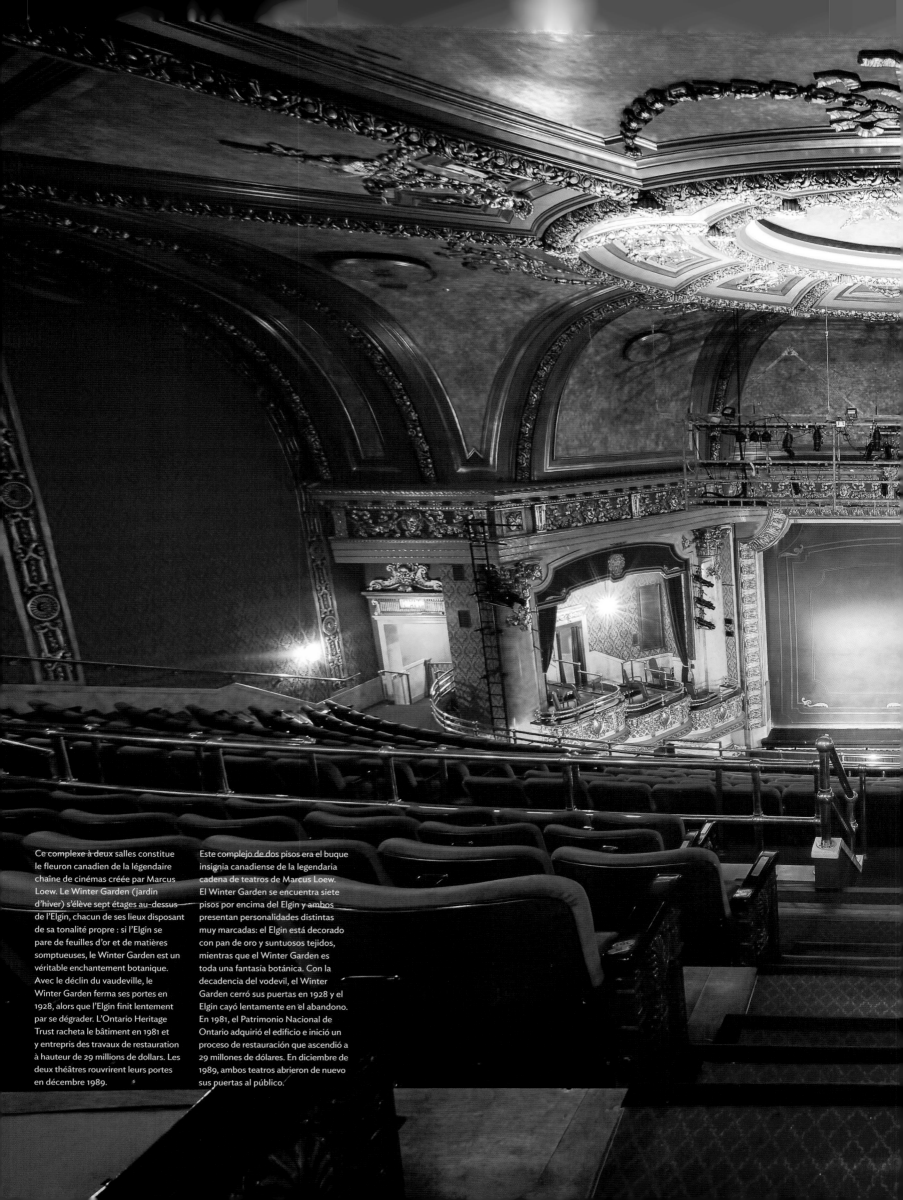

Ce complexe à deux salles constitue
le fleuron canadien de la légendaire
chaîne de cinémas créée par Marcus
Loew. Le Winter Garden (jardin
d'hiver) s'élève sept étages au-dessus
de l'Elgin, chacun de ses lieux disposant
de sa tonalité propre : si l'Elgin se
pare de feuilles d'or et de matières
somptueuses, le Winter Garden est un
véritable enchantement botanique.
Avec le déclin du vaudeville, le
Winter Garden ferma ses portes en
1928, alors que l'Elgin finit lentement
par se dégrader. L'Ontario Heritage
Trust racheta le bâtiment en 1981 et
y entreprit des travaux de restauration
à hauteur de 29 millions de dollars. Les
deux théâtres rouvrirent leurs portes
en décembre 1989.

Este complejo de dos pisos era el buque
insignia canadiense de la legendaria
cadena de teatros de Marcus Loew.
El Winter Garden se encuentra siete
pisos por encima del Elgin y ambos
presentan personalidades distintas
muy marcadas: el Elgin está decorado
con pan de oro y suntuosos tejidos,
mientras que el Winter Garden es
toda una fantasía botánica. Con la
decadencia del vodevil, el Winter
Garden cerró sus puertas en 1928 y el
Elgin cayó lentamente en el abandono.
En 1981, el Patrimonio Nacional de
Ontario adquirió el edificio e inició un
proceso de restauración que ascendió a
29 millones de dólares. En diciembre de
1989, ambos teatros abrieron de nuevo
sus puertas al público.

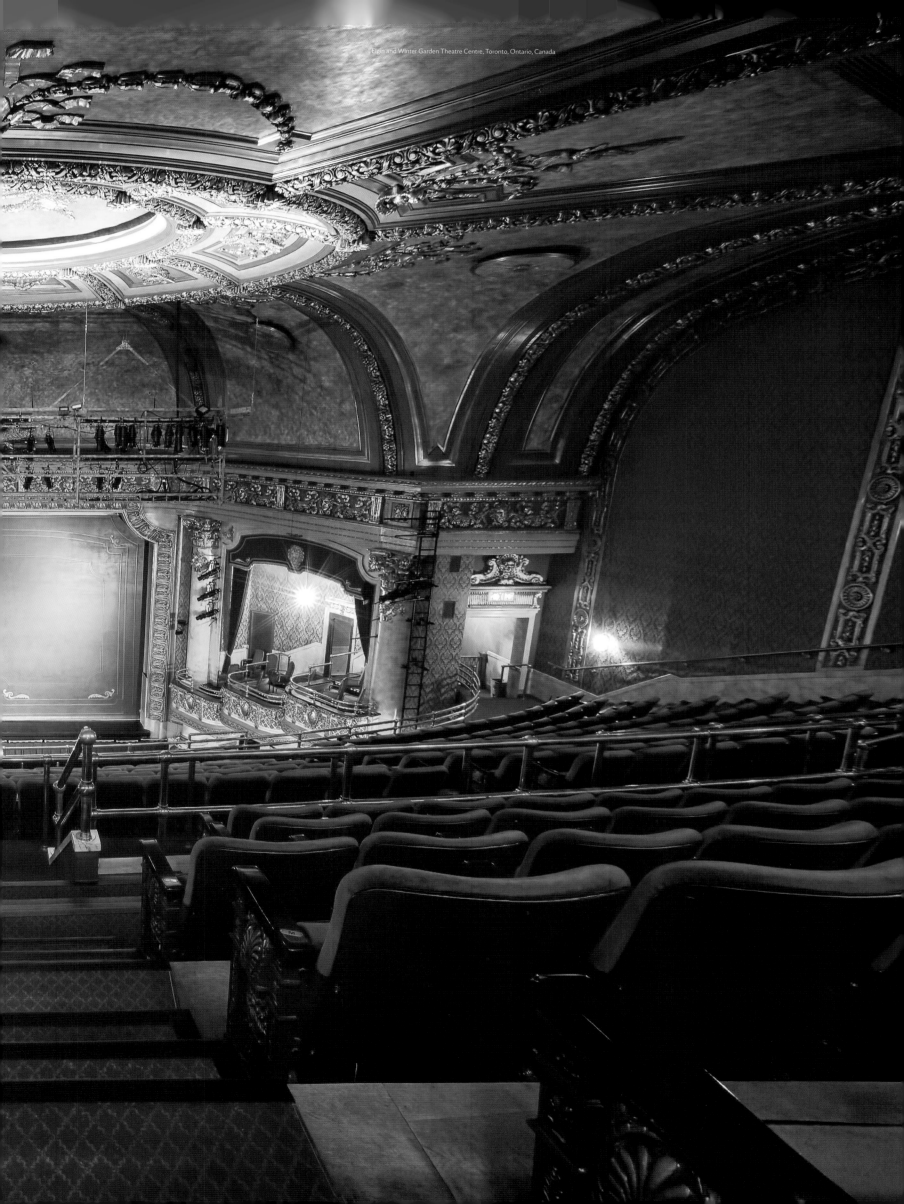

Elgin and Winter Garden Theatre Centre, Toronto, Ontario, Canada

Metropolitan Opera House
Capacity 3,800

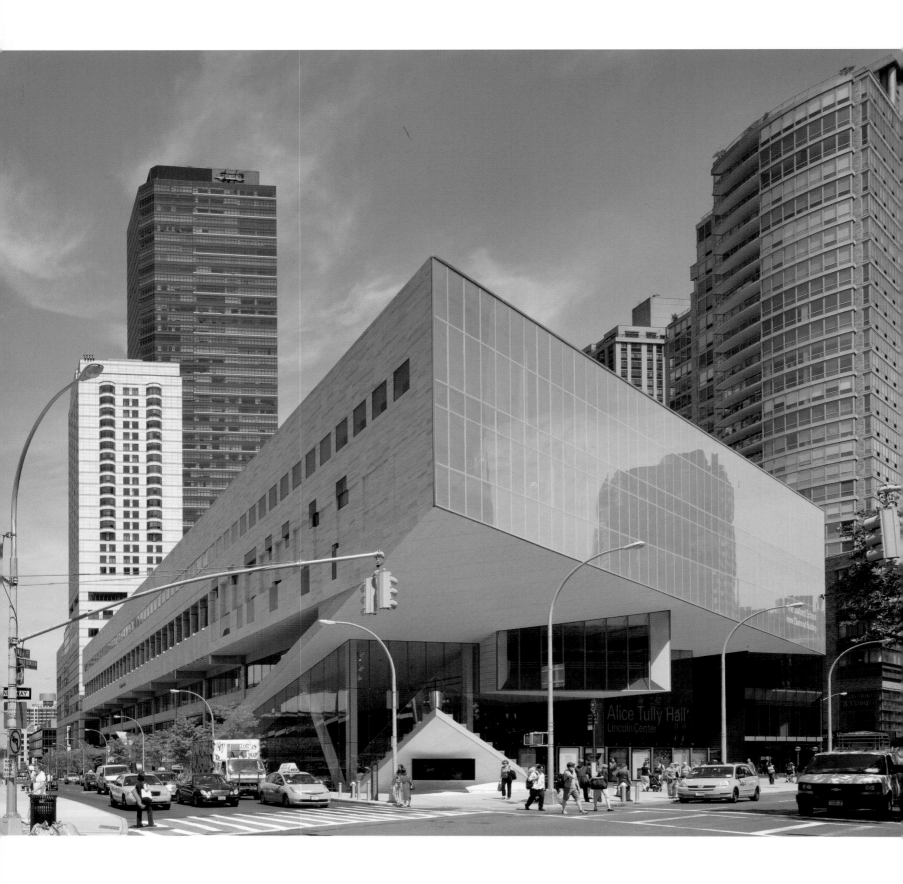

New York, USA
Wallace Harrison, 1966

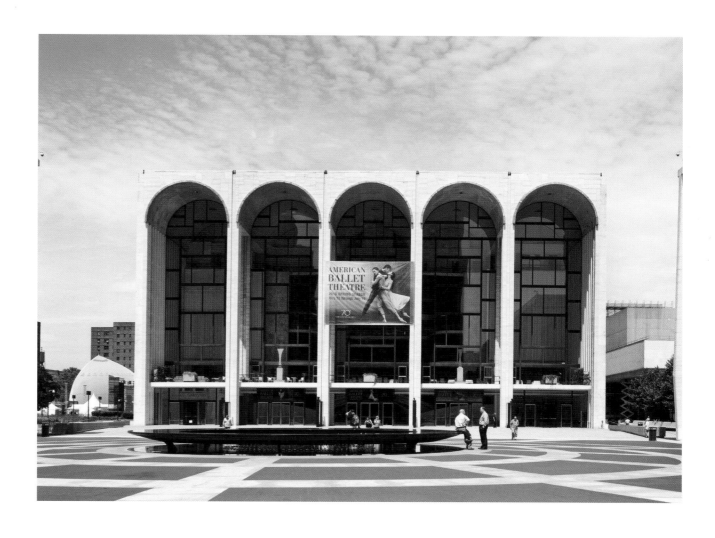

The Metropolitan Opera House is the centrepiece of the Lincoln Center for the Performing Arts complex in New York City, and is home to the Metropolitan Opera Company. The Lincoln Center, a large-scale urban renewal project in Manhattan's Upper West Side, includes this building, the David H. Koch Theater, and Avery Fisher Hall, which overlook a central rectangular plaza. Behind the impressive open façade of the Metropolitan Opera is a lobby dominated by two murals by Marc Chagall.

Die Metropolitan Opera ist das Herzstück des „Lincoln Center for the Performing Arts"-Kulturzentrums in New York City und beherbergt die Metropolitan Opera Company. Das im Rahmen eines groß angelegten Projekts zur Stadterneuerung von Manhattans Upper West Side erbaute Lincoln Center umfasst nämliches Opernhaus, das David H. Koch Theatre sowie die Avery Fisher Hall, welche um einen zentralen, rechteckigen Platz herum angeordnet sind. Hinter der beeindruckenden offenen Opernfassade befindet sich ein durch zwei Wandgemälde von Marc Chagall dominierter Eingangsbereich.

Le Metropolitan Opera est la pièce maîtresse du centre culturel new-yorkais dédié aux arts de la scène, le Lincoln Center for the Performing Arts, et accueille à résidence la compagnie Metropolitan Opera. Outre l'opéra, le Lincoln Center, projet de réhabilitation urbaine de grande échelle de l'Upper West Side à Manhattan, abrite également le David H. Koch Theatre et l'Avery Fisher Hall, qui donnent sur une place centrale rectangulaire. L'impressionnante façade ouverte du Metropolitan dévoile un hall décoré de fresques murales signées Marc Chagall.

El Metropolitan Opera constituye el elemento central del complejo Lincoln Center for the Performing Arts de la ciudad de Nueva York y es la sede de la Metropolitan Opera Company. El Lincoln Center, un proyecto de renovación urbana a gran escala del Upper West Side de Manhattan, consta de este edificio, del David H. Koch Theatre y del Avery Fisher Hall, situados todos ellos en torno a una plaza central rectangular. Detrás de la impresionante fachada abierta del Metropolitan Opera hay un vestíbulo en el que sobresalen dos murales, obra de Marc Chagall.

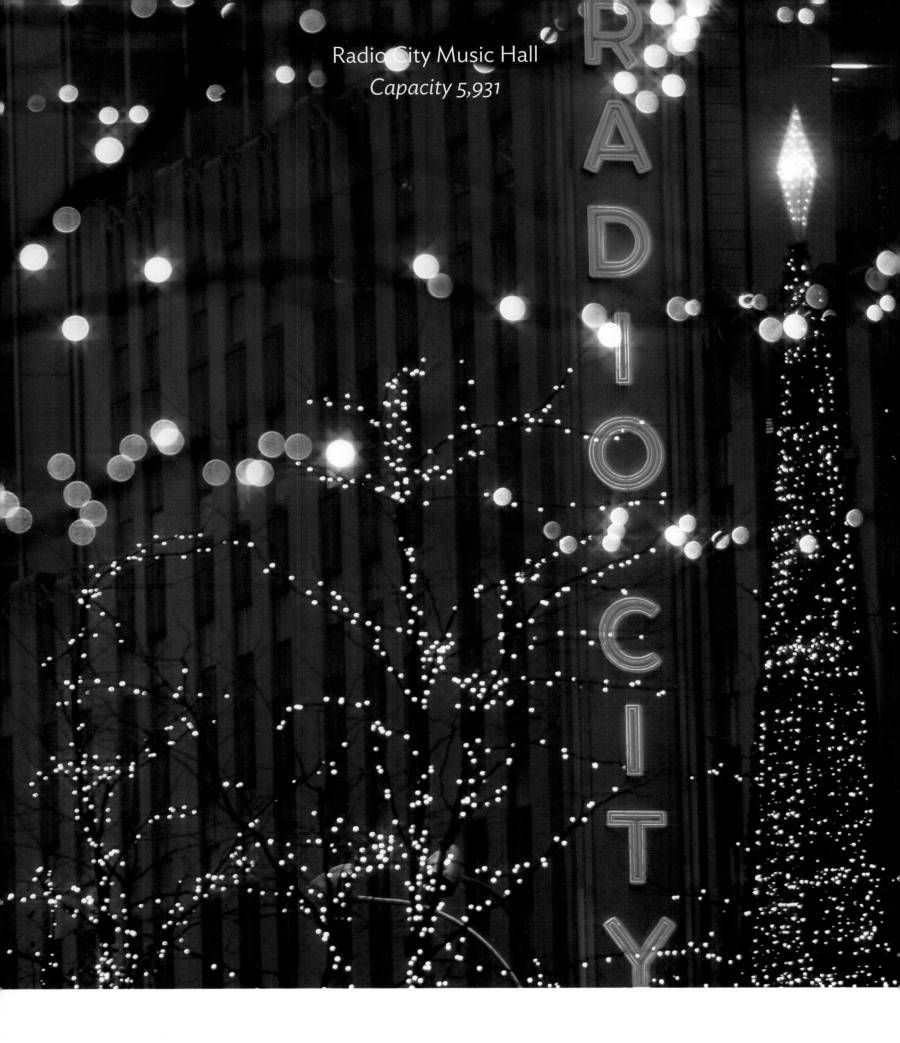

Radio City Music Hall
Capacity 5,931

New York, USA
Edward Durell Stone & Donald Deskey, 1932

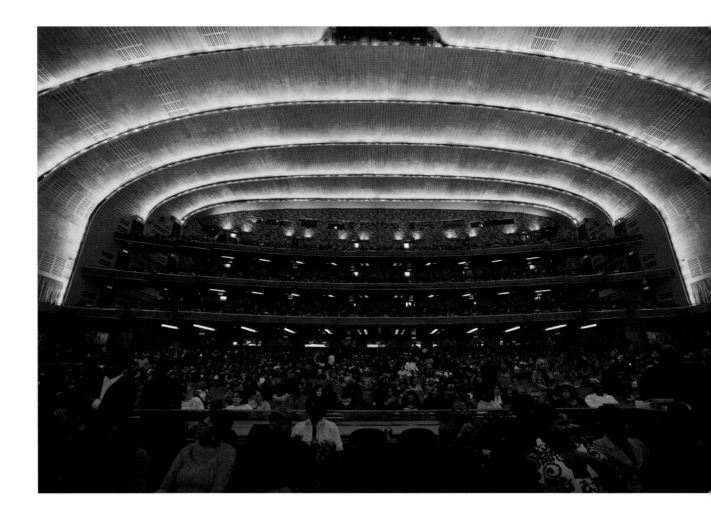

Radio City, the Art Deco behemoth and largest indoor theatre in the world, is one of the main attractions of Manhattan's Rockefeller Center, and indeed, for a time, it was one of the main attractions of New York City itself. The theatre is spectacularly equipped, with a revolving stage, a stage elevator, and the capacity to produce a shower of rain, all of which allow the venue to host extremely lavish stage shows. The music hall features the work of many Depression-era artists.

Die Radio City Music Hall, ein wahrer Gigant im Art-déco-Stil und das größte überdachte Theater der Welt, ist eine der Hauptattraktionen des Rockefeller Centers in Manhattan und zählte vorübergehend sogar zu den bedeutendsten Attraktionen der Stadt New York. Das Haus verfügt über eine spektakuläre Ausstattung, darunter eine Drehbühne, einen Bühnenlift und die technischen Voraussetzungen zur Erzeugung von Regenschauern, was äußerst üppige und aufwändige Inszenierungen ermöglicht. Auf dem Spielplan der Radio City Music Hall finden sich zahlreiche Werke von Künstlern aus der Zeit der Großen Depression.

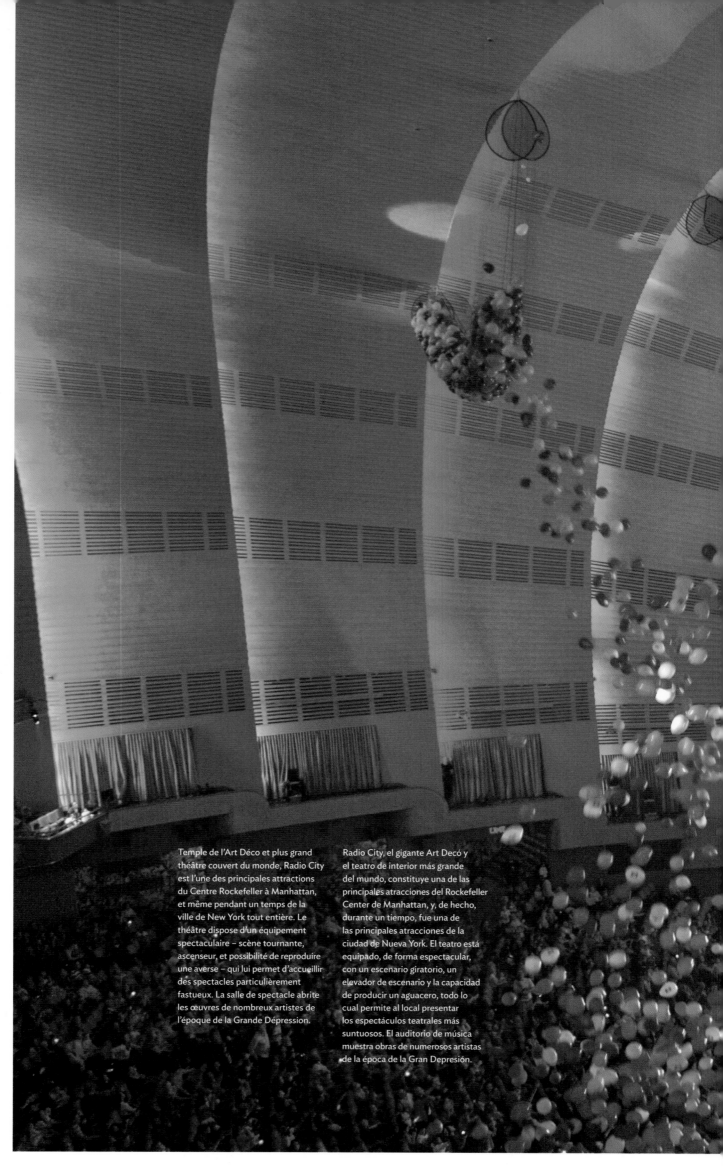

Temple de l'Art Déco et plus grand théâtre couvert du monde, Radio City est l'une des principales attractions du Centre Rockefeller à Manhattan, et même pendant un temps de la ville de New York tout entière. Le théâtre dispose d'un équipement spectaculaire – scène tournante, ascenseur, et possibilité de reproduire une averse – qui lui permet d'accueillir des spectacles particulièrement fastueux. La salle de spectacle abrite les œuvres de nombreux artistes de l'époque de la Grande Dépression.

Radio City, el gigante Art Decó y el teatro de interior más grande del mundo, constituye una de las principales atracciones del Rockefeller Center de Manhattan, y, de hecho, durante un tiempo, fue una de las principales atracciones de la ciudad de Nueva York. El teatro está equipado, de forma espectacular, con un escenario giratorio, un elevador de escenario y la capacidad de producir un aguacero, todo lo cual permite al local presentar los espectáculos teatrales más suntuosos. El auditorio de música muestra obras de numerosos artistas de la época de la Gran Depresión.

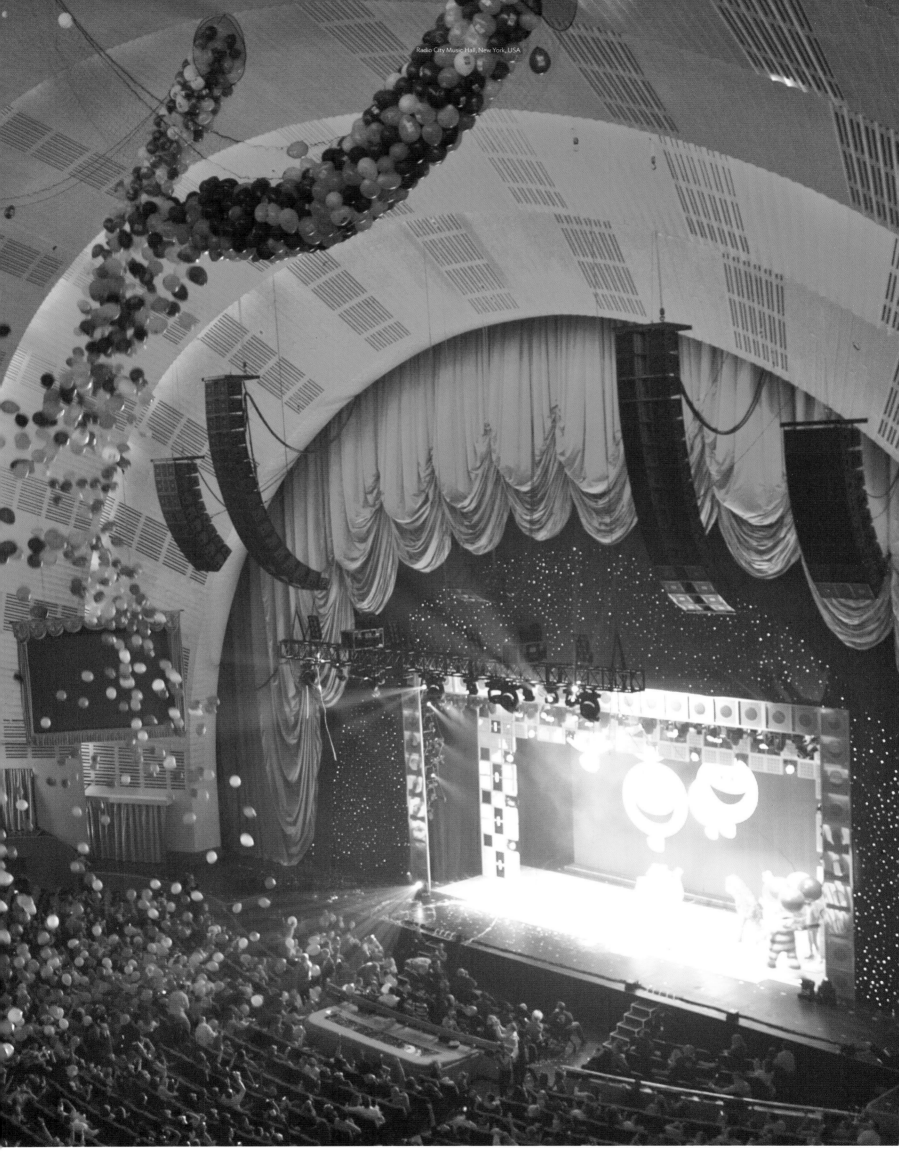

Radio City Music Hall, New York, USA

Boston Opera House
Capacity 2,677

Boston, Massachusetts, USA
Thomas White Lamb, 1928

The Boston Opera House was designed in a combination of French and Italian styles, and built as a memorial to the vaudeville pioneer Benjamin Franklin Keith, after whom the theatre was originally named. At first, it was used as a movie theatre and for live vaudeville, but it became home to the Opera Company of Boston in 1980. It was renovated in 2002 and it reopened in 2004 with a performance of *The Hard Hat Concert: A Boston Vaudeville.*

Das Boston Opera House verbindet französische und italienische Stile und wurde als Gedenkstätte für den Vaudeville-Pionier Benjamin Franklin Keith errichtet, der dem Gebäude ursprünglich seinen Namen lieh. Zunächst diente es als Lichtspieltheater und Spielstätte für live dargebotenes Vaudeville-Theater, bevor die Opera Company of Boston es im Jahr 1980 zu ihrer Heimstätte erwählte. Es wurde 2002 renoviert und 2004 mit der Aufführung von *The Hard Hat Concert: A Boston Vaudeville* wiedereröffnet.

Alliant styles français et italien, le Boston Opera House a été édifié en hommage au précurseur du vaudeville, Benjamin Franklin Keith, dont le nom avait été initialement donné au théâtre. Le bâtiment faisait office à ses débuts de salle de cinéma et servait de salle de spectacle pour les représentations de vaudeville. L'Opera Company de Boston y pris ensuite ses quartiers en 1980. Après une restauration débutée en 2002, le théâtre a réouvert ses portes en 2004 avec une représentation de *The Hard Hat Concert: A Boston Vaudeville.*

El Teatro de la Ópera de Boston se diseñó en una combinación de estilos francés e italiano. Se construyó en recuerdo del pionero del vodevil Benjamin Franklin Keith, de quien tomó originalmente el nombre. Al principio, se utilizó como cine y para funciones de vodevil en directo, pero en 1980 se convirtió en la sede de la Compañía de Ópera de Boston. En 2002 se procedió a su renovación y el teatro abrió de nuevo sus puertas en 2004 con una representación de *The Hard Hat Concert: A Boston Vaudeville.*

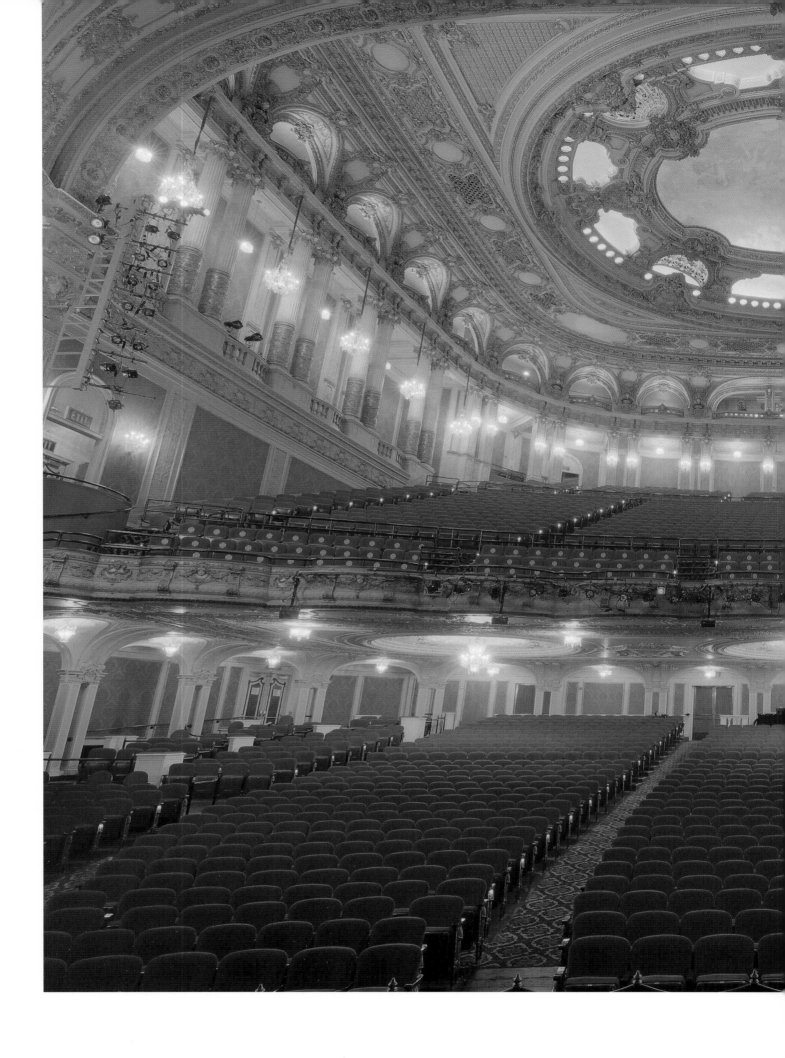

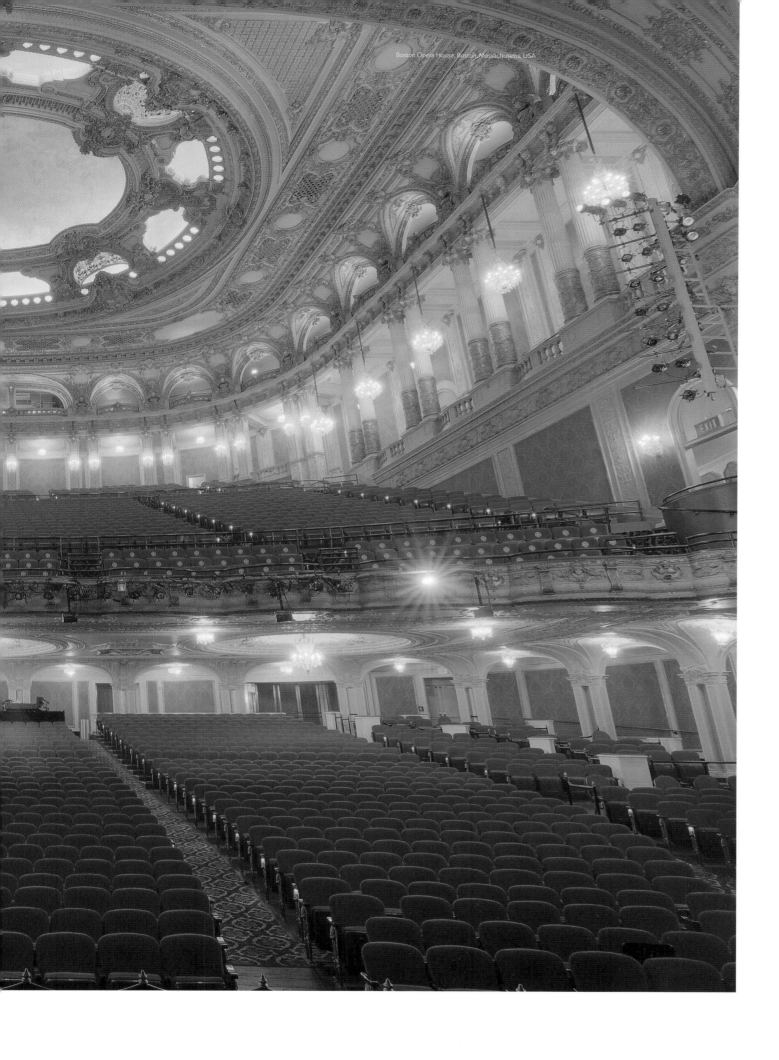

Boston Opera House, Boston, Massachusetts, USA

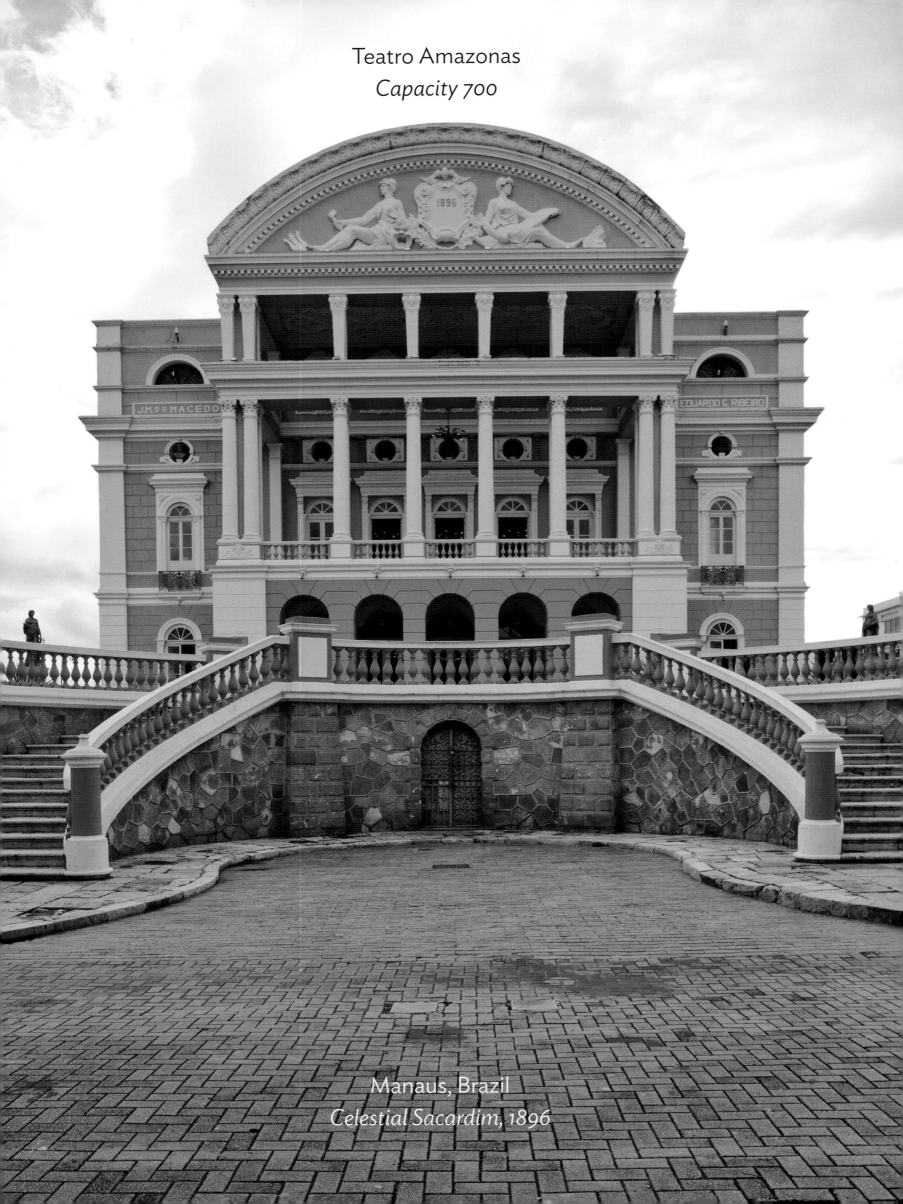

Teatro Amazonas
Capacity 700

Manaus, Brazil
Celestial Sacardim, 1896

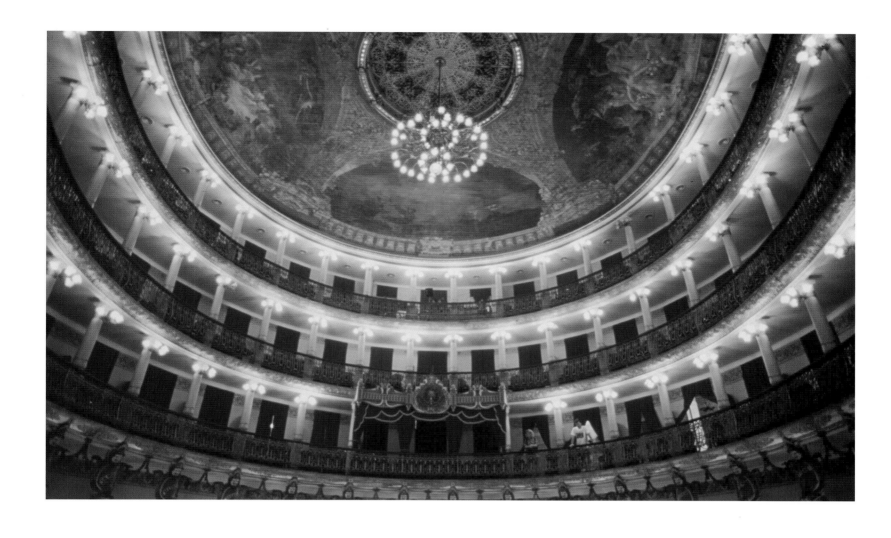

During the *belle époque*, wealthy rubber barons were keen to display their interest in opera, and the construction of the Teatro Amazonas, in the heart of the Amazon rainforest, was the result. The materials used were mostly imported from Europe, and the building is certainly in a European style. It is topped with a dome in which a mosaic was created using 36,000 vitrified ceramic tiles, painted in the colours of the Brazilian flag. The artist Domenico de Angelis painted the panels that adorn the auditorium.

Als während der *belle époque* reiche Kautschukbarone darum bemüht waren, ihr Interesse an der Oper zur Schau zu stellen, führte dies zur Konstruktion des Teatro Amazonas inmitten des gleichnamigen Regenwaldes. Die verwendeten Materialien wurden hauptsächlich aus Europa importiert und auch das Gebäude präsentiert sich zweifellos im europäischen Stil. Das Teatro wird von einer Kuppel gekrönt, die mit einem Mosaik aus 36000 glasierten Keramikfliesen in den Farben der brasilianischen Flagge geschmückt ist. Die Paneele im Auditorium wurden vom Künstler Domenico de Angelis gemalt.

Le Théâtre Amazonas fut construit durant la *belle époque*, en plein cœur de la forêt amazonienne, sous l'impulsion de riches magnats du caoutchouc enclins à afficher leur goût pour l'opéra. Les matériaux utilisés ont été pour l'essentiel importés d'Europe, et le bâtiment s'inspire largement du style européen. Le bâtiment est coiffé d'un dôme en mosaïque recouvert de 36 000 carreaux de céramique vernissés aux couleurs du drapeau brésilien. L'artiste Domenico de Angelis signa les panneaux peints qui parent l'auditorium.

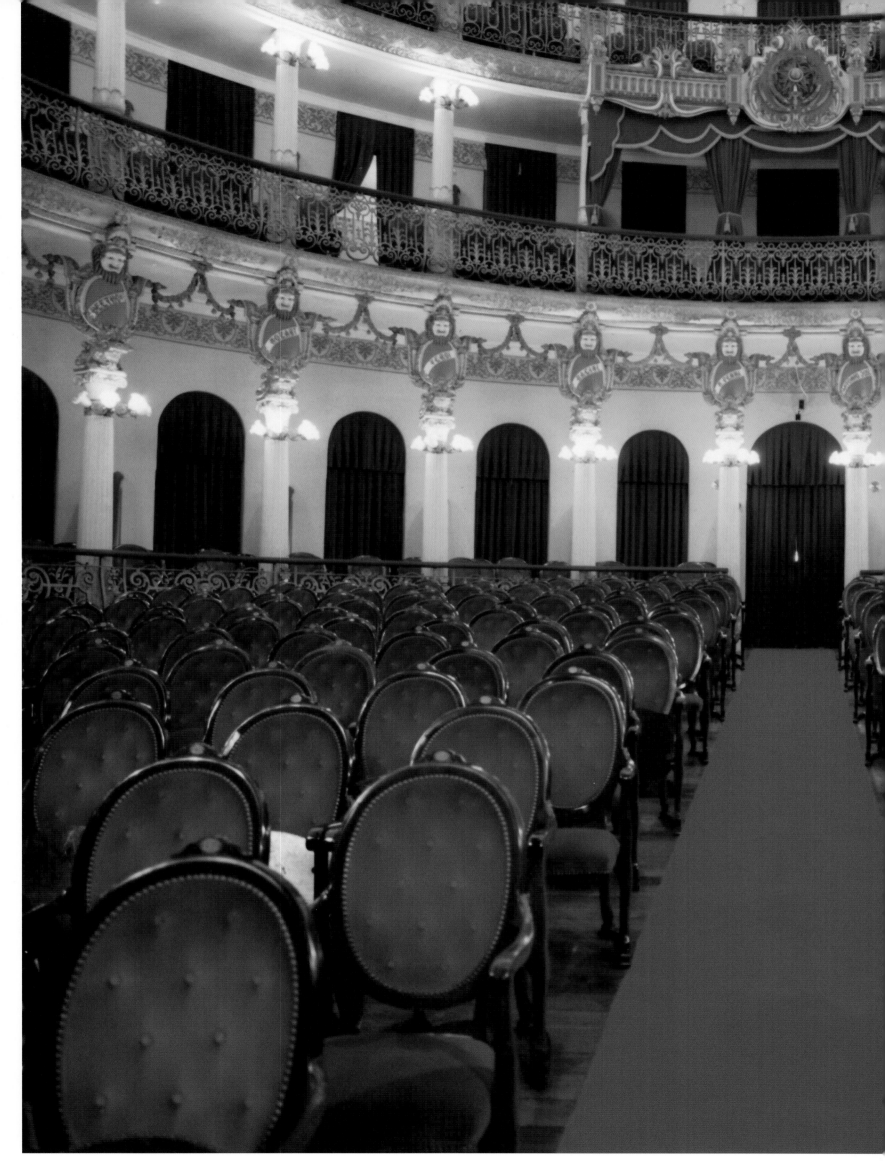

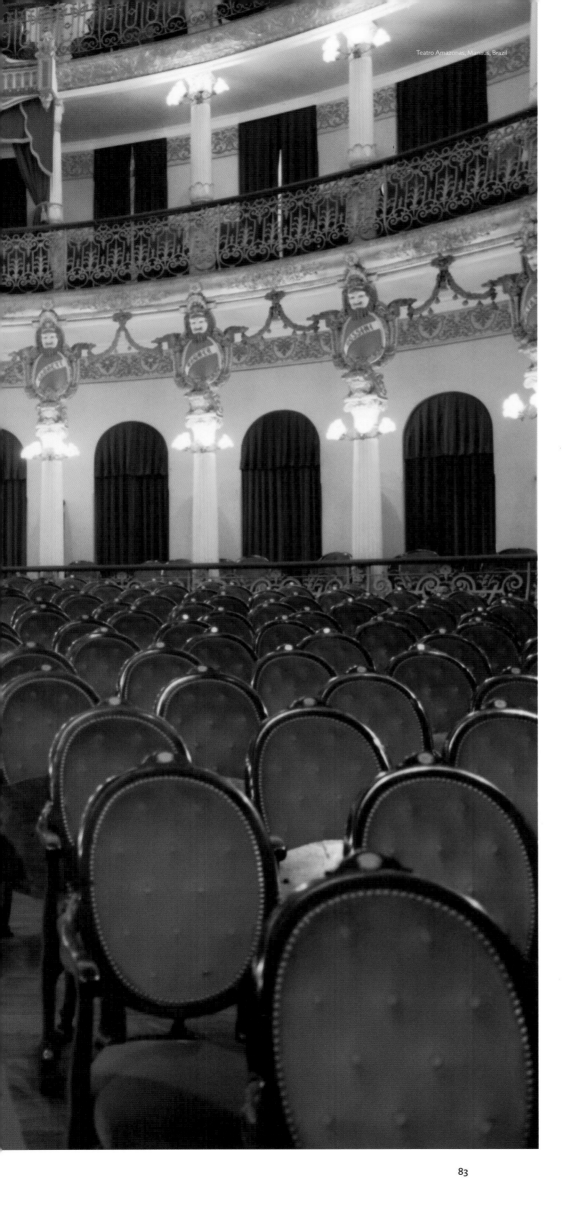

Teatro Amazonas, Manaus, Brazil

Durante la *belle époque*, los opulentos magnates del caucho se entusiasmaron con la idea de mostrar su interés por la ópera y el resultado fue la construcción del Teatro Amazonas, en el corazón de la selva amazónica. Los materiales utilizados se importaron principalmente de Europa y el edificio presenta, sin duda alguna, un estilo europeo. Está rematado por una cúpula en la que se creó un mosaico con más de 36.000 azulejos vitrificados, pintados con los colores de la bandera brasileña. Los paneles que adornan el auditorio son obra del artista Domenico de Angelis.

83

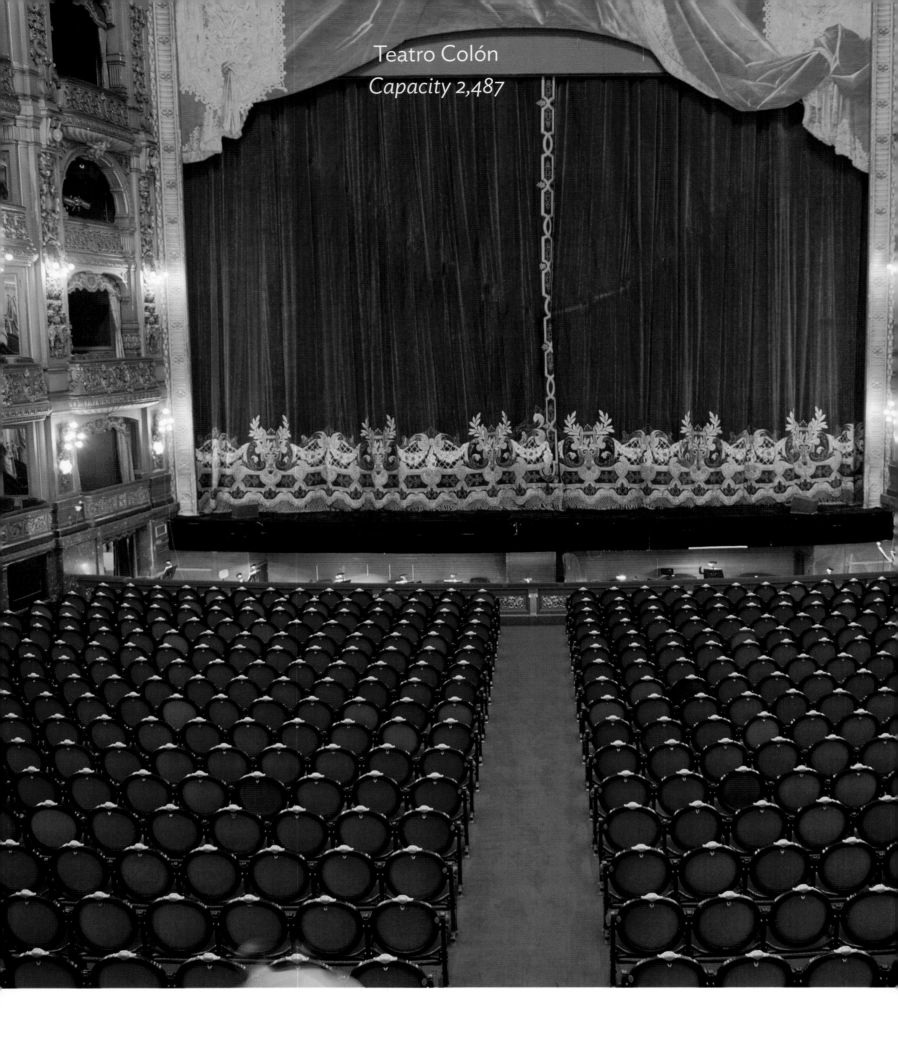

Teatro Colón
Capacity 2,487

Buenos Aires, Argentina
Francesco Tamburini, 1908

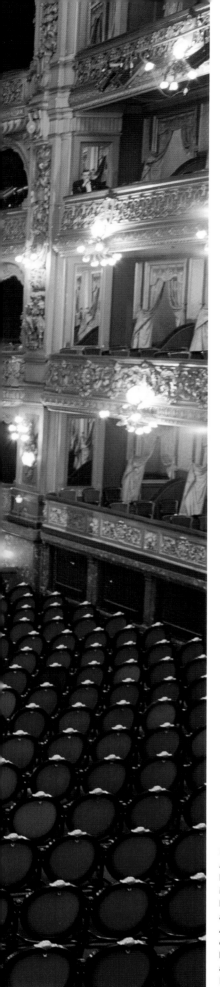

Located in the heart of Buenos Aires, Teatro Colón is considered to be one of the premier opera houses in terms of acoustics. The opera house was inaugurated in 1908, with a performance of Giuseppe Verdi's *Aida*, after a twenty-year period of construction. A number of architects became involved; hence there is a variety of styles associated with European opera in its design. The magnificence of the building is mirrored in its outstanding artistic history, with all of the world's greatest singers and conductors having performed here.

Das im Herzen von Buenos Aires gelegene Teatro Colón gilt in puncto Akustik als eines der führenden Opernhäuser der Welt. Es wurde 1908 nach einer zwanzigjährigen Bauzeit mit einer Aufführung von Giuseppe Verdis *Aida* eröffnet. Da eine Reihe unterschiedlicher Architekten mit dem Bau betraut war, zeigt die Gestaltung des Opernhauses eine breite Palette an Stilelementen, die mit der europäischen Oper in Verbindung stehen. Die Großartigkeit des Hauses spiegelt sich in seiner herausragenden künstlerischen Geschichte wider, in deren Verlauf hier die bedeutendsten Sänger und Dirigenten der Welt Auftritte absolvierten.

Situé en plein centre de Buenos Aires, le Théâtre Colón est considéré comme l'une des meilleures salles d'opéra en termes d'acoustique. La salle a été inaugurée en 1908, avec la représentation d'*Aida* de Giuseppe Verdi, après vingt ans de travaux de construction auxquels ont participé un certain nombre d'architectes ; ce qui explique l'architecture éclectique du lieu qui associe divers styles associés aux opéras européens. La grandeur de l'édifice est à la mesure de son prestigieux passé artistique, les plus grands interprètes et chefs d'orchestre du monde y ayant joué.

Situado en el corazón de Buenos Aires, el Teatro Colón está considerado como uno de los mejores teatros de ópera en lo que a acústica se refiere. Este teatro de ópera se inauguró en 1908, con una representación de *Aida* de Giuseppe Verdi, después de un período de construcción que se extendió a lo largo de veinte años. El proyecto contó con la implicación de varios arquitectos, por lo que hay una gran variedad de estilos procedentes la ópera europea en su diseño. La magnificencia del edificio se refleja en su excepcional historial artístico, ya que los mejores cantantes y directores de orquesta del mundo han actuado aquí.

Teatro Solís
Capacity 1,200

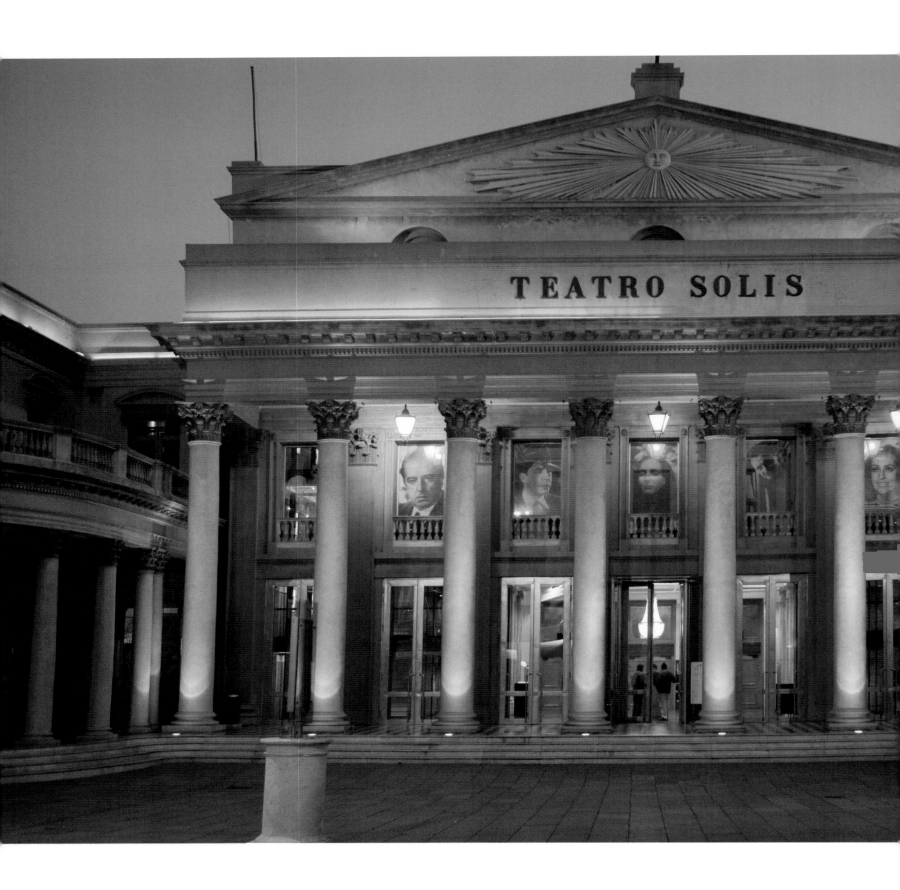

Montevideo, Uruguay
Carlo Zucchi & Francisco Xavier Garmendia, 1856

Teatro Solís was named after Juan Díaz de Solís, the Spanish navigator who sailed up the River Plate in 1516 to become the first European to set foot in Uruguay. It stands at the edge of Plaza Independencia, on the fringe of the Old Town of Montevideo. The original building was constructed in 1856, and opened with Tomás Giribaldi's *La Parisina*, considered to be the first Uruguayan national opera. It closed in 1998, and, after a six-year makeover, it reopened in 2004.

Das Teatro Solís wurde nach dem spanischen Navigator Juan Díaz de Solís benannt, der 1516 den Rio de la Plata hinaufsegelte und als erster Europäer uruguayischen Boden betrat. Das Gebäude befindet sich an der Plaza Independencia am Rande der Altstadt Montevideos. Das ursprüngliche Gebäude wurde 1856 errichtet und mit einer Darbietung von Tomás Giribaldis *La Parisina* eröffnet, einem Stück, das als erste nationale Oper Uruguays gilt. Das Theater schloss 1998 seine Pforten und wurde nach einer sechsjährigen Renovierungsphase im Jahr 2004 wiedereröffnet.

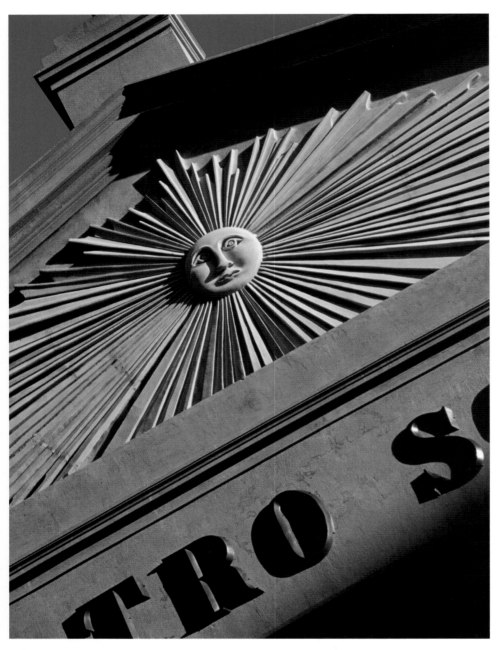

Le Teatro Solís tire son nom de Juan Díaz de Solís, marin espagnol ayant remonté le Rio de la Plata en 1516, devenant ainsi le premier Européen à avoir foulé la terre d'Uruguay. Le théâtre s'élève à l'extrémité de la Place de l'Indépendance, en marge de la vieille ville de Montevideo. Le bâtiment initial fut construit en 1856, et inauguré avec la représentation de *La Parisina* de Tomás Giribaldi, considéré comme le premier opéra national uruguayen. Le théâtre ferma ses portes en 1998, pour les rouvrir en 2004, après six années de transformation.

El Teatro Solís recibió su nombre de Juan Díaz de Solís, el navegante español que desembarcó en el Río de la Plata en 1516 y se convirtió en el primer europeo en pisar Uruguay. Se encuentra al borde de la Plaza Independencia, en la zona limítrofe con la Ciudad Vieja de Montevideo. El edificio original se construyó en 1856 y se inauguró con *La parisina* de Tomás Giribaldi, considerada como la primera ópera nacional uruguaya. Cerró en 1998 y, tras seis años de remodelación, volvió a abrir sus puertas en 2004.

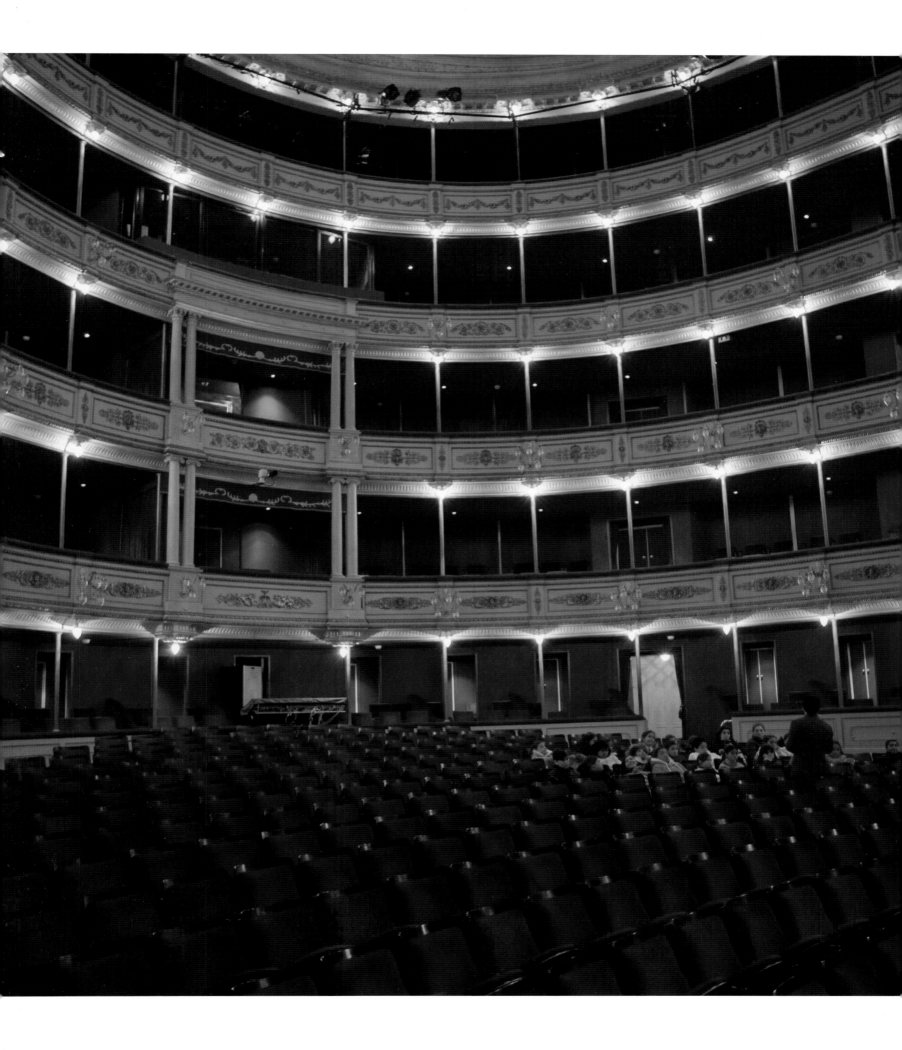

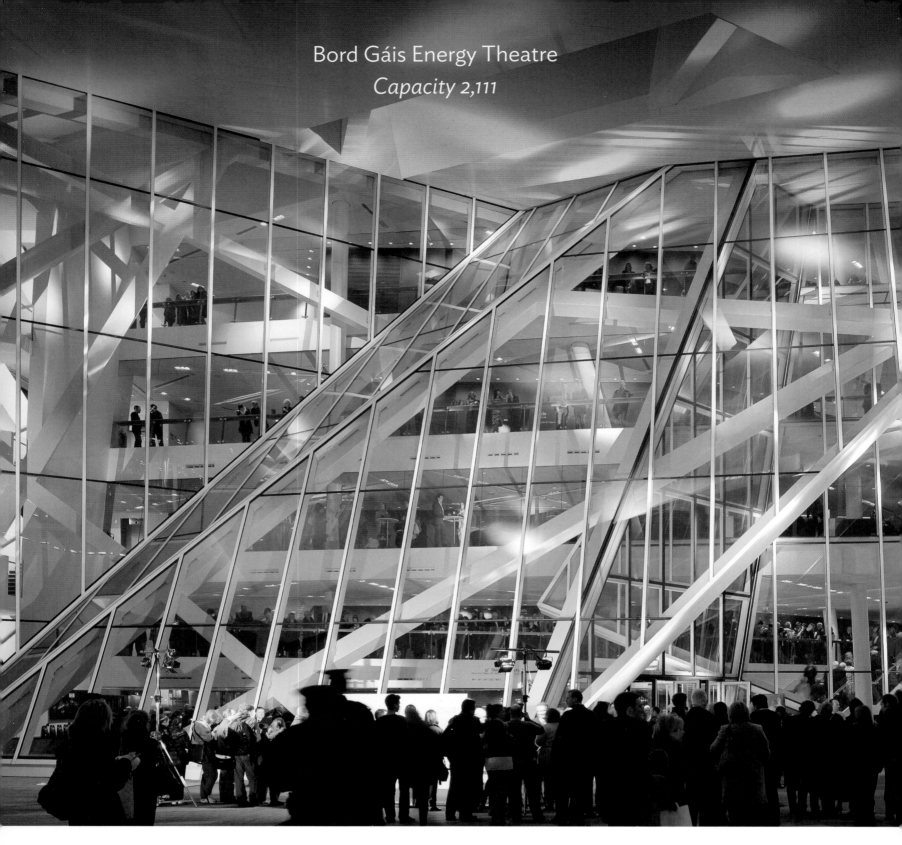

Bord Gáis Energy Theatre
Capacity 2,111

The Bord Gáis Energy Theatre is the focal point of a newly developed piazza at the waterfront of Grand Canal Dock in Dublin. The canal-side square is home to a hotel, apartments and offices, which provide an interesting urban view from the glazed foyer. The distorted rhomboid of the theatre is a brave design, typical of Daniel Libeskind. The curtain rose in March 2010 with the Russian State Ballet, featuring stars from the Bolshoi, performing *Swan Lake*.

Dublin, Ireland
Daniel Libeskind, 2010

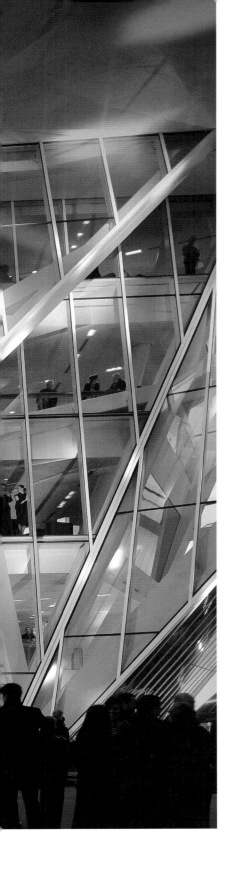

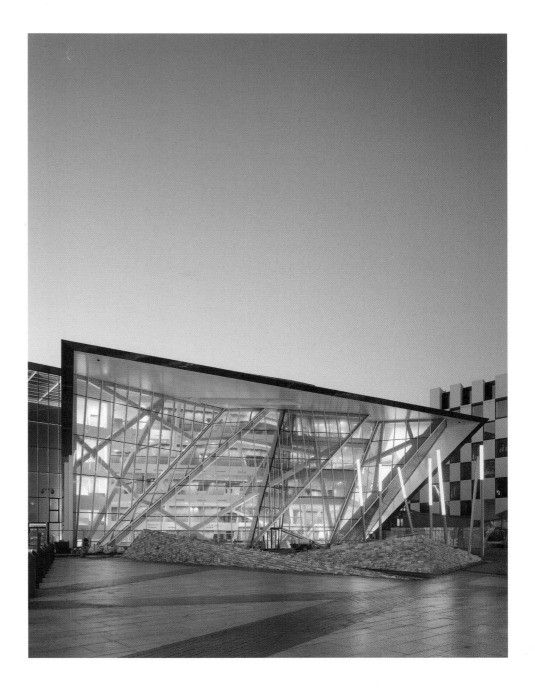

Das Bord Gáis Energy Theatre ist der Brennpunkt einer neu entwickelten Piazza an den Kaianlagen des Grand Canal Dock in Dublin. Am kanalseitig gelegenen Platz erheben sich ein Hotel, Apartments und Bürogebäude, die von der verglasten Vorhalle des Theaters aus gesehen ein beeindruckendes urbanes Panorama bilden. Das extravagante Äußere in Form eines verzerrten Parallelogramms ist typisch für die mutigen Entwürfe eines Daniel Libeskind. Bei der Eröffnung im März 2010 hob sich der Vorhang für eine Aufführung des Russischen Staatsballetts mit einigen Stars des Bolschoi-Theaters, das *Schwanensee* zum Besten gab.

Le Bord Gáis Energy Theatre est l'artère centrale d'une nouvelle esplanade récemment sortie de terre au bord du Grand Canal Dock, à Dublin. La baie vitrée de l'édifice s'ouvre sur un cadre urbain singulier composé d'un hôtel, de résidences et de bureaux qui entourent la place donnant sur le canal. L'allure rhombique déstructurée de l'édifice dénote d'un choix architectural audacieux, emblématique de Daniel Libeskind. Le théâtre a été inauguré en mars 2010 avec une représentation du *Lac des cygnes* joué par les Ballets russes avec en tête d'affiche certains danseurs étoiles du Bolchoï.

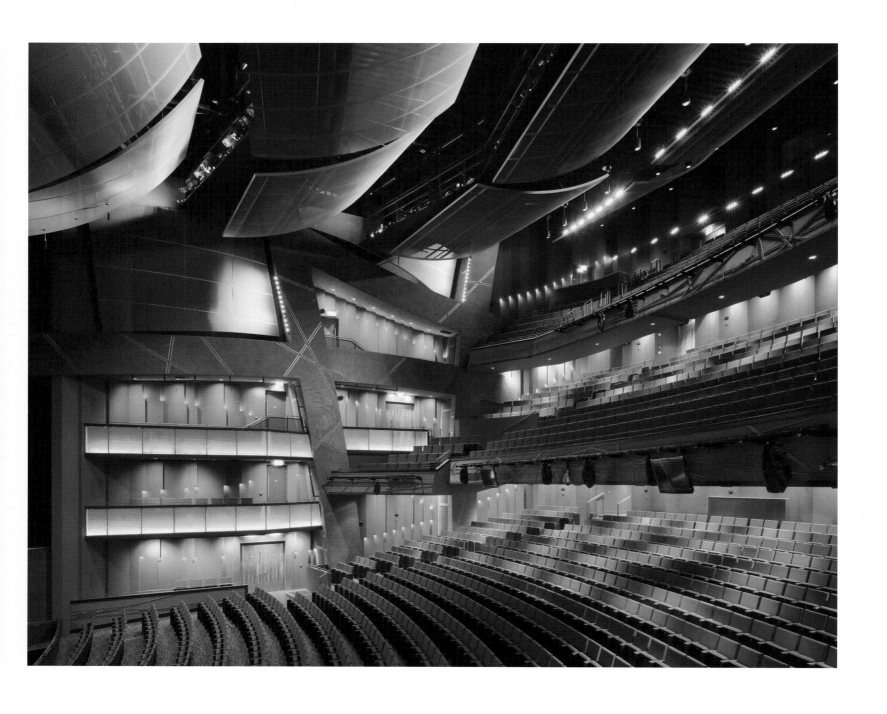

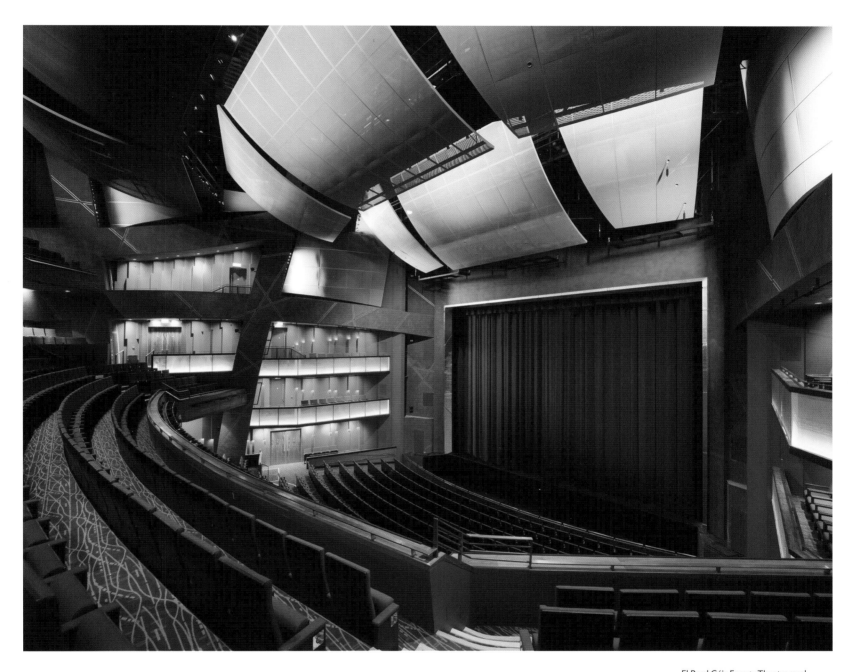

El Bord Gáis Energy Theatre es el epicentro de una plaza de reciente creación a orillas de la zona Grand Canal Dock en la ciudad de Dublín. En la plaza junto al canal hay un hotel, apartamentos y oficinas que proporcionan una vista urbana interesante desde el vestíbulo acristalado. La forma romboidal deforme del teatro se caracteriza por su atrevido diseño, típico de Daniel Libeskind. El telón se alzó en marzo de 2010, con el Ballet Nacional Ruso y estrellas del Bolshoi actuando en *El lago de los cisnes*.

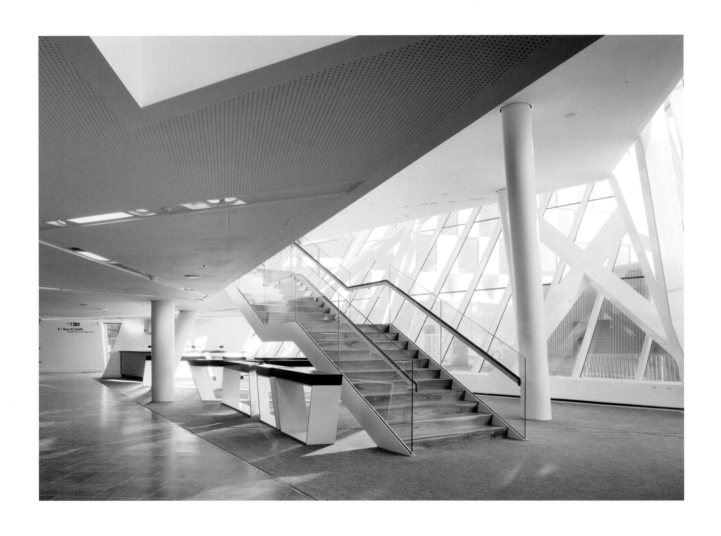

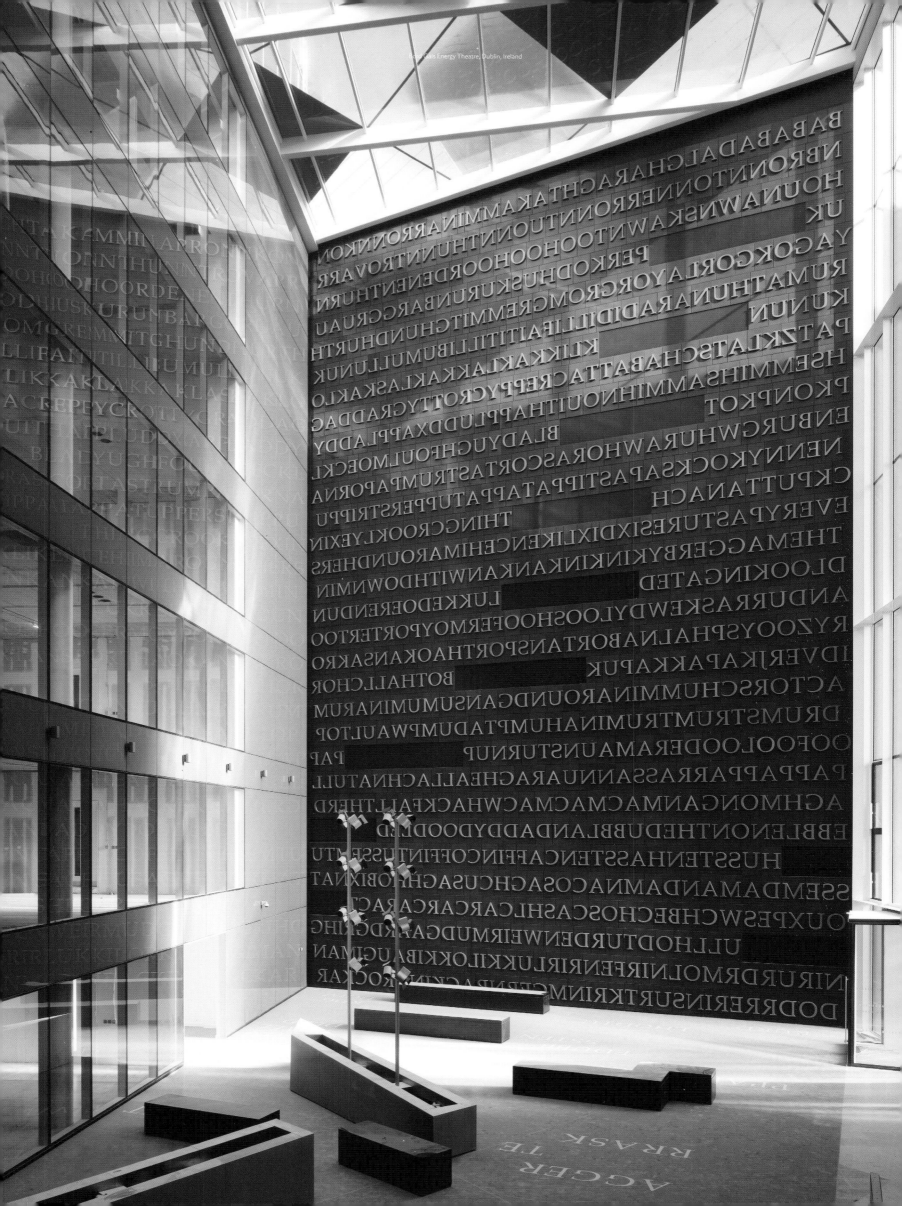

Minack Theatre

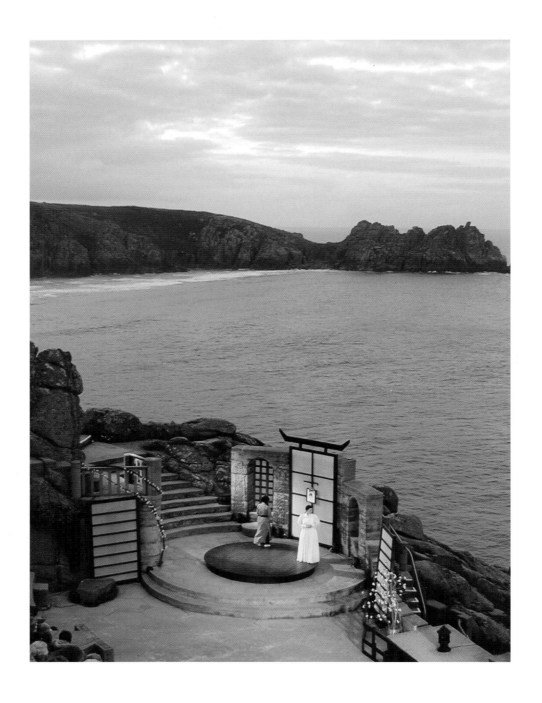

Porthcurno, England
Rowena Cade, 1932

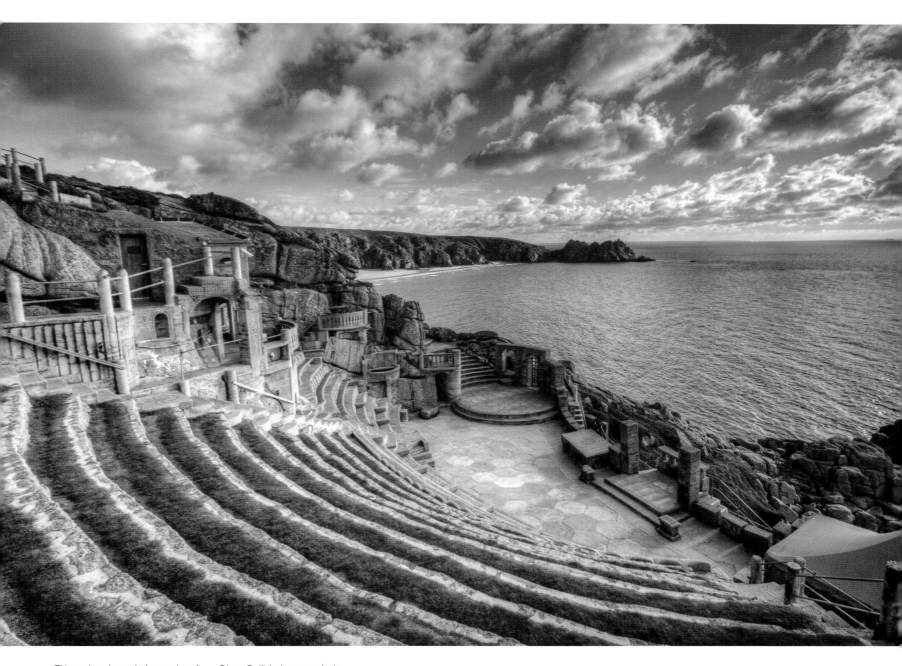

This outdoor theatre is the creation of the determined Rowena Cade. Having bought a house at Minack Point, she offered the use of the garden of her house to a local group of players for a production of *The Tempest*. Miss Cade and her gardener made a terrace and rough seating, so that the sea would provide a dramatic backdrop to the play. Miss Cade made improvements to the theatre throughout her lifetime, and it is now the captivating setting for many plays throughout the summer months.

Dieses Freilichttheater verdankt sich der Beharrlichkeit Miss Rowena Cades. Nachdem sie ein Haus in Minack Point erworben hatte, bot Fräulein Cade einer ortsansässigen Schauspieltruppe ihren Garten für die Aufführung von Shakespeares *Der Sturm* an. Miss Cade und ihr Gärtner errichteten eine Terrasse und behelfsmäßige Sitzgelegenheiten, dank deren Ausrichtung die See selbst als beeindruckende Kulisse für das dargebotene Schauspiel diente. Fräulein Cade sorgte zeitlebens für Verbesserungen am Theater und während der Sommermonate dient es auch heute noch zahlreichen Aufführungen als faszinierende Spielstätte.

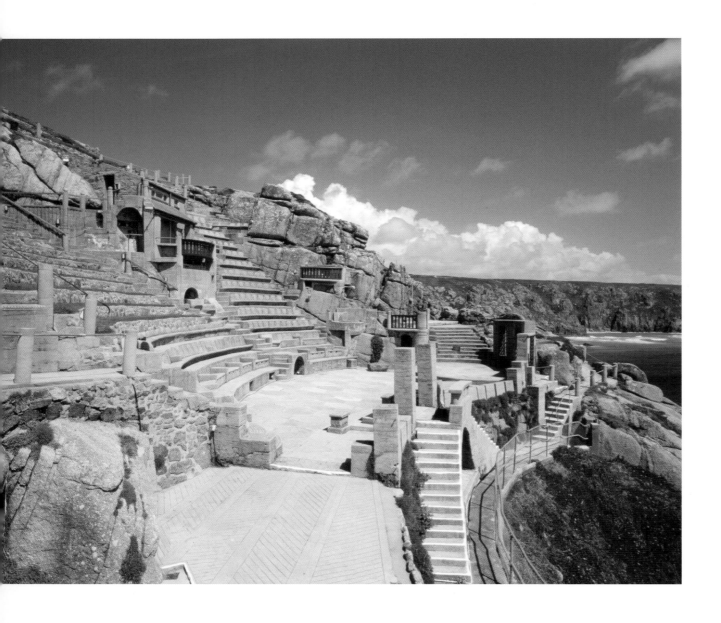

Ce théâtre bâti en plein air est l'œuvre de la très déterminée Miss Rowena Cade. Après avoir acquis une maison à Minack Point, elle proposa à une troupe de théâtre locale d'utiliser son jardin pour jouer La Tempête de Shakespeare. Miss Cade et son jardinier aménagèrent grossièrement une terrasse et des sièges avec la mer comme toile de fond spectaculaire. Miss Cade a consacré sa vie à améliorer le théâtre, qui sert aujourd'hui de cadre enchanteur à de nombreuses pièces jouées en été.

Este teatro al aire libre es obra de Rowena Cade, una mujer de ideas resueltas. Tras adquirir una casa en Minack Point, ofreció el uso de su jardín a un grupo local de actores para la producción de La tempestad. La señora Cade y su jardinero crearon una terraza y unos asientos toscos, de forma que el mar proporcionara un telón de fondo espectacular para la representación. La señora Cade fue realizando mejoras en el teatro a lo largo de toda su vida. En la actualidad, es el fascinante escenario de numerosas representaciones durante la temporada estival.

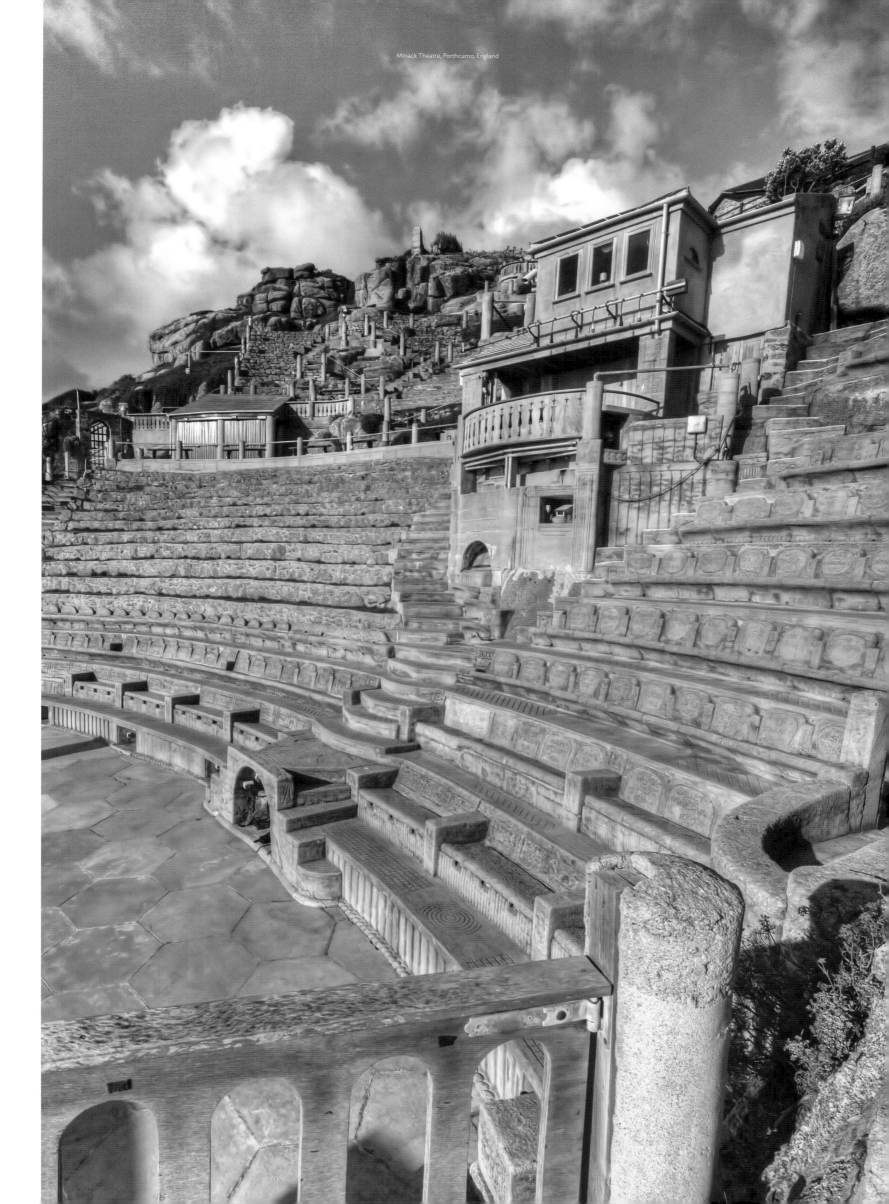

Minack Theatre, Porthcurno, England

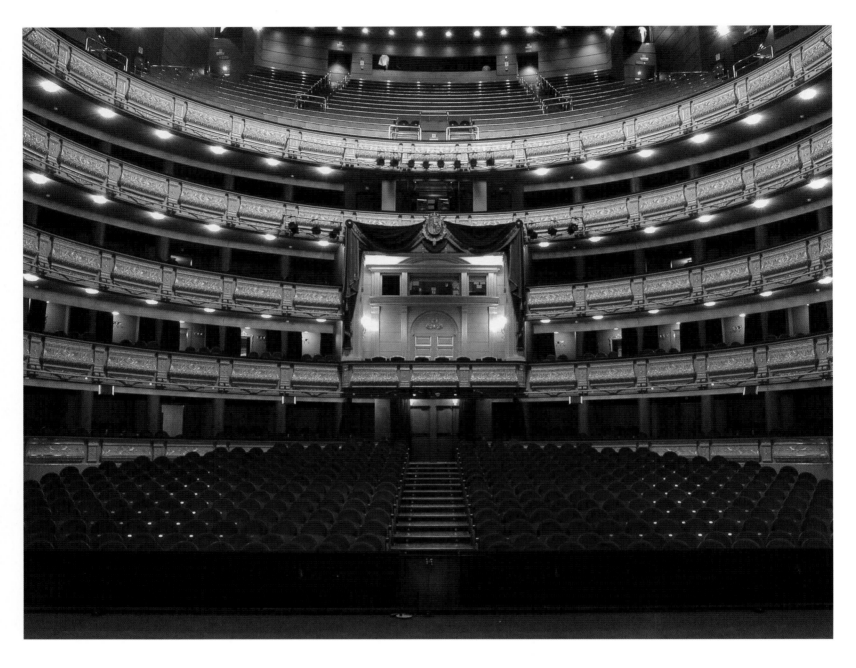

Since 1850, when the theatre was inaugurated with the performance of Donizetti's *La favorite*, Teatro Real has faced many alteration, renovation and construction difficulties. When it reopened in 1997, it was used once more as an opera house, as Queen Isabel II had originally intended. Located just in front of Palacio Real, dominating the Plaza de Oriente, the theatre has twenty-eight boxes on its different floors, and a Royal Box, which extends to twice the height of the others.

Beginnend mit seiner Eröffnung mit Donizettis *La Favorite* im Jahr 1850 war das Teatro Real Schauplatz zahlreicher Veränderungen, Renovierungsmaßnahmen und baulicher Schwierigkeiten. Seit seiner Wiedereröffnung im Jahr 1997 wird es, ganz im Sinne Königin Isabellas II., wieder als Opernhaus genutzt. Das direkt gegenüber dem königlichen Palacio Real gelegene Opernhaus dominiert die Plaza de Oriente und umfasst 28, auf sämtlichen Stockwerken liegende Logen sowie eine Königliche Loge, deren Höhe die der anderen um das Doppelte überragt.

Depuis son inauguration en 1850 avec la représentation de *La favorite* de Donizetti, le Teatro Real a rencontré de nombreux problèmes dus aux altérations, aux rénovations et aux constructions successives. Après sa réouverture en 1997, le théâtre a retrouvé la place que la Reine Isabelle II lui réserva autrefois : celle de salle d'opéra. Situé en face du Palais royal, et surplombant la Plaza de Oriente (Place de l'Orient), le théâtre est organisé en vingt-huit loges distribuées entre ses différents étages, et comprend une Loge royale, deux fois plus haute que les autres.

Desde 1850, año en el que se inauguró el teatro con la representación de *La favorita* de Donizetti, el Teatro Real ha sufrido numerosos problemas de alteraciones, renovaciones y de construcción. Cuando abrió de nuevo sus puertas en 1997, se volvió a utilizar como teatro de ópera, tal y como lo había previsto la reina Isabel II originalmente. Situado justo en frente del Palacio Real, que domina la Plaza de Oriente, el teatro ofrece veintiocho palcos en las distintas plantas y un palco real, que duplica la altura de los demás palcos.

Teatro Real
Capacity 1,854

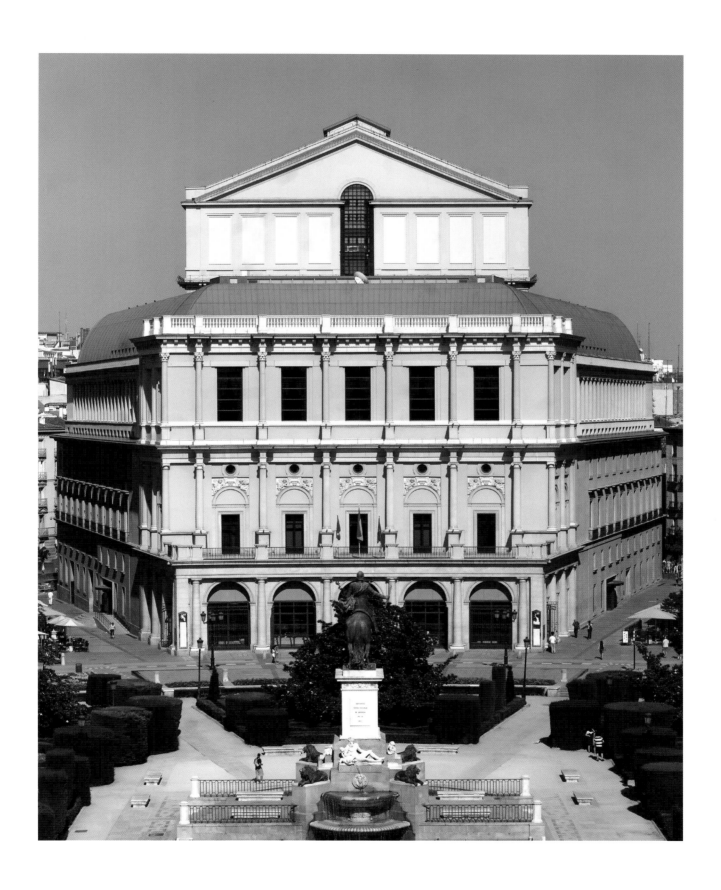

Madrid, Spain

Antonio López Aguado, 1850

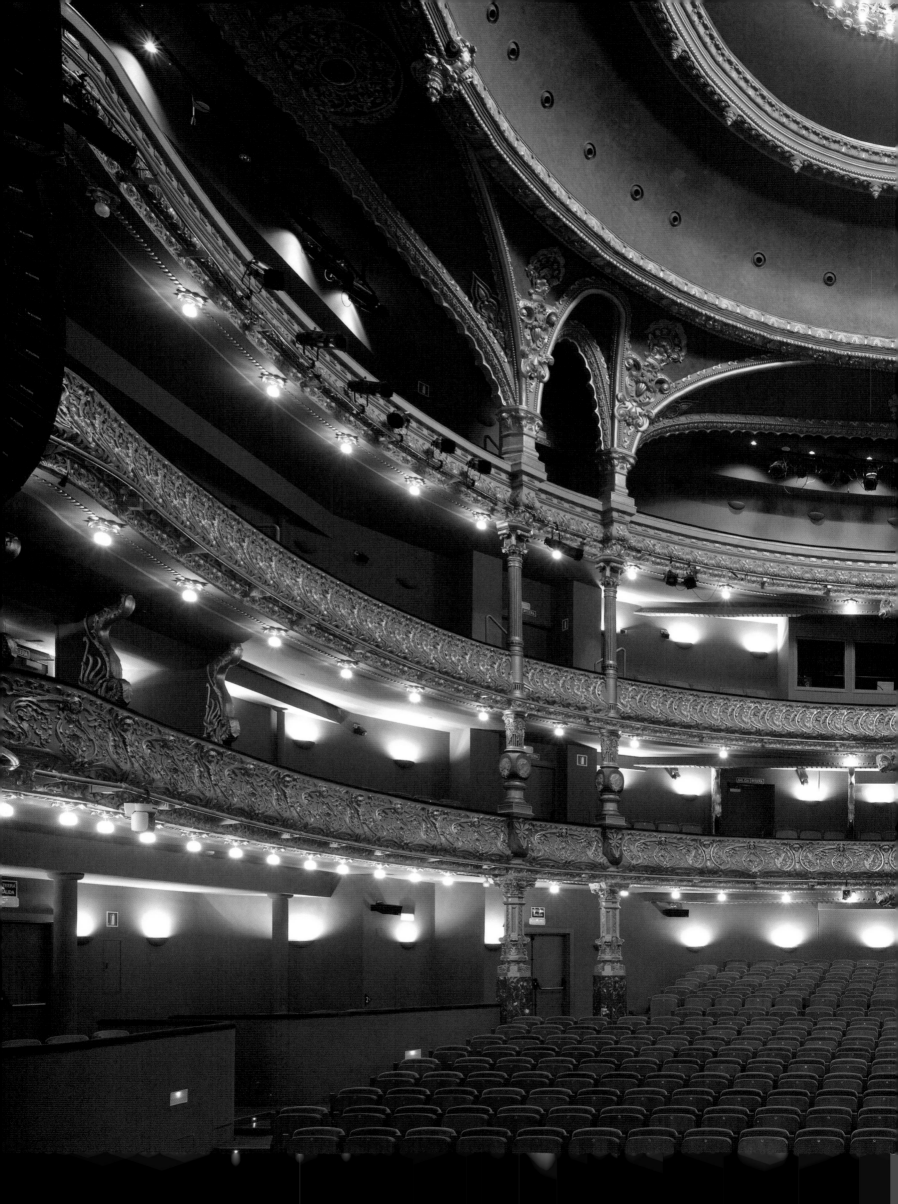

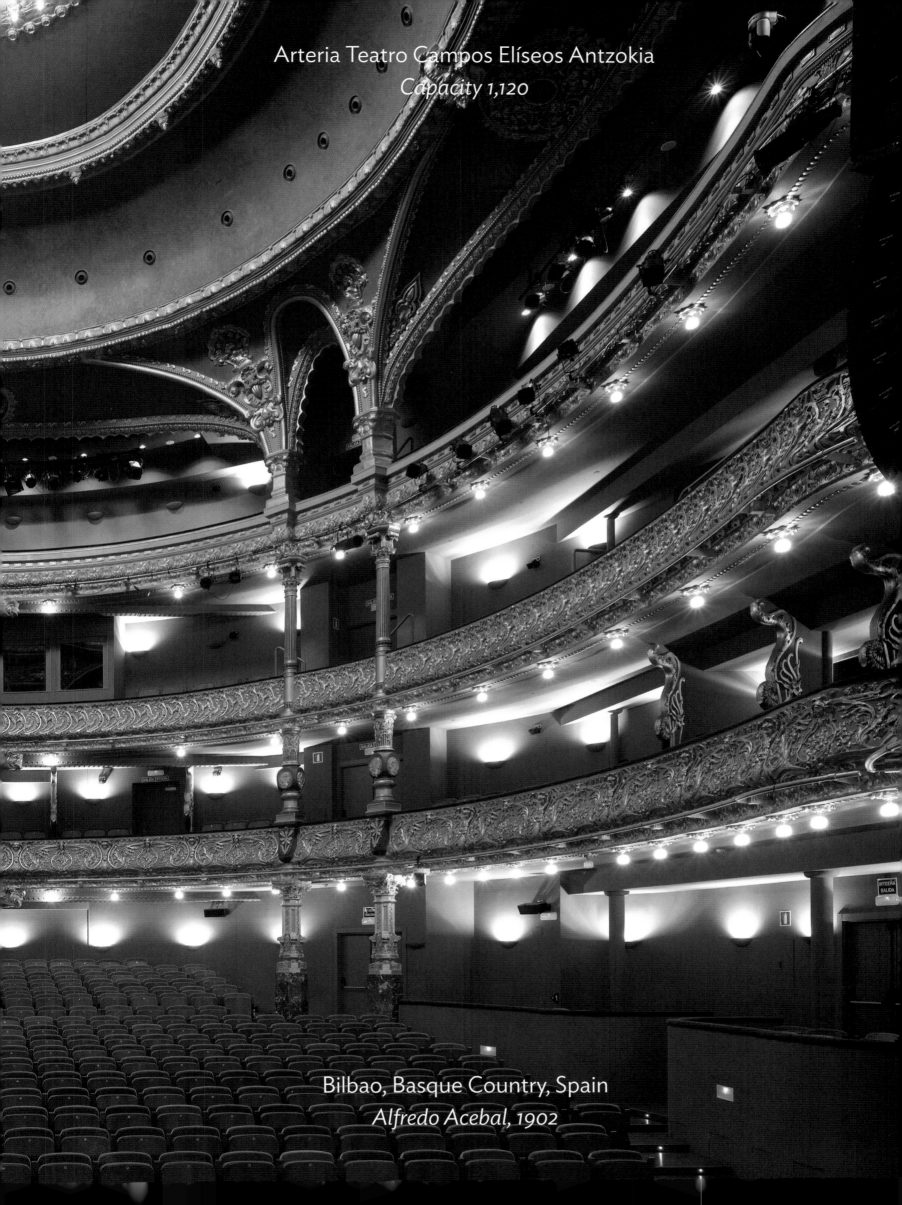

Arteria Teatro Campos Elíseos Antzokia
Capacity 1,120

Bilbao, Basque Country, Spain
Alfredo Acebal, 1902

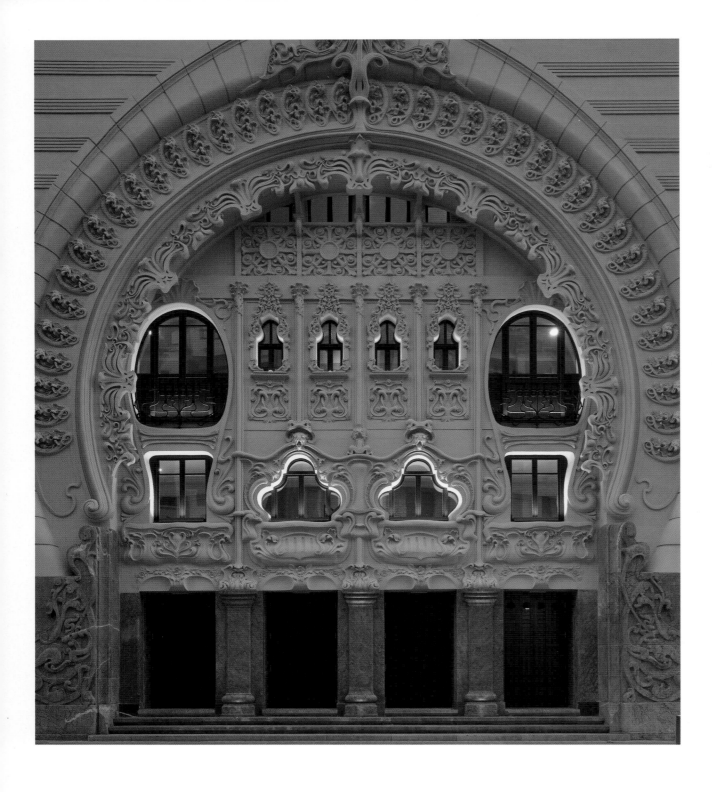

The Teatro Campos, situated on Bertendona Street in Bilbao, is one of the best examples of Art Nouveau architecture in the Basque Country. It is known for its modernist horseshoe façade, with vegetal and animal motifs, designed by the French-Basque architect Jean Batiste Darroquy. It was inaugurated in 1902, as part of the expansion of the city. Following a period of inactivity, the theatre was significantly refurbished, and it was reopened in 2010.

Das Teatro Campos befindet sich in der Calle de Bertendona in Bilbao und ist eines der beeindruckendsten Jugendstilgebäude im gesamten Baskenland. Berühmt ist seine vom französisch-baskischen Architekten Jean Batiste Darroquy entworfene und mit pflanzlichen und tierischen Motiven reichverzierte modernistische Hufeisenfassade. Das Campos wurde im Jahr 1902 als Teil eines Stadter-weiterungsprojekts eröffnet. Nach einer Zeit des Dornröschenschlafs wurde das Theater ausgiebig renoviert und schließlich 2010 wiedereröffnet.

Rue Bertendona à Bilbao s'élève le Teatro Campos, exemple architectural parmi les plus emblématiques de l'Art Nouveau du Pays basque. Le théâtre est réputé pour sa façade résolument moderniste en forme de fer à cheval ornée de motifs végétaux et animaux, conçue par l'architecte français d'origine basque Jean Baptiste Darroquy. Le théâtre a été inauguré en 1902, suite à l'expansion de la ville. Après une longue période d'inactivité, le théâtre a été remanié en profondeur, puis a réouvert ses portes en 2010.

El Teatro Campos, situado en la calle Bertendona de Bilbao, constituye uno de los mejores ejemplos de arquitectura Art Nouveau del País Vasco. Es famoso por su fachada modernista en forma de herradura, decorada con motivos vegetales y animales, y diseñada por el arquitecto vasco-francés Jean Batiste Darroquy. Se inauguró en 1902, en la fase de expansión de la ciudad. Tras un período de inactividad, el teatro se reformó ampliamente y volvió a abrir sus puertas en 2010.

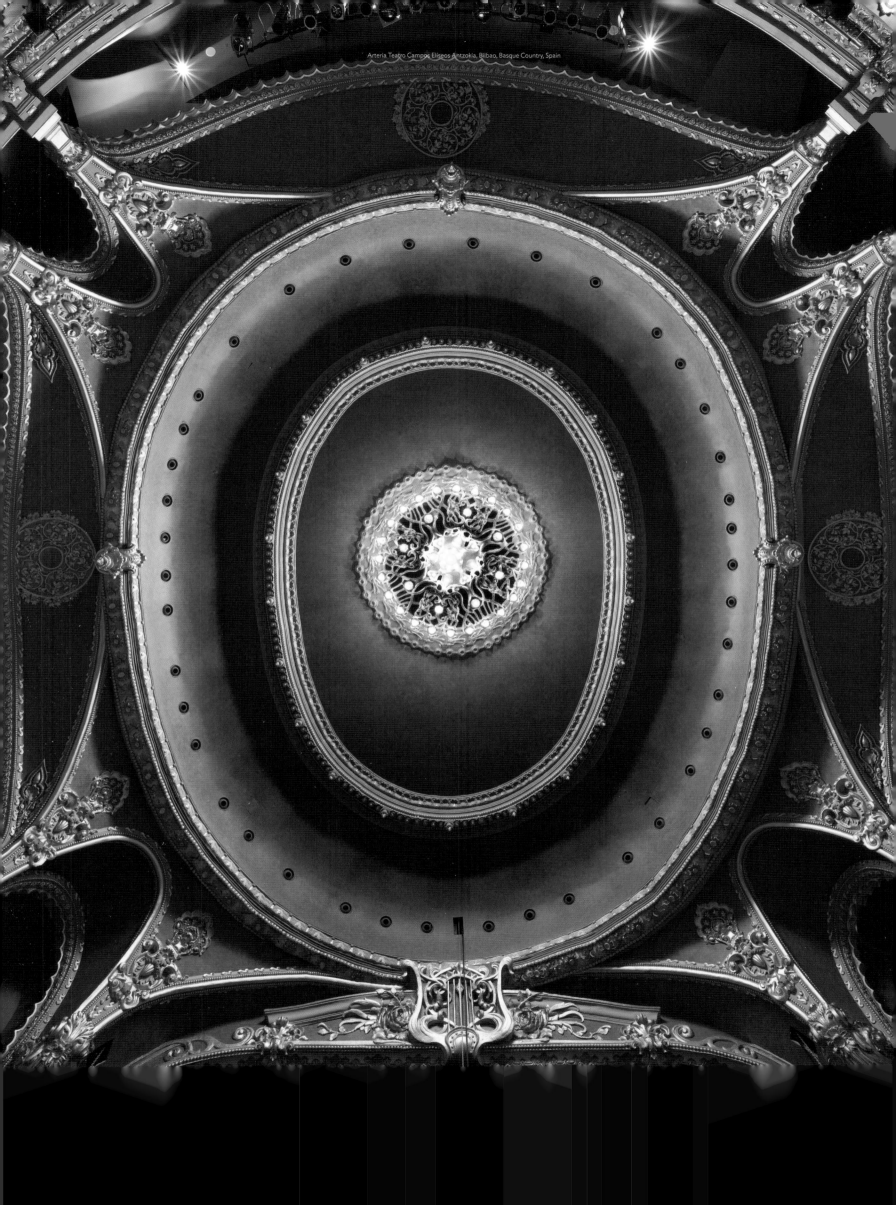

Arteria Teatro Campos Eliseos Antzokia, Bilbao, Basque Country, Spain

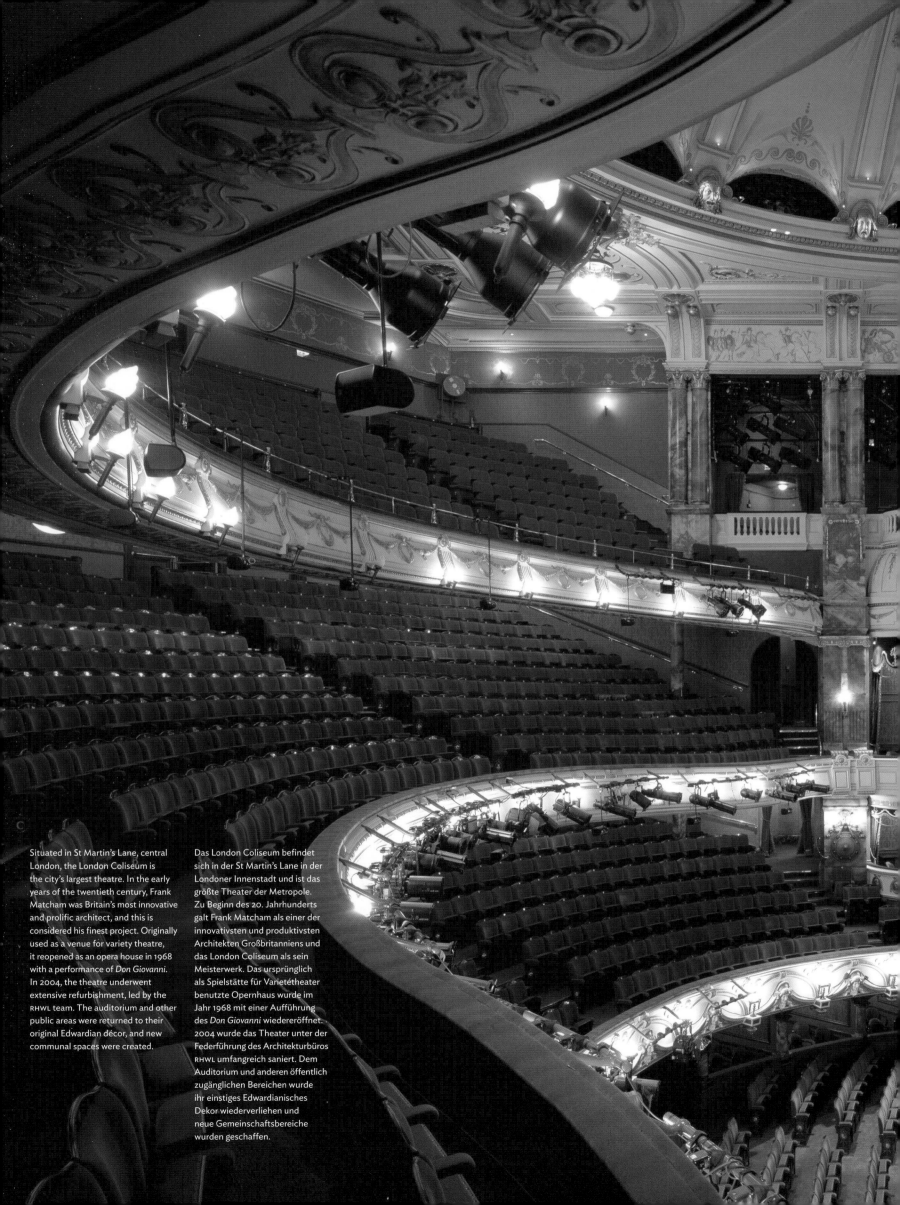

Situated in St Martin's Lane, central London, the London Coliseum is the city's largest theatre. In the early years of the twentieth century, Frank Matcham was Britain's most innovative and prolific architect, and this is considered his finest project. Originally used as a venue for variety theatre, it reopened as an opera house in 1968 with a performance of *Don Giovanni*. In 2004, the theatre underwent extensive refurbishment, led by the RHWL team. The auditorium and other public areas were returned to their original Edwardian décor, and new communal spaces were created.

Das London Coliseum befindet sich in der St Martin's Lane in der Londoner Innenstadt und ist das größte Theater der Metropole. Zu Beginn des 20. Jahrhunderts galt Frank Matcham als einer der innovativsten und produktivsten Architekten Großbritanniens und das London Coliseum als sein Meisterwerk. Das ursprünglich als Spielstätte für Varietétheater benutzte Opernhaus wurde im Jahr 1968 mit einer Aufführung des *Don Giovanni* wiedereröffnet. 2004 wurde das Theater unter der Federführung des Architekturbüros RHWL umfangreich saniert. Dem Auditorium und anderen öffentlich zugänglichen Bereichen wurde ihr einstiges Edwardianisches Dekor wiederverliehen und neue Gemeinschaftsbereiche wurden geschaffen.

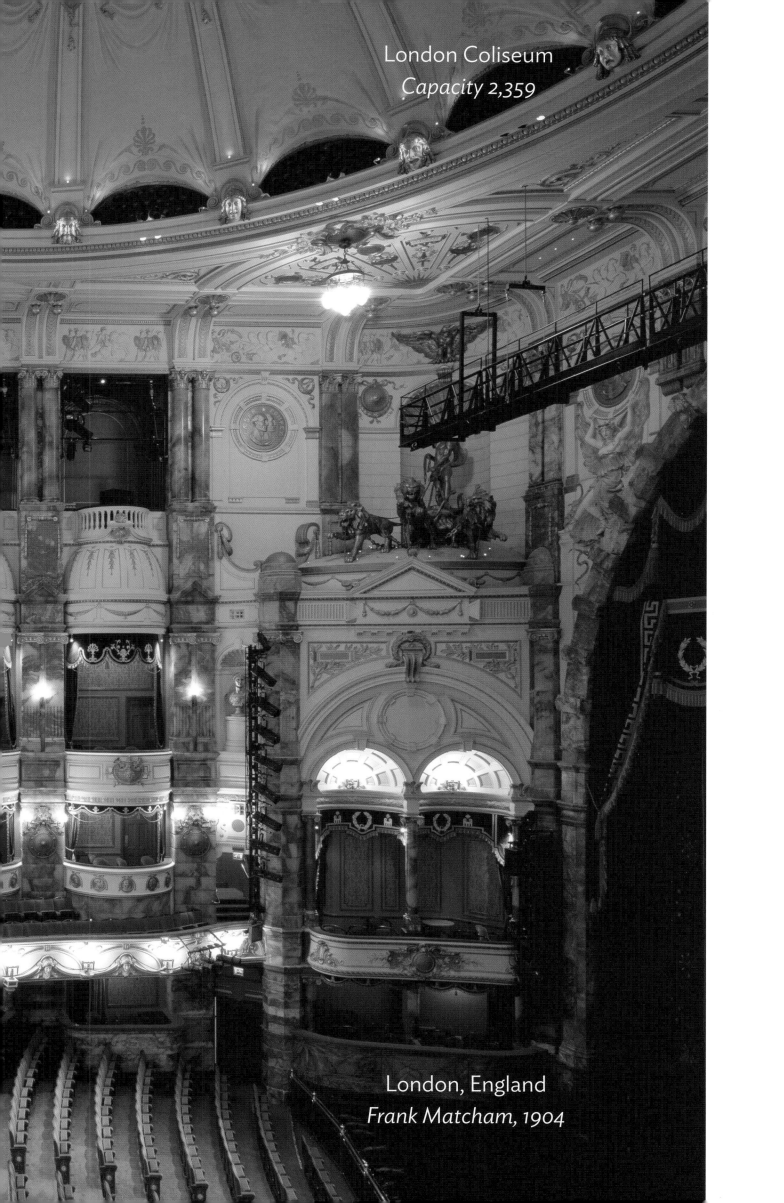

London Coliseum
Capacity 2,359

London, England
Frank Matcham, 1904

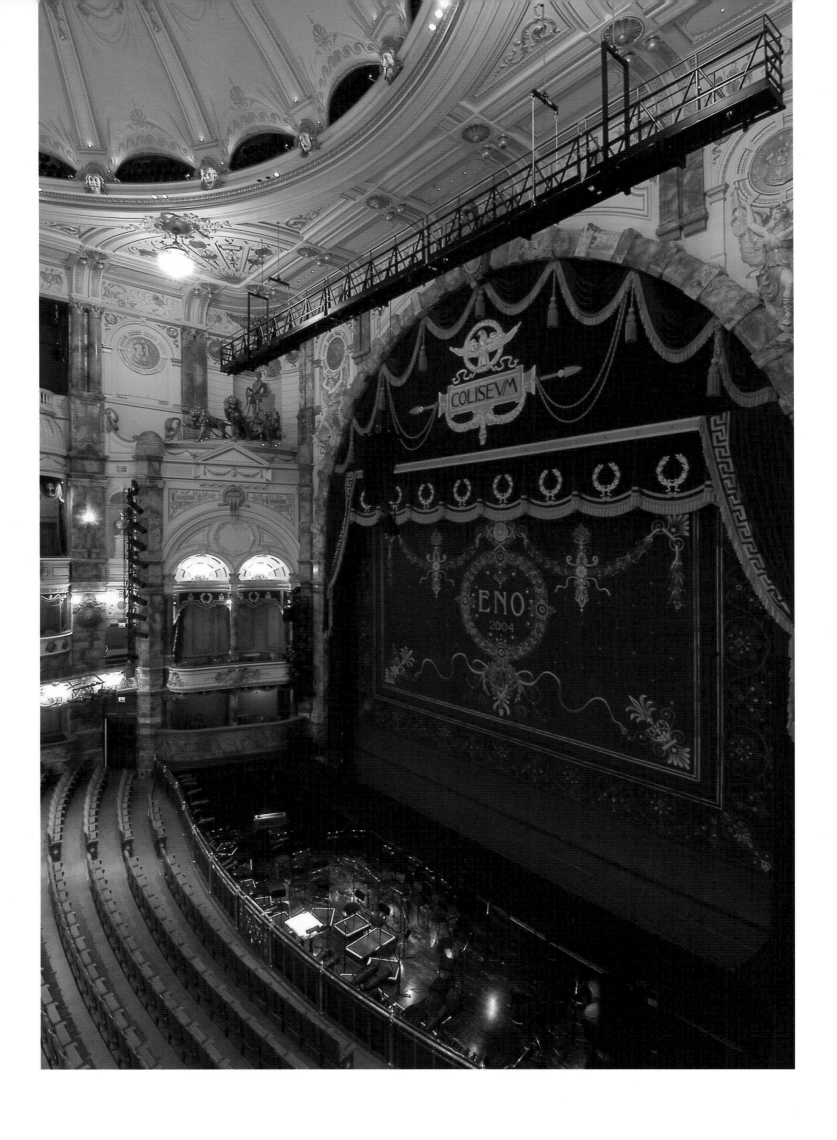

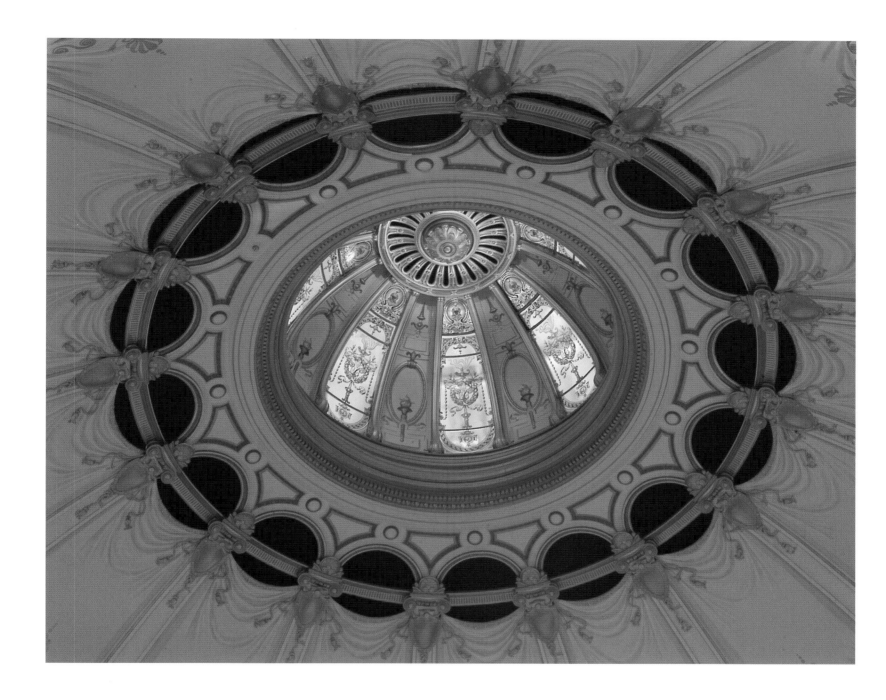

Situé sur St Martin's Lane, en plein
centre de Londres, le London Coliseum
est l'un des plus grands théâtres de
la ville. Au début du vingtième siècle,
Frank Matcham figurait parmi les
architectes les plus avant-gardistes
et prolifiques de Grande-Bretagne.
Ce théâtre est considéré comme son
projet le plus abouti. Initialement
destiné aux émissions de variétés,
le théâtre a rouvert en tant qu'opéra
en 1968 avec la représentation de *Don
Giovanni*. Après une importante remise
en état en 2004, réalisée par l'équipe
d'architectes RHWL, l'auditorium et les
autres espaces réservés au public ont
retrouvé leur décor original de style
édouardien, alors que de nouveaux
espaces communs ont été aménagés.

Situado en St Martin Lane, en el centro
de Londres, el London Coliseum es
el teatro más grande de la ciudad. A
principios del siglo XX, Frank Matcham
era el arquitecto británico más
innovador y prolífico, y éste es el que
se considera su proyecto más logrado.
En su origen, se utilizó como sede de
un teatro de variedades. Se inauguró
como teatro de ópera en 1968 con una
representación de *Don Giovanni*. En
2004, el equipo de RHWL llevó a cabo
una extensa restauración del teatro.
El auditorio y otras zonas públicas
recuperaron su decoración original de
estilo eduardiano y se crearon nuevos
espacios comunitarios.

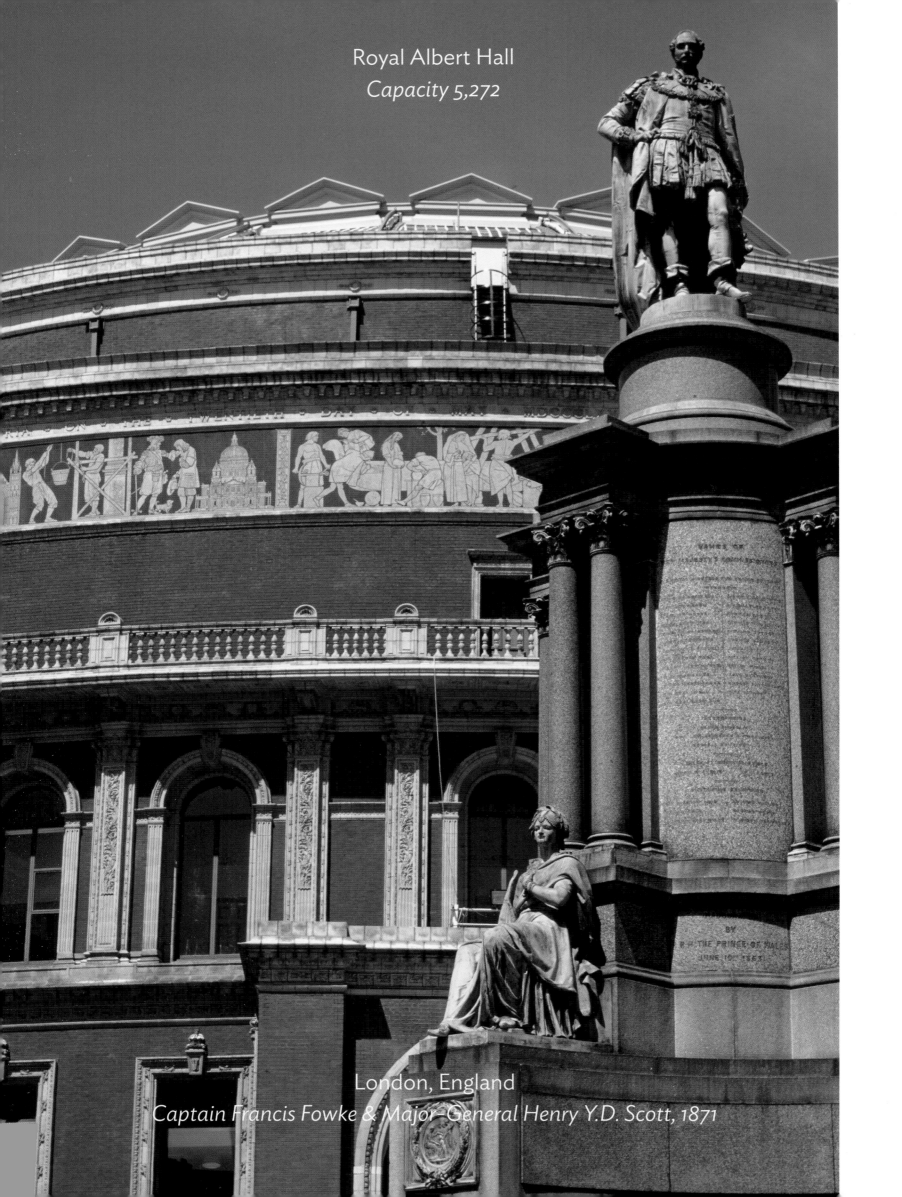

Royal Albert Hall
Capacity 5,272

London, England
Captain Francis Fowke & Major-General Henry Y.D. Scott, 1871

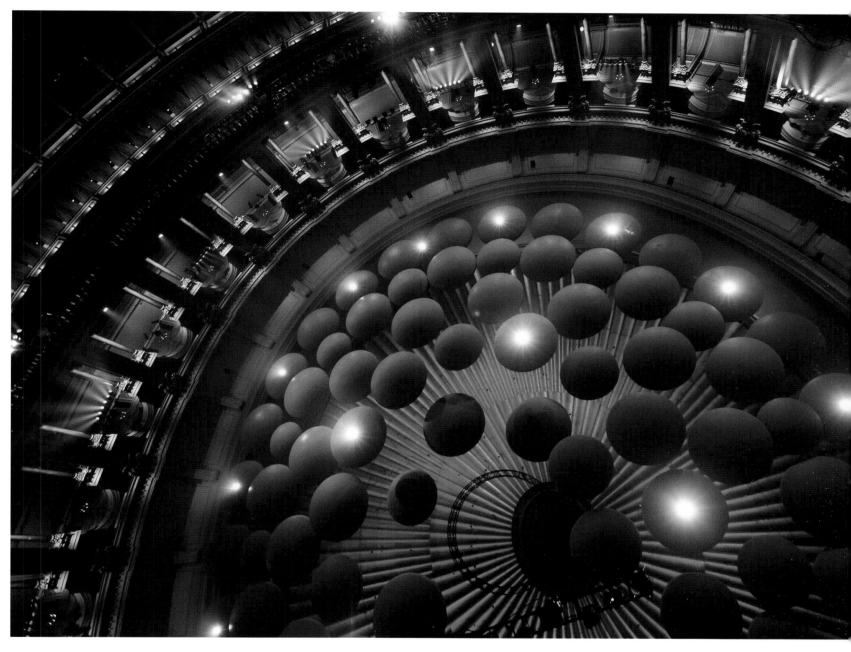

The Royal Albert Hall, in South Kensington, was built to fulfil Prince Albert's vision of a hall used to promote the arts and sciences. It was to be named The Central Hall of Arts and Sciences, but upon construction Queen Victoria decided to name it after her husband, who was by then deceased. Along with hosting opera, ballet, and rock concerts, the building has been the venue for meetings, exhibitions and award ceremonies, and has been in continuous use since its opening in 1871.

Die Royal Albert Hall in South Kensington wurde mit der Absicht errichtet, Prinz Alberts Vision einer Konzerthalle zur Förderung der Künste und Wissenschaften Wirklichkeit werden zu lassen. Ursprünglich sollte sie „Central Hall of Arts and Sciences" heißen, doch nach der Fertigstellung entschied Königin Victoria, das Gebäude nach Ihrem mittlerweile verstorbenen Ehemann zu benennen. Das seit seiner Eröffnung 1871 durchgehend genutzte Gebäude dient nicht nur als Spielstätte für Opernproduktionen, Ballettaufführungen und Rockkonzerte, sondern auch als Veranstaltungsort für Konferenzen, Ausstellungen und Preisverleihungen.

Le Royal Albert Hall, situé dans Kensington sud, a été construit pour donner corps à la vision du Prince Albert d'une salle dédiée à la promotion des arts et des sciences. L'édifice devait initialement s'appeler le Central Hall of Arts and Sciences, mais en cours de construction, la Reine Victoria a décidé de lui donner le nom de son époux, alors décédé. Outre des opéras, des ballets et des concerts de rock, l'édifice accueille également des congrès, des expositions et autres cérémonies de remise de prix, et n'a jamais fermé ses portes depuis son inauguration en 1871.

El Royal Albert Hall, situado en South Kensington, se construyó para hacer realidad la visión del Príncipe Alberto de tener un teatro que se utilizara para fomentar las artes y las ciencias. Se iba a llamar Central Hall of Arts and Sciences, pero al finalizar su construcción, la reina Victoria decidió bautizarlo con el nombre de su esposo, que había fallecido para entonces. Además de celebrar espectáculos de ópera, ballet y conciertos de rock, el edificio ha sido sede de reuniones, exposiciones y ceremonias. Ha estado en uso de forma continuada desde su apertura en 1871.

Royal Opera House
Capacity 2,256

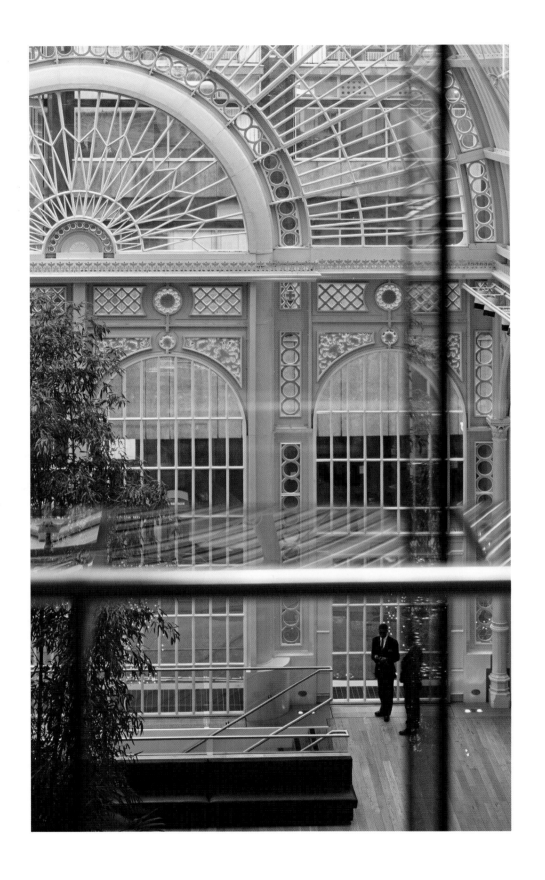

London, England
E.M. Barry, 1858

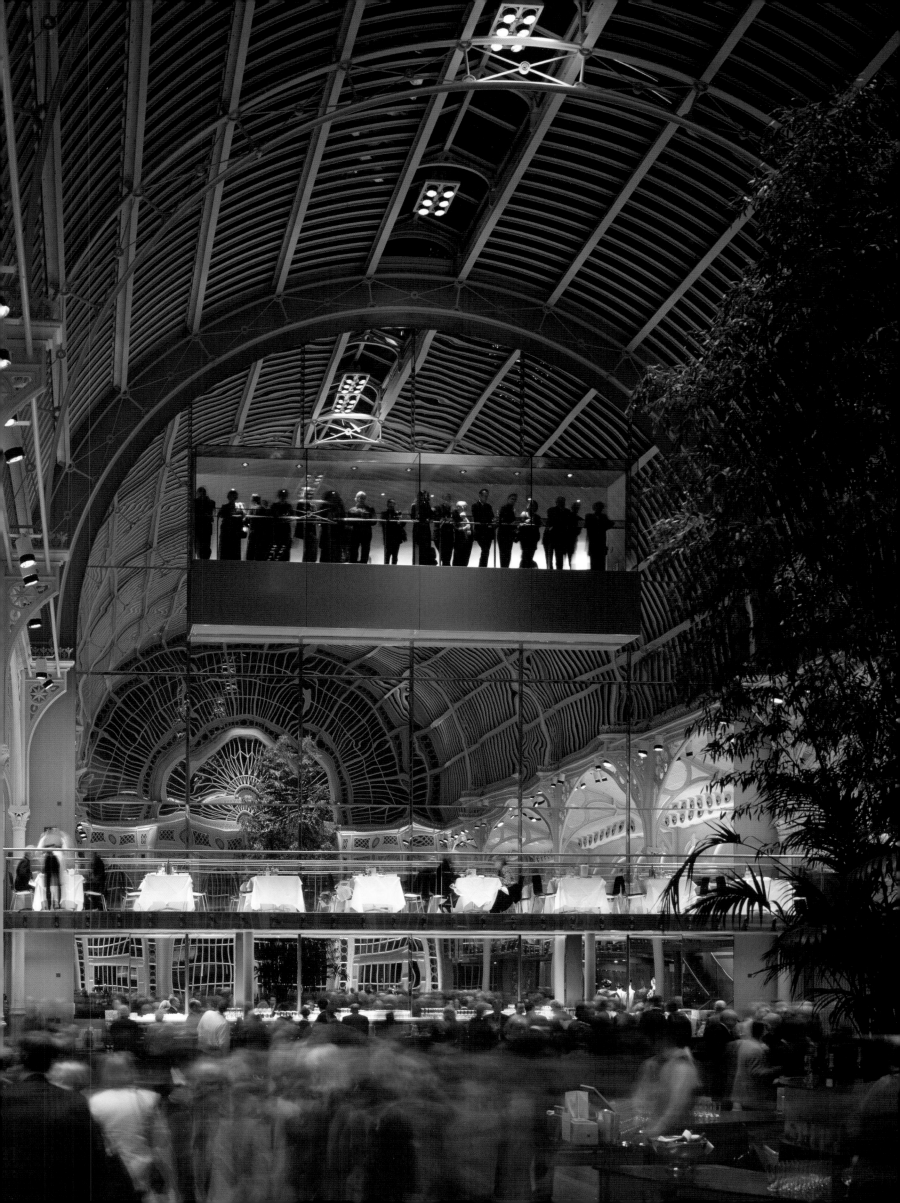

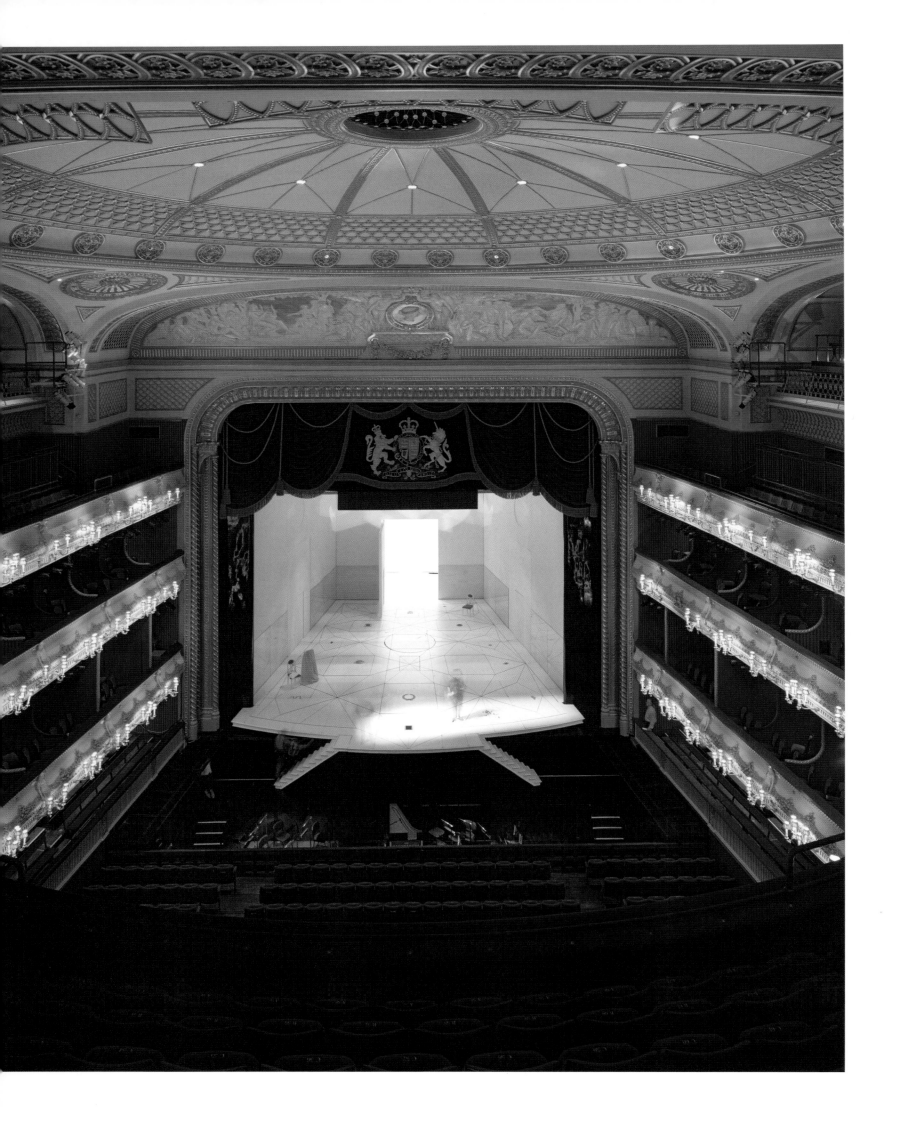

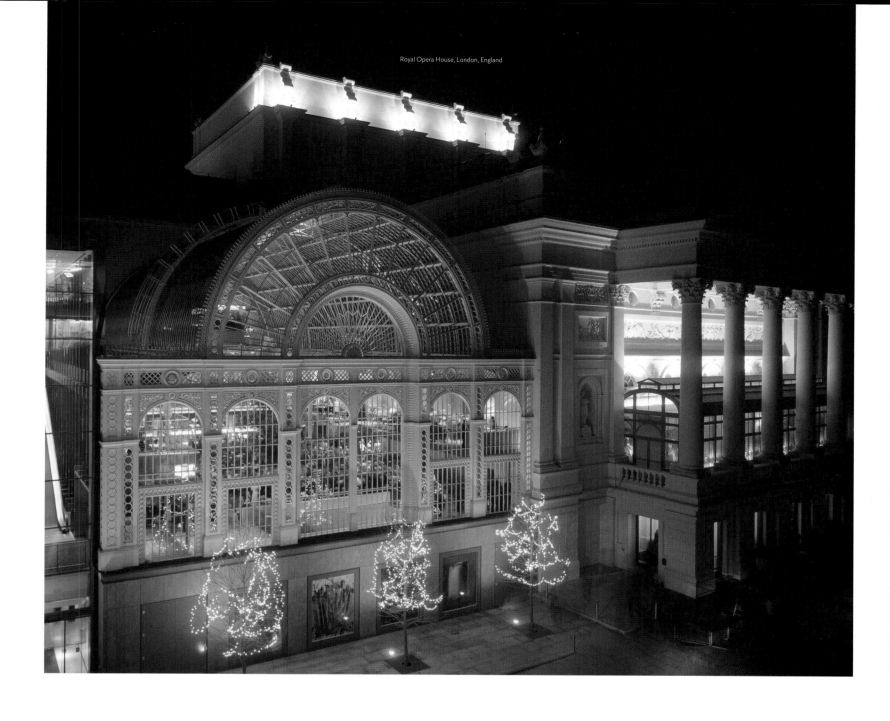

Royal Opera House, London, England

The building that currently stands in Covent Garden is the third theatre on the site, the others being destroyed by fires. It was designed by E.M. Barry, son of Charles Barry, who was the architect for the Palace of Westminster. During the Second World War, it served as a dancehall for servicemen, until it reopened in 1946 with a production of Tchaikovsky's *Sleeping Beauty*. An extensive reconstruction took place during the 1990s, which allowed for much more public space, a new theatre, and improvements to the rehearsal and office spaces.

Das heutzutage auch unter der Bezeichnung des gleichnamigen Stadtviertels als Covent Garden bekannte Gebäude ist bereits das dritte Theater, das an dieser Stelle steht. Seine beiden Vorgänger fielen Feuerkatastrophen zum Opfer. Das Opernhaus wurde von E.M. Barry entworfen, dem Sohn Charles Barrys, der als Architekt des Westminster-Palastes bekannt ist. Während des Zweiten Weltkrieges diente es Soldaten als Veranstaltungsort für Tanztees, bis es schließlich 1946 mit einer Aufführung von Tschaikowskys *Dornröschen* als Oper wiedereröffnet wurde. In den 1990er-Jahren wurde das Opernhaus einer umfassenden Sanierung unterzogen, in deren Rahmen der Publikumsraum vergrößert, ein neuer Vorführungssaal geschaffen und Verbesserungen im Proben- und Bürobereich vorgenommen wurden.

L'édifice qui se dresse aujourd'hui dans Covent Garden est en réalité le troisième théâtre sur cet emplacement, les deux premiers ayant été détruits par des incendies. Il a été conçu par E.M. Barry, fils de Charles Barry, architecte attitré du Palais de Westminster. Réquisitionné par les militaires pendant la Seconde Guerre mondiale, qui en firent une salle de danse, le théâtre a rouvert ses portes en 1946 avec la représentation de *la Belle au bois dormant* de Tchaïkovski. D'importants travaux de rénovation ont été entrepris dans les années 90 pour aménager davantage d'espace public, ainsi qu'un nouveau théâtre, et pour optimiser les espaces de répétition et de bureau.

El edificio, que se encuentra actualmente en Covent Garden, es el tercer teatro que ha habido en este mismo emplazamiento, ya que los demás fueron destruidos por el fuego. Fue diseñado por E.M. Barry, hijo de Charles Barry, el arquitecto del Palacio de Westminster. Durante la Segunda Guerra Mundial, sirvió de sala de baile para los soldados, hasta que se abrió al público de nuevo en 1946 con una producción de *La Bella Durmiente* de Chaikovski. Durante la década de 1990, se procedió a una amplia reconstrucción, lo que permitió que se enriqueciera con un mayor espacio público, un nuevo teatro y mejoras en las zonas de oficinas y de ensayos.

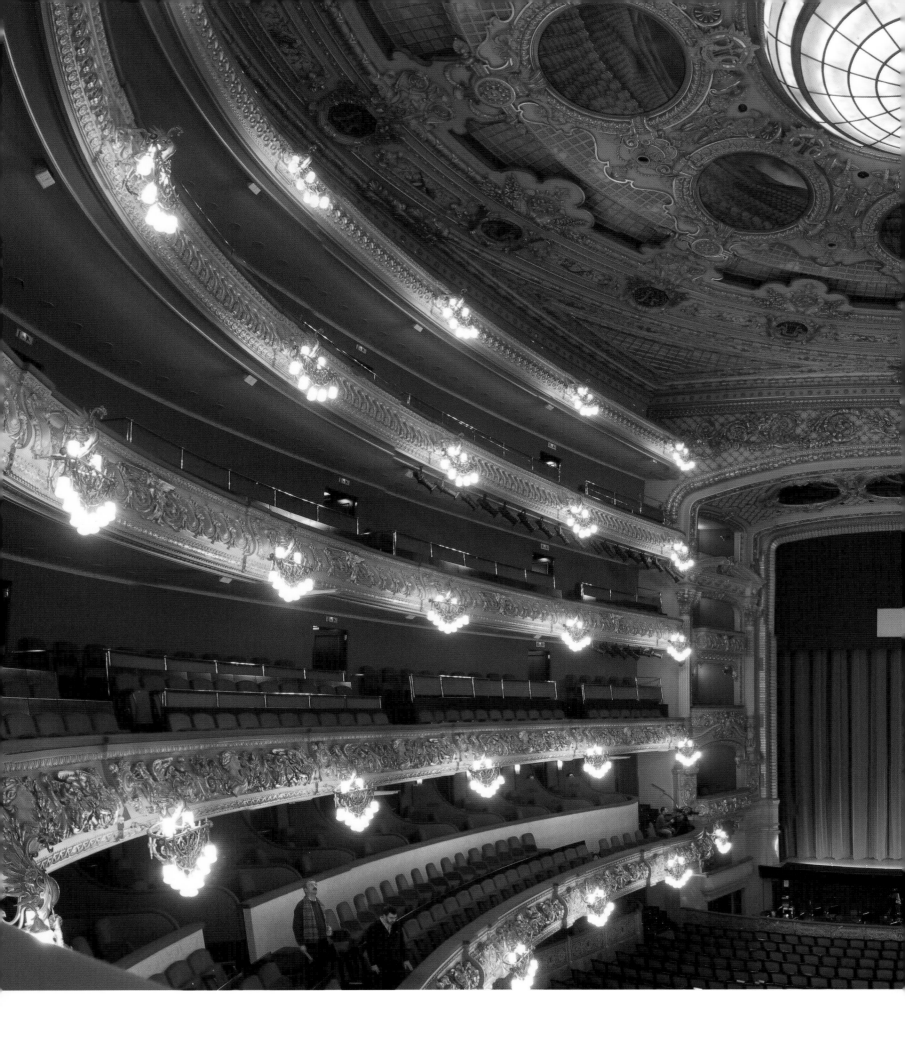

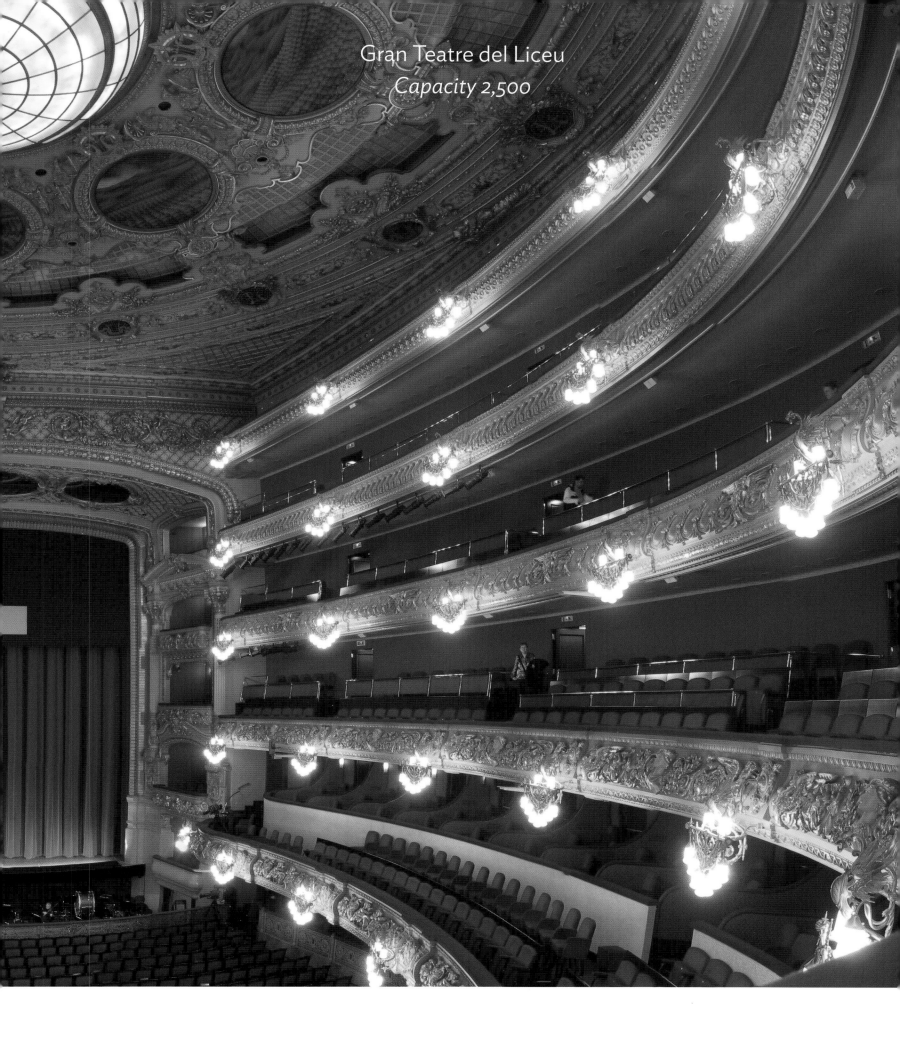

Gran Teatre del Liceu
Capacity 2,500

Barcelona, Spain
Miquel Garriga i Roca & Josep Oriol Mestres, 1847

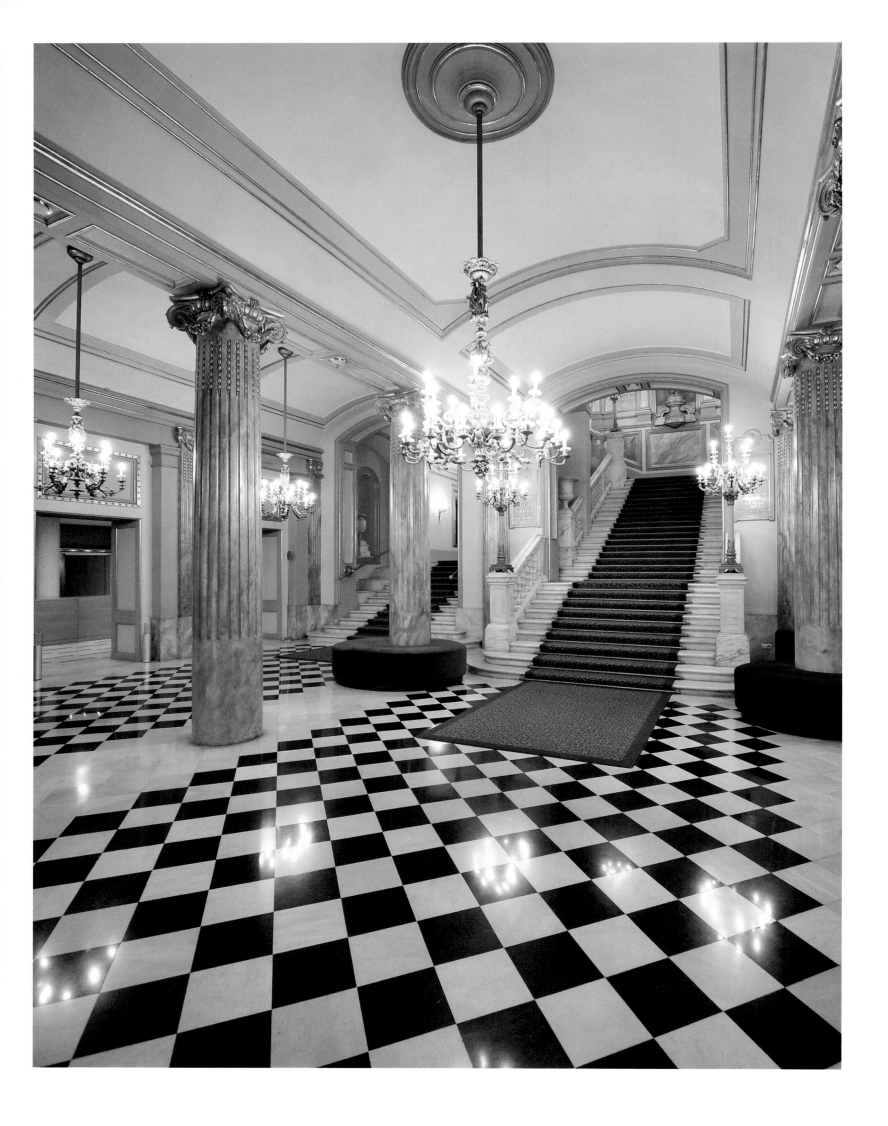

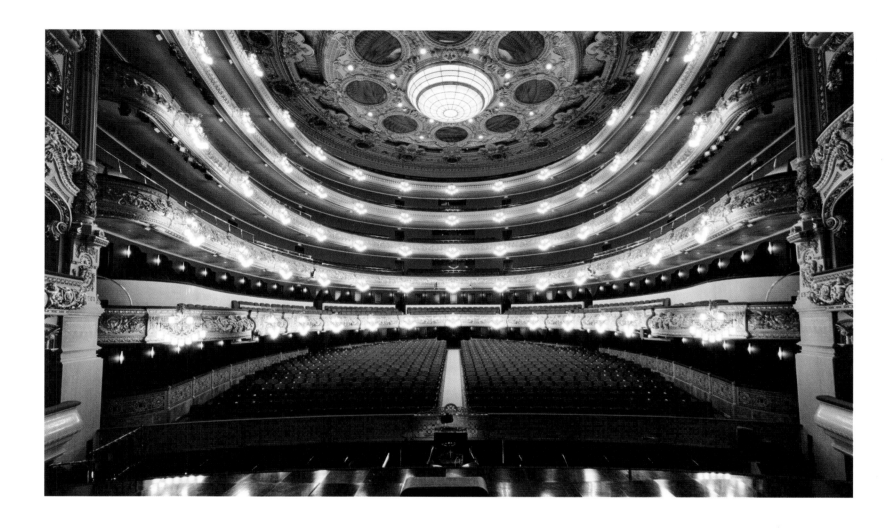

Facing onto the prestigious Ramblas, the Liceu is an important symbol of Barcelona. Unlike many contemporaneous theatres, its creation was thanks to contributions from private shareholders, rather than the monarchy. Its entire history has been plagued by the outbreak of fire. In 1994, a small spark from a routine repair caused flames to engulf the building; it remained closed until 1999, while it was being restored to its former glory.

Das unmittelbar an den prestigeträchtigen Ramblas gelegene Gran Teatre del Liceu gehört zu den bedeutendsten Symbolen Barcelonas. Anders als viele zeitgenössische Theater verdankt sich seine Errichtung der Unterstützung privater Gesellschafter und nicht etwa der Monarchie. Sein gesamtes bisheriges Bestehen stand im Zeichen des Feuers: Im Jahr 1994 entfachte ein kleiner, durch routinemäßige Reparaturmaßnahmen ausgelöster Funke einen Brand, der das gesamte Gebäude erfasste; erst 1999 wurde es, zu alter Pracht zurückgekehrt, wiedereröffnet.

Face à la prestigieuse avenue de La Rambla, le Liceu est un lieu emblématique de Barcelone. À la différence de nombreux théâtres de la même époque dont la construction était assurée par la monarchie, l'édification du Liceu a été rendue possible grâce aux contributions d'actionnaires particuliers. Plusieurs départs d'incendies ont marqué les annales du théâtre. En 1994, quelques étincelles dues à une réparation courante ont embrasé l'ensemble du bâtiment qui est resté fermé jusqu'en 1999, le temps d'être restauré à la hauteur de son faste d'antan.

Situado frente a las célebres Ramblas, el Liceo constituye todo un símbolo de la ciudad de Barcelona. A diferencia de muchos teatros contemporáneos, su creación se financió con contribuciones de accionistas privados y no de la realeza. Durante toda su historia ha sufrido el azote de los incendios. En 1994, una pequeña chispa, mientras se efectuaban unas reparaciones rutinarias, provocó unas llamas que se extendieron a todo el edificio. Permaneció cerrado hasta 1999, cuando recuperó su antiguo y glorioso aspecto.

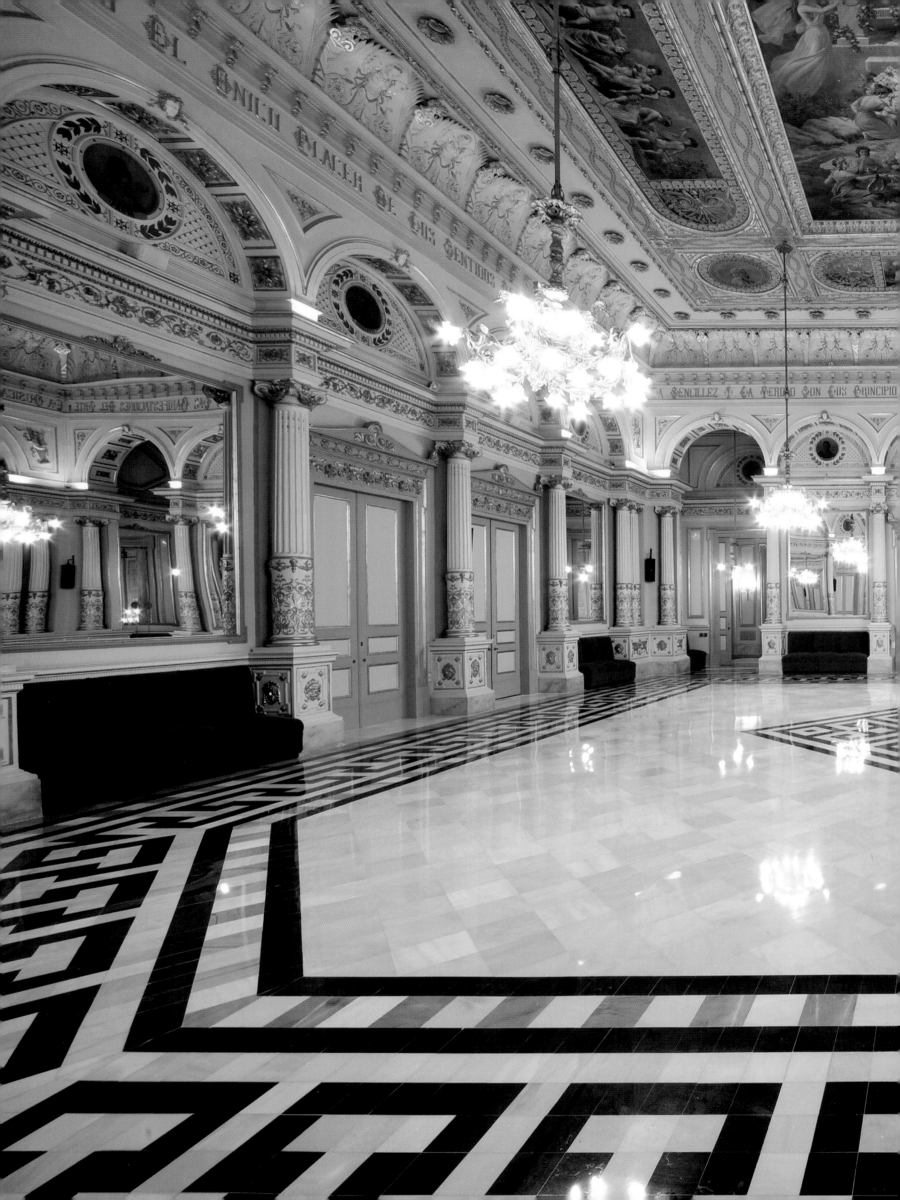

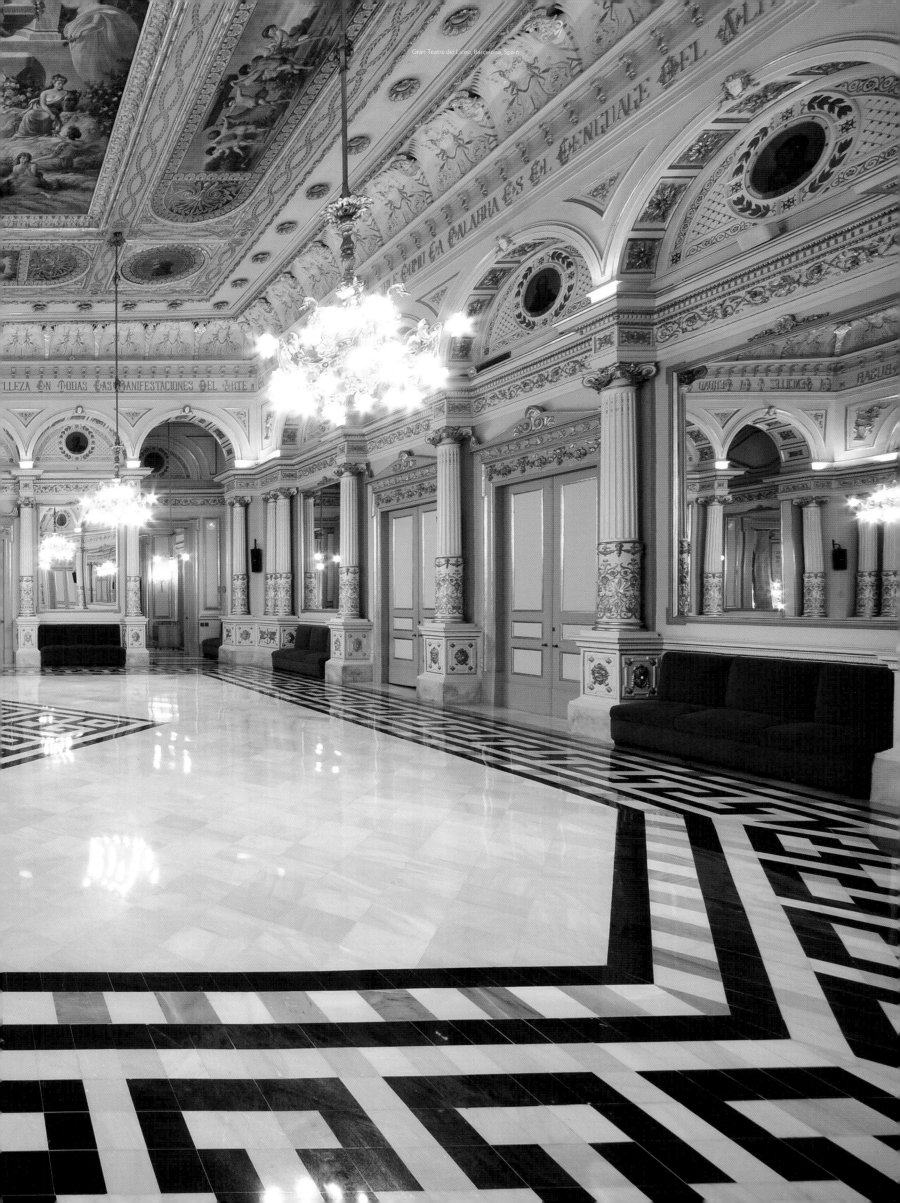

Palau de la Música Catalana
Capacity 2,200

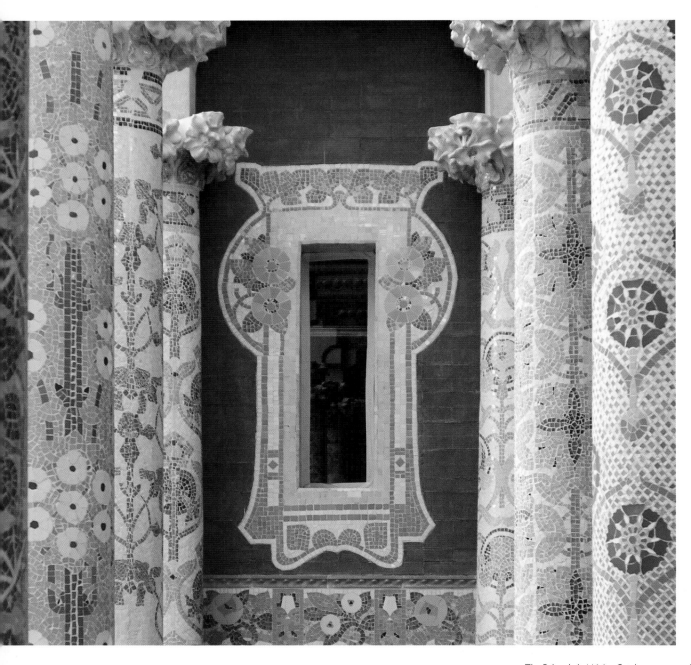

The Palau de la Música Catalana was listed as a UNESCO World Heritage Site in 1997. Along with Antoni Gaudí's buildings, it is one of the highlights of renowned Catalan *modernista* architecture in Barcelona, which is characterised by a preference for curves over straight lines, and rich detail, often involving floral and other organic motifs. It is home to the Orfeó Català, a choral society founded in 1891, and has hosted many of the world's most famous singers.

Der Palau de la Música Catalana wurde 1997 in die Liste des UNESCO-Weltkulturerbes aufgenommen. Zusammen mit den Bauwerken Antoni Gaudís verkörpert er einen der Höhepunkte der berühmten katalanischen *modernista*-Architektur in Barcelona. Diese Strömung bevorzugt geschwungene gegenüber geraden Linien und stellt, oftmals unter Verwendung floraler oder anderer organischer Motive, reichhaltige Details zur Schau. Der Palau de la Música ist die Heimstatt des 1891 gegründeten Chorvereins Orfeó Català und erlebte bereits zahlreiche Auftritte weltberühmter Sänger.

Barcelona, Spain
Lluís Domènech i Montaner, 1908

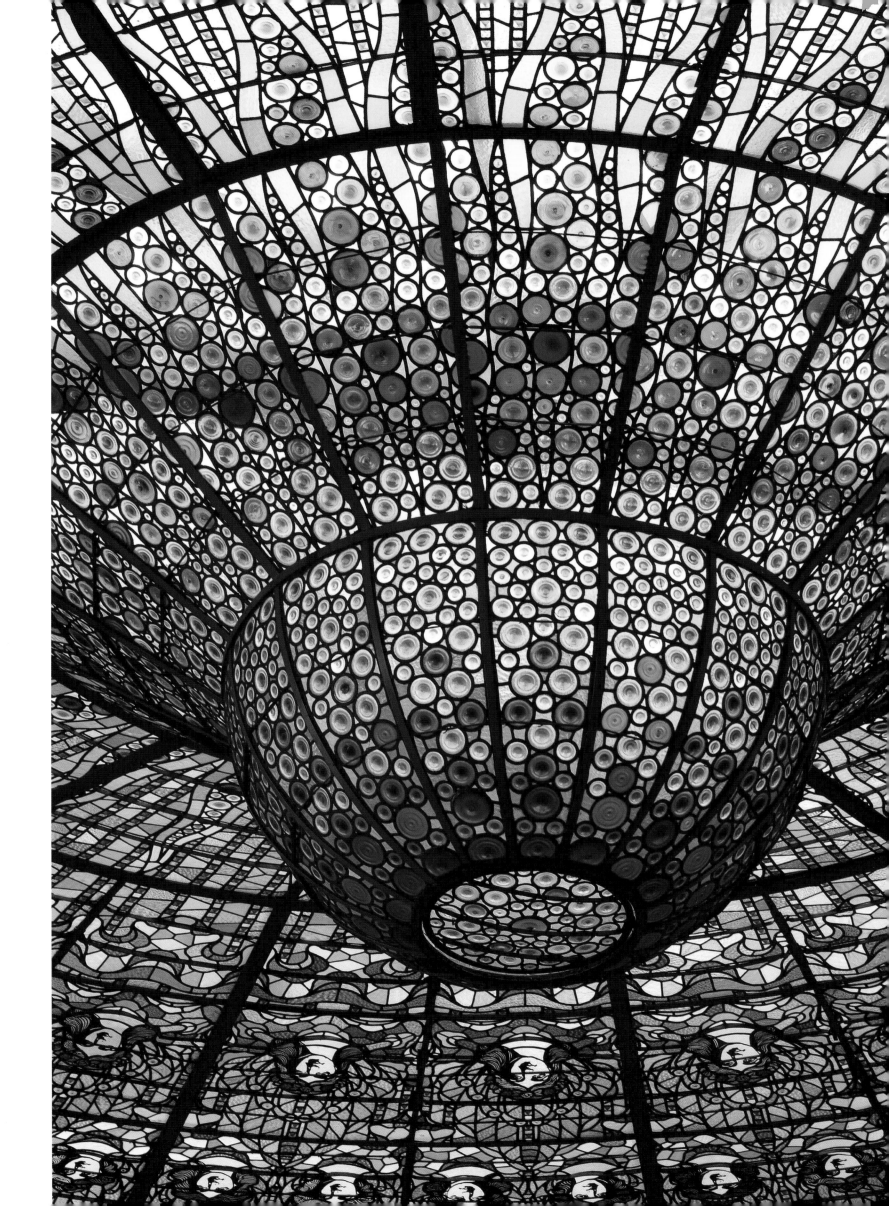

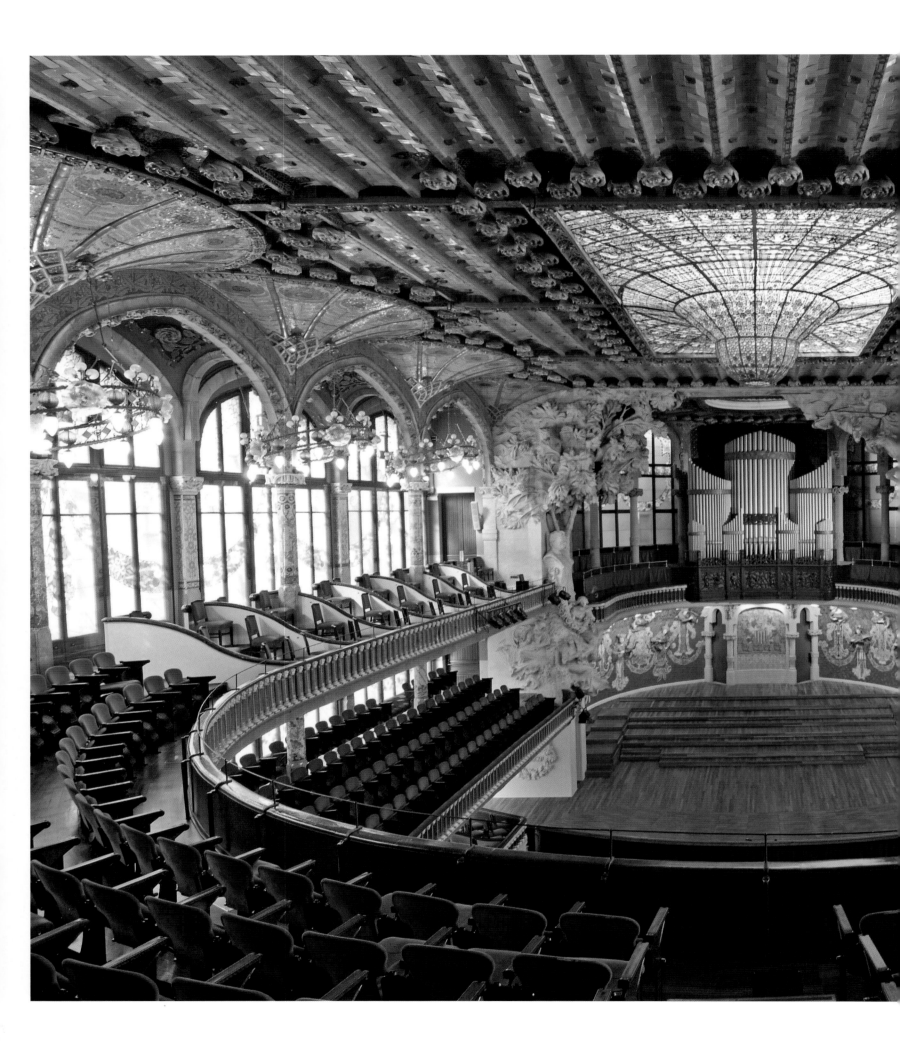

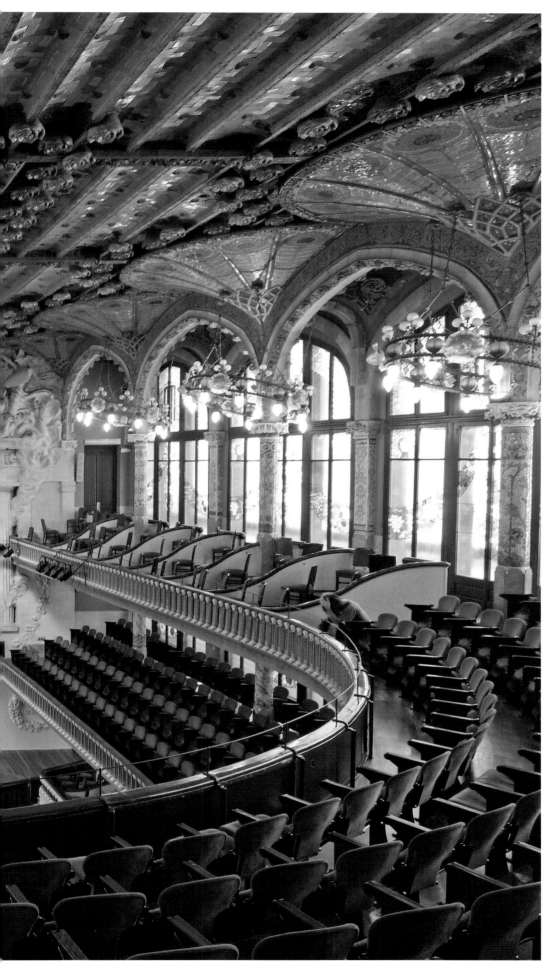

Le Palau de la Música Catalana a été inscrit au Centre du patrimoine mondial de l'UNESCO en 1997. Avec les réalisations d'Antoni Gaudí, le Palais est l'un des monuments emblématiques du célèbre *Modernisme* architectural catalan de Barcelone, qui se caractérise par des courbes, préférées aux lignes droites, et des détails recherchés aux motifs souvent floraux et organiques. La société chorale Orfeó Català, fondée en 1891, a pris résidence au Palais qui accueille de nombreux interprètes parmi les plus célèbres au monde.

El Palau de la Música Catalana fue declarada por la UNESCO Patrimonio de la Humanidad en 1997. Junto con los edificios de Antoni Gaudí, constituye uno de los hitos de la célebre arquitectura modernista catalana de Barcelona, que se caracteriza por una preferencia de las líneas curvas sobre las rectas y por una infinidad de detalles, a menudo con motivos florales y otros de tipo orgánico. Es la sede del Orfeó Català, una asociación coral fundada en 1891, y ha recibido igualmente a muchos de los cantantes más famosos del mundo.

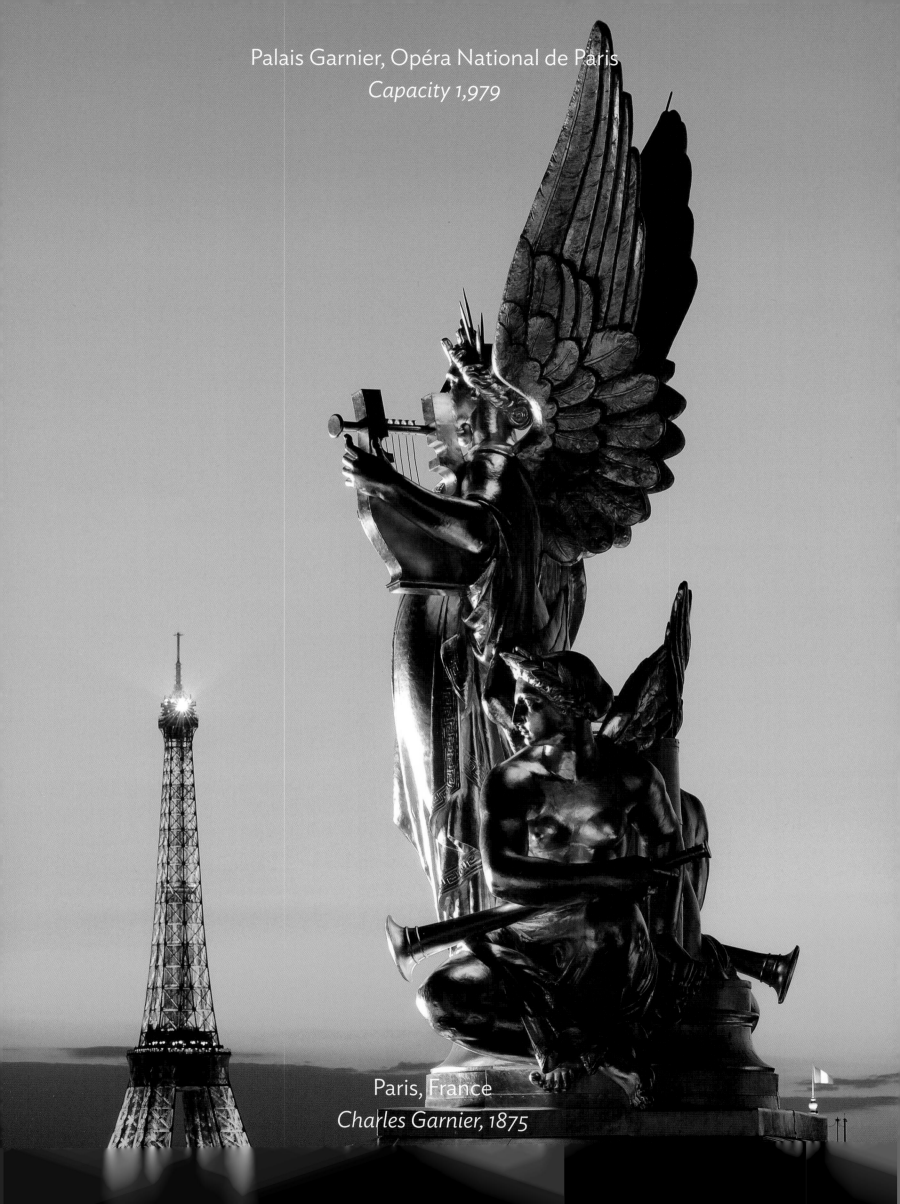

Palais Garnier, Opéra National de Paris
Capacity 1,979

Paris, France
Charles Garnier, 1875

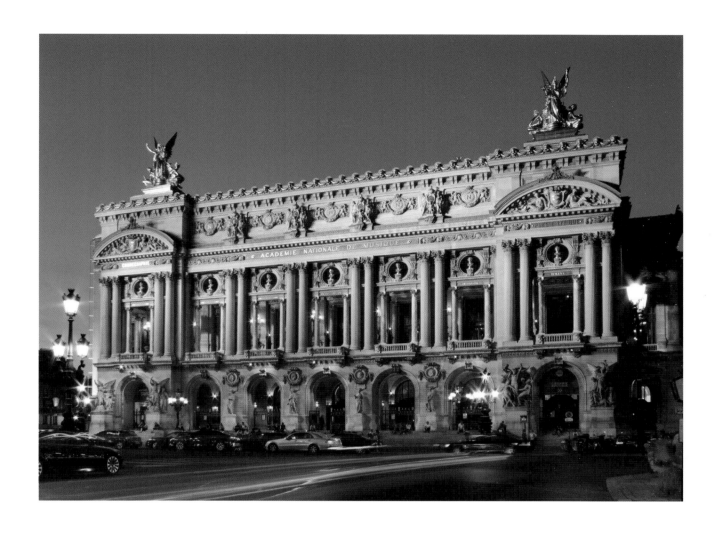

In a city filled with architectural marvels, the Palais Garnier has remained a symbol of the French capital, owing to its rich and opulent decor, which epitomises the grandeur of mid-nineteenth-century French architecture. The construction of the famous Palais Garnier, which took fifteen years, was briefly interrupted by the Paris Commune, when the theatre was used as a prison during the Siege of Paris. The interior has remained mostly unchanged, except for the addition of a Marc Chagall fresco in the centre of the ceiling in 1962.

Dem Palais Garnier ist es selbst in einer Stadt voller architektonischer Juwelen wie Paris gelungen, nach wie vor als Symbol der französischen Hauptstadt angesehen zu werden. Dies verdankt sich seiner üppigen und opulenten Ausstattung, welche die Größe und Bedeutung der französischen Architektur in der Mitte des neunzehnten Jahrhunderts verkörpert. Die fünfzehn Jahre dauernde Errichtung des berühmten Palais Garnier wurde kurz durch die Pariser Kommune unterbrochen, als das Theater im Zuge der Belagerung von Paris vorübergehend als Gefängnis genutzt wurde. Der Innenraum ist größtenteils unverändert erhalten, mit Ausnahme der 1962 in die Kuppel des Zuschauerraums hinzugefügten Fresken Mark Chagalls.

Dans une ville qui regorge de trésors architecturaux, le Palais Garnier reste un des symboles de la capitale française, avec ses décors somptueux et opulents, emblématiques de la grandeur architecturale française de la deuxième moitié du dix-neuvième siècle. La construction du célèbre Palais Garnier, qui a duré quinze ans, a été interrompue pendant la Commune de Paris, épisode durant lequel le Palais a servi de prison lors du Siège de Paris. L'intérieur du palais est resté en grande partie le même, à l'exception de la fresque de Marc Chagall rajoutée au centre du plafond en 1962.

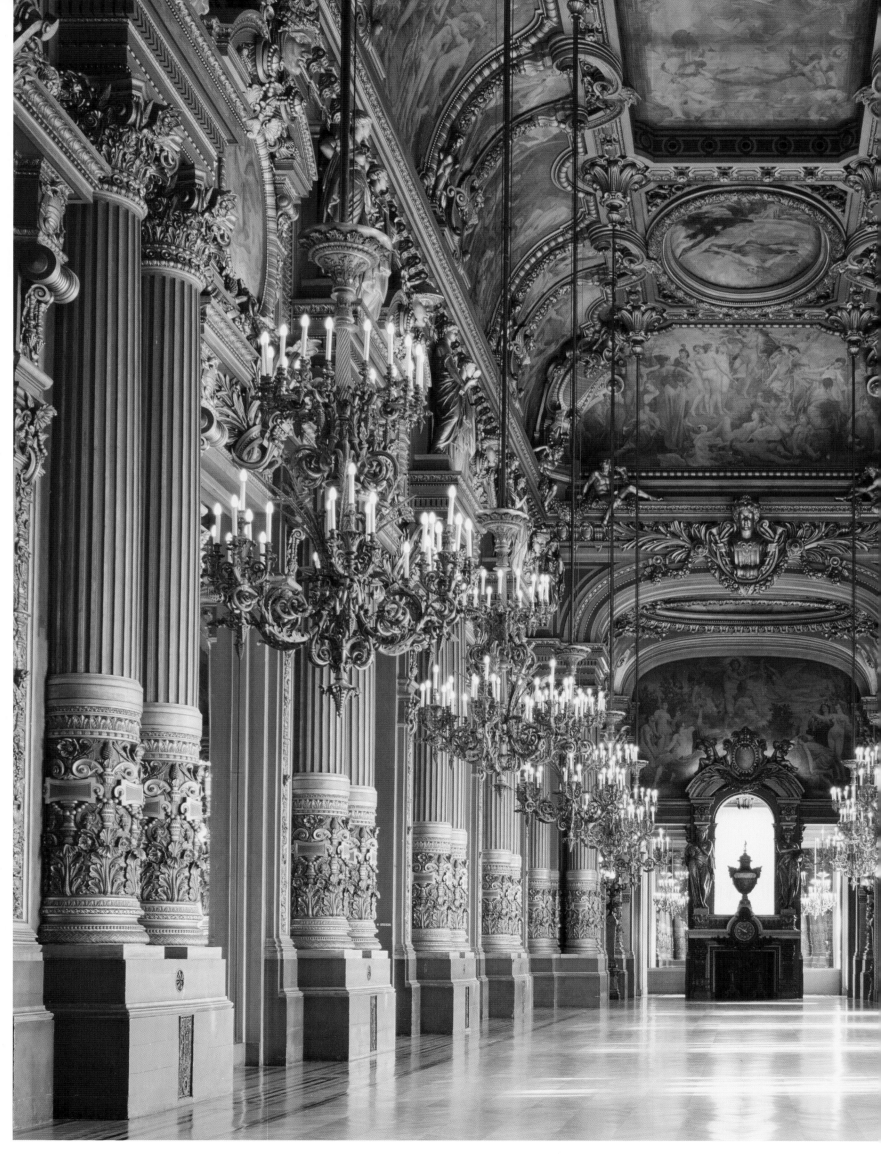

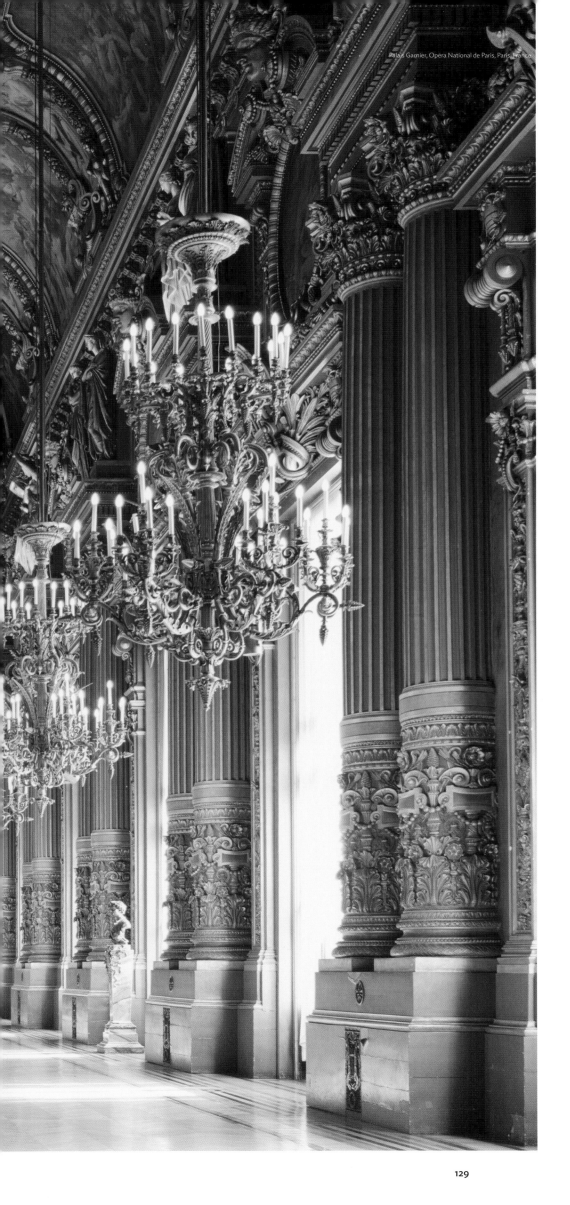

Palais Garnier, Opéra National de Paris, Paris, France

En una ciudad repleta de maravillas arquitectónicas, el Palais Garnier sigue siendo un símbolo de la capital francesa, debido a su suntuosa y opulenta decoración, que personifica la grandiosidad de la arquitectura francesa de mediados del siglo XIX. La construcción del célebre Palais Garnier, que se prolongó durante quince años, sufrió una breve interrupción durante la Comuna de París, cuando el teatro se utilizó como prisión en el Asedio de París. Su interior se ha conservado prácticamente sin alteraciones, excepto por el fresco de Marc Chagall en la parte central de la bóveda, que se añadió en 1962.

Theatre Agora
Capacity 925

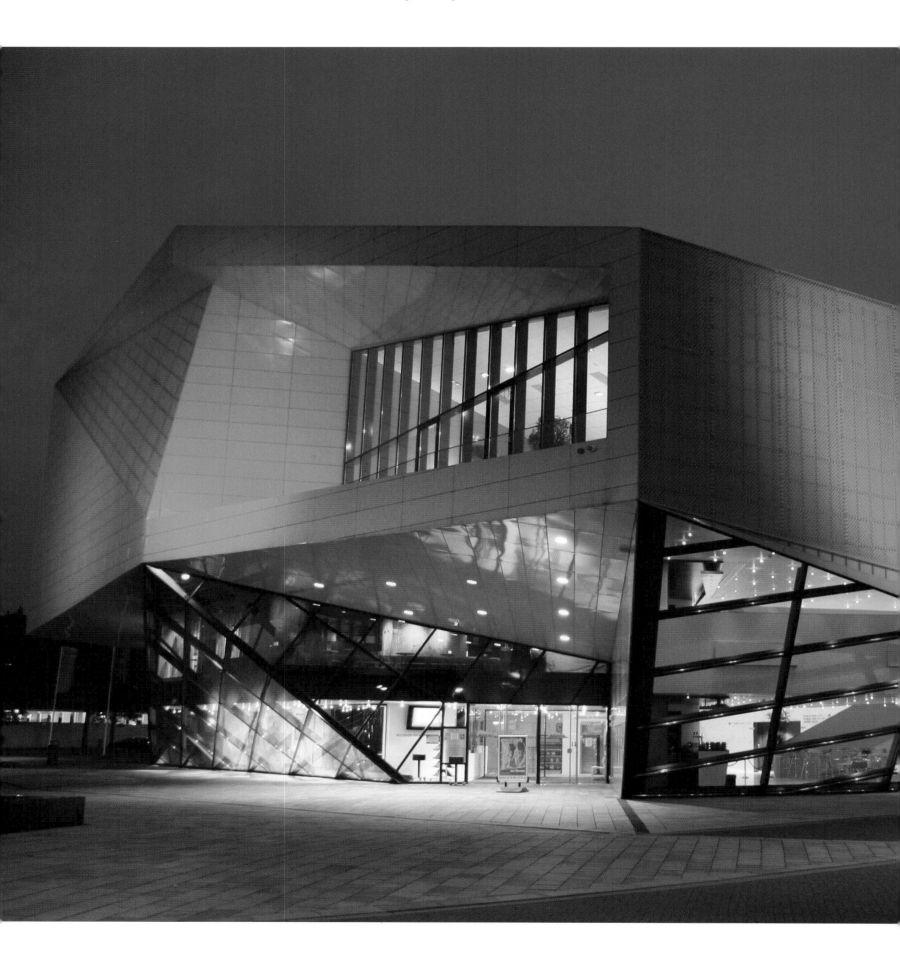

Lelystad, The Netherlands
UN Studio, 2007

Perhaps the most striking feature of this theatre is the brave and dramatic use of colour, with a bright orange exterior, lilac interiors and a red-walled auditorium. When paired with the sharp angles and jutting walls, the Theatre Agora is certainly a brave architectural statement. The construction of the theatre was just one element of a larger plan for Lelystad, which aimed to revitalise the town centre and cluster together a number of buildings to create a cultural area in the town.

Das vielleicht auffälligste Merkmal dieses Theaters ist wohl seine gewagte und effektvolle farbliche Gestaltung, die durch ein Exterieur in leuchtendem Orange, fliederfarbene Interieurs und einem von roten Wänden gerahmten Auditorium besticht. In Verbindung mit seinen zahlreichen spitzen Winkeln und auskragenden Wänden sendet das Agora-Theater so zweifelsfrei eine mutige architektonische Botschaft. Die Errichtung des Theaters ist dabei aber nur ein Element eines größeren Plans für Lelystad, mit dessen Hilfe die Innenstadt wiederbelebt und mehrere Gebäude zu einem urbanen Kulturbezirk zusammengefasst werden sollten.

La caractéristique sans doute la plus frappante de cet édifice réside dans son jeu de couleurs, aussi audacieux que spectaculaire : revêtement extérieur dans des teintes orangées vives, intérieurs lilas, auditorium aux murs rouges. Tout en angles aigus et en facettes saillantes, nul doute que le Théâtre Agora dénote un choix architectural particulièrement ambitieux. La construction de ce théâtre n'est qu'une des pierres d'un projet d'urbanisme plus vaste visant à revitaliser le centre-ville de Lelystad et à regrouper un certain nombre de bâtiments pour aménager un véritable espace urbain dédié à la culture.

La característica más llamativa de este teatro sea quizá el uso soberbio y espectacular del color, con un exterior naranja brillante, interiores de color lila y un auditorio de paredes rojas. Al combinarlo con unos ángulos marcados y paredes prominentes, el Teatro Agora constituye, no cabe duda, una atrevida afirmación arquitectónica. La construcción del teatro no fue sino un elemento más de un amplio plan para Lelystad, cuyo objetivo era revitalizar el centro ciudad y agrupar algunos edificios con idea de crear un área cultural en la ciudad.

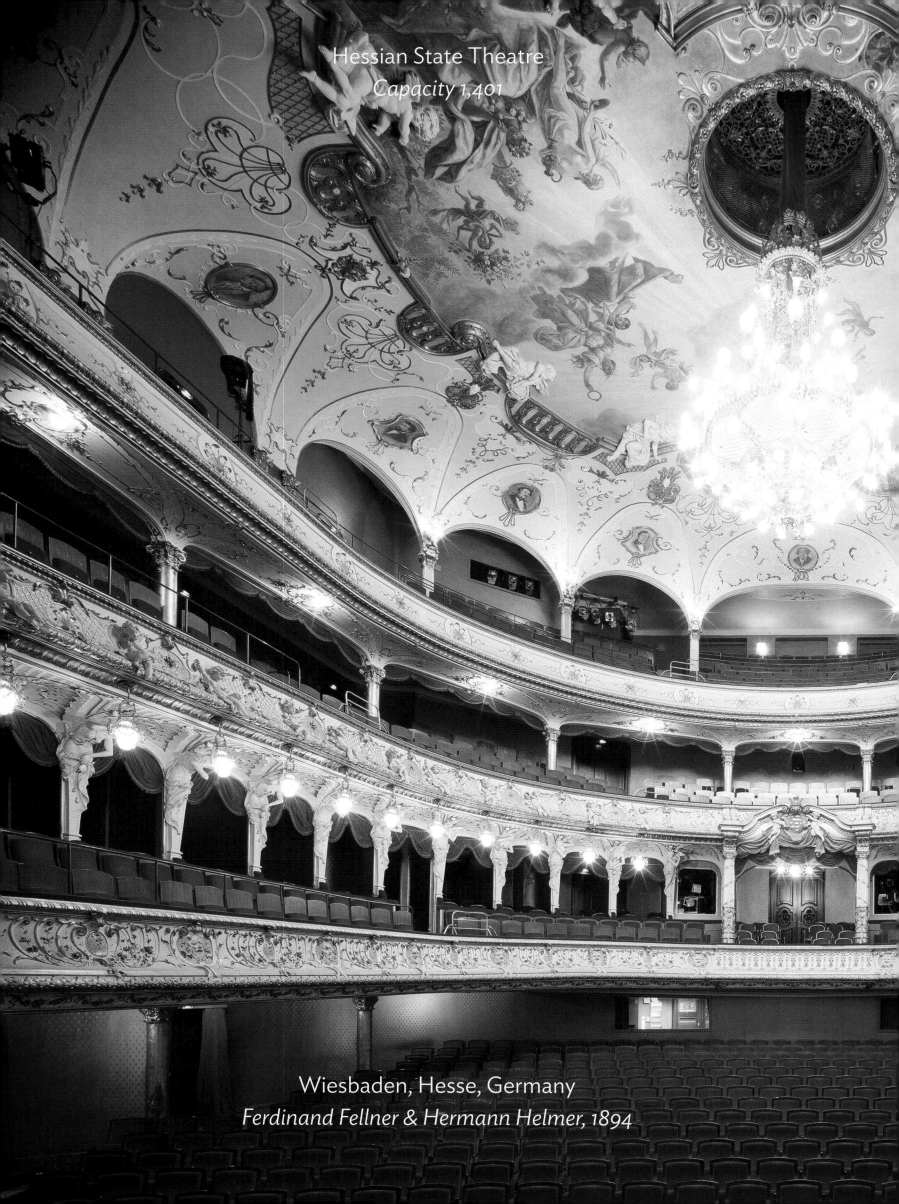

Hessian State Theatre
Capacity 1,401

Wiesbaden, Hesse, Germany
Ferdinand Fellner & Hermann Helmer, 1894

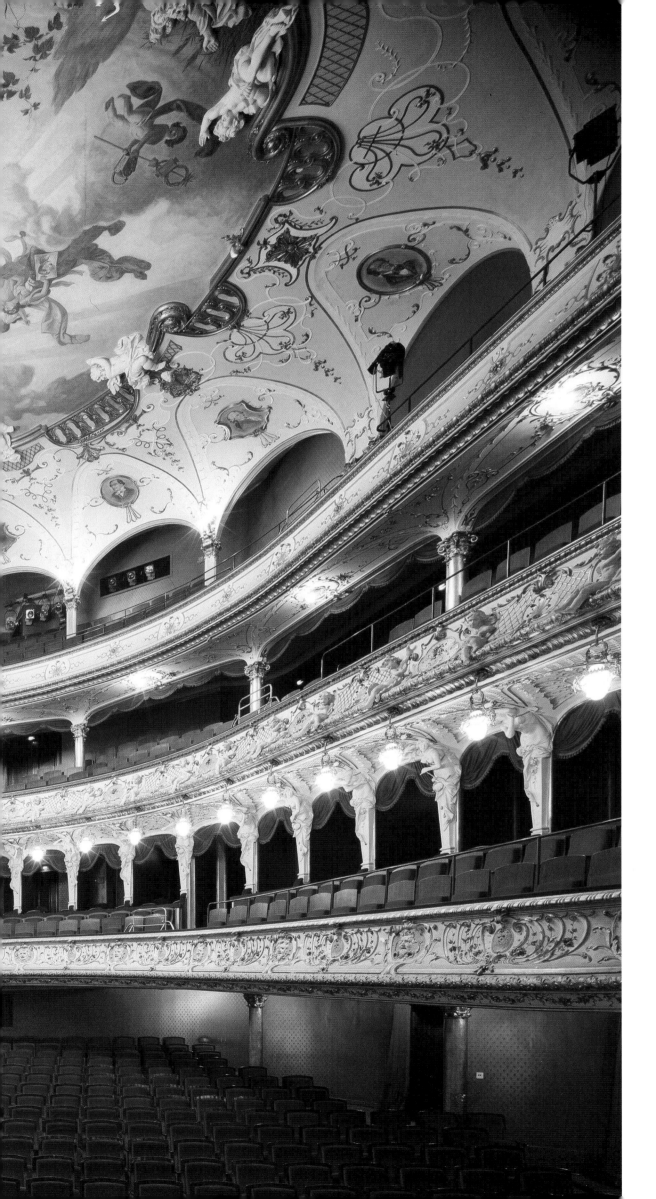

Situated in south-west Germany, the capital of the state of Hesse, Wiesbaden dates back to the Roman era, when the settlement was famous for its thermal springs. The Hessian State Theatre was built at the behest of Kaiser Wilhelm II, who regularly visited these famous spas. In 1892, the renowned Viennese architects Fellner and Helmer began work on the graceful neo-Baroque auditorium. The opulent neo-Rococo foyer was later added in 1902. The building was seriously damaged by a bomb on 3 February 1945, after which the façade was restored in a simplified way. The theatre hosts the annual International May Festival, which began in 1896.

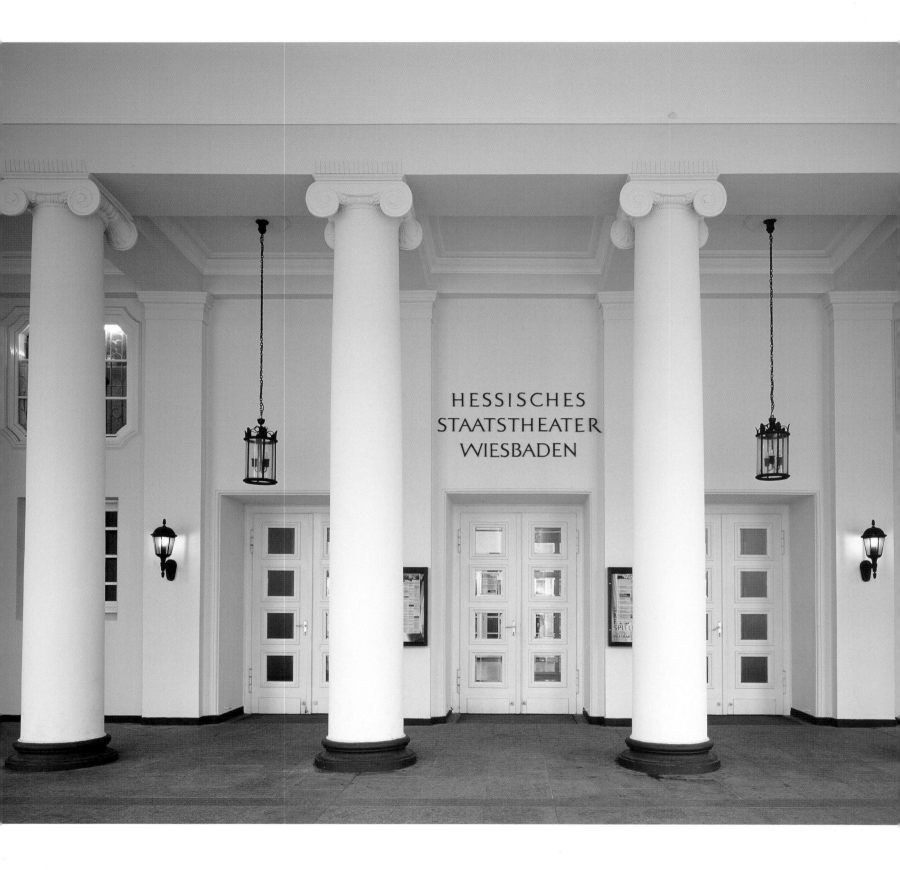

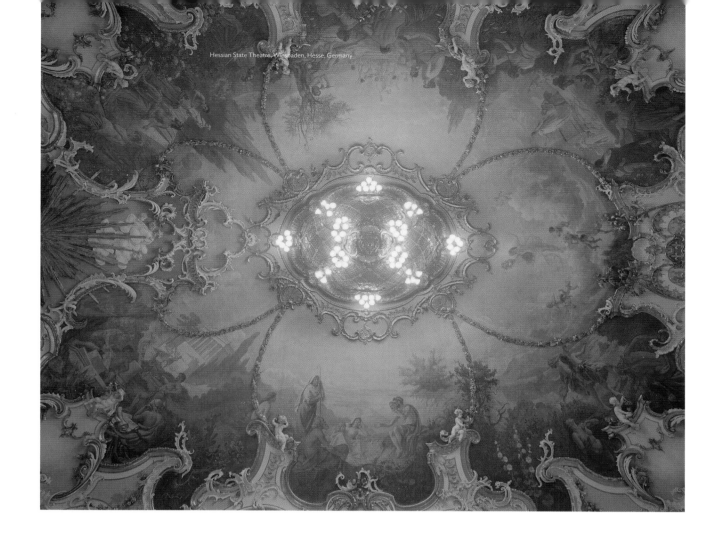

Hessian State Theatre, Wiesbaden, Hesse, Germany

Wiesbaden, die im Südwesten Deutschlands gelegene Hauptstadt des Bundeslandes Hessen, war bereits als Siedlung in römischer Zeit für seine Thermalquellen bekannt. Das Hessische Staatstheater wurde auf Geheiß Kaiser Wilhelm II. erbaut, der regelmäßig Gast in den berühmten Bädern war. Im Jahr 1892 erfolgte unter den renommierten Wiener Architekten Fellner d. J. und Helmer der Spatenstich zum anmutigen neobarocken Auditorium. Das opulente Foyer im Stil des Neorokoko wurde erst 1902 realisiert. Am 3. Februar 1945 wurde das Gebäude durch einen Bombentreffer schwer beschädigt und die Fassade danach in einer schlichteren Form wiedererrichtet. Im Staatstheater Wiesbaden finden seit 1896 alljährlich die Internationalen Maifestspiele statt.

Dans le sud-ouest de l'Allemagne, la capitale du Land de la Hesse, Wiesbaden, date de l'époque romaine. La colonie d'alors était déjà prisée pour ses sources thermales. Le Théâtre de la Hesse fut construit sous l'impulsion de l'empereur Guillaume II d'Allemagne, qui se rendait régulièrement dans les thermes de la ville. En 1892, les célèbres architectes viennois Fellner et Helmer ont débuté le travail sur l'élégante salle de style néobaroque. L'opulente salle de style néo-rococo ne fut ajoutée que plus tard, en 1902. Gravement endommagée à la suite d'un bombardement le 3 février 1945, la façade de l'édifice a été depuis restaurée dans un style plus épuré. Le théâtre accueille chaque année l'*International May Festival* (festival international de théâtre du mois de mai), inauguré en 1896.

Situada en el suroeste de Alemania, Wiesbaden, la capital del estado de Hesse, data del período romano, época en la que esta población ya era conocida por sus aguas termales. El Teatro Estatal de Hesse se construyó a instancias del Káiser Guillermo II que solía visitar con asiduidad estos famosos balnearios. En 1892, los célebres arquitectos vieneses Fellner y Helmer comenzaron con las obras del elegante auditorio neobarroco. El opulento foyer neorrococó fue añadido posteriormente en 1902. El edificio sufrió graves daños debido a una bomba caída el 3 de febrero de 1945, tras lo cual se restauró la fachada de un modo más sencillo. En este teatro se celebra anualmente el Festival Internacional de Mayo, que inició su andadura en 1896.

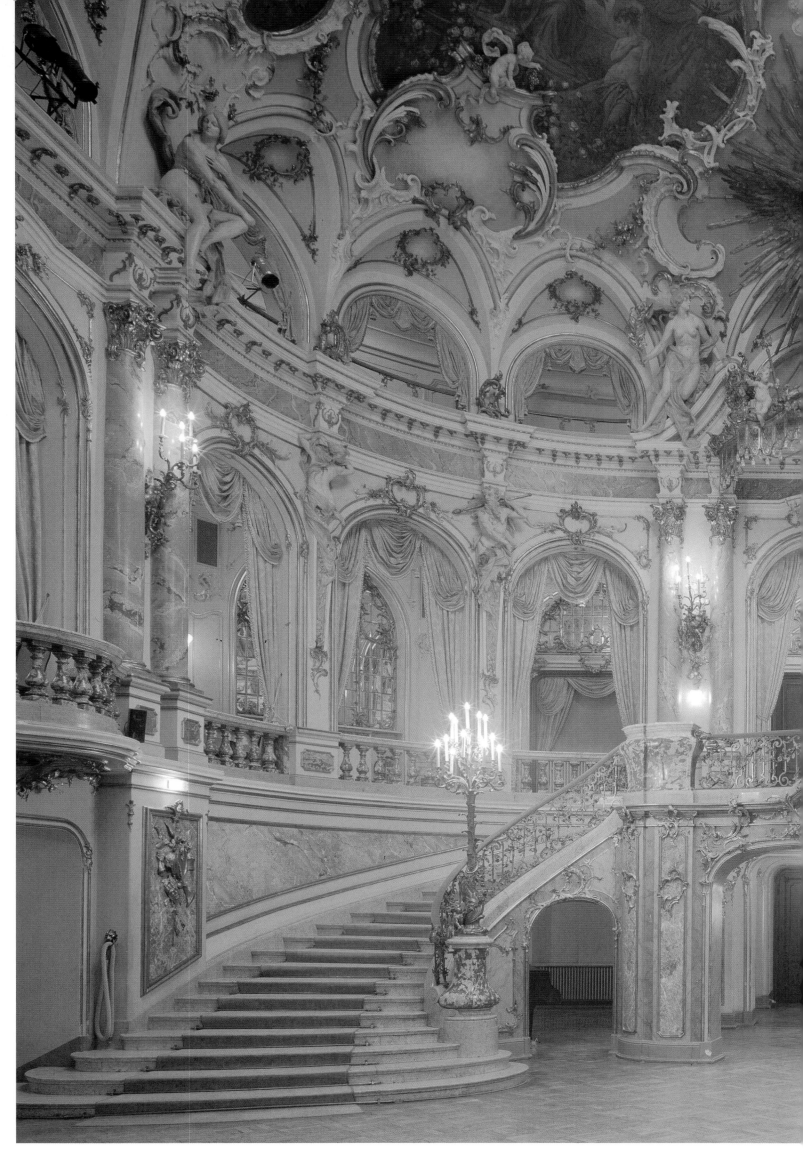

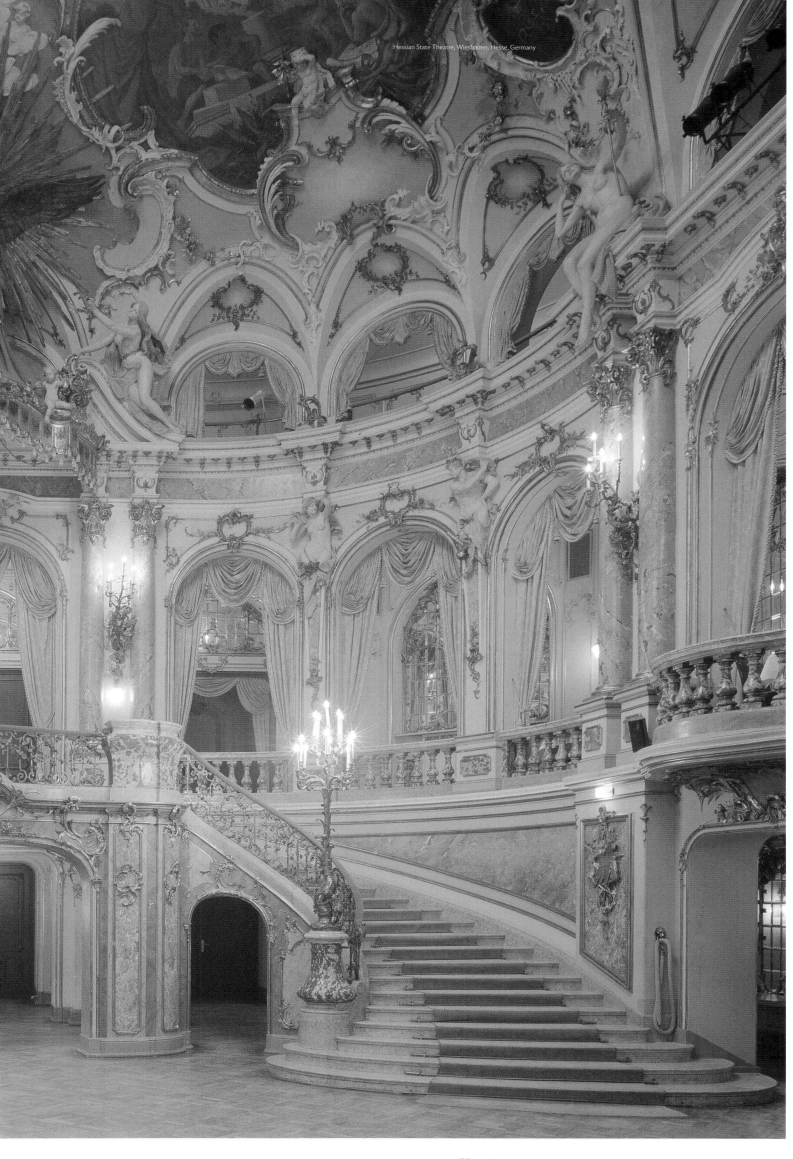

Hessian State Theatre, Wiesbaden, Hesse, Germany

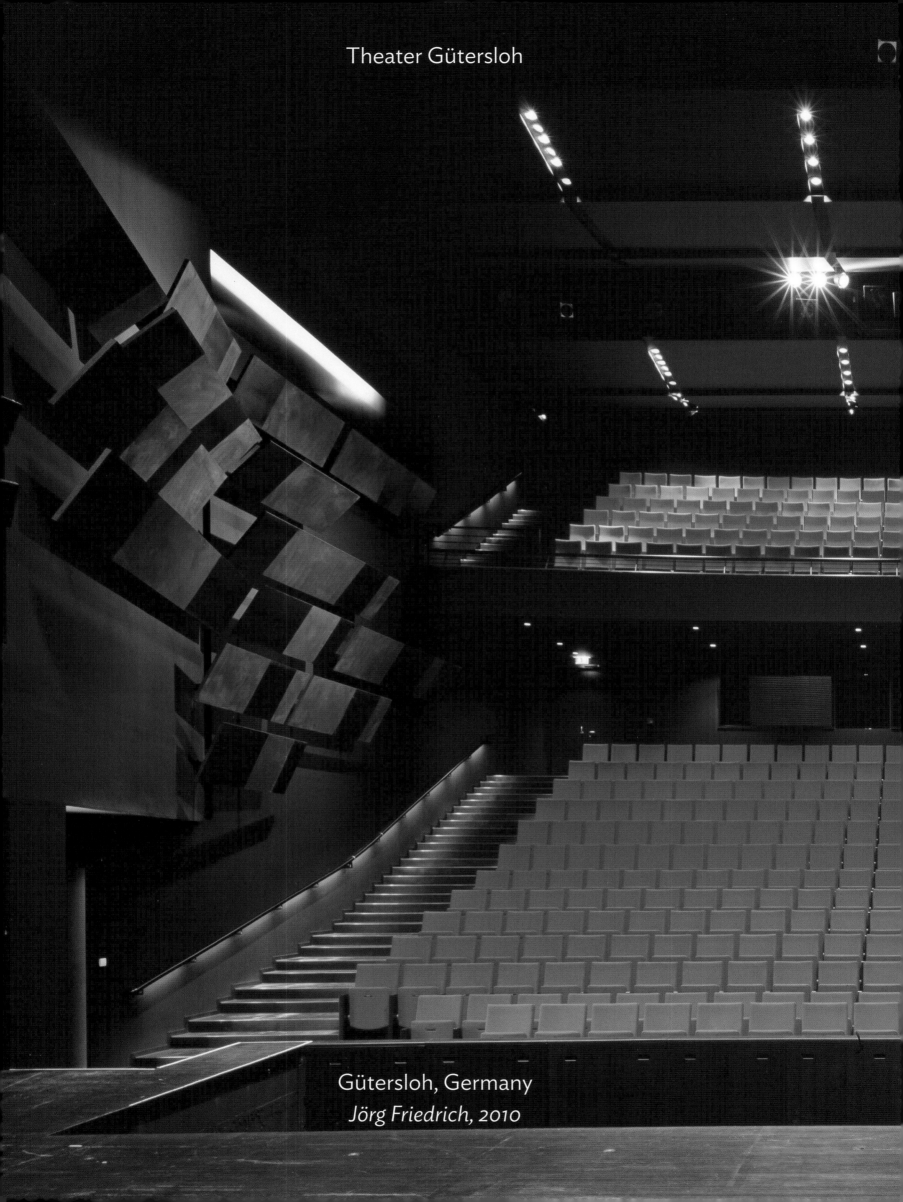

Theater Gütersloh

Gütersloh, Germany

Jörg Friedrich, 2010

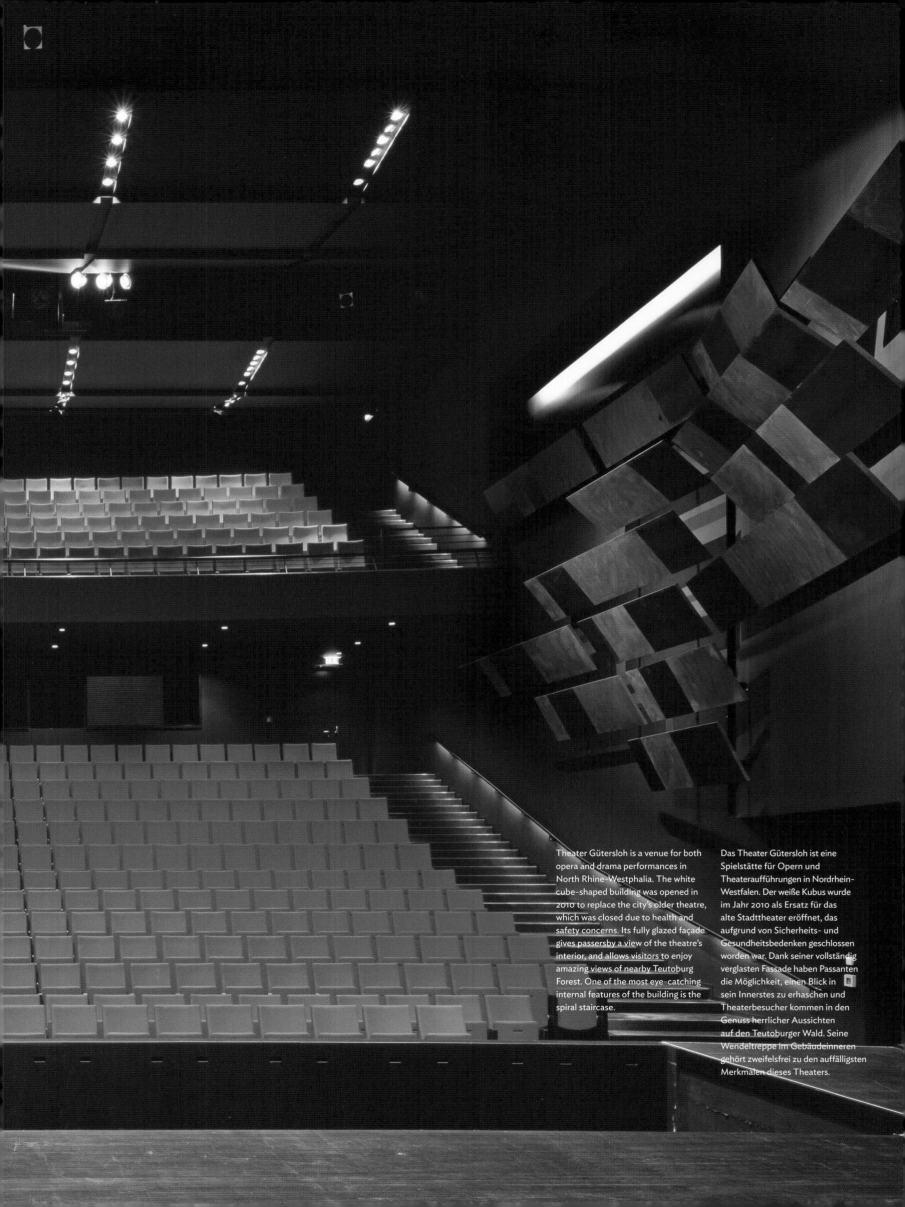

Theater Gütersloh is a venue for both opera and drama performances in North Rhine-Westphalia. The white cube-shaped building was opened in 2010 to replace the city's older theatre, which was closed due to health and safety concerns. Its fully glazed façade gives passersby a view of the theatre's interior, and allows visitors to enjoy amazing views of nearby Teutoburg Forest. One of the most eye-catching internal features of the building is the spiral staircase.

Das Theater Gütersloh ist eine Spielstätte für Opern und Theateraufführungen in Nordrhein-Westfalen. Der weiße Kubus wurde im Jahr 2010 als Ersatz für das alte Stadttheater eröffnet, das aufgrund von Sicherheits- und Gesundheitsbedenken geschlossen worden war. Dank seiner vollständig verglasten Fassade haben Passanten die Möglichkeit, einen Blick in sein Innerstes zu erhaschen und Theaterbesucher kommen in den Genuss herrlicher Aussichten auf den Teutoburger Wald. Seine Wendeltreppe im Gebäudeinneren gehört zweifelsfrei zu den auffälligsten Merkmalen dieses Theaters.

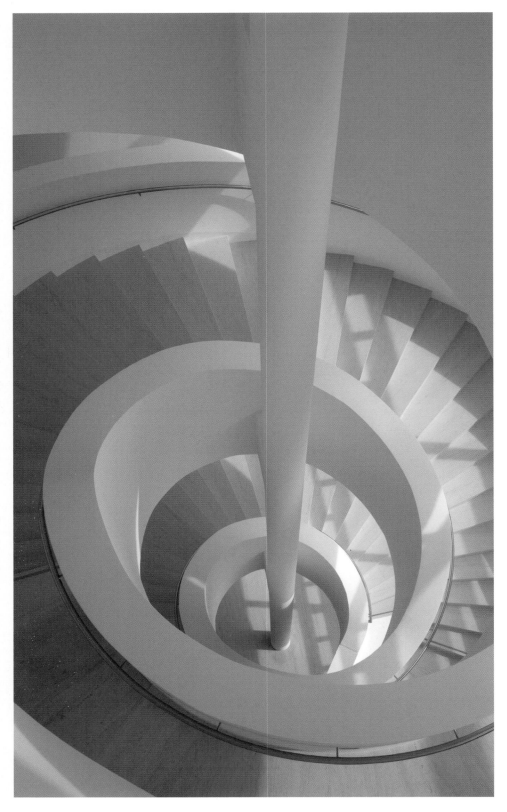

Le Gütersloh Theatre propose représentations d'opéra et pièces de théâtre en Rhénanie-du-Nord-Westphalie. Ouvert en 2010, l'édifice blanc en forme de cube a été construit pour remplacer l'ancien théâtre municipal, fermé pour des raisons de santé et de sécurité. Sa façade entièrement vitrée offre aux passants une vue complète sur l'intérieur du théâtre, et aux visiteurs un panorama exceptionnel sur la forêt de Teutoburg, toute proche. A l'intérieur, l'édifice se distingue par son escalier en colimaçon.

El Teatro Gütersloh es la sede de representaciones tanto operísticas como dramáticas en el estado de Renania del Norte-Westfalia. Este edificio blanco en forma de cubo abrió sus puertas en 2010 en sustitución del antiguo teatro de la ciudad, que se cerró debido a problemas de malv estado y seguridad. Su fachada totalmente acristalada proporciona a los transeúntes una vista del interior del edificio y permite a los visitantes disfrutar de unas panorámicas sorprendentes del cercano bosque de Teutoburgo. Una de las características más llamativas de este teatro es su escalera de caracol.

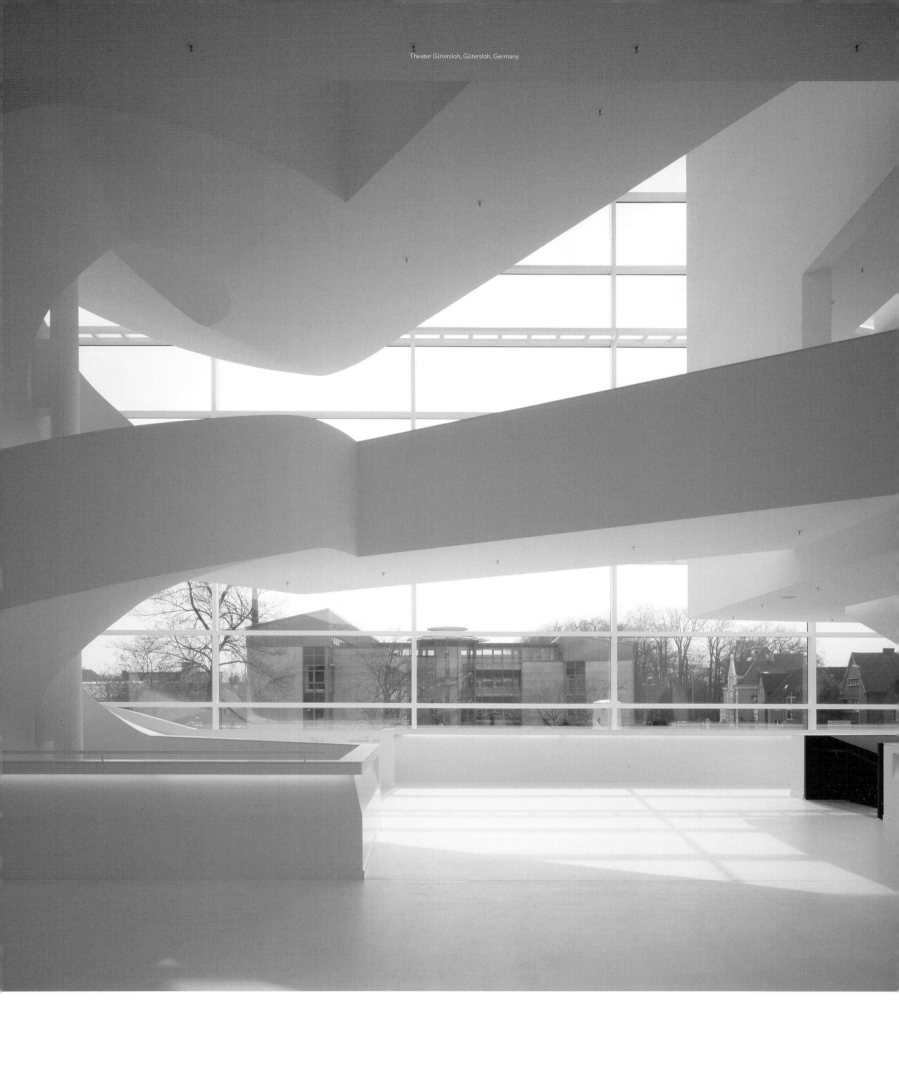

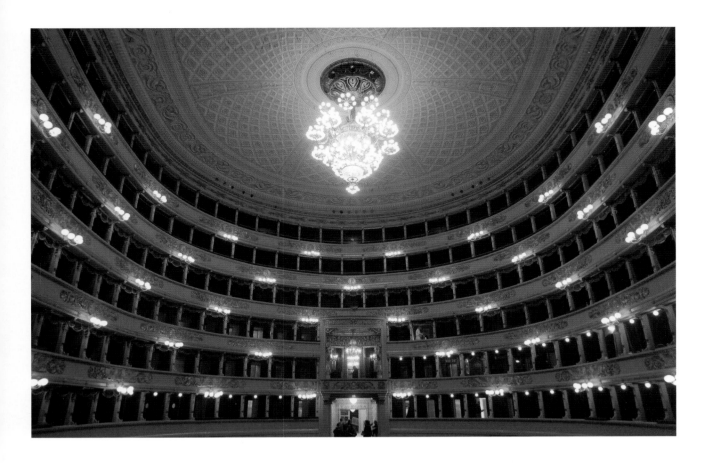

Teatro alla Scalla is arguably the most famous opera house in the world. Along with its spectacular artistic history, its auditorium has been imitated in opera houses around the world. A Second World War bombing attack, in 1943, destroyed the lavish interior and its stage. The Milanese rapidly rebuilt their theatre, and by 1946 it was completely restored. In 2002, the theatre was closed for extensive reconstruction, and opened again with a performance of Salieri's *Europa riconosciuta*, which had been the inauguration performance in 1778.

Das Teatro alla Scala zählt zweifelsohne zu den berühmtesten Opernhäusern weltweit. Neben seiner beeindruckenden künstlerischen Geschichte wurde auch sein Auditorium in so mancher ausländischen Oper imitiert. Ein Bombentreffer zerstörte im Jahr 1943 das aufwendige Interieur und die Bühne. Die Mailänder bauten das Theater jedoch rasch wieder auf und bereits 1946 öffnete das vollständig erneuerte Haus erneut seine Pforten. Im Jahr 2002 wurde die Scala aufgrund umfangreicher Sanierungsmaßnahmen geschlossen. Die Wiedereröffnung erfolgte mit der Aufführung von Salieris *Europa riconosciuta*, einem Werk, das bereits bei der ursprünglichen Eröffnung 1778 gegeben worden war.

Teatro alla Scalla, ou La Scala, est incontestablement l'opéra le plus célèbre du monde. Fort d'un prestigieux passé artistique, sa salle a inspiré de nombreux opéras de part et d'autre du monde. La scène et les somptueux décors intérieurs furent détruits par un bombardement lors de la Seconde Guerre mondiale en 1943. Les Milanais ont rapidement reconstruit leur théâtre, dont la restauration s'est achevée en 1946. Le théâtre a fermé ses portes en 2002 pour cause de vaste rénovation avant de rouvrir avec la représentation d'*Europa riconosciuta* de Salieri, œuvre qui avait été jouée lors de son inauguration en 1778.

El Teatro alla Scalla es posiblemente el teatro de ópera más famoso del mundo. Junto con su espectacular historial artístico, su auditorio se ha imitado en teatros de ópera de todo el mundo. En 1943, un ataque con bombas durante la Segunda Guerra Mundial, destruyó el suntuoso interior y el escenario. Los milaneses no tardaron en reconstruir el teatro y, en 1946, ya estaba totalmente restaurado. En 2002, el teatro cerró sus puertas para proceder a una reconstrucción exhaustiva y volvió a abrirlas con la representación de *Europa riconosciuta* de Salieri, la obra con la que se inauguró en 1778.

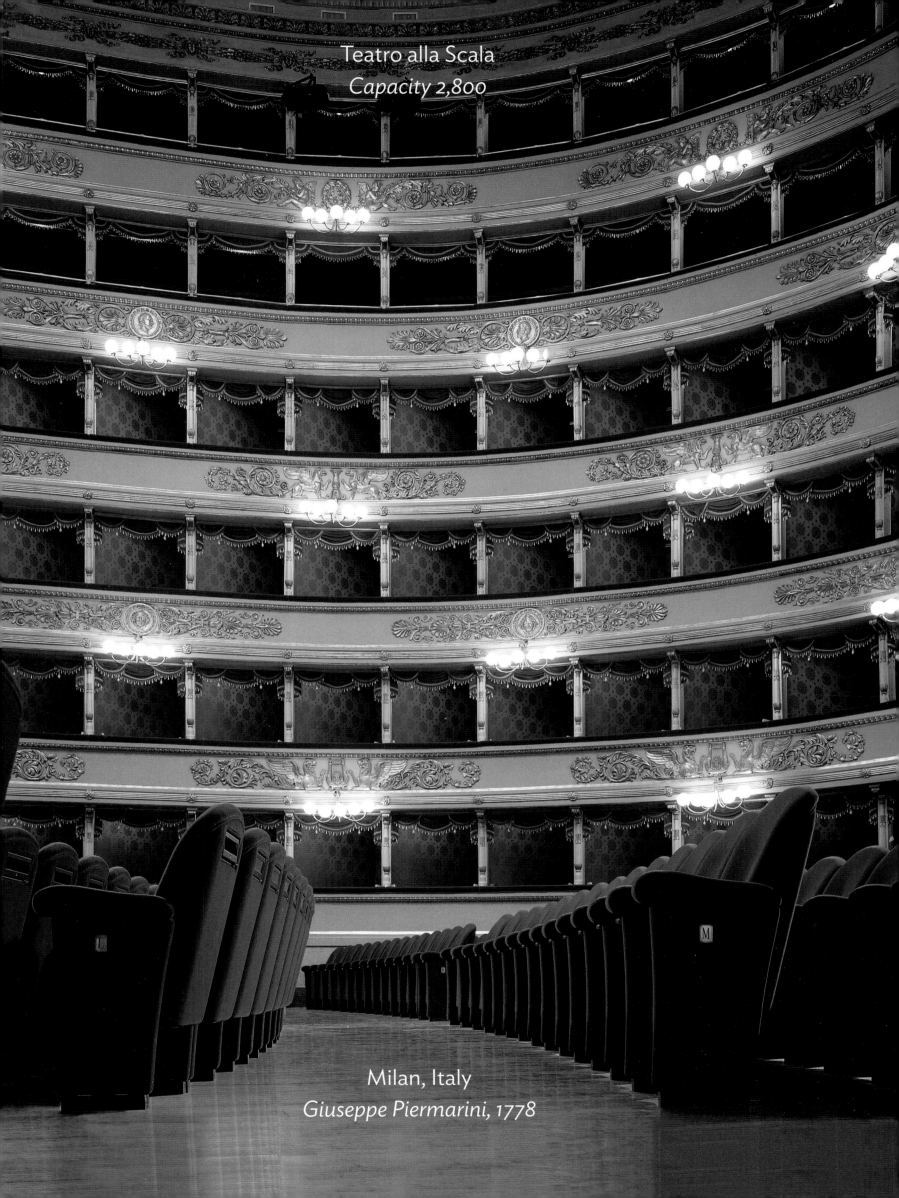

Teatro alla Scala
Capacity 2,800

Milan, Italy
Giuseppe Piermarini, 1778

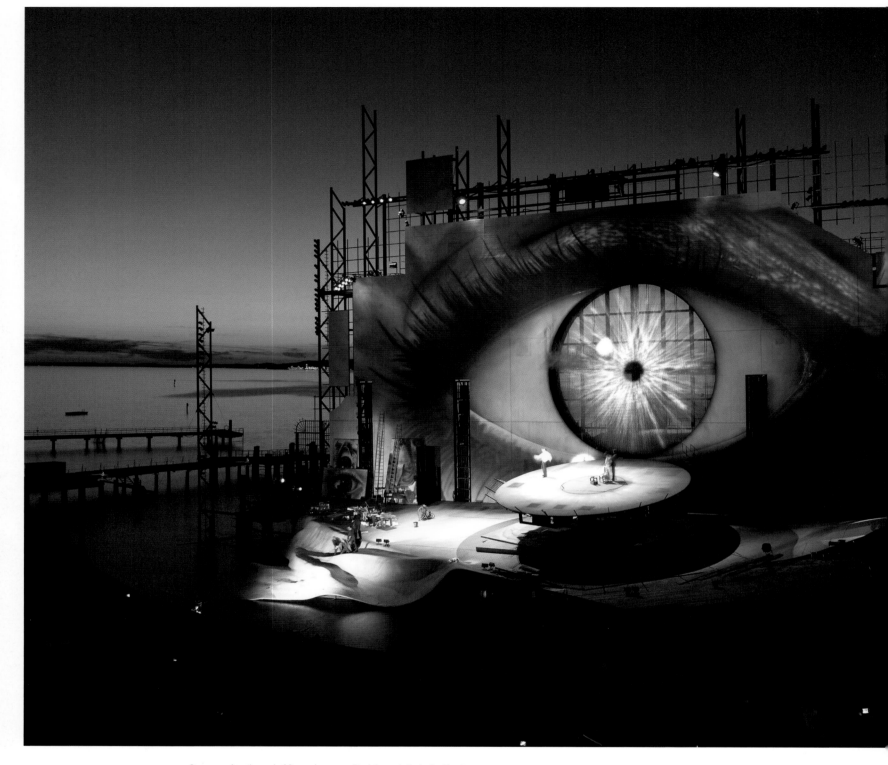

One year after the end of Second World War, the city of Brengenz held its first Bregenzer Festspiele, an annual performing arts festival. The highlight of the festival is considered to be the inimitable experience of witnessing the performances of musicals and large-scale operas on this off-shore floating stage on Lake Constance. The stage designers frequently take advantage of the unique setting of Seebühne by using the water as an extension of the stage, and echoing the visual drama of the surroundings in their bold stage designs.

Ein Jahr nach Ende des Zweiten Weltkrieges veranstaltete die Stadt Bregenz zum ersten Mal ihre Bregenzer Festspiele, ein alljährlich stattfindendes Festival für darstellende Kunst. Als dessen Höhepunkt gilt das unvergleichliche Erlebnis, die Darbietung von Musicals und großen Opernproduktionen auf der schwimmenden Bühne im Bodensee mitzuerleben. Häufig nutzen die Bühnenbildner die einzigartige Umgebung der Spielstätte selbst, indem sie das Gewässer wie eine verlängerte Bühne einsetzen und die dramatische Landschaft in ihren gewagten Bühnenbildern widerspiegeln.

Seebühne
Capacity 7,000

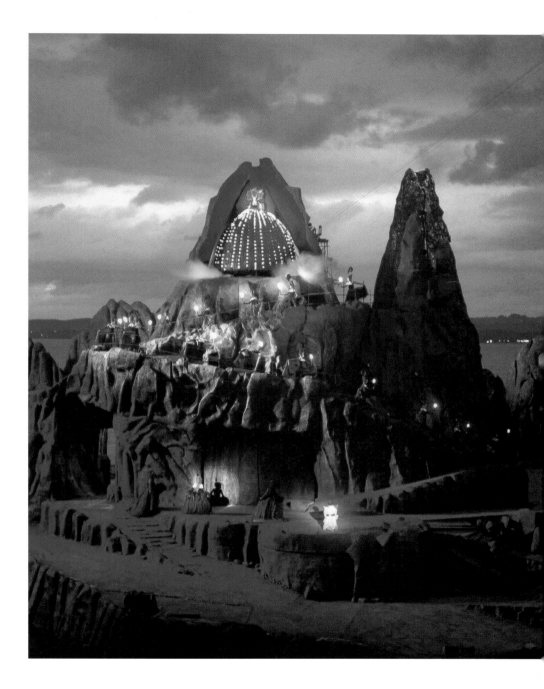

Bregenz, Austria

1950

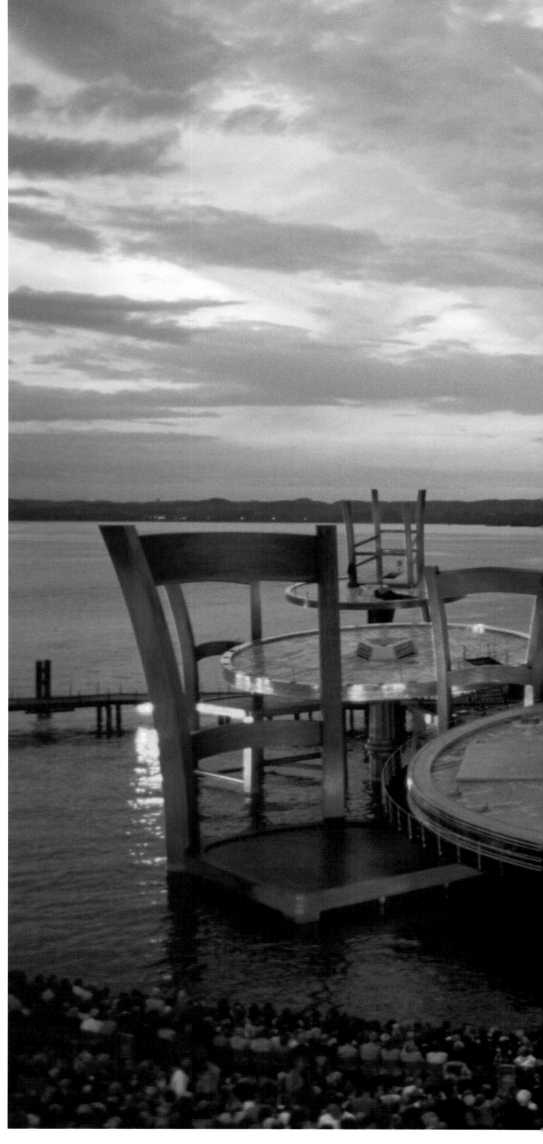

Un an après la fin de la Seconde Guerre mondiale, la ville de Bregenz organisait son premier festival annuel consacré aux arts de la scène, le *Bregenzer Festspiele.* Ce festival tire son originalité de l'expérience inimitable qu'il procure aux spectateurs qui peuvent apprécier les performances musicales et assister à des opéras de grande échelle joués depuis la scène flottante installée sur le lac de Constance. Les metteurs en scène exploitent généralement les avantages que leur offre le cadre unique de Seebühne en se servant de l'eau comme d'une extension de la scène, et en intégrant cet environnement enchanteur dans des mises en scène audacieuses.

Un año antes de que finalizara la Segunda Guerra Mundial, la ciudad de Bregenz celebró su primer Bregenzer Festspiele, un festival anual de artes escénicas. El momento cumbre del festival lo marca la experiencia incomparable de presenciar los grandes espectáculos musicales y de ópera en este escenario lacustre flotante del Lago Constanza. Con frecuencia, los escenógrafos sacan partido del exclusivo entorno de Seebühne utilizando el agua como extensión del escenario y reflejando el aspecto dramático visual de los alrededores en sus audaces escenografías.

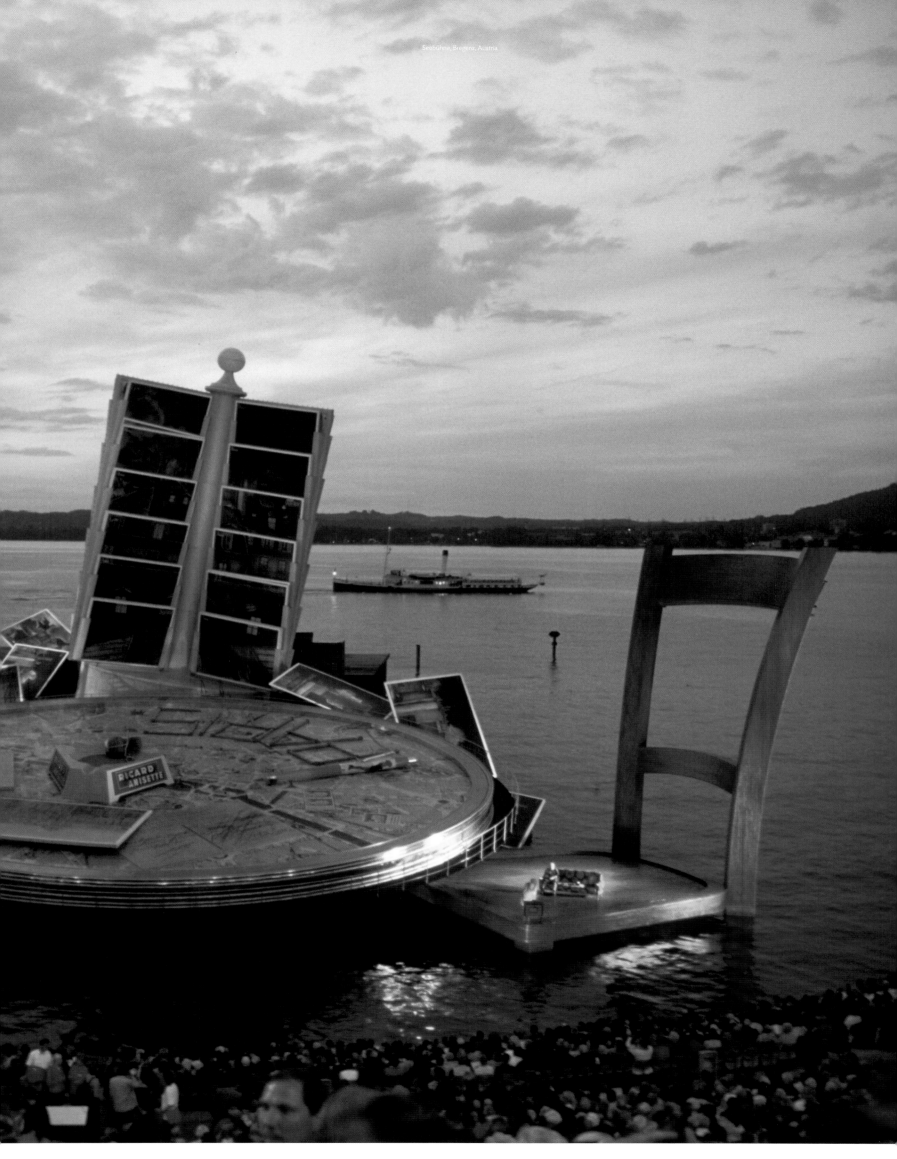

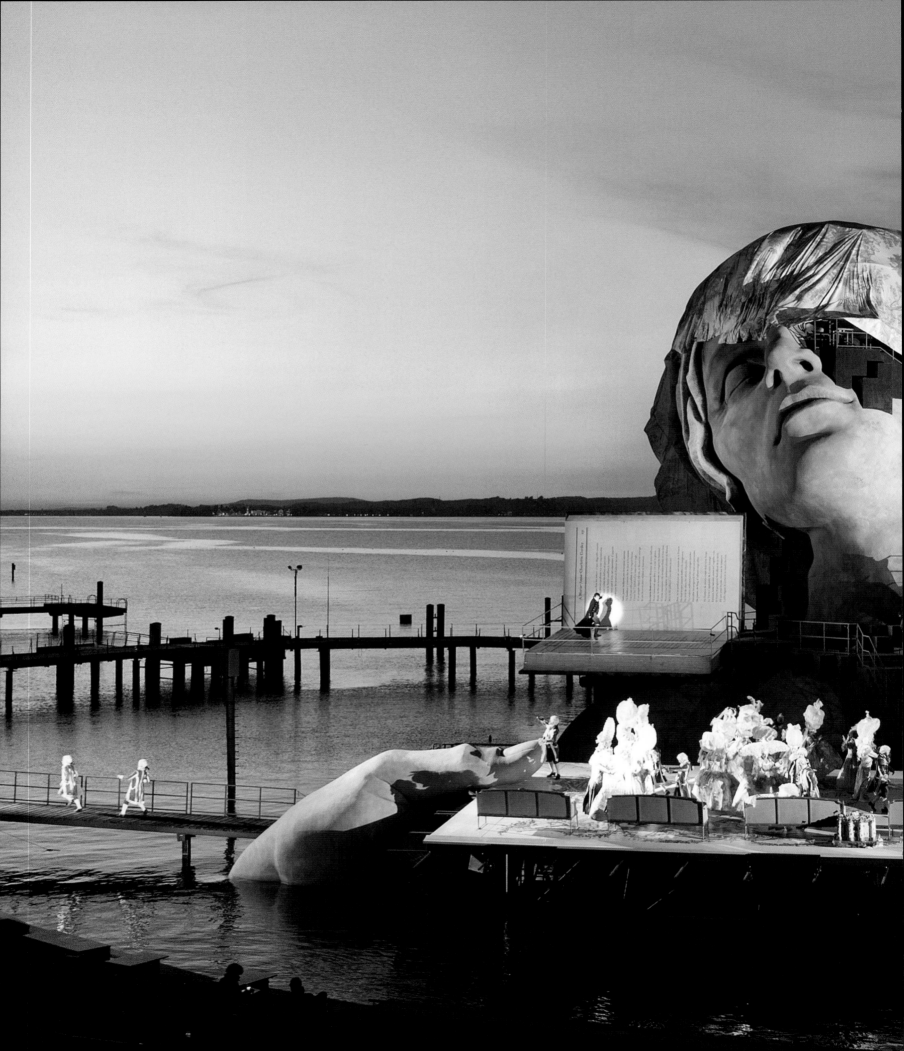

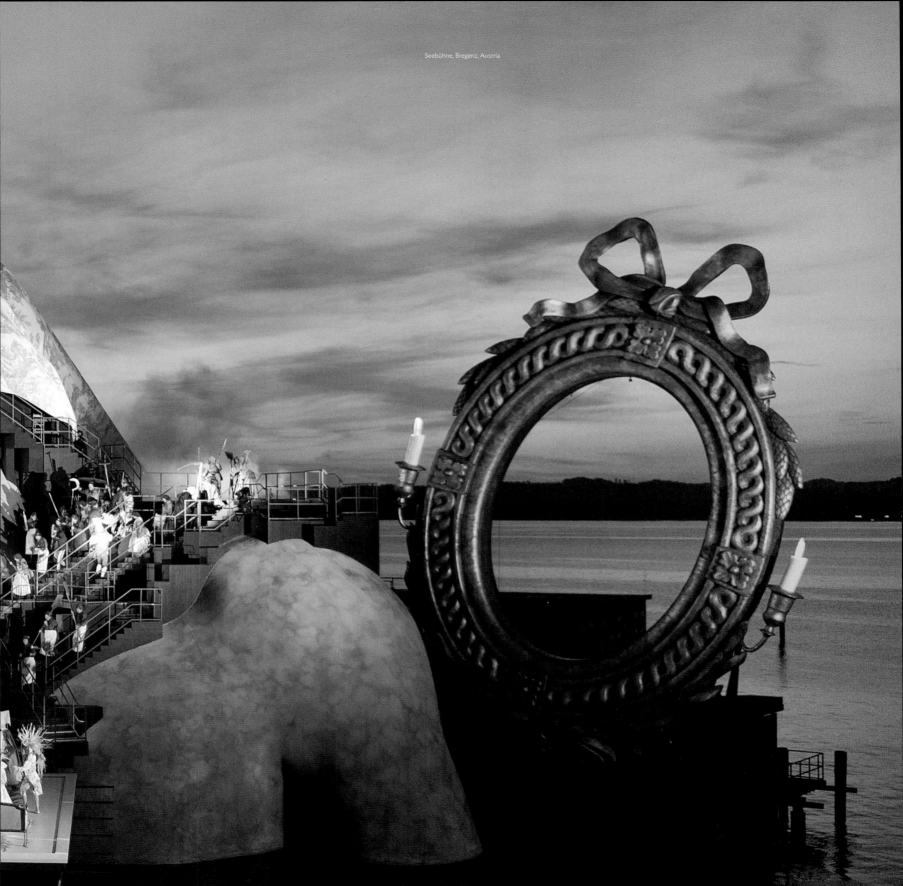

Seebühne, Bregenz, Austria

Oslo Opera House
Capacity 1,364

Oslo, Norway

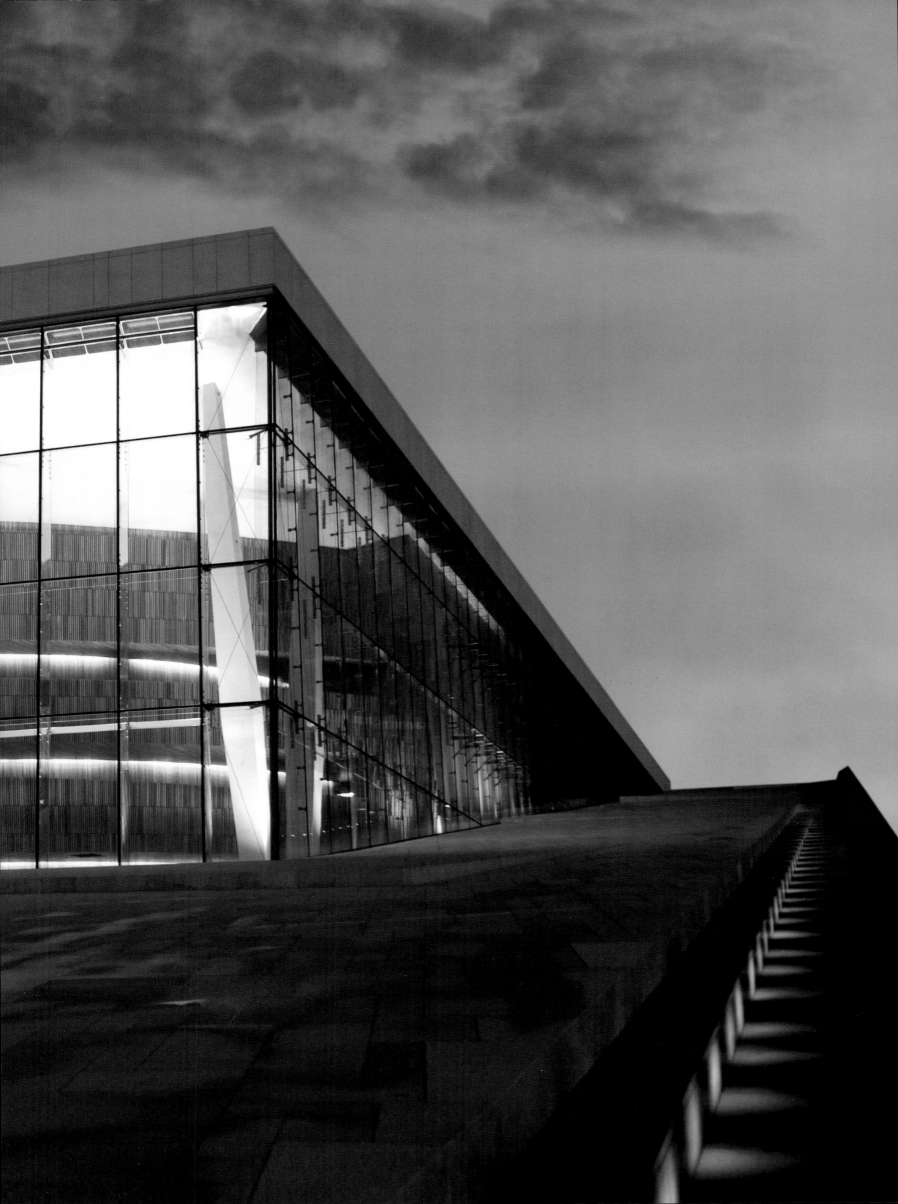

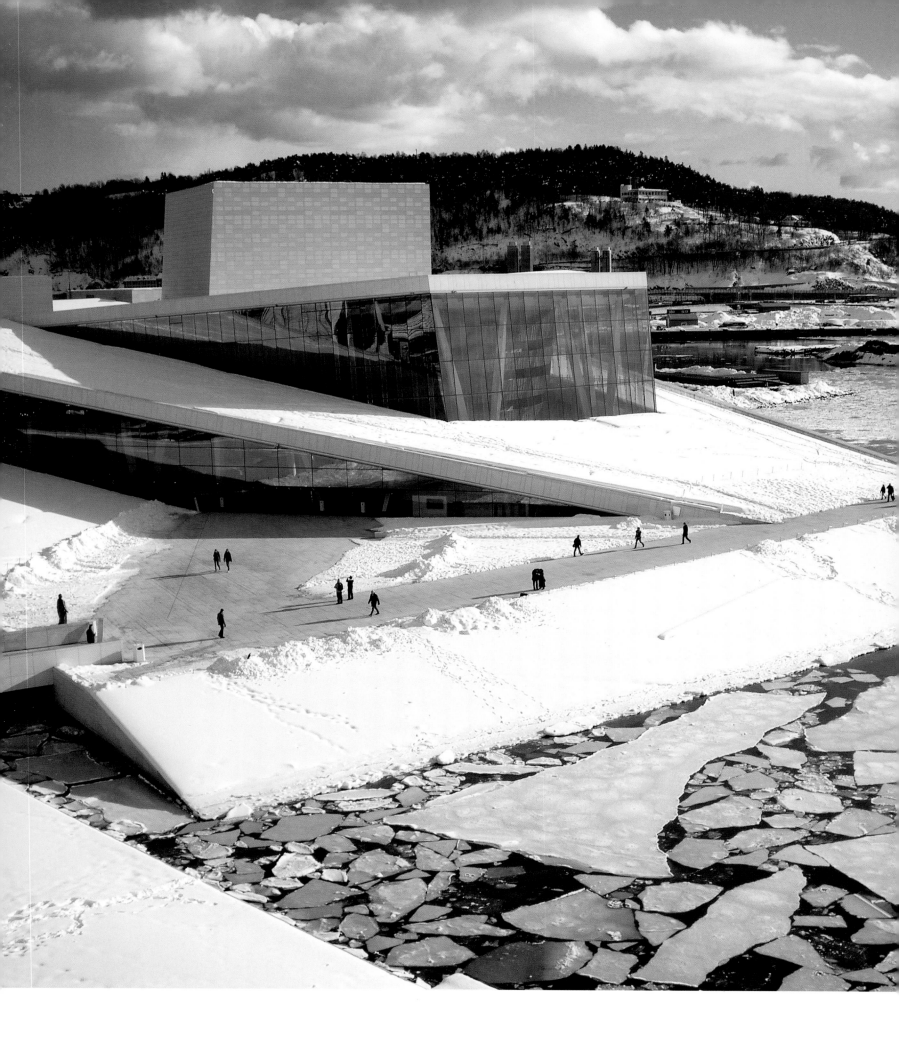

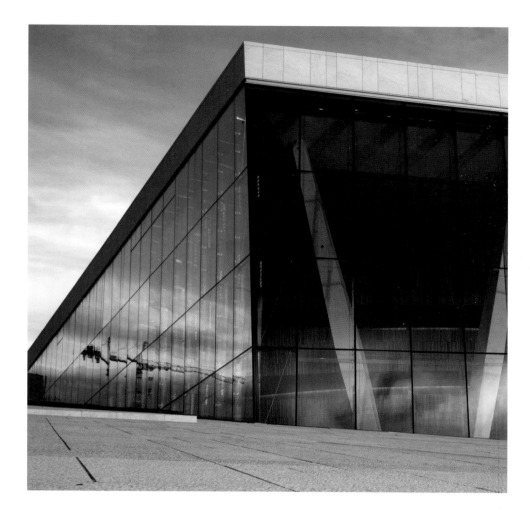

Situated in the city's old Bjørvika harbour area, the Oslo Opera House is the culmination of over a century's debate about a dedicated opera and ballet venue in Norway. It was the first construction in Bjørvika's urban development project. The angular architecture, arising from Oslo Fjord, is the signature of the building, as was the intention of Snøhetta, the architects behind this iconic design. In addition, they wanted to make the roof accessible to all, creating a new public space in the centre of Oslo.

Die Osloer Oper liegt im alten Hafenviertel von Bjørvika und verkörpert den Höhepunkt einer Jahrhunderte währenden Debatte über einen Veranstaltungsort für Opern- und Ballettaufführungen in Norwegen. Es war das erste Gebäude, das im Rahmen des Stadtentwicklungsplans für Bjørvika errichtet wurde. Die lineare, kantige Architektur des scheinbar aus dem Oslo-Fjord aufsteigenden Gebäudes wurde von seinen Erbauern Snøhetta bewusst als ikonisches Erkennungsmerkmal gewählt. Außerdem wollten sie ein allen zugängliches Dach und damit einen neuen öffentlichen Raum im Herzen Oslos schaffen.

Situé dans le vieux quartier portuaire de Bjørvika, l'Opéra d'Oslo marque l'aboutissement de plus d'un siècle de débat sur la construction d'un site dédié à l'opéra et au ballet en Norvège. Le théâtre a été la première construction du projet de développement urbain de Bjørvika. S'élevant au-dessus du Fjord d'Oslo, l'édifice se distingue par une architecture tout en angle, conformément au souhait du cabinet d'architecture Snøhetta, à l'origine de cette conception emblématique. L'architecture a été en outre dictée par la volonté de rendre accessible à tous le toit de l'édifice, aménageant un nouvel espace public en plein centre d'Oslo.

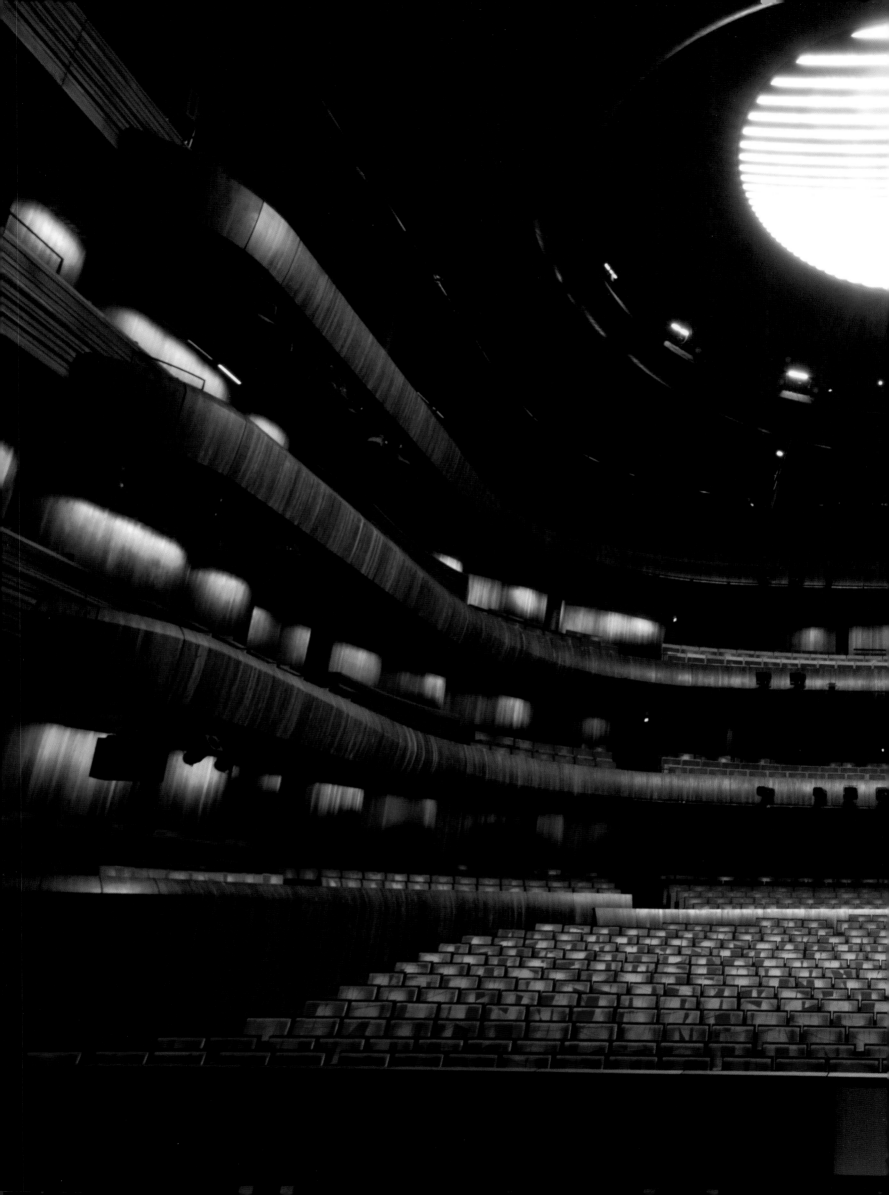

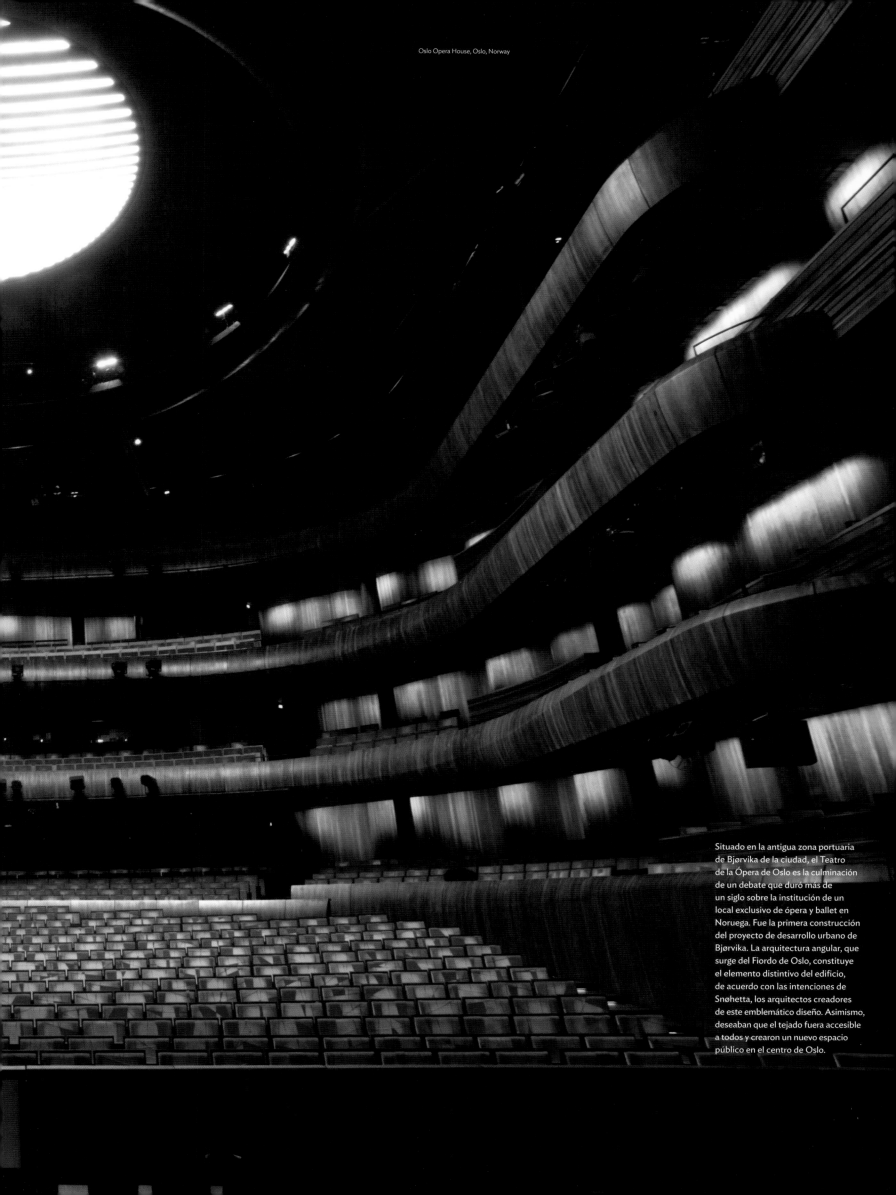

Oslo Opera House, Oslo, Norway

Situado en la antigua zona portuaria de Bjørvika de la ciudad, el Teatro de la Ópera de Oslo es la culminación de un debate que duró más de un siglo sobre la institución de un local exclusivo de ópera y ballet en Noruega. Fue la primera construcción del proyecto de desarrollo urbano de Bjørvika. La arquitectura angular, que surge del Fiordo de Oslo, constituye el elemento distintivo del edificio, de acuerdo con las intenciones de Snøhetta, los arquitectos creadores de este emblemático diseño. Asimismo, deseaban que el tejado fuera accesible a todos y crearon un nuevo espacio público en el centro de Oslo.

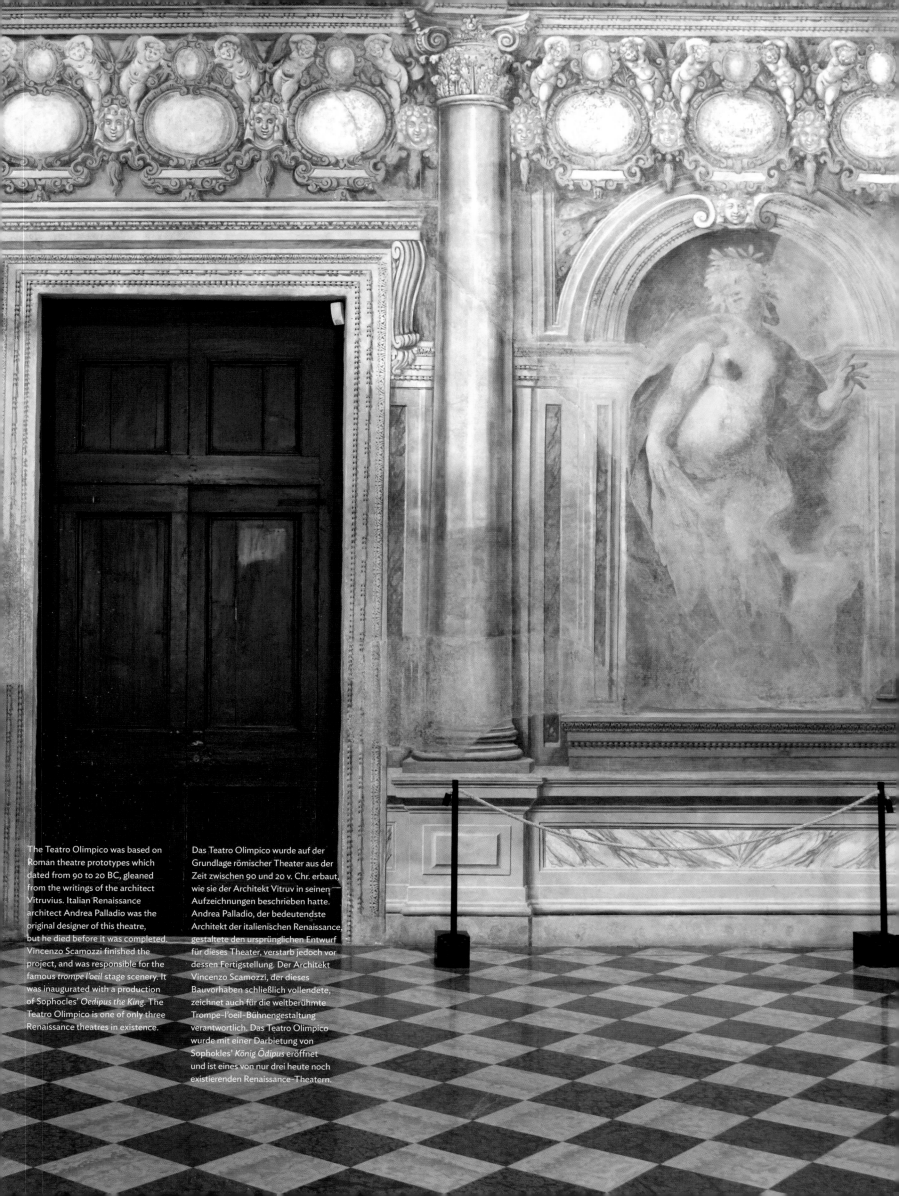

The Teatro Olimpico was based on Roman theatre prototypes which dated from 90 to 20 BC, gleaned from the writings of the architect Vitruvius. Italian Renaissance architect Andrea Palladio was the original designer of this theatre, but he died before it was completed. Vincenzo Scamozzi finished the project, and was responsible for the famous *trompe l'oeil* stage scenery. It was inaugurated with a production of Sophocles' *Oedipus the King*. The Teatro Olimpico is one of only three Renaissance theatres in existence.

Das Teatro Olimpico wurde auf der Grundlage römischer Theater aus der Zeit zwischen 90 und 20 v. Chr. erbaut, wie sie der Architekt Vitruv in seinen Aufzeichnungen beschrieben hatte. Andrea Palladio, der bedeutendste Architekt der italienischen Renaissance, gestaltete den ursprünglichen Entwurf für dieses Theater, verstarb jedoch vor dessen Fertigstellung. Der Architekt Vincenzo Scamozzi, der dieses Bauvorhaben schließlich vollendete, zeichnet auch für die weltberühmte Trompe-l'oeil-Bühnengestaltung verantwortlich. Das Teatro Olimpico wurde mit einer Darbietung von Sophokles' *König Ödipus* eröffnet und ist eines von nur drei heute noch existierenden Renaissance-Theatern.

Teatro Olimpico
Capacity 496

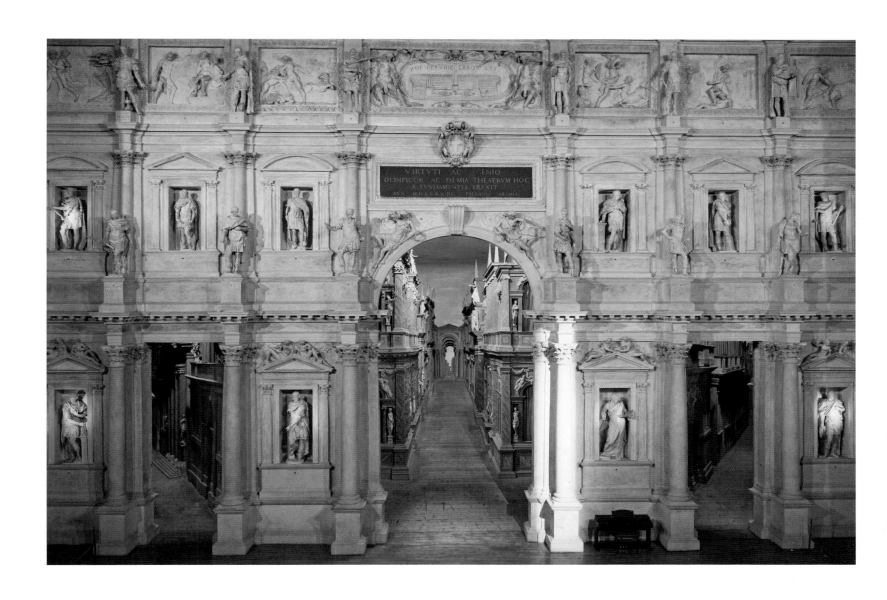

Le Teatro Olimpico a été inspiré par
les modèles de théâtres romains
datant de 90 à 20 avant J.-C. tirés
des écrits de l'architecte Vitruve.
Concepteur original du projet,
l'architecte italien de la Renaissance
Andrea Palladio décéda avant son
achèvement. Le théâtre fut terminé
par Vincenzo Scamozzi à qui l'on
doit le célèbre décor scénique en
trompe-l'œil. Le théâtre fut inauguré
avec une représentation d'*Œdipe
roi* de Sophocle. Le Teatro Olimpico
figure parmi les trois derniers théâtres
de la Renaissance encore sur pied.

Vicenza, Italy
Andrea Palladio, 1585

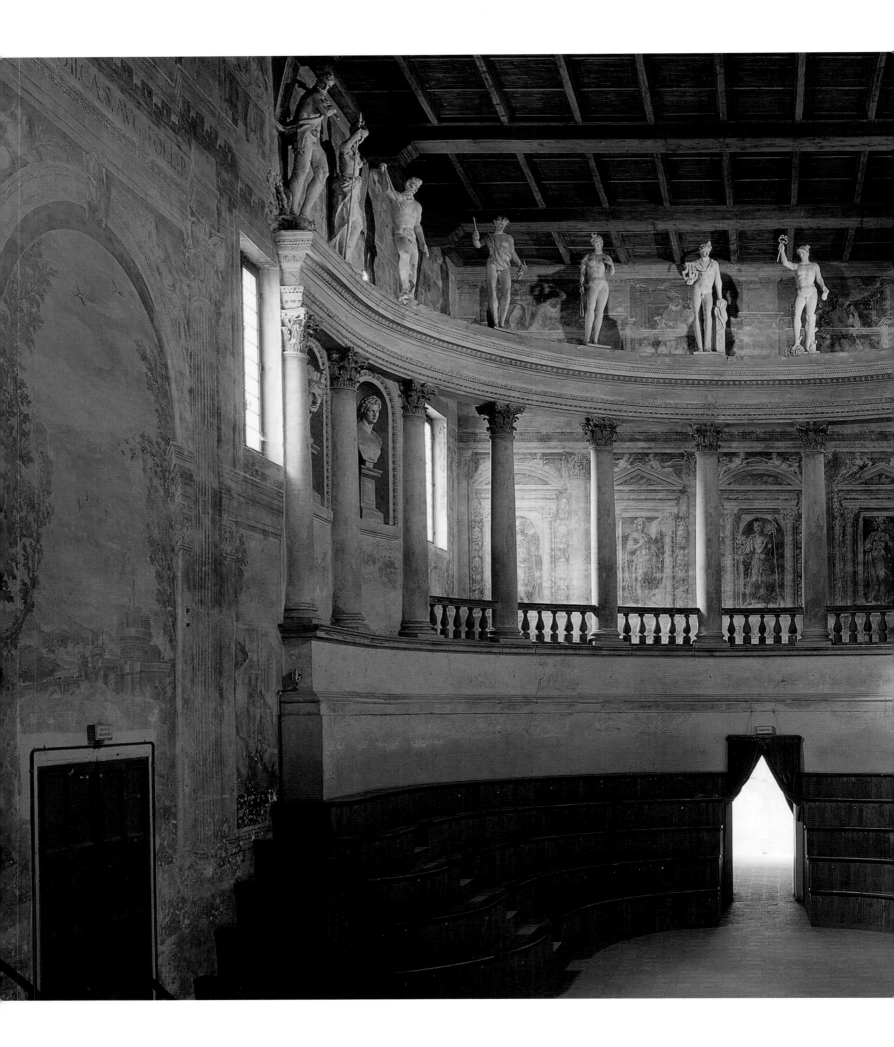

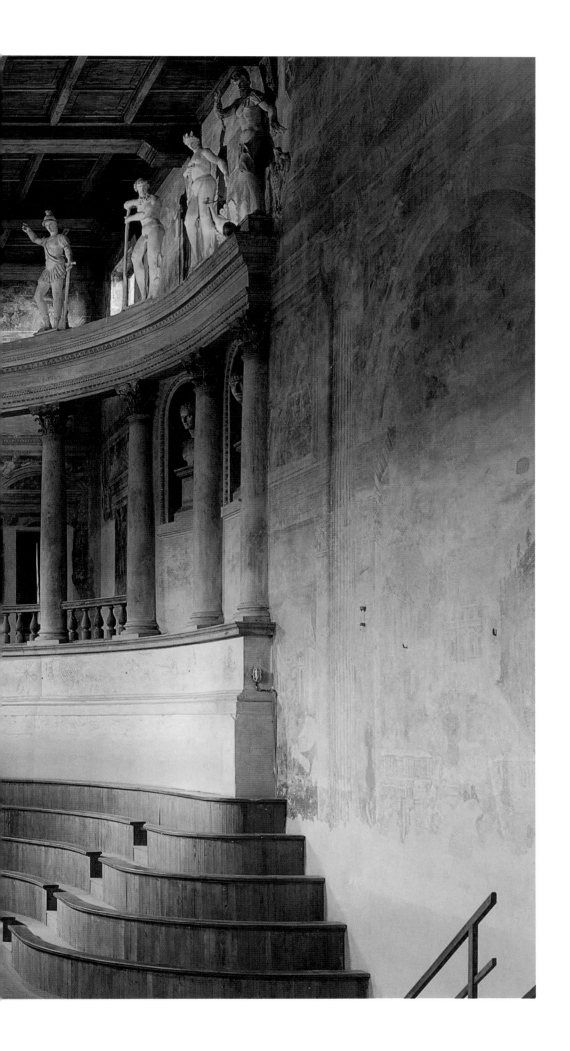

El Teatro Olímpico está basado en prototipos de teatros romanos entre los años 90 y 20 a.C., inspirados en la obra del arquitecto Vitruvio. El arquitecto del Renacimiento italiano Andrea Palladio fue el diseñador original de este teatro pero falleció antes de su finalización. Vincenzo Scamozzi terminó el proyecto y fue responsable del famoso decorado de trampantojo del escenario. Fue inaugurado con una producción de *Edipo Rey* de Sófocles. El Teatro Olímpico es uno de los tres únicos teatros renacentistas que existen.

Gran Teatro La Fenice
Capacity 1,000+

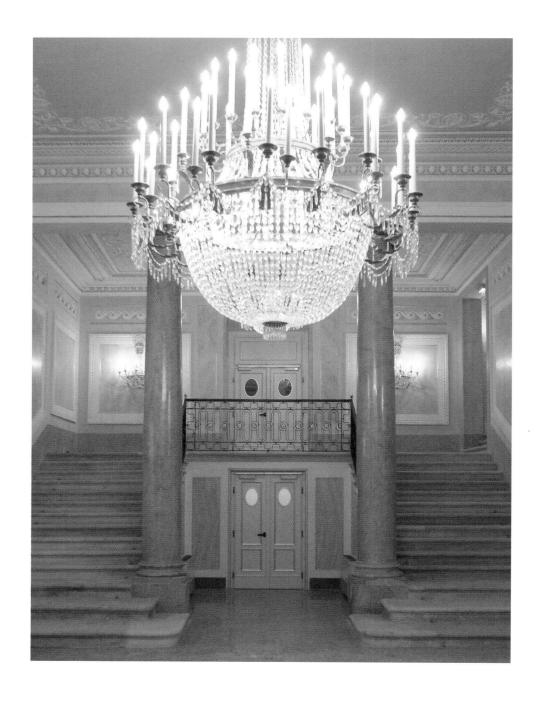

Venice, Italy
Giannantonio Selva, 1792

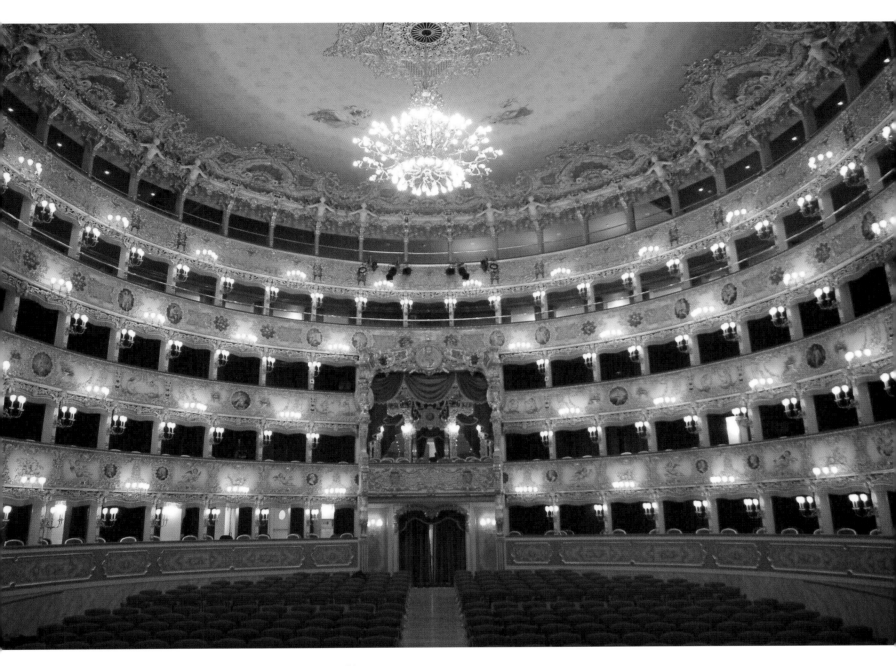

Gran Teatro La Fenice is the most important opera house in Venice. Throughout its turbulent history, it has staged world premieres of operas by Rossini, Donizetti and Verdi. Since its original conception, by the neoclassical architect Giannantonio Selva, the theatre has burnt down twice. Its name, 'La Fenice', or 'The Phoenix', could not be more appropriate, at it has re-emerged from these fires as a place of extraordinary beauty and prestige.

Beim Gran Teatro La Fenice handelt es sich um das bedeutendste Opernhaus Venedigs. Im Laufe seines turbulenten Bestehens fanden hier Weltpremieren von Opern von Rossini, Donizetti und Verdi statt. Das ursprünglich vom neoklassizistischen Architekten Giannantonio Selva erbaute Theater fiel bereits zwei Mal den Flammen zum Opfer, weshalb der Name „La Fenice" („Der Phönix") nicht besser zu ihm passen könnte. Und gleich seinem legendären Namensgeber erstand auch diese Oper ein ums andere Mal aus ihrer Asche zu außerordentlicher Schönheit und Geltung.

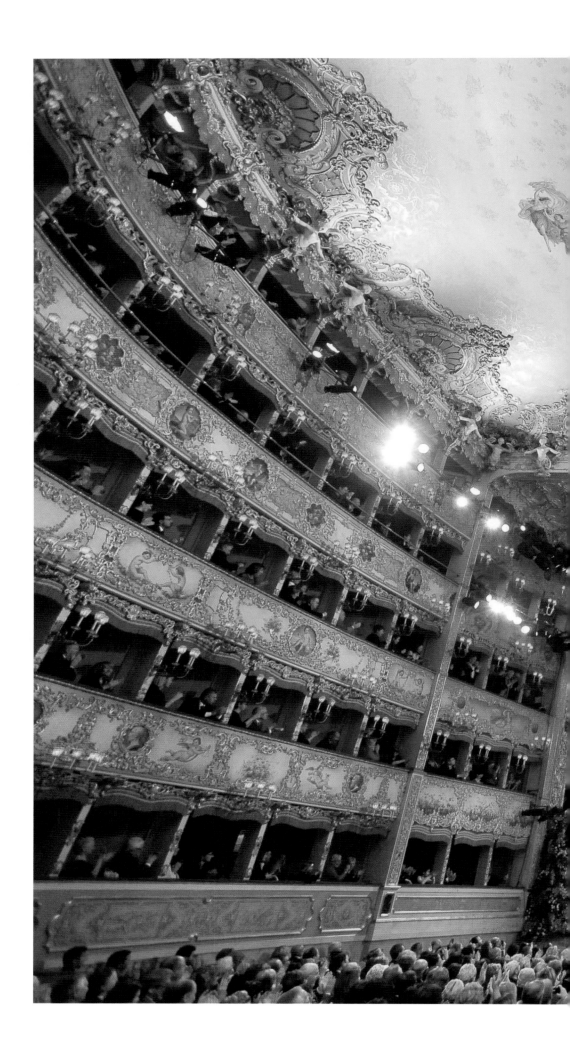

La Fenice est l'opéra le plus illustre de Venise. Malgré maints accidents, l'édifice a joué les premières mondiales des opéras de Rossini, de Donizetti et de Verdi. Depuis sa toute première construction par l'architecte néoclassique Gian Antonio Selva, l'opéra a brûlé par deux fois. Bien nommé s'il en est, 'La Fenice', ou 'le Phénix' en français, a su à chaque fois renaître de ses cendres pour s'imposer comme un lieu dont le prestige n'a d'égal que la beauté exceptionnelle.

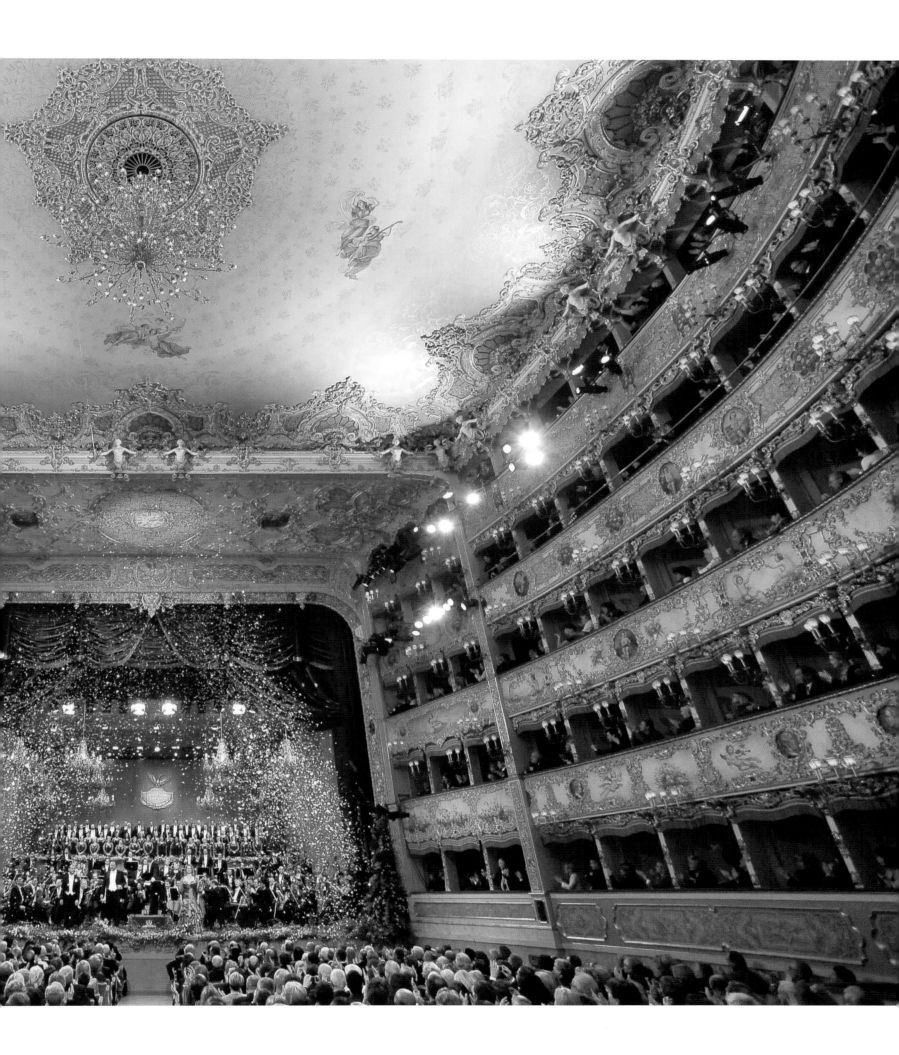

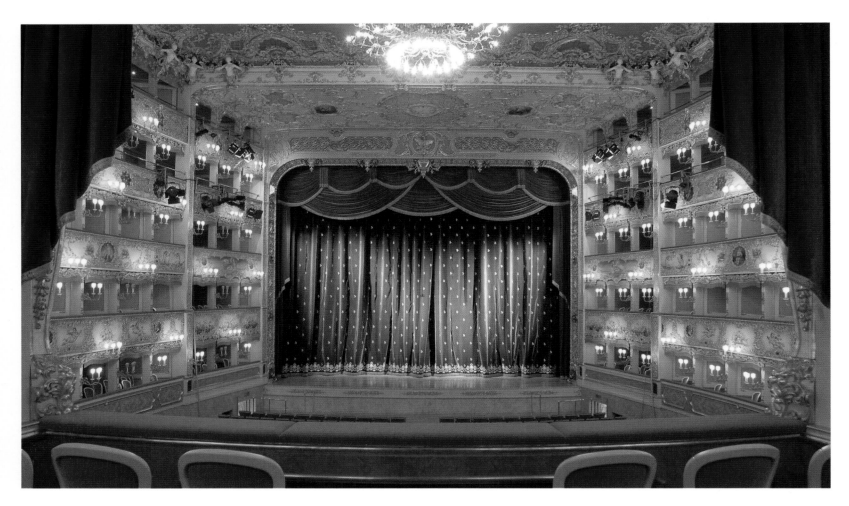

El Gran Teatro La Fenice representa la sede operística más importante de Venecia. A lo largo de su turbulenta historia, ha albergado estrenos mundiales de óperas de Rossini, Donizetti y Verdi. Desde su concepción original, por el arquitecto neoclásico Giannantonio Selva, el teatro ha quedado reducido a cenizas dos veces. El nombre de "La Fenice" o "Ave Fénix" no puede resultar más adecuado para él, al haber renacido del fuego como un lugar de extraordinaria belleza y prestigio.

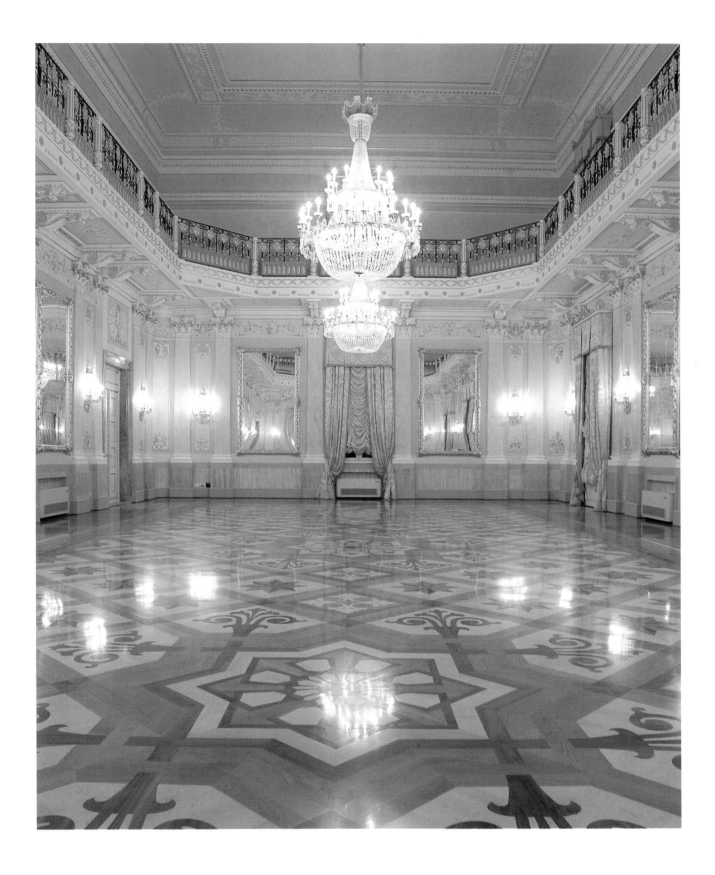

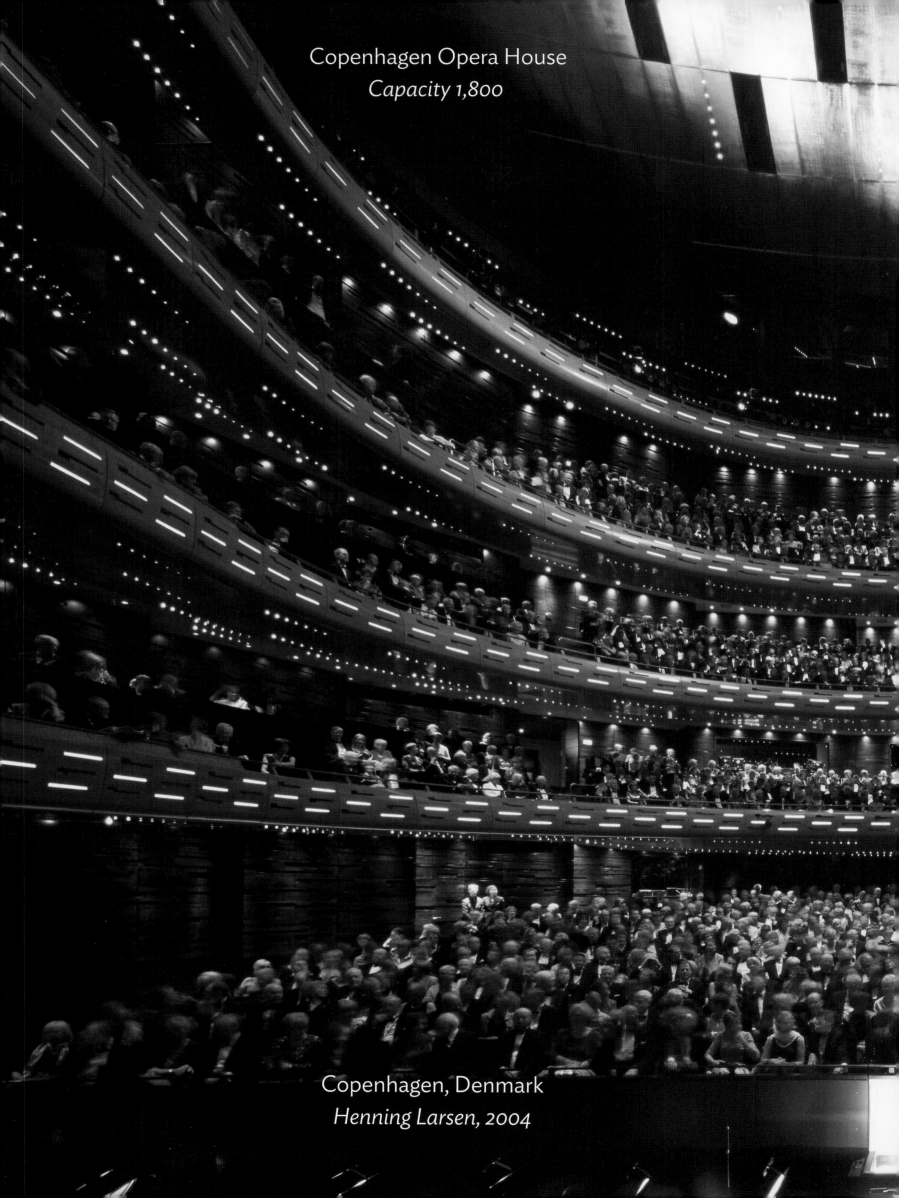

Copenhagen Opera House
Capacity 1,800

Copenhagen, Denmark
Henning Larsen, 2004

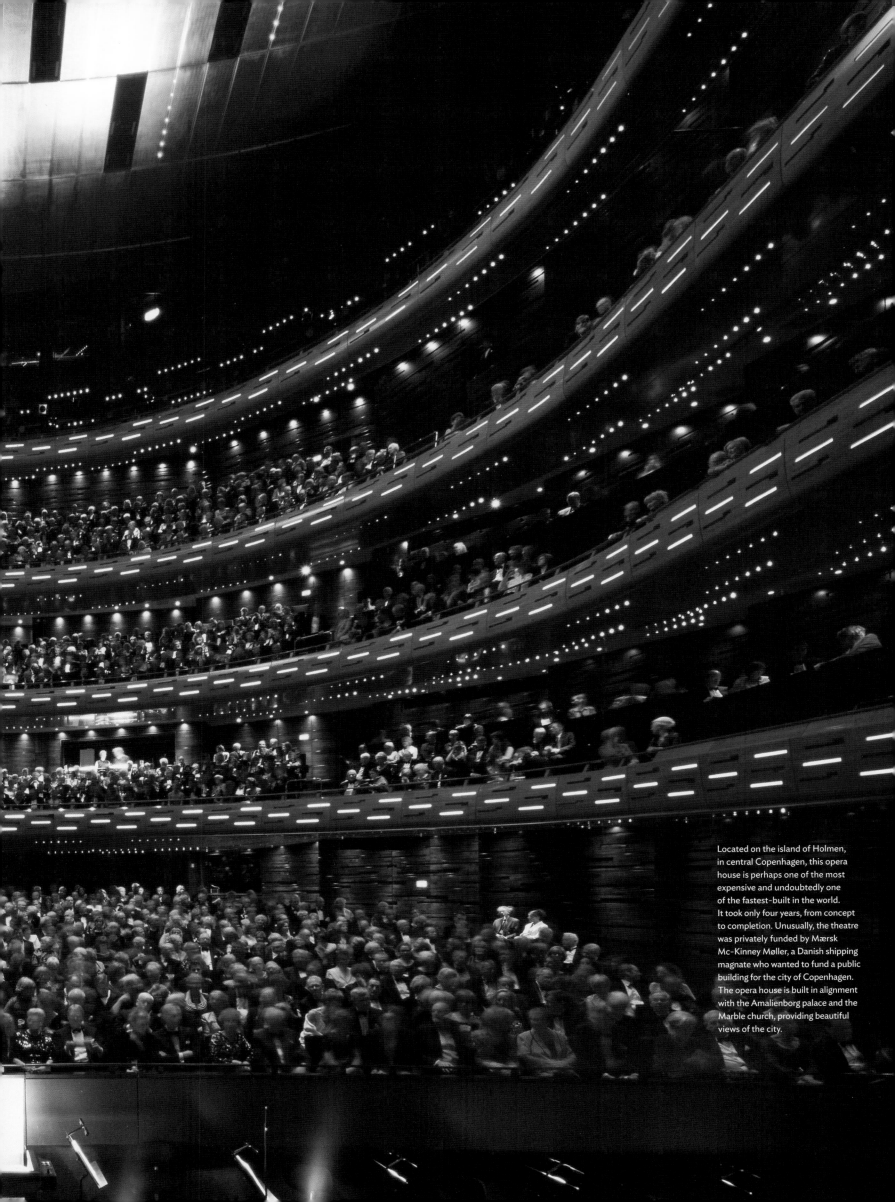

Located on the island of Holmen, in central Copenhagen, this opera house is perhaps one of the most expensive and undoubtedly one of the fastest-built in the world. It took only four years, from concept to completion. Unusually, the theatre was privately funded by Mærsk Mc-Kinney Møller, a Danish shipping magnate who wanted to fund a public building for the city of Copenhagen. The opera house is built in alignment with the Amalienborg palace and the Marble church, providing beautiful views of the city.

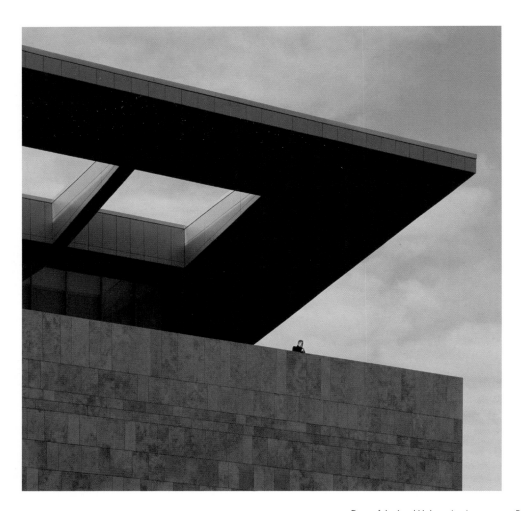

Das auf der Insel Holmen inmitten der Innenstadt Kopenhagens gelegene Opernhaus gehört wohl zu den teuersten, zweifelsfrei aber zu den am schnellsten errichteten Opern der Welt. Vom Entwurf bis zur Fertigstellung vergingen gerade einmal vier Jahre. Ungewöhnlich ist auch seine private Finanzierung durch den Mäzen Mærsk Mc-Kinney Møller, einen dänischen Reederei-Magnaten, der den Wunsch hegte, der Stadt Kopenhagen ein öffentliches Gebäude zu stiften. Die Oper wurde in einer Flucht mit Schloss Amalienborg und der Marmorkirche errichtet, was einzigartige Stadtansichten ermöglicht.

Bâti sur l'île d'Holmen, en plein centre de Copenhague, cet opéra mérite sans conteste de figurer au palmarès des édifices les plus coûteux et les plus rapidement construits du monde. L'opéra a en effet vu le jour en seulement quatre ans, de la conception à l'achèvement. Fait assez rare, la construction du théâtre a été entièrement financée par un particulier, Mærsk Mc-Kinney Møller, magnat danois du transport maritime désireux d'offrir à la ville de Copenhague un bâtiment public. Faisant face au palais de la Reine, l'Amalienborg, et à la Marble Church, l'Opéra offre un magnifique point de vue sur la ville.

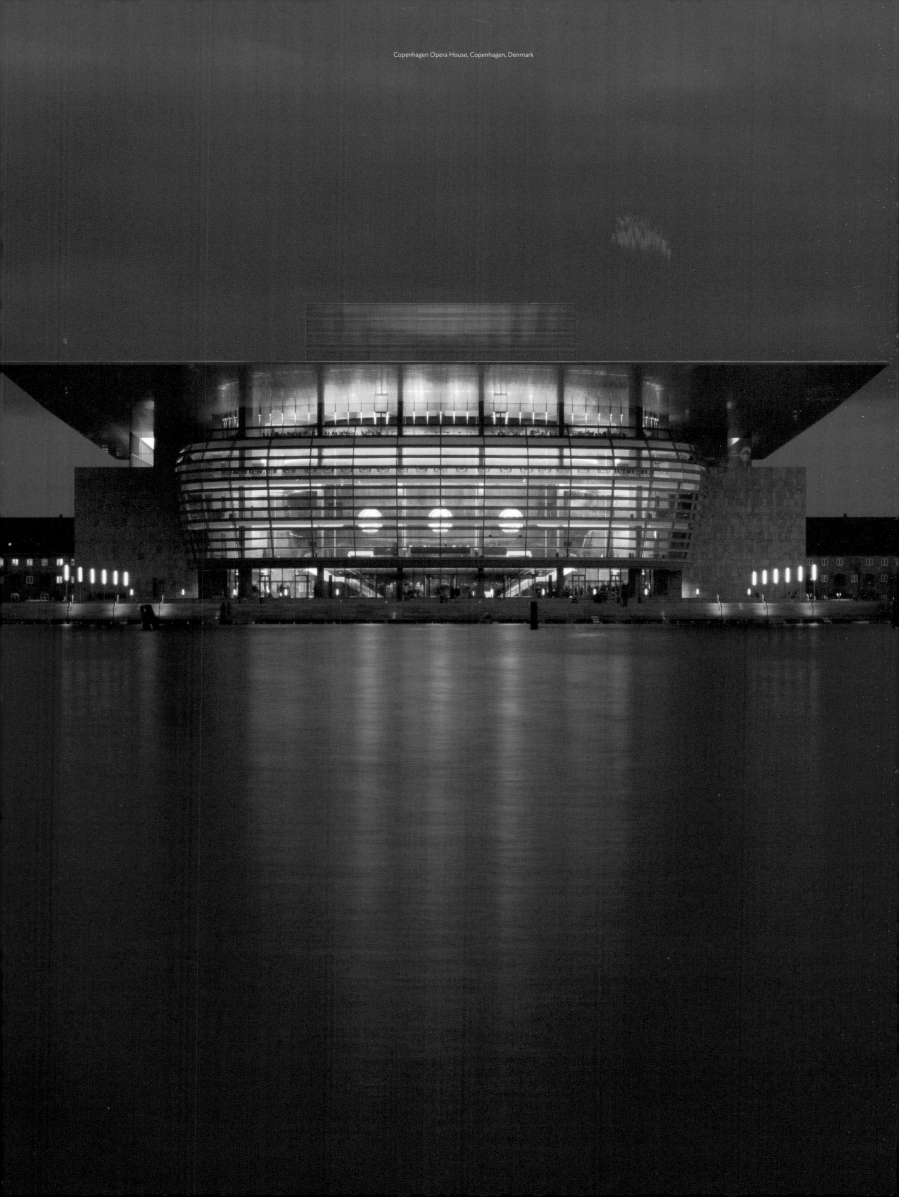

Copenhagen Opera House, Copenhagen, Denmark

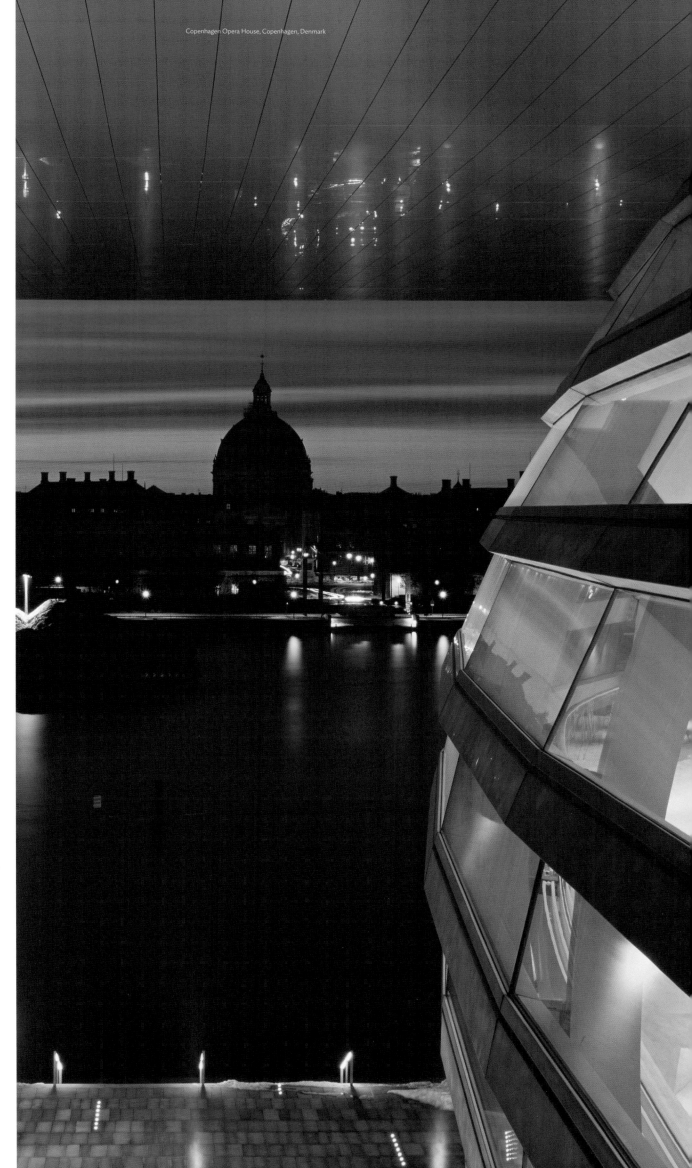

Copenhagen Opera House, Copenhagen, Denmark

Situado en la isla de Holmen, en el centro de Copenhague, este teatro de ópera es quizá uno de los edificios más costosos del mundo y, sin duda alguna, uno de los que más rápidamente se ha construido. Desde el diseño hasta su finalización, solo se tardaron cuatro años. Lo más insólito es que el teatro fue sufragado de forma privada por Mærsk Mc-Kinney Møller, un magnate naviero danés que deseaba financiar un edificio público para la ciudad de Copenhague. El teatro de ópera está construido en línea con el palacio de Amalienborg y la Iglesia de Mármol, lo que proporciona unas magníficas vistas a la ciudad.

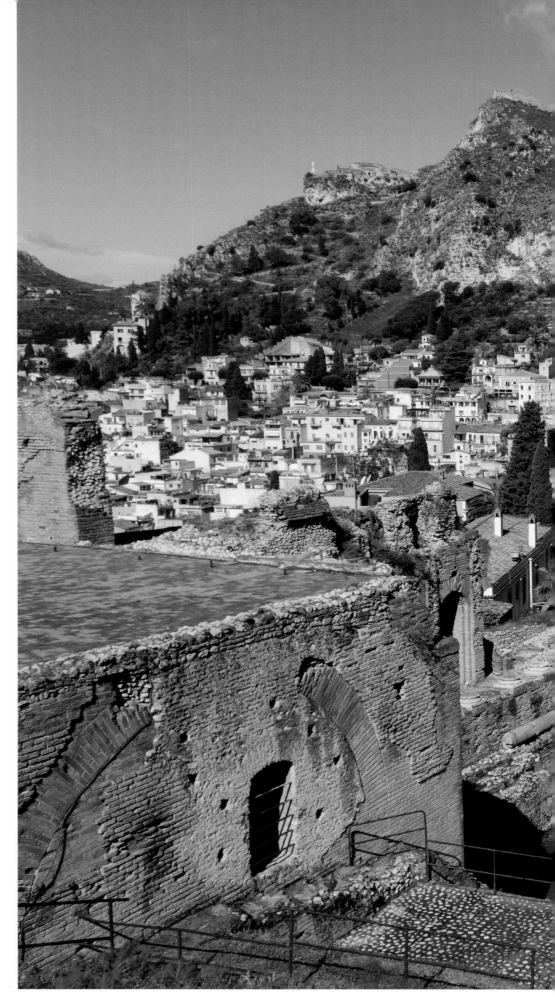

The Greek theatre in Taormina is one of the most celebrated ruins in Sicily, due in equal measure to its historical significance and the remarkable nature of its setting. It is built into the hillside of Monte Tauro, in north-east Sicily, and offers spectacular views of the smouldering Mount Etna. It probably dates from the Roman period of the island's history, but it is built in accordance with the style of Greek theatre. It is regularly used in the summer months for theatre performances and concerts.

Das Griechische Theater in Taormina zählt gleichermaßen aufgrund seiner historischen Bedeutung wie der bemerkenswerten umliegenden Naturkulisse zu den berühmtesten Ruinen Siziliens. Es wurde in den Hang des Monte Tauro im nordöstlichen Sizilien gebaut und bietet eine atemberaubende Aussicht auf den schwelenden Ätna. Es stammt vermutlich aus der römischen Periode der Insel, wiewohl es im griechischen Theaterbaustil errichtet wurde. Und auch heute noch finden während der Sommermonate regelmäßig Theateraufführungen und Konzerte innerhalb seiner Mauern statt.

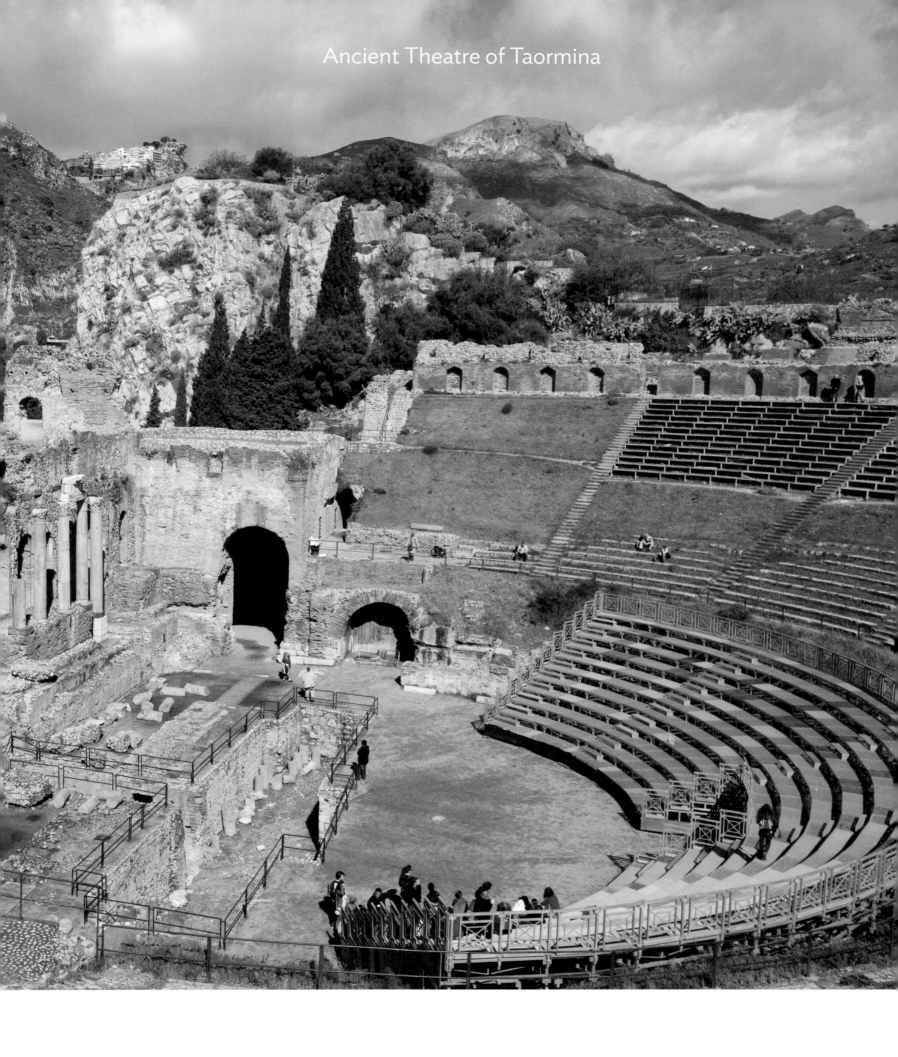

Ancient Theatre of Taormina

Taormina, Sicily, Italy
Early Seventh Century BC

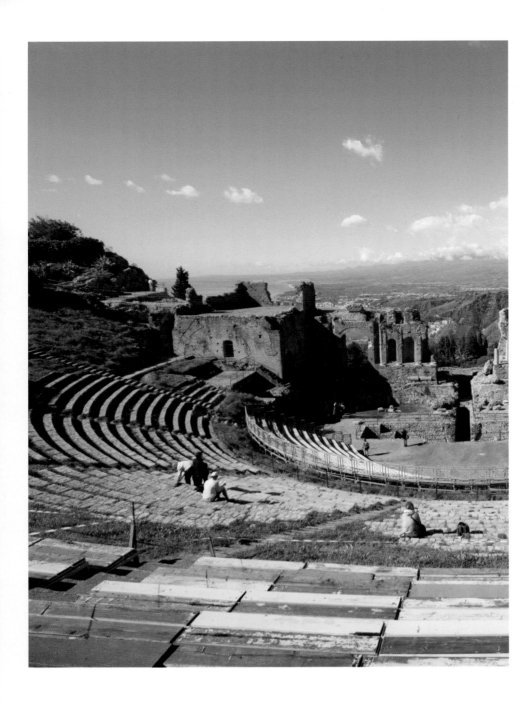

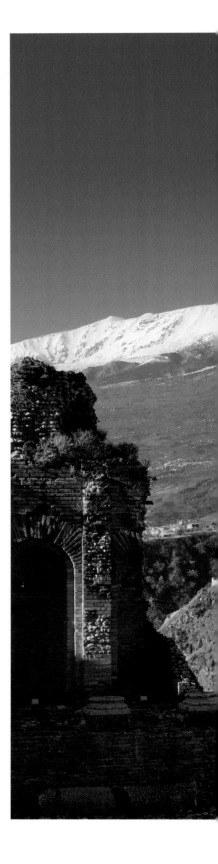

Le théâtre antique gréco-romain de Taormine est l'un des vestiges les plus célèbres de Sicile, tant par son importance du point de vue historique que par la beauté de son cadre. Bâti à flanc du Monte Tauro, au Nord-Est de la Sicile, le théâtre offre un point de vue exceptionnel sur l'Etna toujours fumant. Il date probablement de l'époque romaine de l'île, même si sa construction rappelle davantage les théâtres de style grec. En été, le site accueille régulièrement des représentations ainsi que des concerts.

El Teatro Griego de Taormina es una de las ruinas más célebres de Sicilia, gracias, en igual medida, a su significado histórico y al extraordinario paisaje de su entorno. Está construido en la ladera del Monte Tauro, en el nordeste de Sicilia, y ofrece unas espectaculares vistas del humeante Monte Etna. Su origen remonta, probablemente, al periodo romano de la historia de la isla, pero se erigió siguiendo el estilo de los teatros griegos. Se suele utilizar con regularidad en el período estival para representaciones teatrales y conciertos.

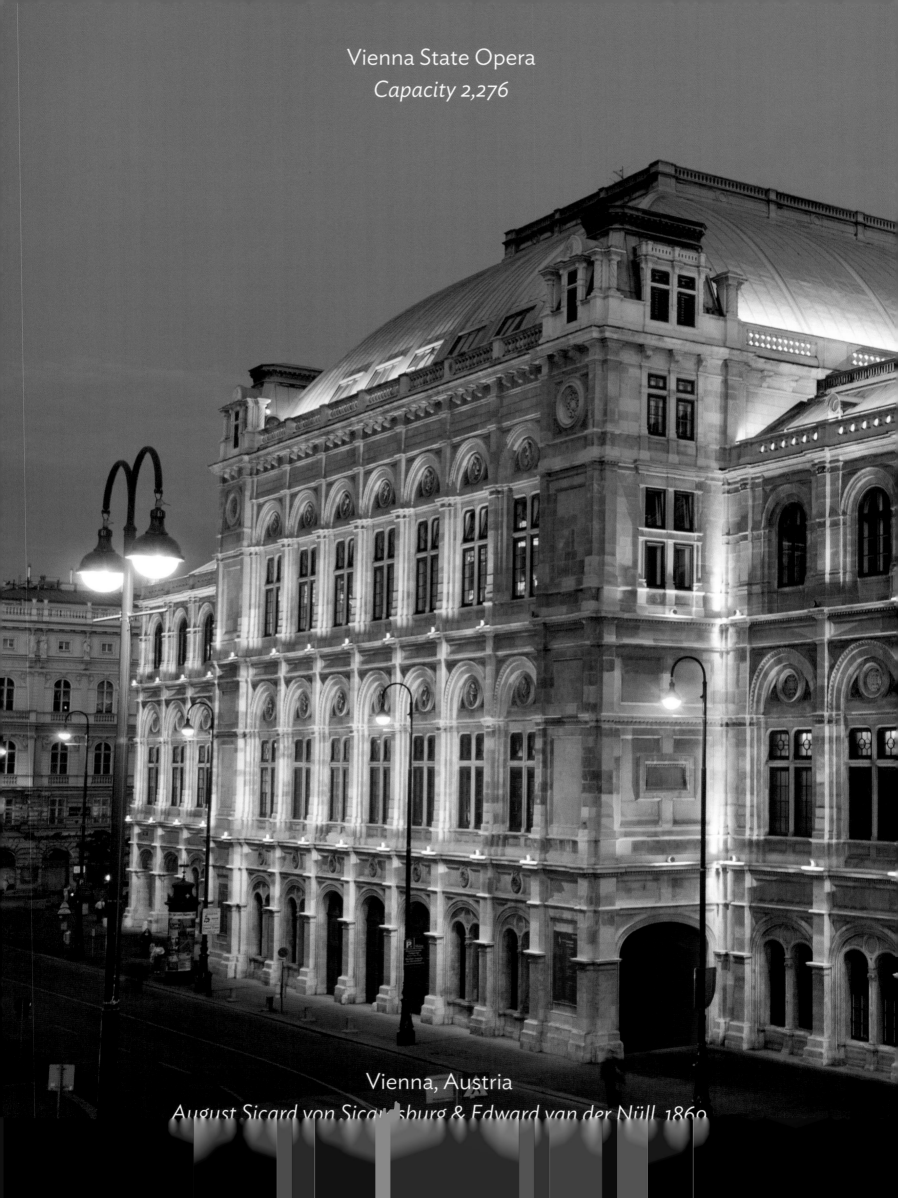

Vienna State Opera
Capacity 2,276

Vienna, Austria
August Sicard von Sicardsburg & Edward van der Nüll, 1869

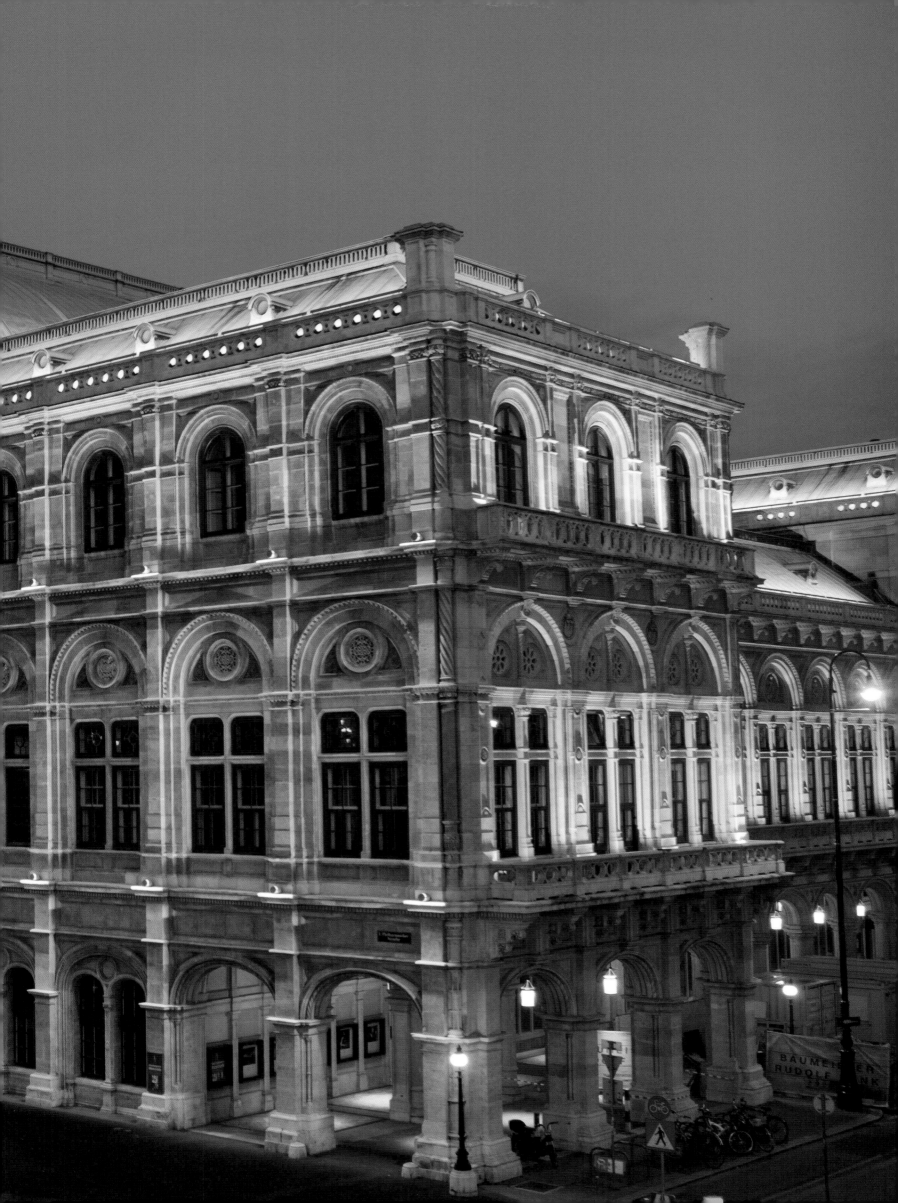

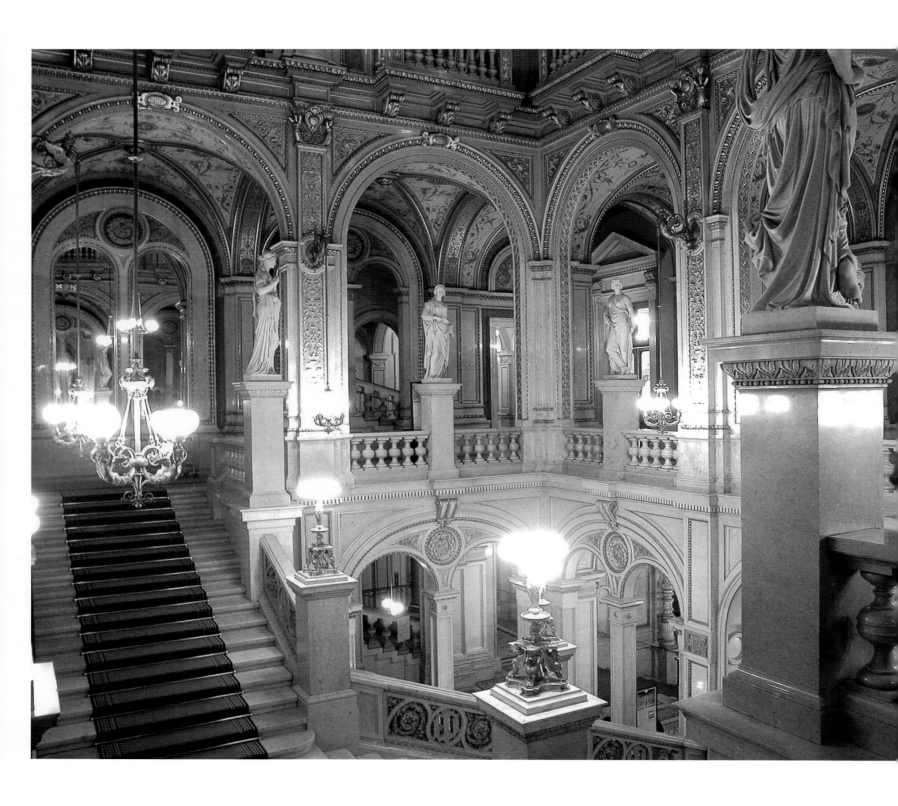

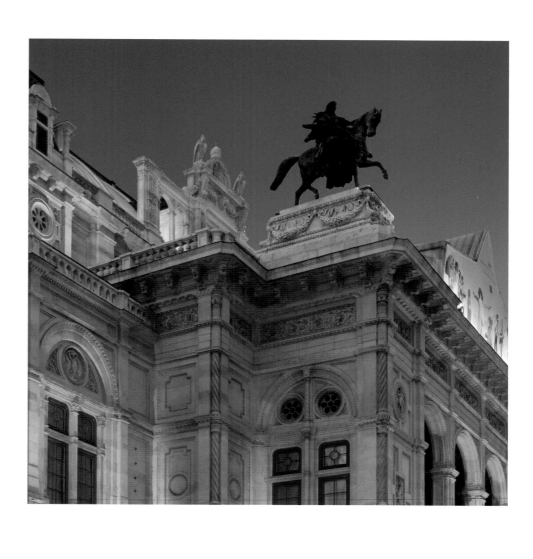

In the 1850s, when an expansion of Vienna led to the creation of the Ringstrasse, replacing the ancient walls of the city with a wide boulevard, a prominent site was reserved for a new opera house. In 1869, the Italian-Renaissance-style building opened with a performance of Mozart's *Don Giovanni*. Late in the Second World War, the opera house was severely damaged by bombs, which gutted the auditorium and stage area. The new interior is in a modern classical style that remains close to the original.

Als im Rahmen der Stadterweiterung Wiens um 1850 die alten Stadtmauern geschleift und durch den breiten Repräsentationsboulevard der Ringstraße ersetzt wurden, sah man einen Standort für das neue Opernhaus in prominenter Lage vor. Im Jahr 1869 wurde das Gebäude im Stil der Neorenaissance mit einer Darbietung von Mozarts *Don Giovanni* eröffnet. Gegen Ende des Zweiten Weltkrieges wurde die Oper durch Bombentreffer schwer beschädigt, wobei vor allem das Auditorium und der Bühnenbereich in Mitleidenschaft gezogen wurden. Das neue im klassisch-modernen Stil gehaltene Innendekor ist stark an die ursprüngliche Ausführung angelehnt.

Dans les années 50, alors que Vienne s'agrandit avec la création de la Ringstrasse, venant remplacer la vieille enceinte de la ville par un large boulevard, un vaste espace fut réservé à la construction d'un nouvel opéra. L'édifice, bâti dans le style de la Renaissance italienne, fut inauguré en 1869 par une représentation du *Don Giovanni* de Mozart. Les bombardements à la fin de la Seconde Guerre mondiale ont gravement endommagé l'opéra dont la salle et la scène furent entièrement détruites. Le nouvel intérieur a été repensé dans un style classique moderne, proche de l'original.

En la década de 1850, cuando la expansión de Viena impulsó la creación de la Ringstrasse, que sustituyó los antiguos muros de la ciudad por un amplio bulevar, se reservó un espacio importante para un nuevo teatro de ópera. En 1869, el edificio de estilo renacentista italiano se inauguró con la representación de *Don Giovanni* de Mozart. Posteriormente, durante la Segunda Guerra Mundial, el teatro de ópera sufrió daños considerables debido a las bombas, que destrozaron el auditorio y la zona del escenario. El nuevo interior presenta un estilo clásico moderno que sigue pareciéndose al original.

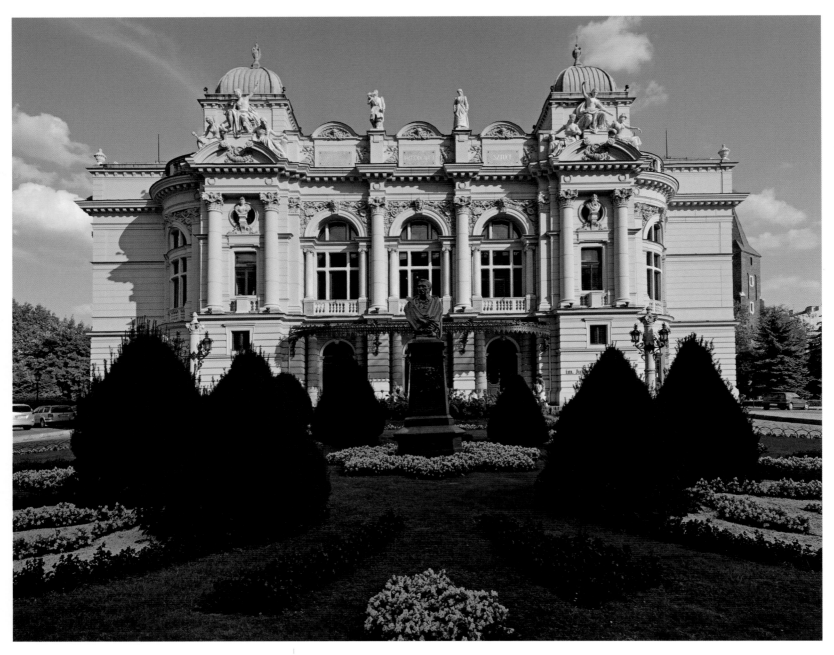

Situated in Holy Ghost Square in Krakow, this theatre gets its name from the Polish Romantic poet and playwright Juliusz Słowacki. It opened during an especially fruitful period in Poland's artistic life. Many from the *Młoda Polska* (Young Poland) generation of artists, including the playwright Stanisław Wyspiański, made their stage debuts here. During the Nazi occupation of Poland, it was run by a German troupe, and it reopened for Polish audiences in 1945. Interiors are decorated with frescoes by Viennese artist Anton Tuch.

Dieses am Heilig-Geist-Platz in Krakau gelegene Theater trägt den Namen des polnischen Nationaldichters und Dramatikers der Romantik, Juliusz Słowacki. Es öffnete seine Pforten während einer für Polens Kunstschaffen besonders fruchtbaren Periode. Zahlreiche Künstler des *Młoda Polska* (Junges Polen), darunter der Bühnenautor Stanisław Wyspiański, feierten an diesem Haus Prämieren. Während der Besetzung Polens durch die Nazis wurde es von einer deutschen Theatertruppe geführt, bevor es im Jahr 1945 für das polnische Publikum wiedereröffnet wurde. Die Fresken der Interieurs gestaltete der Wiener Künstler Anton Tuch.

Edifié sur la place du Saint-Esprit à Cracovie, ce théâtre tire son nom du poète et dramaturge romantique polonais Juliusz Słowacki. Il fut inauguré alors que la Pologne était à l'apogée de son rayonnement culturel. De nombreux artistes issus de la génération *Młoda Polska* (la Jeune Pologne), dont l'écrivain Stanisław Wyspiański, y ont fait leurs débuts. Pendant l'occupation de la Pologne par le régime nazi, le théâtre a été dirigé par une troupe allemande avant de rouvrir ses portes au public polonais en 1945. Le théâtre abrite les fresques intérieures de l'artiste viennois Anton Tuch.

Situado en la Plaza del Santo Espíritu de Cracovia, este teatro recibe su nombre del poeta y dramaturgo romántico polaco Juliusz Słowacki. Se inauguró durante un período especialmente fructífero de la vida artística de Polonia. Muchos de los artistas de la generación de *Młoda Polska* (Joven Polonia), incluido el dramaturgo Stanisław Wyspiański, hicieron su debut teatral en este escenario. Durante la ocupación nazi de Polonia, fue dirigido por una compañía teatral alemana, tras lo que volvió a abrir sus puertas para el público polaco en 1945. Los interiores están decorados con frescos de la mano del artista vienés Anton Tuch.

Juliusz Słowacki Theatre

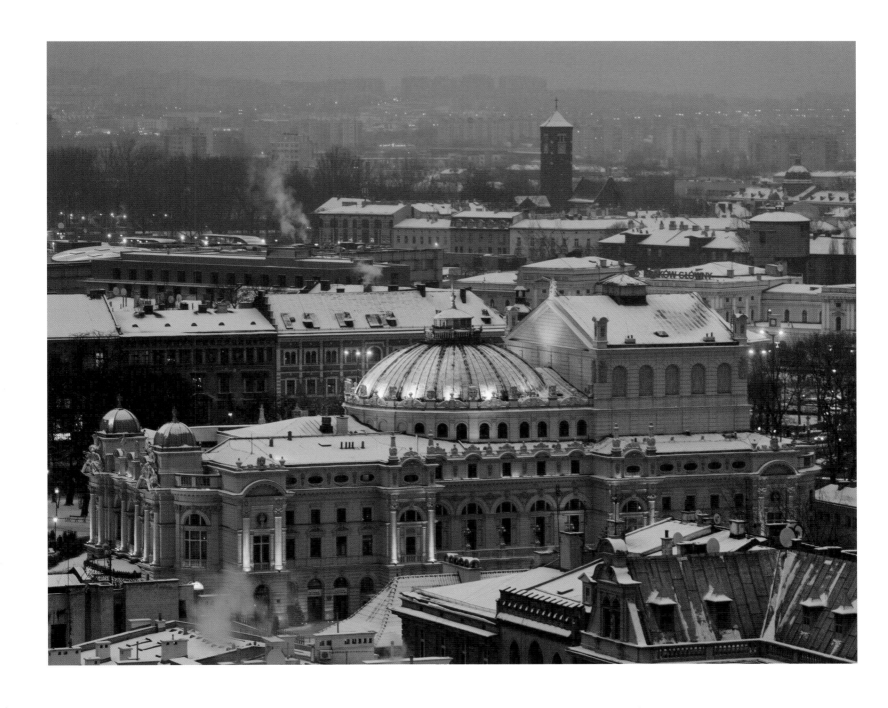

Krakow, Poland
Jan Zawiejski, 1893

Finnish National Opera
Capacity 1,350

Helsinki, Finland
Eero Hyvämäki, Jukka Karhunen & Risto Parkkinen, 1993

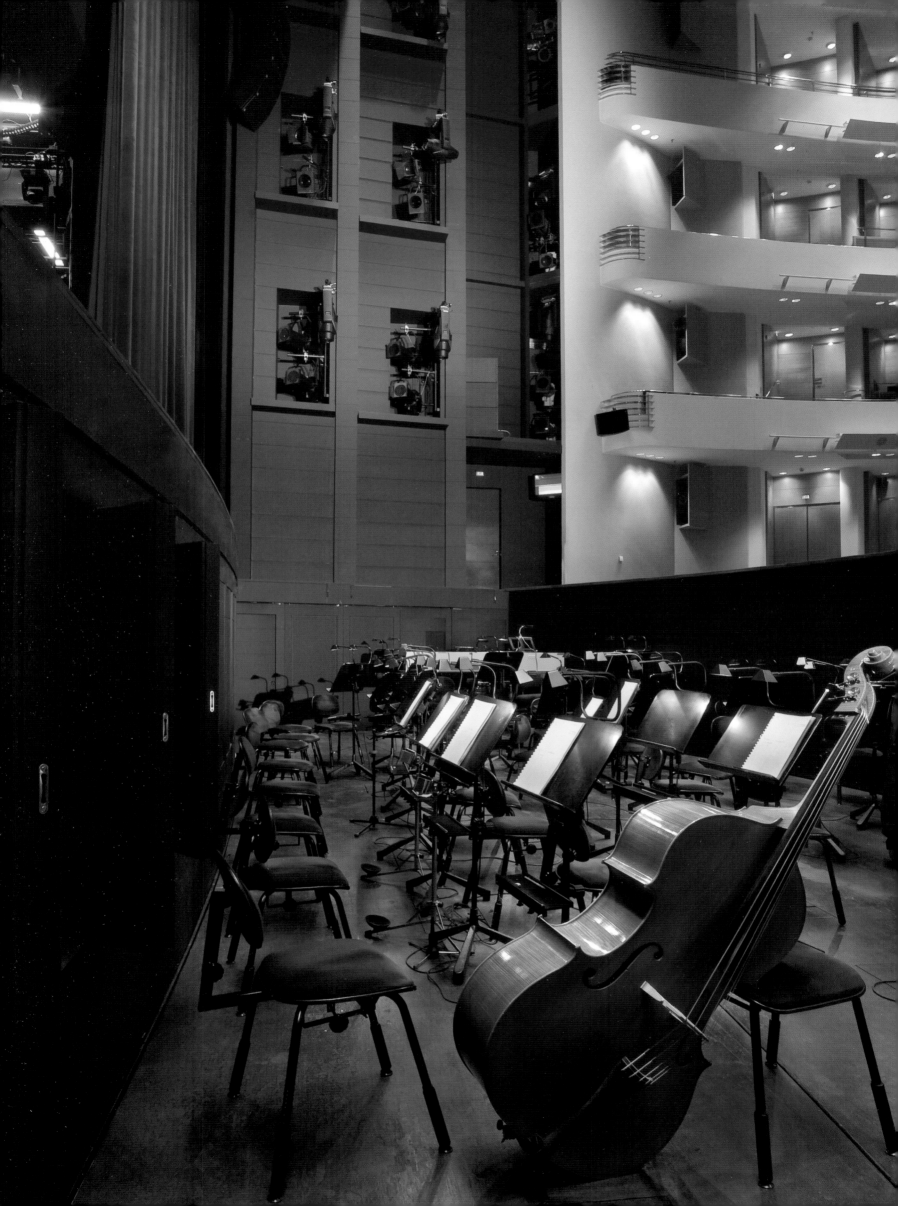

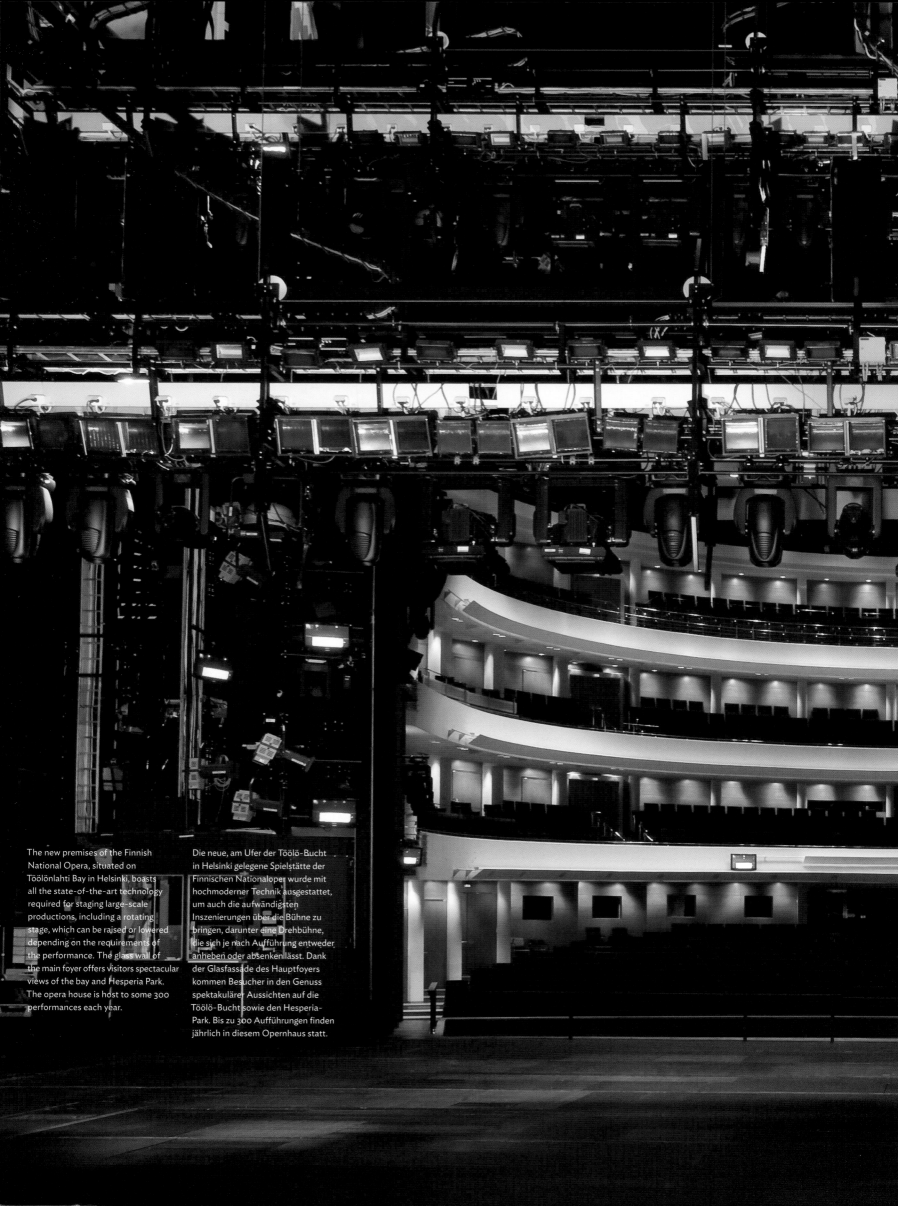

The new premises of the Finnish National Opera, situated on Töölönlahti Bay in Helsinki, boasts all the state-of-the-art technology required for staging large-scale productions, including a rotating stage, which can be raised or lowered depending on the requirements of the performance. The glass wall of the main foyer offers visitors spectacular views of the bay and Hesperia Park. The opera house is host to some 300 performances each year.

Die neue, am Ufer der Töölö-Bucht in Helsinki gelegene Spielstätte der Finnischen Nationaloper wurde mit hochmoderner Technik ausgestattet, um auch die aufwändigsten Inszenierungen über die Bühne zu bringen, darunter eine Drehbühne, die sich je nach Aufführung entweder anheben oder absenken lässt. Dank der Glasfassade des Hauptfoyers kommen Besucher in den Genuss spektakulärer Aussichten auf die Töölö-Bucht sowie den Hesperia-Park. Bis zu 300 Aufführungen finden jährlich in diesem Opernhaus statt.

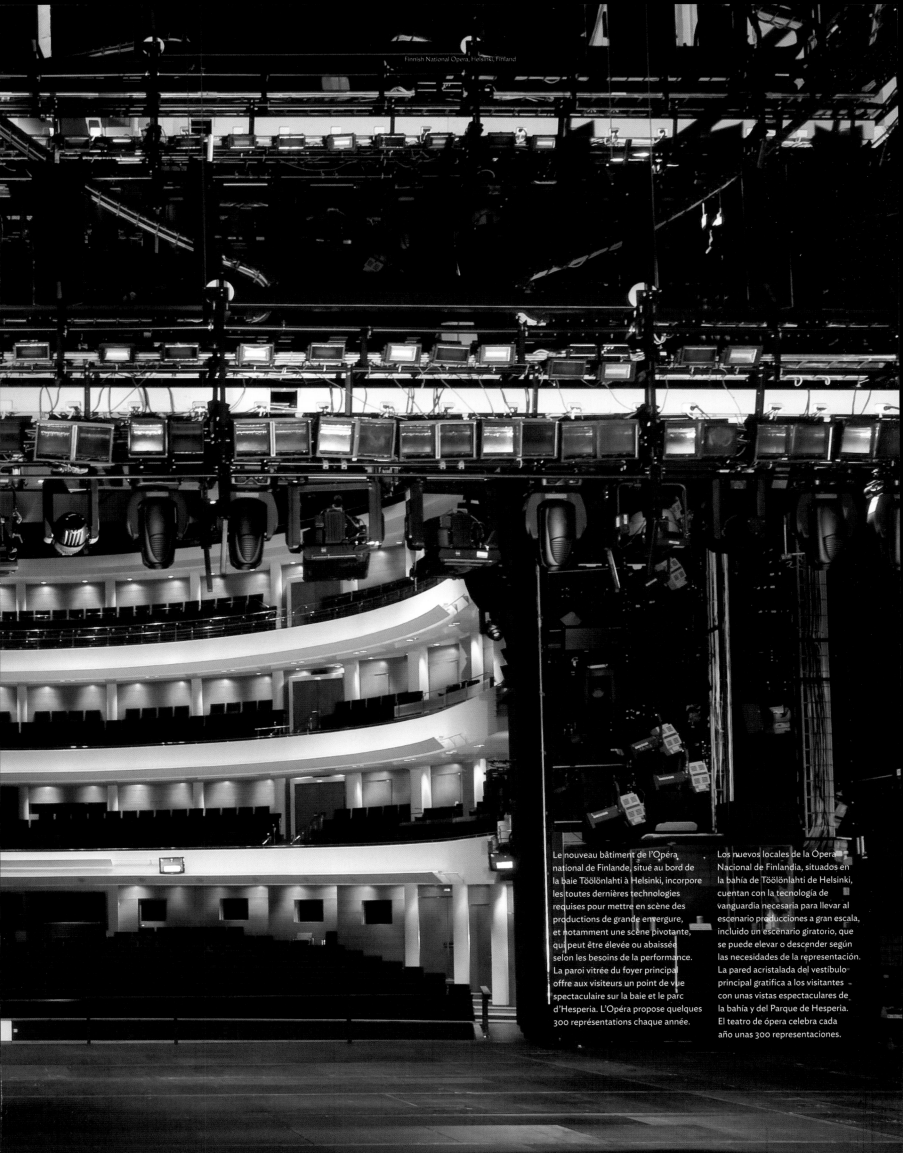

Finnish National Opera, Helsinki, Finland

Le nouveau bâtiment de l'Opéra
national de Finlande, situé au bord de
la baie Töölönlahti à Helsinki, incorpore
les toutes dernières technologies
requises pour mettre en scène des
productions de grande envergure,
et notamment une scène pivotante,
qui peut être élevée ou abaissée
selon les besoins de la performance.
La paroi vitrée du foyer principal
offre aux visiteurs un point de vue
spectaculaire sur la baie et le parc
d'Hesperia. L'Opéra propose quelques
300 représentations chaque année.

Los nuevos locales de la Ópera
Nacional de Finlandia, situados en
la bahía de Töölönlahti de Helsinki,
cuentan con la tecnología de
vanguardia necesaria para llevar al
escenario producciones a gran escala,
incluido un escenario giratorio, que
se puede elevar o descender según
las necesidades de la representación.
La pared acristalada del vestíbulo
principal gratifica a los visitantes
con unas vistas espectaculares de
la bahía y del Parque de Hesperia.
El teatro de ópera celebra cada
año unas 300 representaciones.

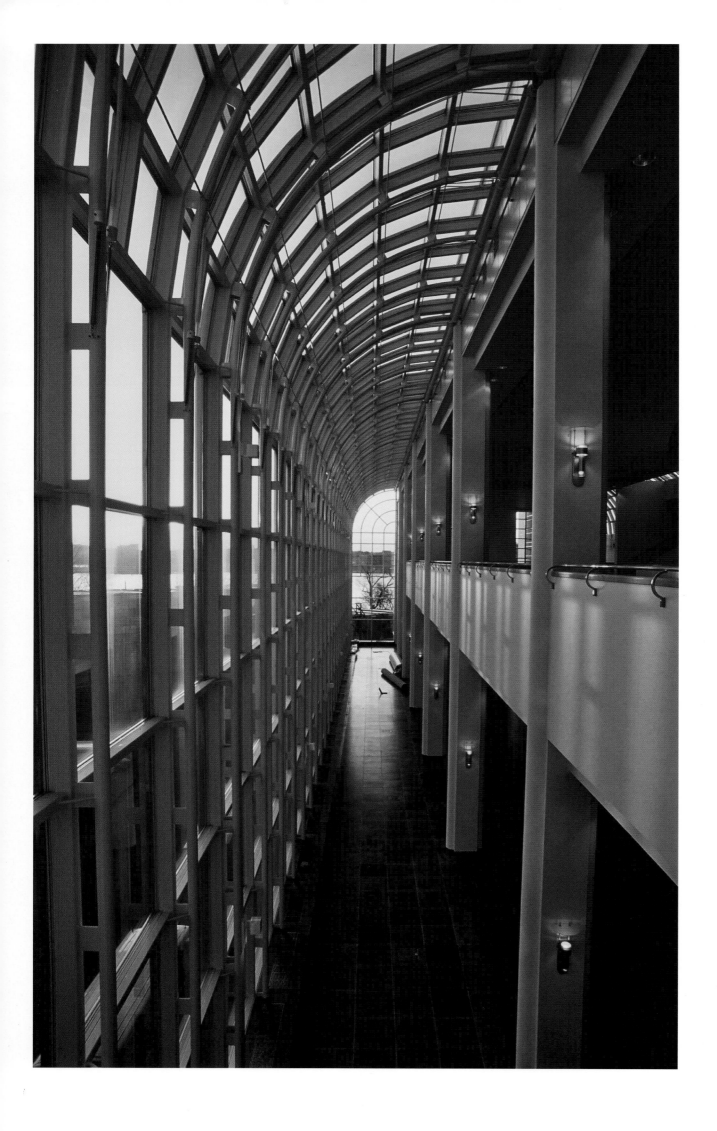

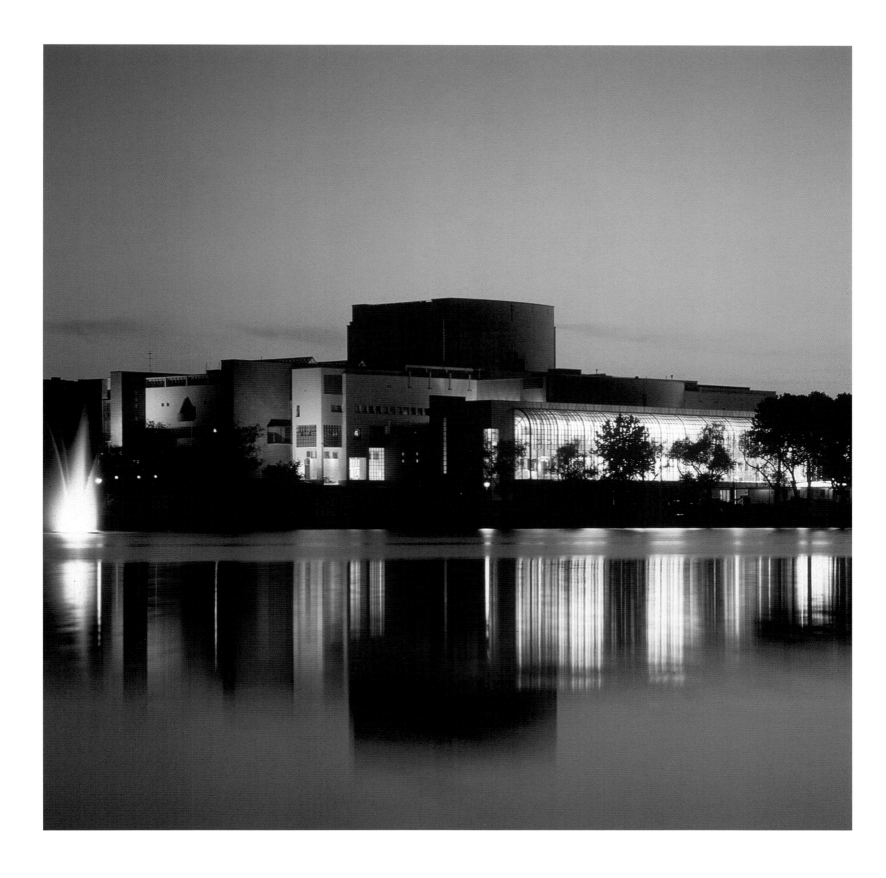

Photography Credits

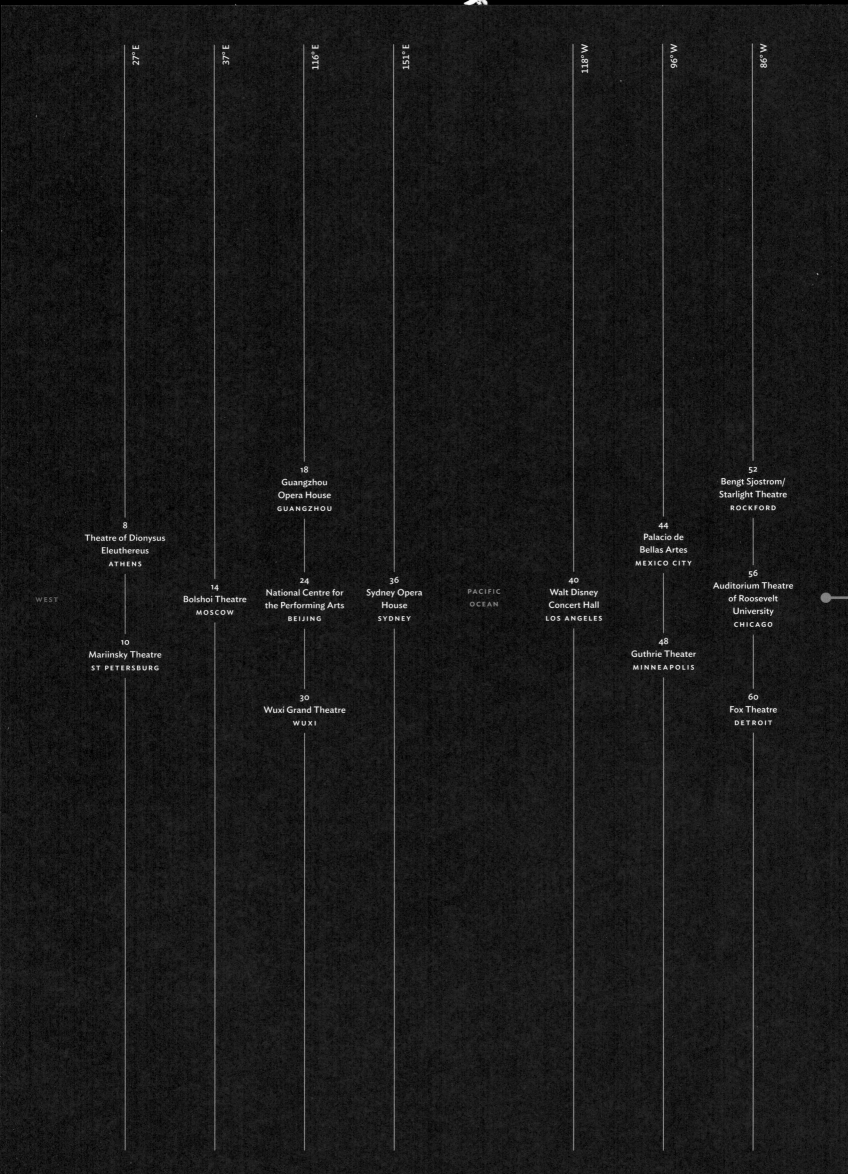

27° E

37° E

116° E

151° E

118° W

96° W

86° W

18
Guangzhou
Opera House
GUANGZHOU

52
Bengt Sjostrom/
Starlight Theatre
ROCKFORD

8
Theatre of Dionysus
Eleuthereus
ATHENS

44
Palacio de
Bellas Artes
MEXICO CITY

WEST

14
Bolshoi Theatre
MOSCOW

24
National Centre for
the Performing Arts
BEIJING

36
Sydney Opera
House
SYDNEY

PACIFIC
OCEAN

40
Walt Disney
Concert Hall
LOS ANGELES

56
Auditorium Theatre
of Roosevelt
University
CHICAGO

10
Mariinsky Theatre
ST PETERSBURG

48
Guthrie Theater
MINNEAPOLIS

30
Wuxi Grand Theatre
WUXI

60
Fox Theatre
DETROIT